The Florilegium

The Royal Botanic Gardens Sydney *Celebrating* **200** *years*

PLANTS OF THE THREE GARDENS OF
THE ROYAL BOTANIC GARDENS AND DOMAIN TRUST

Colleen Morris Louisa Murray

Kew Publishing
Royal Botanic Gardens, Kew

The Florilegium Society at The Royal Botanic Gardens Sydney

Published in 2017 by the Royal Botanic Gardens, Kew to celebrate an exhibition of The Florilegium in 2018 at the Shirley Sherwood Gallery of Botanical Art, Royal Botanic Gardens, Kew

First published in 2016 by The Florilegium Society at the Royal Botanic Gardens Sydney Inc.

ISBN 978 1 84246 649 0

Royal Botanic Gardens, Kew, Richmond, Surrey, TW9 3AE, UK
www.kew.org

Distributed on behalf of the Royal Botanic Gardens, Kew in North America
by the University of Chicago Press, 1427 East 60th St, Chicago, IL 60637, USA.

British Library Cataloguing in Publication Data
A catalogue record for this book is available from the British Library.

We are grateful to Warren Macris at High Res Digital, Stan Lamond and Gil Teague of Florilegium Bookshop for their generous advice and guidance in the publishing of this book.

Colour work/pre-press: High Res Digital
Design: Stan Lamond
Editing: Marie-Louise Taylor
Printed in China by Prosperous Printing (Shenzhen) Co. Ltd, ISO 14001 accredited

Cover: *Wollemia nobilis* (detail), Beverly Allen

For information or to purchase all Kew titles please visit shop.kew.org/kewbooksonline or email publishing@kew.org

Kew's mission is to be the global resource in plant and fungal knowledge, and the world's leading botanic garden.

Kew receives about half of its running costs from Government through the Department for Environment, Food and Rural Affairs (Defra). All other funding needed to support Kew's vital work comes from members, foundations, donors and commercial activities, including book sales.

This book was published with the generous support of the Australian Garden History Society – Kindred Spirits Fund. The fund's purpose is to support the AGHS in carrying out its mission and objectives to foster the scholarly, literary, education, scientific and artistic aspects of the Society and for the advancement of education and other purposes beneficial to the community.

The Royal BOTANIC GARDEN Sydney **The Australian BOTANIC GARDEN** Mount Annan **The Blue Mountains BOTANIC GARDEN** Mount Tomah *Foundation & Friends of the* **BOTANIC GARDENS**

Artists

Mariko Aikawa
Beverly Allen
Gillian Barlow
Sue Bartrop
Christine Battle
Deirdre Bean
Margaret Best
Helen Yvonne Burrows
Linda Catchlove
Deb Chirnside
Gillian Condy
Rosemary Joy Donnelly
Elisabeth Dowle
Delysia Jean Dunckley
Lesley Elkan
Helen Lesley Fitzgerald
The Hon. Gillian Foster
Leigh Ann Gale
Mayumi Hashi
Anne Hayes
Cheryl Hodges
Tanya Hoolihan
Annie Hughes
Nalini Kumari Kappagoda
Jee-Yeon Koo
Angela Lober
David Mackay
Elizabeth Mahar
Beth McAnoy
Fiona McGlynn
Fiona McKinnon
Maggie Munn
Elaine Musgrave
Julie Nettleton
Dorothee Nijgh de Sampayo Garrido
Kate Nolan
Anne O'Connor
Susan Ogilvy
Tricia Oktober
Annie Patterson
John Pastoriza-Piñol
Jenny Phillips
Margaret Pieroni
Gabrielle Pragasam
Penny Price
Marta Salamon
Sandra Sanger
Robyn Seale
Laura Silburn
Shirley Slocock
Halina Steele
Sally Strawson
Dianne Sutherland
Narelle Thomas
Vicki Thomas
Anita Walsmit Sachs
Ruth Walter
Noriko Watanabe
Catherine M Watters
Colleen Werner
Marion Westmacott
Hazel West-Sherring
Sue Wickison
Jennifer B Wilkinson

Contents

Preface Dr Brett Summerell . 7

Foreword Dr Shirley Sherwood OBE 9

Introduction Beverly Allen .11

Historic Overview Colleen Morris14

The paintings .21

Botanical descriptions Louisa Murray

Historic text Colleen Morris

Endnotes. .196

References. .199

Biographies . 200

Select bibliography .222

Index .223

Acknowledgement of subscribers224

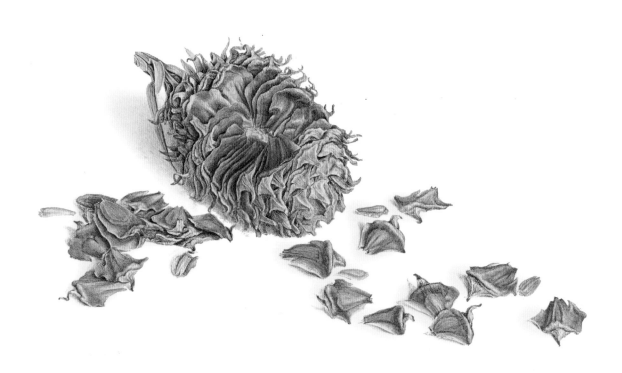

Preface

The plant kingdom is full of a myriad of forms, displaying adaptations that allow them to survive, colonise and thrive in almost all the environments on Earth. These evolutionary adaptations come in the most surprising, beguiling and beautiful forms, and as a consequence it is not surprising that artists have been drawn over the centuries to portray them in a variety of ways and forms. Of course, there is no better attribute of plants than the flowers they produce and the way in which the evolutionary process has responded to habitats and ecological niches, relationships with pollinators and the need to disperse genes in an astonishing array of forms, structures and colours that is breathtaking. Almost equally other attributes of the plant, the leaves, stems and trunks, also provide rich fodder for those with an artistic perception.

When I viewed the collection in this florilegium, I was immediately drawn to the processes that had resulted in the evolution of these species of plants. The specificity of the adaptations to allow survival in unique locations and habitats or to entice bird or insect pollinators are amazing and are portrayed in great detail. A number of orchids are included, and here the adaptations reach a pinnacle and the specificity of the interaction between the plants and their pollinators has fascinated biologists for centuries, most famously intriguing Charles Darwin for much of his life. Also included are species such as the Wollemi Pine, a so-called 'living fossil' that appears to have remained unchanged hidden in a gorge in Wollemi National Park till its 'discovery' in 1994.

An organisation like the Royal Botanic Gardens and Domain Trust, and indeed any other major botanic garden, will always focus on both the need to provide information about plants and their forms and the desire to highlight the diversity and beauty of plants. Plant illustrations and botanical art allows the observer to see all of the features of a plant at one time and has been a key way in which we have communicated information about species of plants. The botanical art displayed in this book is definitely at the high end of the spectrum; these are works of incredible accuracy and of undeniable beauty that fully respect the plants they portray.

I am so pleased that this florilegium was completed to commemorate the bicentenary of the Royal Botanic Garden, Sydney. It is a fitting celebration of the diversity of plants that grow in the three gardens that make up our organisation, and a clear statement that what we do is focused on plants! It is also an appropriate recognition of the importance of plants to humanity and all the other forms of life, and a reminder that our sustainability is truly dependent on their continued existence.

Dr Brett Summerell

Director Science and Conservation
Royal Botanic Gardens and Domain Trust
November 2015

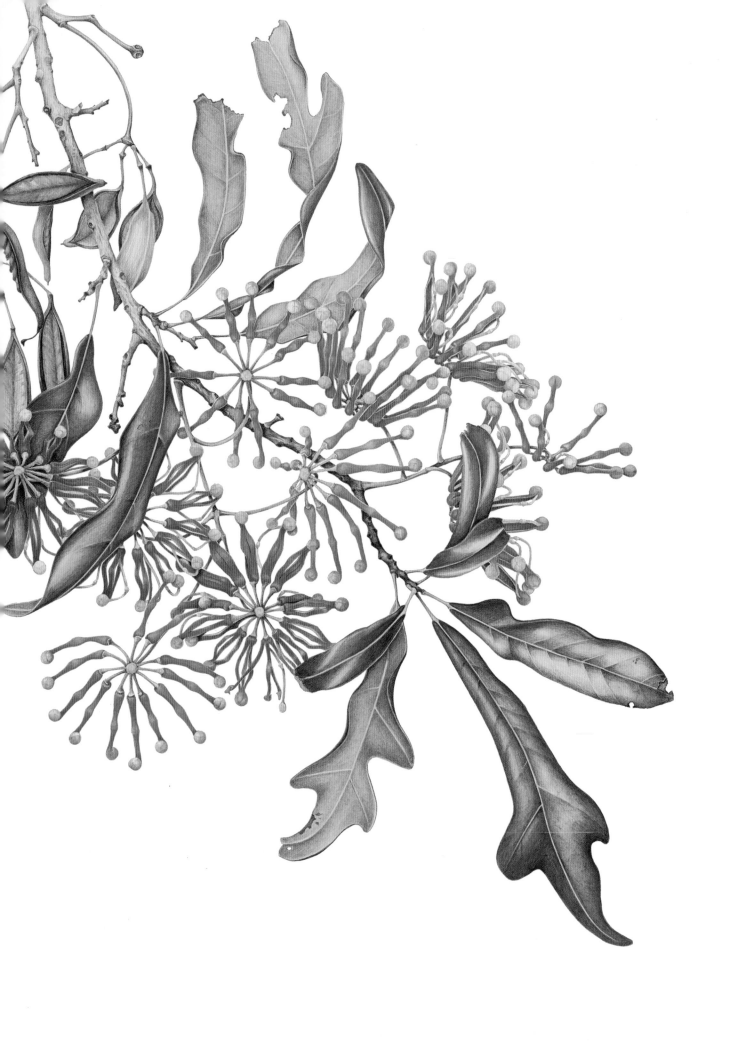

Foreword

I am very honoured to be the Patron of this splendid Florilegium Society at the Royal Botanic Gardens Sydney. I am also particularly delighted to learn that the exhibition I opened in Sydney in 1998 of my collection of contemporary botanical artists' work had such a significant effect on Australian botanical artists. I remember saying at the end of my lecture, 'Now it's up to you!' Many took up the challenge and paved the way for this florilegium.

While I was in Sydney I had organised a class taught by Jenny Phillips, and we took the students to the Museum of Sydney to see Ferdinand Bauer's paintings from his voyage with Matthew Flinders. These were on view at the same time as my exhibition. Although the Bauer paintings were normally stored in London at the Natural History Museum, I had never seen them before. It was a wonderful experience (and an inspired yet subdued class that returned with us to the studio).

Only a year later, I visited Lion Gate Lodge where curator Margot Child had taken up my challenge and had mounted the first *Botanica* exhibition with the Friends of the Garden. This became an annual show and I bought a number of paintings there, including a spectacular yellow lotus by Beverly Allen.

The concept of a florilegium was revived by Anne-Marie Evans at the Chelsea Physic Garden in 1995, where her students started to make plant portraits of specimens currently growing in the garden. The idea was embraced, and a number of other florilegia were initiated including a florilegium for Highgrove, the Prince of Wales's garden,

and two in the United States. *Botanica* was showcasing some excellent work and Beverly and Margot felt that a florilegium in Sydney, to cover the three gardens in New South Wales, would be feasible. It was formed in 2005.

Most of the artists are from Australia (41), but there are 13 well-known artists from the United Kingdom, one each from France, the United States of America, Canada, The Netherlands, Korea and New Zealand, and two each from South Africa and Japan. I was pleased to see there is a sizeable number of artists who are also represented in the Shirley Sherwood Collection.

The result has been a superb body of work, documenting plants in the Royal Botanic Garden, Sydney and the Domain, the Australian Botanic Garden, Mount Annan and the Blue Mountains Botanic Garden, Mount Tomah. There are paintings of a wealth of specimens creating an invaluable record of both the indigenous Australian plants as well as introductions from Asia, the Americas, South Africa and Europe. The standard of the plant portraits is so high and the text so illuminating that this has made a memorable book and exhibition in the Museum of Sydney celebrating 200 years of the Royal Botanic Gardens, Sydney in 2016.

Now I am delighted that there will be another exhibition at the Shirley Sherwood Gallery of Botanical Art, Kew in 2018, at a time when Kew's splendid historic Temperate House is re-opening after extensive restoration. The exhibition will include a number of paintings of the freshly planted flora.

Dr Shirley Sherwood OBE
August 2017

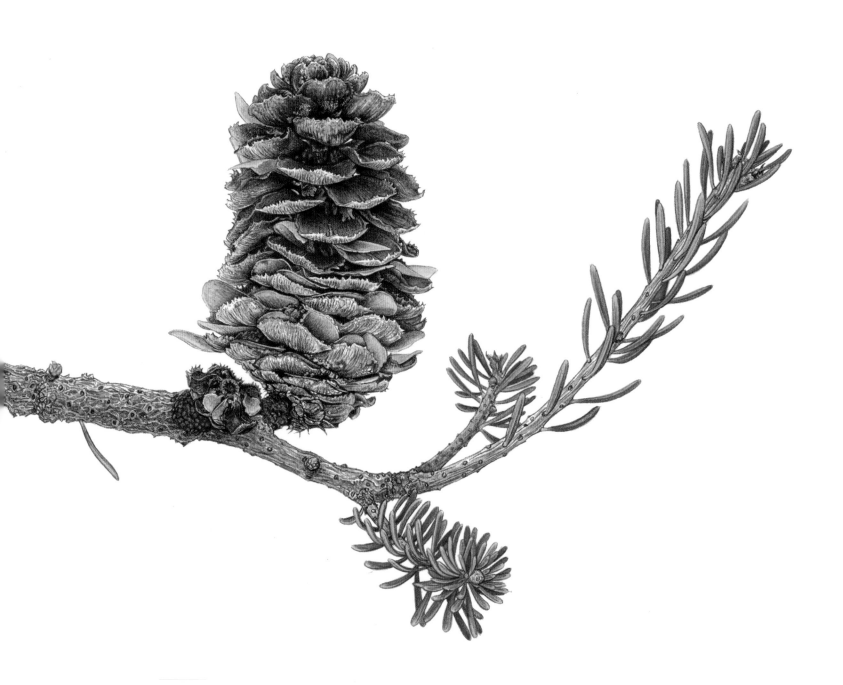

Introduction

The Florilegium Society at the Royal Botanic Gardens Sydney Inc was formed to create a collection of contemporary botanical paintings of plants in the living collections of the Royal Botanic Gardens and Domain Trust (the Trust). These original paintings and the copyright have been gifted to the Trust by the artists and are held in the Daniel Solander Library in the National Herbarium of New South Wales. They join one of the most important collections of botanical and horticultural reference in Australia, from Dioscorides' *De Materia Medica* (1150) and Ferdinand Bauer's 1813 *Illustrationes Florae Novae Hollandae* to *Banks' Florilegium, The Banksias* and *The Highgrove Florilegium*.

The word 'florilegium' is now generally used to describe a collection of paintings of a particular garden or place. It was first used by the artist Adriaen Collaert (1560–1618) for his work entitled *Florilegium* and published in 1590 in Antwerp. Unlike the earlier herbals, Collaert's *Florilegium* focused on the beauty of the plant rather than on its medicinal value.

Many fine florilegia were produced in the following 250 years, notably Pierre Vallet's *Le Jardin du Roy tres Chrestien Louis X1V* (1608), Basilius Besler's *Hortus Eystettensis* (1612) and the *Vélins du Roi*, a superb collection of paintings on vellum by Nicholas Robert (1614–1685), Gerard van Spaendonck (1746–1822) and Pierre-Joseph Redouté (1759–1840). Redouté's work in painting, engraving and publishing was outstanding, and his influence on botanical artists remains today. *Histoire des plantes grasses, Les Liliacées* and *Les Roses* are among many of his notable works. *Jardin de la Malmaison* portrayed many plants from Australia, reflecting the scientific interest and plant exchanges between France and Australia at the time. Sir Joseph Banks' plates from Sydney Parkinson's drawings of Australian flora were prepared in the period 1771–84,

although nearly 200 years passed until 1980 when they were printed as intended.

After this 'golden age of botanical art' between 1750 and 1850, there followed a hiatus until the mid 20th century. With the present renaissance of botanical art, the creation of florilegia is also being revived. Now it is often groups of artists who are the driving force in creating collections to record plants growing in particular gardens, both botanical and historic, and of species that are now rare and endangered, rather than those of earlier times which celebrated newly collected curiosities and exotics from afar.

In 1995, the Chelsea Physic Garden Florilegium Society was the first of many societies formed in association with botanical institutions or historic gardens. It was soon followed by the Brooklyn Botanic Garden and Filoli Garden in the United States of America, the Sheffield Botanic Garden, the Eden Project and Hampton Court Palace Gardens in the United Kingdom to name but a few. The Japanese Society of Botanical Artists created a florilegium of indigenous rare and endangered species and *The Highgrove Florilegium* was published by the Prince of Wales's Charitable Trust. *The Government House Florilegium Victoria* was published by the Botanical Art School of Melbourne. Many of our artists have contributed to these and other recent florilegia.

The genesis of our Society can be traced to two landmark exhibitions held in Sydney in 1998. *An Exquisite Eye*, curated by Peter Watts and Jo Anne Pomfrett at the Museum of Sydney, exhibited Ferdinand Bauer's superb paintings of Australian flora and fauna, painted between 1801 and 1820 after his epic voyage on the *Investigator* with Matthew Flinders. These paintings had rarely been seen and never in Australia. They were a revelation, exquisite works of fine detail and vibrant colour.

Concurrently the Shirley Sherwood Collection of Contemporary Botanical Art was shown at the SH Ervin Gallery. It exemplified the renaissance in this genre as it encompassed a broad diversity of painting styles and new approaches to the subjects, chosen with a discerning and scientific eye. Dr Shirley Sherwood OBE had been collecting since 1990, actively seeking and supporting artists around the world. Since 1996 her collection has been shown in many prestigious venues, from the Smithsonian Institute in Washington to the Marciana Library in Venice and the Ashmolean Museum in Oxford. This has stimulated a greater public appreciation of botanical art and raised the standard. We are honoured to have Dr Sherwood as patron of our Society.

More than two hundred years separated the paintings in these two exhibitions, a new world had been revealed and I was not alone in being inspired. The Friends of the Gardens held the inaugural *Botanica: The Art of the Plant*, in the Lion Gate Lodge in the Royal Botanic Gardens Sydney in 1999. Since then *Botanica* has flourished as an internationally recognised and successful annual exhibition of contemporary botanical art.

With the high quality of works being shown, former *Botanica* curator Margot Child and I believed we could well begin a florilegium, and in 2005 we proposed a self-funded voluntary project to Dr Tim Entwisle, then Executive Director of the Trust, who gave his enthusiastic support. It was endorsed by the Trust, which is represented on our committee. The paintings donated would create a historical record of the plants growing in the three Gardens in the ten years prior to the bicentenary of the Royal Botanic Gardens Sydney in 2016.

To focus on some of the more significant plants in the three Gardens, Professor Carrick Chambers, a former Director (1986–96), in consultation with the curators at each Garden, created a list that reflected its collection and function. When the Trust's plans to commemorate 2016 were evolving and publishing the florilegium was considered, the list was further edited by garden historian

Colleen Morris. The species selected by the artists are representative of how the living collections have developed over 200 years.

It was evident from those two influential exhibitions in 1998 that over time the artistic image, the plant 'portrait' and the scientific illustration had a shifting focus and productive reciprocal influences. The common denominator is the true representation of nature. This informed our approach to the style of painting that would give the florilegium a broad appeal and celebrate the beauty of the plant in a botanically accurate portrayal.

Leonardo da Vinci (1452–1519) and Albrecht Dürer (1471–1528) are two of the earliest artists to draw from life and focus attention on plant detail – and this is the approach used in these works. The medium is watercolour on paper, the method of choice for naturalistic painters since then.

The plants are painted life-size, unless noted otherwise on the painting, and most are reproduced in this book at about half of the painted size. Some show the plant in its entirety, some the flower and fruiting bodies; in others, the focus is that most recognisable and showiest of structures, the flower, further playing out its biological role in attracting attention. Several combine an aesthetic objective with the scientific and include habit and fine morphological detail. The different painting styles typify an individual artistic response to the plant, and this is evident in the collection.

These diverse approaches reflect the backgrounds and interests of the artists. The majority are professional artists and illustrators, while others are highly skilled amateur artists who paint for their own, and our, pleasure. As their biographies reveal, they are from many artistic fields and a variety of professions and disciplines. Most of the artists live too far away to enjoy the Gardens, particularly those who joined when membership was extended to overseas artists in 2013.

Botanical art demands patient and detailed observation of the subtleties of form and structure, fine drawing skills

and technical expertise in analysing and applying colour, as well as an ability to compose the painting in a pleasing manner in order to draw attention to the plant. To achieve a true representation they are painted from life, their transience a challenge to the artist as well as an inspiration.

This process of exploration and observation rewards artists with an insight into the diversity and intricacy of pattern, colour and design created in nature, a world beyond imagination. The best of botanical art serves science and inspires the senses, and evokes the emotional and intellectual responses that we call art.

The attentive viewer can now share the journey of exploration that has inspired these paintings. And perhaps future visits to these Gardens will be enhanced, and the viewer will be able to explore them afresh, with a more informed eye. We hope these artworks offer an insight into the Gardens' history and the richness of their living collections.

We were delighted that Sydney Living Museums showcased the florilegium at the Museum of Sydney from July to October 2016 in a major exhibition exploring the role of the Gardens and their influence on the private gardens, landscapes and public parks of New South Wales since 1816. Our grateful thanks go to Colleen Morris for instigating and writing the exhibition proposal; for her unstinting support of the publication and exhibition projects as well as for sharing her extensive knowledge of the Gardens' history in her overview essay and the text that accompanies and enriches each painting.

We thank the Trust for their support and permission for the scientists to advise us and for allowing Louisa Murray, *Flora of NSW* botanist, to write the botanical descriptions for the text. For the encouragement and advice we have received from the staff – the botanists, horticulturists, gardeners, Library staff and volunteer guides – we are most grateful. We offer our sincere thanks to Dr Brett Summerell, Director Science and Conservation, for his support and for so kindly writing the preface.

So many people have helped us since the Society began and in the publishing of this book. Margot Child created a sound structure for the Society and her support and counsel is truly appreciated. I thank each of our members who served on the committee, and Robyn Macintosh and our supporting members for facilitating the subscriber program. Our subscribers generously contributed to the production costs of publishing and we are most grateful for their support. Angela Lober's assistance in compiling the artists' biographies was invaluable. As one of our founding committee members, Sue Maple-Brown AM has provided constant encouragement and generous support for both the exhibition and the publication, and we are most grateful to her.

Our sincere thanks are offered to Dr Shirley Sherwood OBE for her contribution to botanical art over the last 25 years, for her patronage and encouragement, and for graciously writing the foreword.

To our honorary members who endorsed a fledgling project, we thank you for your trust: Dr Pamela Bell OAM, the late James J White and Lugene Bruno of the Hunt Institute for Botanical Documentation, Anne-Marie Evans MA FLS, Robyn Macintosh, Jenny Phillips FLS, Celia Rosser OAM Hon MSc Hon LLD Monash, Margaret Stones AM MBE Hon DSc Louisiana State and Melbourne, and Gil Teague.

Finally and most importantly, I thank the artists for creating this florilegium to commemorate 200 years of the Royal Botanic Gardens Sydney. It is a lasting tribute to this fine institution and to their skill and generosity.

Beverly Allen

President
The Florilegium Society at the Royal Botanic Gardens Sydney Inc

Historic Overview

When a botanist first enters on the investigation of so remote a country as New Holland, he finds himself as it were in a new world. ... Whole tribes of plants, which at first sight seem familiar to his acquaintance ... prove [to be] total strangers, ... not only all new species that present themselves are new, but most of the genera, and even natural orders.[1]

The extraordinary flora of the east coast of Australia had beguiled Sir Joseph Banks in 1770, and he directly influenced the decision to establish a penal colony in New South Wales (NSW). For the people of the First Fleet, who arrived in 1788, the trees and shrubs were strange and new, barely a leaf resembled the nature they had left behind. Tall eucalypts surrounded Sydney Cove, Swamp Oak and Port Jackson Fig grew near the shoreline with ferns and Cabbage Tree Palm along the streams that fed into the coves. Vegetation was immediately cleared to establish a small farm to the east of the settlement on Sydney Cove, simply named Farm Cove by the European newcomers. Its significance lies not in its underwhelming agricultural success, but as the site later chosen for the Government Garden, Australia's first botanic garden.

Explorers and plant collectors sought plants that would be valuable for commerce as well as satisfying a fascination for new species. Captain Arthur Phillip, the first Governor, carried instructions from London to investigate the viability of using Norfolk Island Pine (*Araucaria heterophylla*) for ships' masts, and a party was sent to the nearby island almost immediately. Although the wood of this species proved decidedly unsuitable as a building material, the stately tree became prized for its ornamental use.

Sir Joseph Banks maintained his interest in the young colony and his fascination with Australian flora, sending botanists to expand both his own and the Kew Gardens collections. David Burton, George Caley, Robert Brown (and with him the botanical artist Ferdinand Bauer), George Suttor and Allan Cunningham all worked under the aegis of Banks.

The Domain, attached to First Government House, was land set aside for the Crown by Governor Arthur Phillip in 1792, just prior to his departure. In 1807, Governor William Bligh declared it was for the express use of the Governor's residence, named it the Government Domain and began clearing it of leased farms. It was Bligh's successor, the fifth Governor, Lachlan Macquarie and his wife Elizabeth who enclosed The Domain and began improving it. English oaks, relatively short-lived in the Sydney climate, were among their first avenue plantings. In 1814, Macquarie planted a Norfolk Island Pine at 'the intended grand entrance' to the new Government Garden on the site of the 1788 farm at the head of Farm Cove and within The Domain. Mrs Macquarie planned a road to her favourite vantage point overlooking Port Jackson. It was opened on her birthday, 13 June 1816, the date later taken as the foundation date for the Royal Botanic Garden, Sydney.

Macquarie assigned Scottish gardener and soldier, Charles Fraser, as a botanical collector in 1816. Allan Cunningham, appointed as King's Botanist, arrived in late 1816 and Fraser was named Colonial Botanist before both men set off on Surveyor John Oxley's 1817 expedition to the Lachlan River marshes. For botany in NSW, it was a wonderful synchronicity – both men were the same age; the Kew-trained Cunningham had expertise and Fraser energy with a keen capacity to learn. Cunningham's collections went directly to Banks and Kew, while Fraser, who was also the first Superintendent of the Sydney Botanic Garden, collected for Earl Bathurst, Secretary of State for the Colonies, for the new Government (Botanic) Garden in Sydney and for plant exchange with like institutions.

Together and individually the two men, particularly Cunningham, collected a vast number of new species.

Among the most striking species for horticultural use that Cunningham and Fraser collected were those of the subtropical rainforest, a planting theme that later directors at Sydney Botanic Garden reinforced. Collecting, experimenting, acclimatising and exchanging plants at Sydney's Garden were central to the establishment of agriculture, commerce and horticulture in New South Wales. In 1818, Fraser took charge of the 'Exotics' in the Government Garden. International plant exchange commenced and brought a wealth of both new and well-known plants to Sydney gardens. From the Botanic Garden's beginning, there was a direct relationship between collecting, exchanging and the horticultural display.

Among the earliest introductions to the Government Garden prior to 1820 and Fraser's official appointment as Superintendent in 1821 were species collected in New Zealand, NSW and Van Diemen's Land (Tasmania) as well as plants cultivated from seeds sent from Europe and from India by Nathaniel Wallich, Superintendent of the East India Company's Calcutta Botanic Garden. In the 1820s plants were exchanged with Rio de Janiero, Cape Town, Marseilles and Macao, with Charles Telfair of Pamplemousses (the Botanic Garden of Mauritius), with Liverpool Botanic Garden, with Loddiges nurserymen in Hackney and plants came from John Reeves in Canton, among others. By far the most plants came from André Thouin of the *Jardin des Plantes* in Paris, reflecting the immense interest French scientists had in Australia. In 1827–28, Fraser carefully recorded the introductions of the previous decade. This manuscript catalogue provides an invaluable record of the early development of the Garden. Fraser corresponded and exchanged plants with William McNab of the Royal Botanic Garden, Edinburgh; William Hooker, then Professor of Botany at Glasgow; and Stewart Murray, Superintendent of the Glasgow Botanic Garden. Hooker, in particular, became a regular correspondent and published Fraser's accounts of trips to the Swan River, Western Australia, and Moreton Bay, Queensland.

Following Fraser's death in 1831, the well-established mode of plant exchange continued under Acting Superintendent John McLean. Although Sydney was remote from London and Europe, it was the scientific centre for newly developing Australian colonies such as the Swan River Colony in Western Australia and Port Phillip (Melbourne). Kew-trained botanist Richard Cunningham, who had catalogued the species arriving from Banks' collectors, was Superintendent from 1833 until his death on an 1835 expedition. Richard Cunningham continued the development of the Lower Garden with its informal layout. This new garden was to the north of the earliest part of the Garden, the Middle Garden, which had the rectangular layout of a systematic garden. In 1834, visiting Austrian noble and botanist Baron Charles von Hügel, who found the mixture of plants in the garden remarkable if haphazardly arranged, described the new area:

> *This contains many plants from Moreton Bay and the north coast, which were brought in by A. Cunningham. The choicest of these plants include Araucaria Cunningham, Grevillea asplenifolia (a tree), Agnotis, some species of Ficus and several plants from King George Sound,... such as Adenanthos cuneifolia and Sericia, Banksia (...), Dryandra formosa, and two magnificent Banksias, quercifolia and coccinea.*[2]

The first long voyage experiment of Nathaniel Ward's enclosed glass container – the Wardian case – arrived in Sydney on New Year's Day, 1834. Assistant Superintendent John McLean transplanted the ferns, grasses and mosses from London into the Botanic Garden. He restocked the case for its return journey, again with grasses and ferns, among them *Gleichenia microphylla*, previously only known in Europe from dried specimens.[3] The success of this exercise effectively revolutionised plant distribution worldwide.

Richard Cunningham and his much-respected brother, Allan Cunningham, who was Superintendent in 1837–38, brought superior botanical knowledge to the

position, particularly of Australian plants. Although their incumbencies were short-lived, their respective recommendations in 1820 and 1832–33 about how the Botanic Garden should function were far-reaching. A lingering legacy of the Garden's beginning that chafed was that the Governor's kitchen garden came under the responsibilities of the Superintendent, a situation that was increasingly at odds with the role of a scientific botanic garden. Following Allan Cunningham's resignation in disgust in 1838, the Superintendent, Cunningham's former assistant, Scottish-born James Anderson, was no longer expected to concern himself with the Governor's cabbages.

Alexander Macleay (McLeay), former Secretary of the Linnaean Society of London and avid plant collector with a renowned garden at Elizabeth Bay, was Colonial Secretary of NSW from 1826 to 1837. Both Macleay and gentleman-nurseryman William Macarthur of Camden Park took a keen interest in the Botanic Garden during the 1820s and 1840s. Links with Camden Park were strengthened when Macarthur's former principal gardener, Naismith Robertson, served as Superintendent of the Sydney Botanic Garden from 1842 to 1844. Following Robertson's death, James Kidd took charge. A former convict, as a trained gardener Kidd was assigned to the Botanic Garden on his arrival in Sydney in 1830 and became Assistant Superintendent after being granted a conditional pardon in 1843. Kidd's convict past proved an obstacle to him being appointed Superintendent, but it did not prevent him from acting in the role or planting the grounds around the new Government House constructed in the Inner Domain. Kidd later reported that the Superintendent's role required that a third of their time be spent on collecting expeditions.

The Sydney scientific community welcomed the appointment of John Carne Bidwill as Government Botanist and the first Director of the Botanic Garden in 1847. Bidwill, who had strong links with the Macarthur family, was well known as a plant collector and was arguably Australia's first hybridiser of plants.

Unbeknown to colonial powers, Charles Moore, had, at the recommendation of Dr John Lindley and Professor John Henslow, already been appointed to the position in London. Moore, a Scot by birth, was an Irish-trained horticulturist and botanist and brother of David Moore, Director of Glasnevin Botanic Gardens, Dublin. He arrived in 1848 to a somewhat unfriendly environment; however, after enduring exacting criticism early in his tenure, he served as Director until 1896 – a period of almost fifty years.

Moore's obituary in 1905 noted that many plants with which gardeners in NSW 'are now quite familiar' were introduced to the state under Moore's directorship.[4] Like his predecessors, he delighted in species from the rainforest and saw their potential for horticultural use. He favoured the bold foliage of the native *Doryanthes* and *Macrozamia* in new designs he introduced and soon developed a love of the expansive umbrageous form of the Moreton Bay Fig. The initial steps in a process to expand the Lower Garden through the reclamation of land from Farm Cove had already started, but Moore commenced the process in earnest – a project that took 30 years to complete and enabled him to design an expanded Lower Garden in a Gardenesque style.

When his European counterparts cultivated a taste for tropical and subtropical plants from the South Seas, Moore was already at the forefront of this horticultural fashion. In 1850 he had joined the HMS *Havannah* for a collecting expedition in the South Seas, returning with a bounty of plants including new species of *Agathis* which were planted in the Garden. When English nurseryman John Gould Veitch stayed with Moore in 1864, he wrote of the most remarkable plants in the Garden, among which was a magnificent clump of 'Dammaras' (*Agathis*), noting five of the species it included.[5]

Moore collected in northern NSW and travelled to Moreton Bay and Wide Bay, Queensland. He enhanced a fern gully established next to the creek that ran through the Garden, and in 1862 he began converting Fraser and

Cunningham's 'Experimental' Garden to a Palm Grove, initially planting out 'hardy' palms. He expanded it at a great rate later in his directorship, and the inclusion of his own discoveries, *Howea* species from Lord Howe Island, surely brought him great satisfaction. The 19th century fashions for pinetums and rockeries planted with succulents were also accommodated in the gradually expanding Botanic Garden. Charles Moore prepared three catalogues of *Plants in the Government Botanic Garden, Sydney* in 1857, 1866 and 1895 that indicate the botanical riches planted under his direction.

In 1879, with resounding acclaim, Sydney hosted the International Exhibition in the enormous Garden Palace building erected in part of the Governor's 'Inner Domain' adjacent to the Sydney Botanic Garden. After the Garden Palace burnt to the ground in 1882, the grounds were absorbed by the Botanic Garden and redeveloped as an ornamental pleasure garden. When the English-born Joseph Henry Maiden took over as Director in 1896, the Garden was, in a landscape sense, substantially complete, converted by the 'hand of man ... into smiling gardens'.[6]

JH Maiden came from the position of Curator of the Sydney Technological Museum; he had a keen interest in history and had developed an expertise in botany and the study of Australian flora. Soon after his appointment, he directed that *A Guide to the Botanic Gardens, Sydney* be prepared, although it was some years before it was published in 1903. This *Guide* only included plants where the species had been identified, and time has shown that some old unidentified trees escaped mention. He visited the Royal Botanic Gardens, Kew, in a move that would strengthen ties with that august institution. Maiden's focus turned to building a new Botanical Museum and National Herbarium, which was completed in 1901. He appointed the first botanical illustrator, Margaret Flockton, in 1901, an appointment made permanent in 1909. Flockton worked at the Botanic Garden for 26 years, her remarkable skill as illustrator perfectly complementing Maiden's extraordinary output as he documented the flora of New South Wales. Like many directors who followed him, Maiden was acutely aware of the skills of the staff immediately under him, acknowledging that true success lay in a team that harnessed the expertise of all its members.

Maiden strengthened ties with botanical correspondent Jorge Perez in the Canary Islands, and the Canary Island Palm became one of his signature plantings. He researched species in the *Opuntia* genus, which yielded vital new information and, for a time, some of the most bizarre display beds ever to grace the Garden. Like Moore, Maiden saw great value in reinforcing a subtropical appearance for not only the Botanic Garden, but also all of Sydney. The centenary of the Botanic Garden was celebrated with commemorative plantings in land ceded to the Garden during the final contraction of the grounds attached to Government House. When Maiden retired in 1924, he left a showpiece in both a scientific and horticultural sense, and his legacy still resonates.

The inter-war and immediate post World War II years were difficult for the Botanic Garden. Dr George Darnell-Smith, a microbiologist and pathologist, succeeded Maiden. However, following his retirement in 1933, the administration of the Herbarium and the Garden was split into two, resulting in a widening disconnect between the living collections and the Herbarium. Nevertheless, there were modest advances in both horticulture and science. Curators Edward Ward (1924–34) and GF Hawkey (1934–45) were advocates for botany and horticulture in the broader community. The succulent garden, begun under Maiden in the east area of the Middle Garden, developed into a substantial collection. The Spring Walk, a border initially planted by Charles Moore in 1855–56, was expanded. In 1935, at the height of a fashion for what some considered the queen of flowers, a large new rose garden was commenced and an increasing succulent collection was marshalled into new rockery display beds in the Middle Garden. In 1938 the Pioneer's Memorial Garden, celebrating 150 years since European settlement, was opened on the site of the Garden Palace dome. A strong but less prominent area of

collecting was orchids, and Honorary Curator the Reverend Rupp fostered an appreciation for indigenous orchids.

In 1945 Robert Henry Anderson, who had joined the staff as a probationary botanical assistant in 1921, was appointed Chief Botanist and Curator. Anderson hosted a visit from Queen Elizabeth II in 1954, and in celebration the Royal epithet was granted in 1959. However, he also saw the splitting of his beloved Royal Botanic Garden and Domain into two – sundered by the Cahill Expressway. Anderson was the first Australian-born director and retired in 1964, after which he published a new guide-book, *An ABC of the Royal Botanic Gardens, Sydney*.

In the 1950s, botanist George Chippendale had prepared a manuscript census of the trees in the Garden. In his *ABC*, Anderson highlighted favourite aspects of the place where he had worked for 43 years and wrote that the 526 species of trees indicated the richness of the tree life in the Garden. He emphasised that one role of a botanic garden was to introduce 'new species of plants from all parts of the world, building up a collection of living plants as varied as possible'.[7] This had included securing some of the first seed collected of the recently discovered *Metasequoia glyptostroboides* in 1948.[8]

The sparkling Sydney Harbour has always contributed to the character of the Royal Botanic Garden, Sydney, and in many ways the trees of the Lower Garden, especially the large *Magnolia grandiflora*, the *Araucaria heterophylla* and the figs, are enhanced by the juxtaposition. Garden authority Edward Hyams visited during the directorship of (Herbert) Knowles Mair (1964–70). In recalling the account of English novelist Anthony Trollope who visited in the 1870s and 'despaired' of being able to convey the beauty of the harbour to his audience, Hyams wrote: 'But I have not seen a botanical garden, and only one garden of any kind (Illnacullin, off Glengariff) so prettily sited as Sydney's on the foreshore of Port Jackson'.[9]

Under Knowles Mair, the study of ecology and specialisation in Australian plants came to the fore. Following a generous proposal from Alfred and Effie Brunet who ran a nursery at Mount Tomah in the Blue Mountains, Mair began a process that would ultimately result in a cool-climate annexe for the Royal Botanic Garden. Although the Botanic Garden had boasted various glasshouses since the Moore era, one of Mair's final responsibilities was to commission the first building in a new glasshouse complex. The Pyramid glasshouse, more architecturally impressive than horticulturally functional, was commenced in 1971–72 and completed in 1976 under Director Lawrie Johnson. The Arc Tropical Centre opened in 1990 when Professor Carrick Chambers was Director. These enabled the Garden to showcase an expanded range of tropical species.

After a short tenure by British-born ecologist Dr John Beard, Dr Lawrie Johnson, who had joined the Garden's staff in 1948, was Director from 1972 to 1985. Ably assisted by Dr Barbara Briggs, Johnson oversaw a scientific resurgence at the Royal Botanic Garden, Sydney, which included the opening of a new National Herbarium in 1982. With commencement of work on the *Flora of New South Wales* in 1982, botanical illustrators were employed at the Herbarium for the first time since Margaret Flockton's retirement. Johnson's interest in the eucalypts and Australian flora in general heralded a new era in the study of Australian plants, which was reflected in the living collections. Horticultural botanists Tony Rodd and Dr Ben Wallace curated the plant collections and developed thematic plans. Collecting expeditions to Papua New Guinea, Tasmania, New Zealand and Chile followed the decision to feature Gondwanan flora at the new garden at Mount Tomah.[10]

State Premier Neville Wran expedited the development of the Botanic Garden at Mount Tomah and declared that a new native botanic garden and arboretum to celebrate the bicentenary of European settlement in Australia in 1988 would be established at Mount Annan in western Sydney. In a flurry of activity, special collecting trips across Australia gathered a total of 587 species for the new Australian Garden in 1984–85. In the midst of this excitement, Johnson was obliged to retire at the age of

sixty. It fell to his successor, Professor Carrick Chambers, former Professor of Botany at the University of Melbourne, appointed in 1986, to oversee the completion of both projects. The Blue Mountains Botanic Garden, Mount Tomah opened in 1987 and the Australian Botanic Garden, Mount Annan opened in 1988. The development of these two gardens enabled the institution to explore new emphases in plant collecting and display and at Mount Annan, the management of the Cumberland Plain Woodland vegetation.

Over the decade of Chambers' directorship a new rose garden, 'Starting from Scratch' (a garden that interpreted the first farm at Farm Cove), a new fernery to house genera that were a particular research interest of Chambers and a herb garden were developed at the Royal Botanic Garden, Sydney. Chambers fostered an enthusiasm for the plants of China, particularly Yunnan province. Planning for new thematic displays of species collected in China and South East Asia began at both the Mount Tomah and Sydney Gardens.

Botanically, the single most significant event of Professor Chambers' directorship was the discovery of the Wollemi Pine, *Wollemia nobilis*, in late 1994. News of the discovery of a new 'living fossil' flashed around the globe. The excitement of its identification and propagation was shared by the botanists, ecologists and pathologists at all three Gardens and spanned three directorships – Chambers, Howarth and Entwisle. It was a decade between discovery and the eagerly awaited auction of the first propagated trees in 2005.

Frank Howarth, a geologist with expertise in science policy, was Director and Chief Executive from 1996 to 2003. Involvement with the Aboriginal community was strengthened with Aboriginal education programs and the opening of the Cadi Jam Ora garden in the old Middle Garden. At the Royal Botanic Garden, Sydney the Oriental Garden was redesigned and a flurry of activity ensured displays of Australian plants greeted visitors to the Olympic Games in 2000.

Dr Tim Entwisle, a specialist in freshwater algae who had been Director of Plant Sciences since 1998, became Executive Director in 2004. In 2007, he was appointed the 12th Government Botanist in New South Wales. An enthusiastic communicator, through radio and social media, Entwisle took plants and botany to the people. He grappled with the challenges of the increasing destruction of historic trees and the Palm Grove by a colony of flying foxes, and senior staff navigated the legal difficulties of relocating the colony of an endangered species. A new camellia garden, allied to recent research at the Royal Botanic Garden, Sydney and displaying the species collected during 21st century plant hunting trips, was introduced. Under Entwisle's initiative, the project to build PlantBank, a new science, research and seedbank facility at the Australian Botanic Garden, Mount Annan, was commenced before his departure in 2011. When PlantBank opened in 2013, Acting Executive Director Dr Brett Summerell, a plant pathologist who had joined the staff in 1989, presided.

Renowned botanist Professor David Mabberley was Executive Director from 2011 to 2013. He initiated an international peer review of the Royal Botanic Gardens Sydney and commissioned a Master Plan. After the success of the flying fox relocation program and the donation of a spectacular collection of 400 palms, rejuvenation of the historic Palm Grove was undertaken during 2013 and 2014.

It was the task of Mabberley's successor Kim Ellis, appointed Executive Director in 2014, to complete the Master Plan and prepare for the 2016 bicentenary celebrations of the Royal Botanic Garden, Sydney. In the tradition established by Charles Fraser, the first Colonial Botanist in Australia, in 2013–14 staff discovered and described 36 new species of plants, algae and fungi as part of the Trust's scientific research program.[11] It lies with Ellis, a former soldier and operations manager, and his staff to chart a course for the future while conserving and showcasing the significance and complexity of the living collections in the gardens that comprise the Royal Botanic Gardens and Domain Trust, Sydney.

The Paintings

Eucalyptus tereticornis Sm.

Myrtaceae

Eucalyptus from the Greek *eu-*, *eu-* + Greek *kaluptos* (covered), referring to the cap covering of the buds; *tereticornis* from *terete* (cylindrical) and *cornis* (horned), referring to the shape of the bud caps.

Eucalyptus tereticornis is a very large tree, often up to 50 metres tall, with an open crown and long straight trunk. The leaves are very narrow and lance-shaped. Its distribution extends along the east coast of Australia from north of Cairns to near Warragul in Victoria. It also occurs in New Guinea. It inhabits the more fertile soils and typically occurs in open forest.

The original vegetation around Port Jackson included trees of *Eucalyptus tereticornis*, Forest Red Gum. First Fleet surgeon and naturalist John White collected specimens of the eucalypt in 1793, sending them to London. There they were given to James Edward Smith, English botanist and founder of the Linnean Society, for identification and publication. Smith published White's findings in *Zoology and Botany of New Holland* in 1793. Smith's description was republished in *A Specimen of the Botany of New Holland* in 1793–95.[1] Although White supplied illustrations of a number of plants he collected, this species was not sketched and so Smith's description for *E. tereticornis* lacks the recognition that some of the other species in the same volume command. George Caley, botanical collector for Sir Joseph Banks in New South Wales from 1800 to 1810, wrote that two Aboriginal (Dharug) names for the tree in the Greater Sydney region were 'Burringora' and 'Yarro'.[2]

Descendants of the original trees of the Government Domain grow in the Royal Botanic Garden, Sydney and the Domain, reminders of the ancient forest that the officers, soldiers and convicts of the First Fleet encountered in 1788. JH Maiden noted the variability of the species – three trees of *E. tereticornis* in the Sydney Botanic Garden and Domain 'growing within a few hundred yards of each other, differ in flowering period, in habit and bark ...'[3] *Eucalyptus tereticornis* is an important tree of the Australian Botanic Garden, Mount Annan, where it is a species of the Cumberland Plain Woodland.

Artist Cheryl Hodges

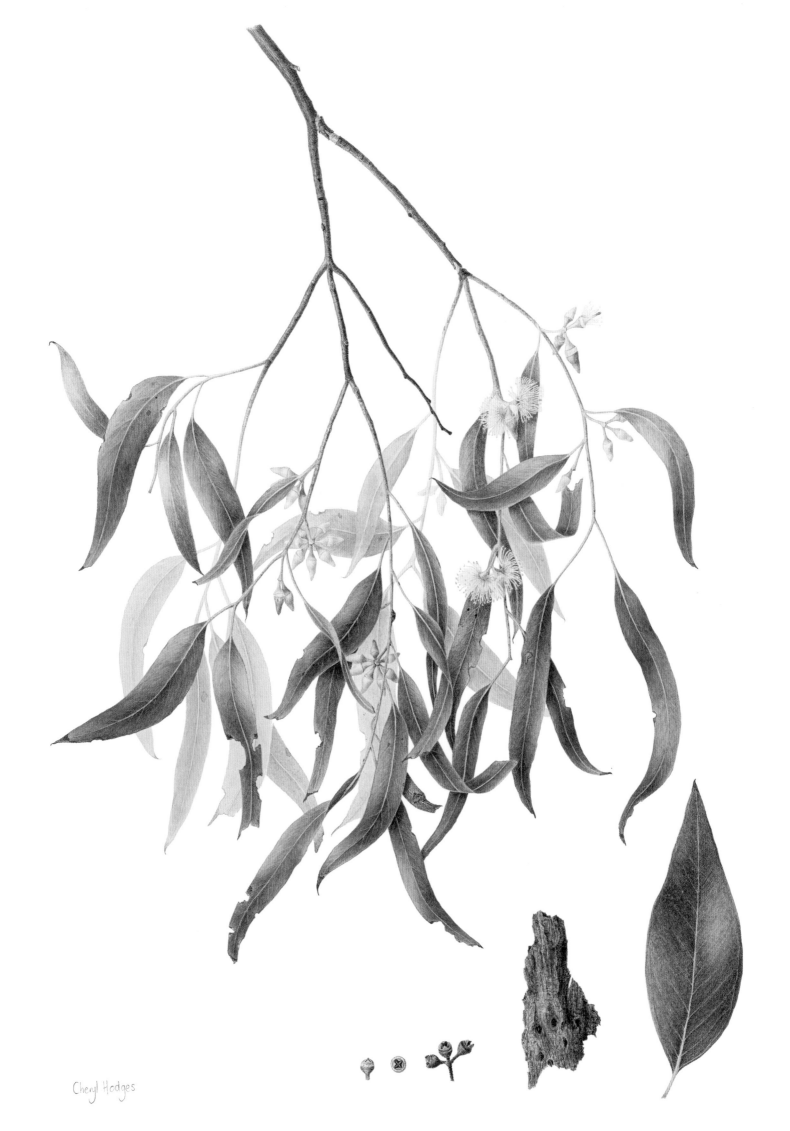

Cheryl Hodges

Ficus rubiginosa Desf. ex Vent.

Moraceae

Ficus is the Latin for Fig; *rubiginosa* (rusty red), probably referring to the orange-red of the fruit or the reddish hairs on the calyx and the underside of the leaves.

The canopy of this fig can be broad, domed and pendulous in habit and can reach heights of 20 metres. The leaves are dark green on top and mostly rusty brown underneath. The fruit is arranged in opposite pairs with no stalk, and it ripens in autumn. Like all figs, the flower occurs inside the fruit structure and is pollinated by a species of native wasp that spends most of its life cycle inside the fig. The adult wasp crawls over the fertile flowers, cross-pollinating them before escaping.

Ficus rubiginosa, the Port Jackson or Rusty Fig, was part of the rocky shoreline vegetation of Sydney. JH Maiden recorded that the local Aboriginal name was 'Dthaaman', although 'Damun' is in more recent use among the Dharug people.[4] Trees of Port Jackson Fig cluster around the rocky outcrops of Mrs Macquarie's Point and grow throughout the Domain, which surrounds the Royal Botanic Garden, Sydney. Charles Fraser recorded that he introduced the species to the Garden in 1817, the year he commenced at the Government Garden.

Among the plants collected for the Empress Josephine's garden at Malmaison, *Ficus rubiginosa* was first named by René Louiche Desfontaines and painted by Pierre-Joseph Redouté for *Jardin de la Malmaison* by EP Ventenat in 1804. The English-born physician and naturalist Dr George Bennett noted that the Fig was always conspicuous in the forest scenery from its enormous size, its rounded head and its dark foliage.[5] *Ficus rubiginosa* fruit is highly favoured by native flying foxes (fruit bats).

Artist Deb Chirnside

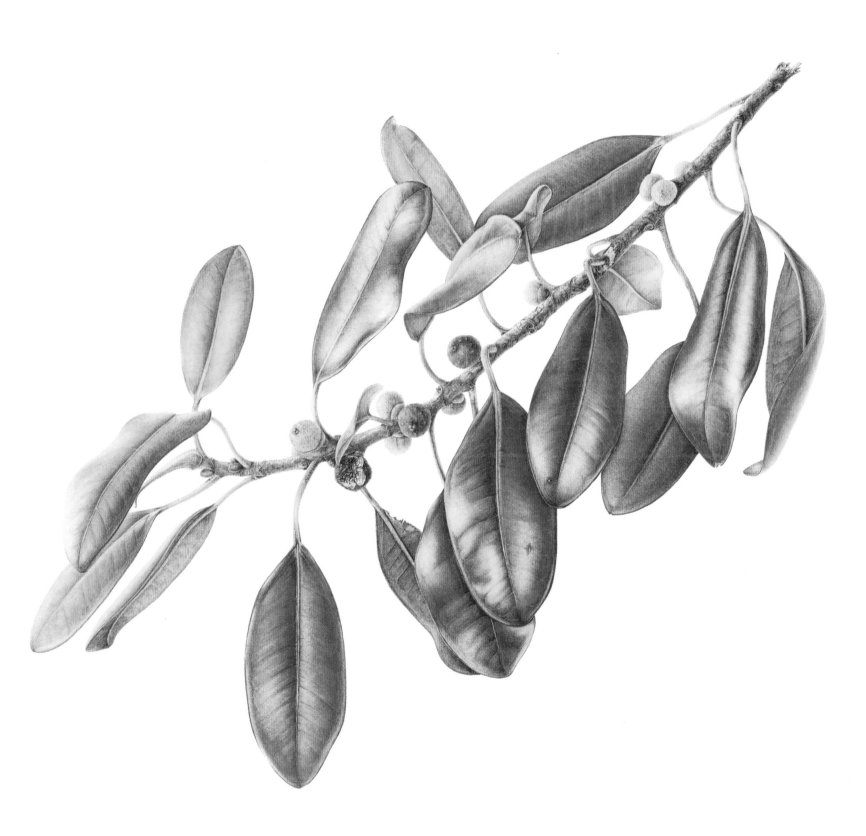

Casuarina glauca Sieber ex Spreng.

Casuarinaceae

Casuarina from *casuarius*, the Latin name for cassowary, as the green branchlets of many species hang down like cassowary feathers; *glauca* from the Greek *glaukos* and Latin *glaucus* meaning sea green or greenish grey, referring to the grey-green colour of the foliage.

Casuarina glauca is native to Queensland and New South Wales, occurring in brackish situations along coastal streams and further inland along major river valleys. It often forms pure stands.

There are male and female trees (i.e. the species is dioecious), the female tree bearing small, cone-like, complex structures structures containing containing numerous small, winged fruits in whorls. The male trees are easy to see when in flower because the tree has a red tinge as a result of the orange-red stamens in numerous whorls at the ends of the branchlets. The trees range from 8–20 metres high with the branchlets characteristically stiffly drooping. The leaves are reduced to small teeth in whorls along the green branchlets. On coastal headlands *Casuarina glauca* becomes a shrub, adapting to the salt spray and windy conditions.

Casuarina glauca, commonly known as the Swamp Oak or River Oak, forms part of the original vegetation around Farm Cove. Casuarina timber was valued as a building material during the early years of settlement, being the preferred wood for roof shingles. This species is long-lived with the capacity to regrow when cut down. The stand of *Casuarina glauca* within the Royal Botanic Garden, Sydney is thought to be part of the original vegetation and signals the high-tide mark of the original shoreline. *Casuarina glauca* was described from one of the many Australian specimens collected by Franz Sieber, who was among the earliest botanists who collected Australian species as a commercial enterprise, when he visited Sydney in 1823.[6] An article in the *Sydney Morning Herald* in 1832 reported that near the Dockyard in Sydney Cove, a Swamp Oak, upon which the British flag was first raised, had been cut down. It was said that Governor Macquarie had considered the tree sacred.

Sir William Macarthur recorded the use of the Aboriginal name 'Oomburra' or 'Comburra' for this species. 'Guman' is the name used by the Cadigal of Sydney.

Artist Ruth Walter

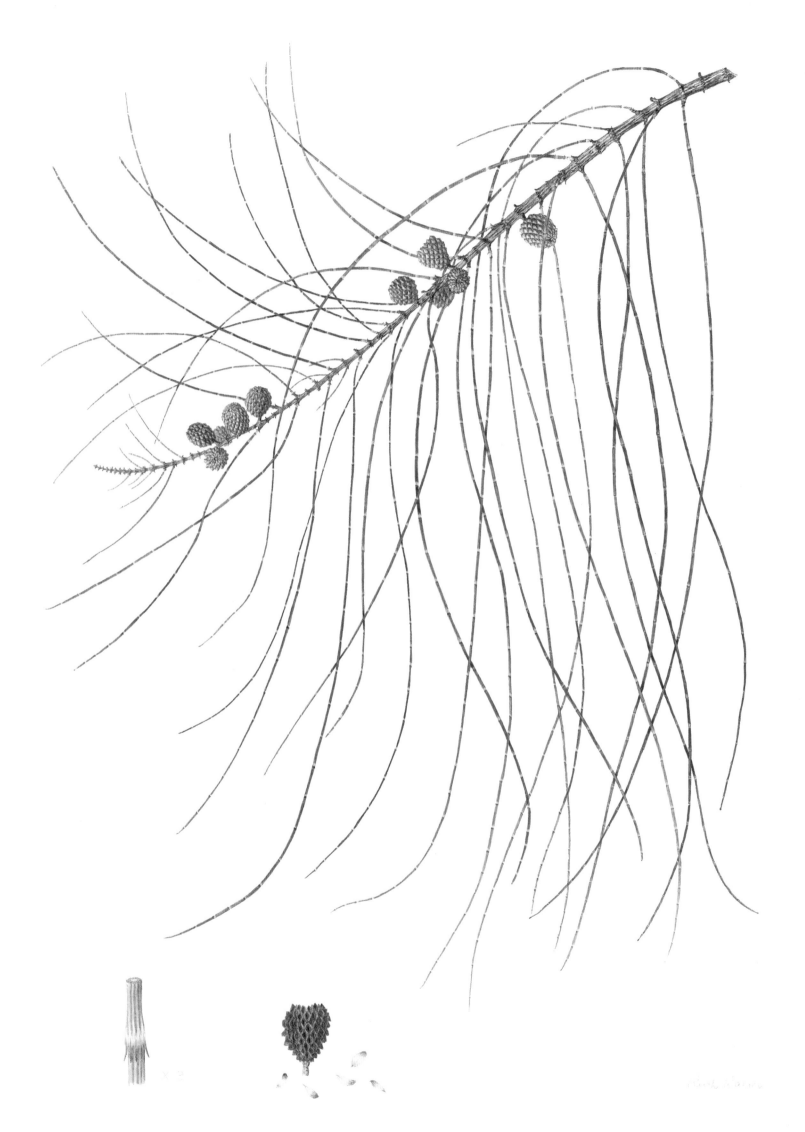

Hardenbergia violacea (Schneev.) Stearn

Fabaceae

Hardenbergia for German Countess Hardenberg; *violacea* for the plant's violet-coloured flowers.

A native vine with leathery leaves and violet flowers, with climbing stems often to 2 metres long, it is widespread along the coast and ranges in eastern and southern states of Australia. It is a widely cultivated native plant of Australia.

When Charles Fraser compiled his 'Catalogue of Plants cultivated in the Botanic Garden, Sydney, January, 1828', he noted that *Kennedia monophylla*, False Sarsaparilla, was a 'native of the Garden'. It was first described as *Glycine violacea* in *Icones Pantarum Rariorum* 1 in 1781. However, the name commonly used in colonial Australia was *Kennedia* (or *Kennedya) monophylla* because it was named by French botanist EP Ventenat and illustrated by Pierre-Joseph Redouté in *Jardin de la Malmaison*, Volume 2, 1805. It became a popular subject for colonial botanical artists. In 1887, Sydney botanical artist Annie Walker wrote that it was 'known as the Blue Creeper throughout the County of Cumberland' [Greater Sydney].[7] William T Stearn officially classified the species as *Hardenbergia violacea* in 1940.

Hardenbergia violacea is also significant to the Australian Botanic Garden, Mount Annan, opened in 1988, as it is a native of the Cumberland Plain Woodland, the indigenous vegetation of the area.

Artist Anne O'Connor

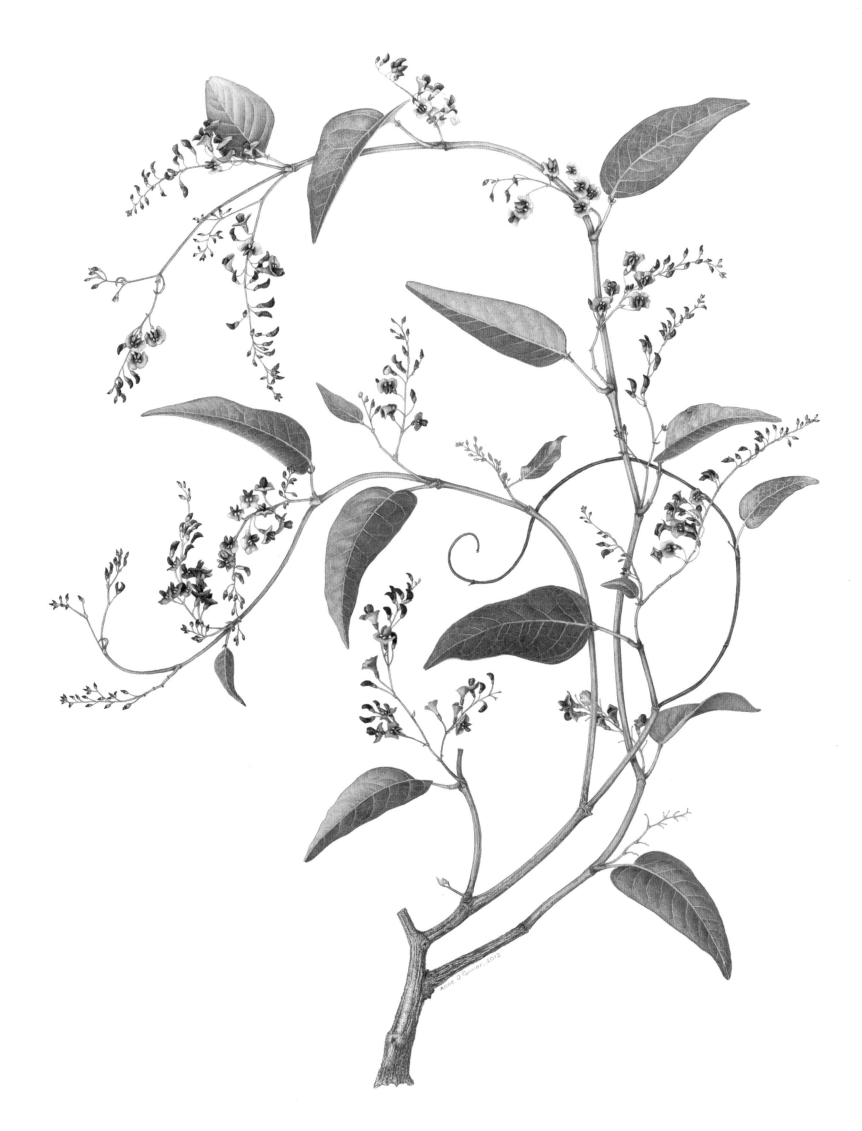

Banksia integrifolia L.f.

Proteaceae

Banksia named for Joseph Banks, the naturalist on board the *Endeavour*, accompanying Captain James Cook on his first Pacific voyage when specimens were collected at Botany Bay, between 28 April to 5 May 1770; *integrifolia* from *integer* (entire or whole) and *folia* (leaved), meaning with whole leaves.

This species is widespread along the east coast of Australia from south of Cairns in Queensland along the NSW and Victorian coastlines. It is a highly variable species with three subspecies through its range: *Banksia integrifolia* subsp. *integrifolia*, *B. integrifolia* subsp. *compar* and *B. integrifolia* subsp. *monticola*. It is well known for the long, yellow, brush-like flowers and the fruits with follicles holding the seed in a cone-like structure. The silvery undersides of the leaves are easily seen from a distance.

Banksia integrifolia, Coast Banksia, is part of the original vegetation of the headlands of Port Jackson. According to William Macarthur of Camden Park, the local Aboriginal name was 'Curridjah' and the honey from the flowers was steeped in water to make a sweet drink.[8] Two very old trees of this long-lived species, which regenerates after fire, grew between Government House and Farm Cove until 1913, when they were removed due to senescence.[9] Trees of *Banksia integrifolia* grow at all the gardens of the Royal Botanic Gardens and Domain Trust.

Banksia integrifolia was named by Carl Linnaeus the younger from a specimen collected by Joseph Banks at Botany Bay, NSW, in April–May 1770.

Artist Annie Hughes

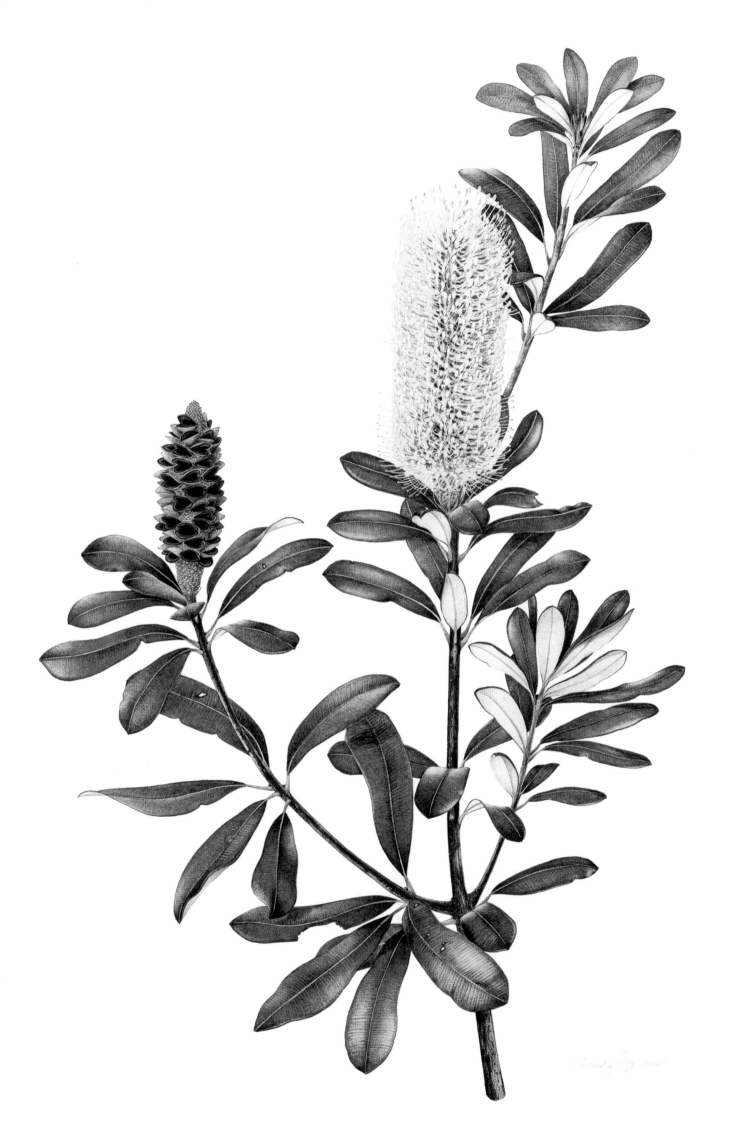

Araucaria heterophylla (Salisb.) Franco

Araucariaceae

Araucaria from Arauco, a former province of south-central Chile; *heterophylla* from the Greek *heteros* (different) and *phyllon* (leaf), referring to the different leaves in juvenile and adult leaf stages.

This species is endemic to Norfolk Island and is abundant on the island. It has become naturalised on Lord Howe Island and is widely cultivated in Australia in coastal areas. It is also cultivated in many humid subtropical areas around the world.

Araucaria heterophylla is a tree to 70 metres tall with a trunk up to 2 metres in diameter. The bark sheds in thin flakes. Dominating many landscapes, both in its natural habitat and as a cultivated tree, its horizontal branches form the shape of the tree – wide at the bottom of the tree and progressively getting smaller at the top, forming a triangle or Christmas tree.

Sighted on Norfolk Island by Captain Cook in 1774, *Araucaria heterophylla*, the Norfolk Island Pine, is among the most historically significant species for the Royal Botanic Garden, Sydney. Prized since the founding of Sydney, a small *Araucaria* was brought back from Norfolk Island for Governor Phillip and planted in the garden of First Government House. Lachlan Macquarie, Governor from 1810 to 1821 who with his wife Elizabeth founded what would become the Royal Botanic Garden, Sydney, was equally entranced by the statuesque pine. In June 1814, one specimen was planted at 'the intended grand Entrance into the new Govt Garden in Farm Cove'[10] and in 1818 another was transplanted from Government House to the intersection of two major pathways in the Garden. It is believed that the tree known with great affection as 'The Wishing Tree' was the latter planting. These were among a number planted at strategic locations around the Garden and Domain. A replacement 'Wishing Tree' was planted in 1935 and the original tree removed a decade later.

Described as *Eutassa heterophylla* by Richard Salisbury in 1807, it was mistakenly known as *Araucaria excelsa* from Robert Brown's 1813 description until 1952 when it was renamed.

Artist Angela Lober

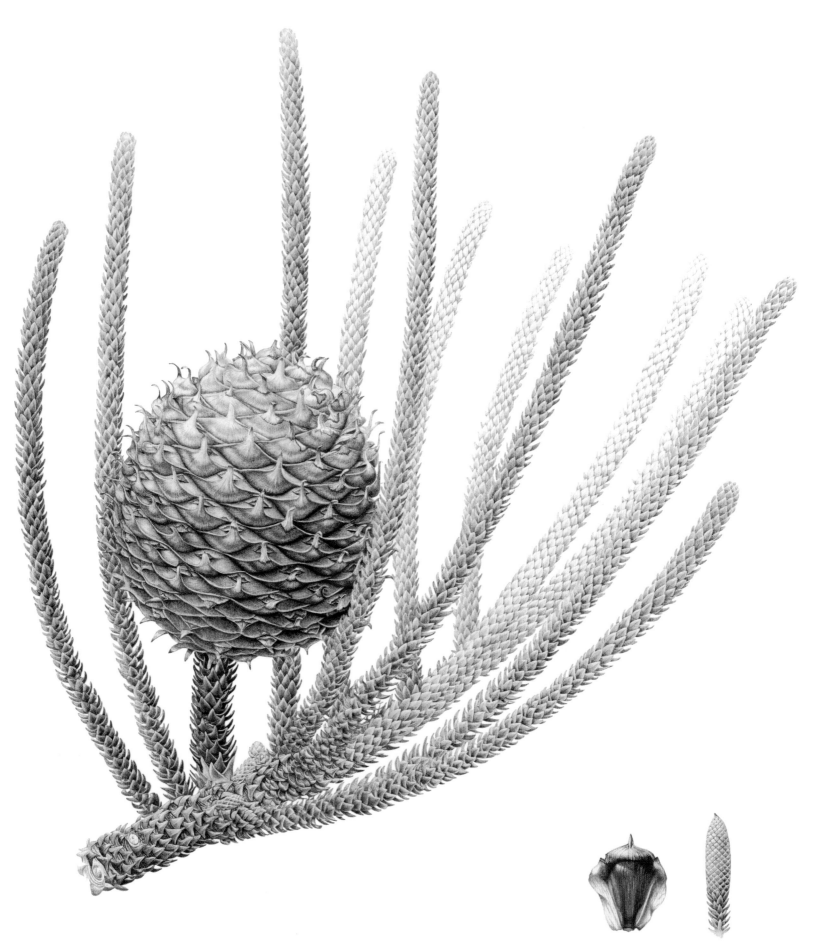

ALBER 2015

Dendrobium speciosum Sm.

Orchidaceae

Dendrobium from the Greek *dendron* (tree) and the Greek *bios* (life); *speciosum* is Latin for beautiful, showy, handsome, splendid, referring to the flowering event.

This orchid usually grows on rocks in open forest, particularly on sandstone, but occasionally also on the branches of rainforest trees. It is found around the Cann River in Gippsland, Victoria, and along the New South Wales coast as far inland as the upper Hunter Valley.

The Rock Lily is an orchid that has succulent, spreading, usually erect pseudobulbs (stems), thickest near the base and tapering markedly towards the top where the leaves appear. Its roots are smooth and creeping and its leaves are smooth and leathery. Beautiful flower spikes appear in August through to October and with a profusion of many perfumed, creamy-yellow flowers.

This orchid was much admired from the arrival of the First Fleet in 1788. Captain John Hunter, when he served as an officer from 1788 to 1790, and the artist midshipman George Raper sketched the Rock Lily, annotating their drawings 'Can-no', possibly an interpretation of an Aboriginal name for the plant.[11] Introduced to the Botanic Garden by Colonial Botanist Charles Fraser in 1817, it is intrinsically associated with the character of the Royal Botanic Garden, Sydney.

James Edward Smith first described the Rock Lily in 1804 with the statement that 'the natives call it *Wer-gal-derra*'. The source for Smith's description is unknown.[12] However, the Eora people of Sydney call it 'Wargaldarra' and 'Buruwan' and the starchy stems can be roasted and eaten.

Artist Elaine Musgrave
Donated by Prof. Lynne Madden and Prof. Peter Sainsbury

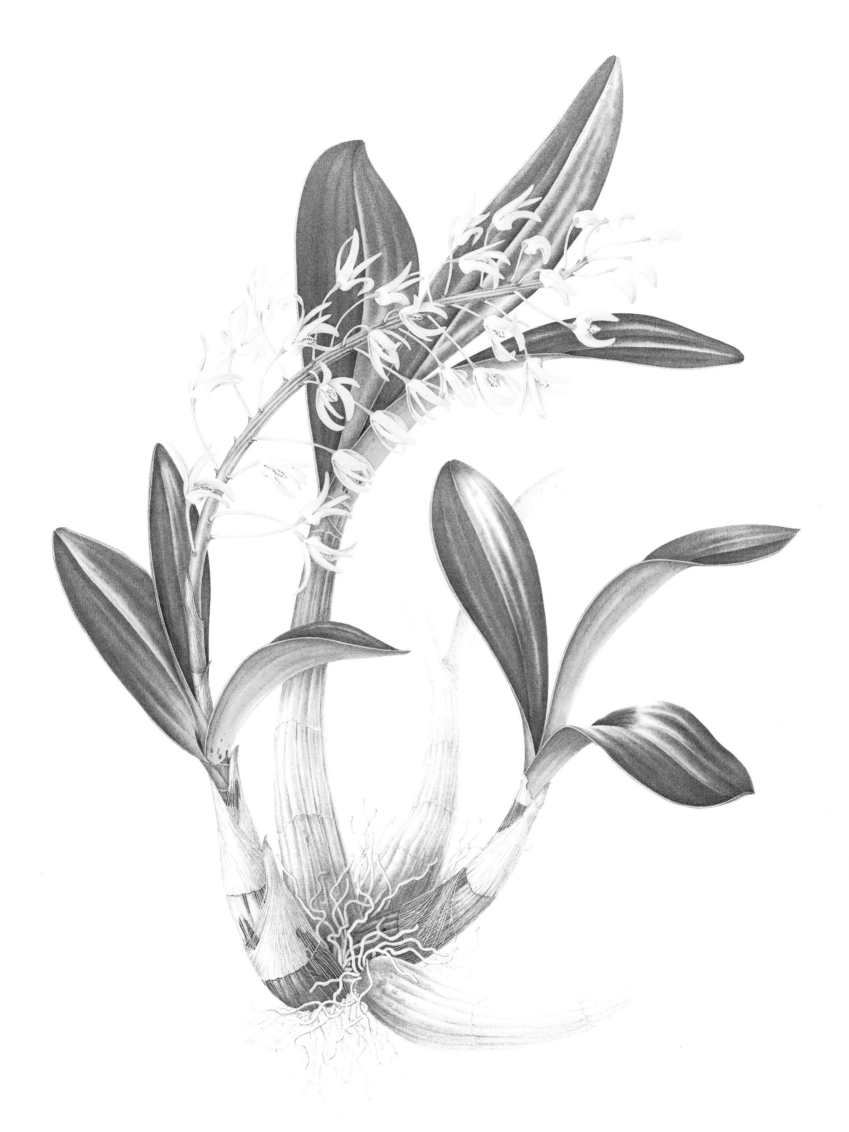

Doryanthes excelsa Corrêa

Doryanthaceae

Doryanthes from two Greek words: *doratos* (spear) and *anthos* (flower); *excelsa* from the Latin *excelsus* (high or lofty).

Growing in dry sclerophyll forest and woodland on sandstone and partly clay soil, the Gymea Lily is one of eastern Australia's most spectacular flowering plants. It extends, in patches from the Illawarra region to the northern coastal regions near Red Rock, NSW. With basal sword-shaped leaves and a flower spike up to 5 metres high, each year in spring it produces numerous brilliant pinkish red, lily-like flowers in massive heads on the top of the spike.

Charles Fraser introduced the Giant or Gymea Lily, *Doryanthes excelsa*, to the Sydney Botanic Garden in 1819. Described by the botanist and priest Corrêa de Serra in *Transactions of the Linnean Society London* in 1802 from a type specimen collected by surgeon-explorer George Bass c. 1795–96, it was highly venerated by the local Dharawal (Aboriginal) people.[13] In 1836, Aboriginal people of the Lake Macquarie district of New South Wales were observed roasting the stems, having cut them when they were partway to maturity and as thick as an adult human's arms.[14]

The striking architectural form of the 'Gigantic' Lily fascinated early colonial artist John Lewin, who produced multiple paintings of it after Governor Hunter sent him to Port Hacking in search of the lily in 1800.[15] A symbolic plant, it is thought to be the first plant described in a colonial publication, the *New South Wales pocket almanack and colonial remembrancer* (1813). Gymea Lily grows in the Royal Botanic Garden, Sydney and at the Australian Botanic Garden, Mount Annan.

Artist Deirdre Bean

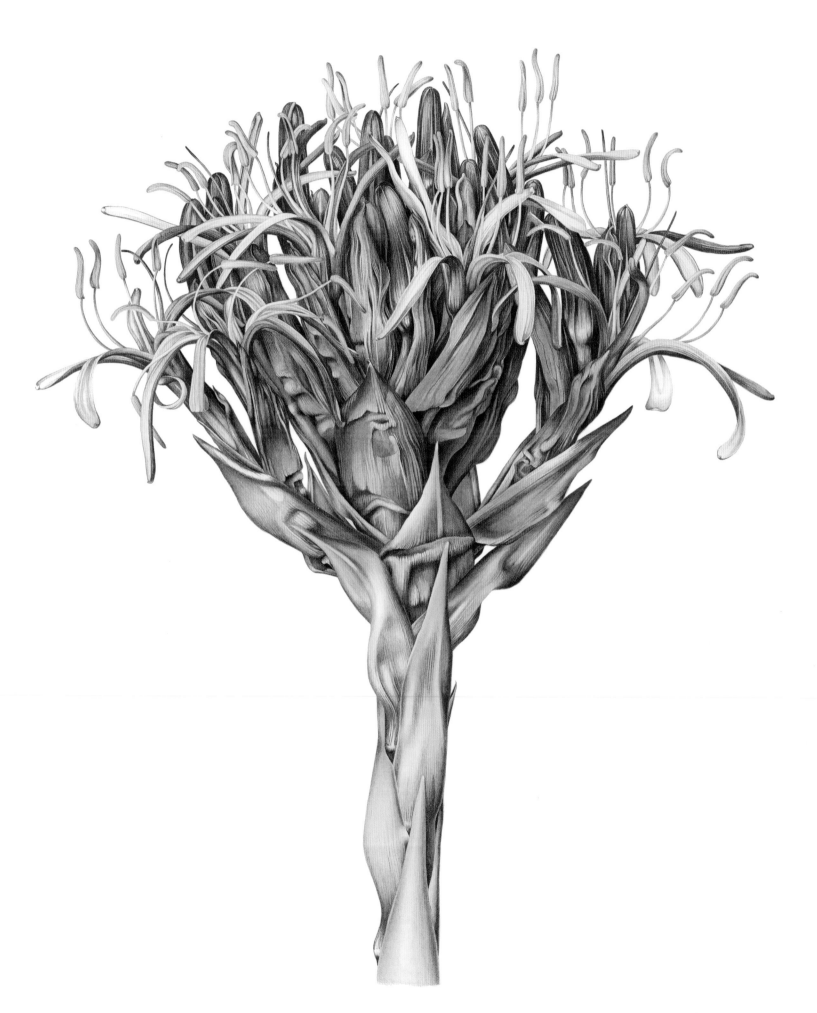

Deirdre Bean 2008

Eucalyptus robusta Sm.

Myrtaceae

Eucalyptpus from the Greek *eu-*, *eu-* + Greek *kaluptos* (covered), referring to the cap covering of the buds; *robusta* (robust).

Eucalyptus robusta is a medium-sized tree to 25 metres with a wide and straight trunk. It is locally abundant in heath and on low swampy sites on sandy soils and clays, from Moruya on the south coast of New South Wales to north of Yeppoon in Queensland. It mainly occurs in swamps and on the edges of saltwater lagoons and estuaries where it is often found in pure stands.

Eucalyptus robusta, Swamp Mahogany, was one of eight species of eucalypts collected close to Sydney Cove by First Fleet surgeon John White. It was described by James Edward Smith in 1793 and illustrated by James Sowerby, based on drawings sent by White. The Aboriginal people of the Illawarra call *Eucalyptus robusta* 'Burram Murra'. JH Maiden wrote that 'the term "Mahogany" was applied to Port Jackson timbers within the very first year of Australian settlement'.[16]

A row of *Eucalyptus robusta* to the north of the Macquarie Wall in the Royal Botanic Garden is significant as the remnant of the first avenue planting in Australia using a native species. Often associated with the founding of the Garden in 1816 and planted at the behest of Elizabeth Macquarie by Jack Wright, who had a potato stall at the markets, and others, the date of planting of the row is unclear. In his manuscript 'Catalogue of Plants cultivated in the Botanic Gardens, Sydney, January, 1828', Fraser notes the date of introduction of this species to the Botanic Garden as 1820.[17]

Artist Helen Lesley Fitzgerald

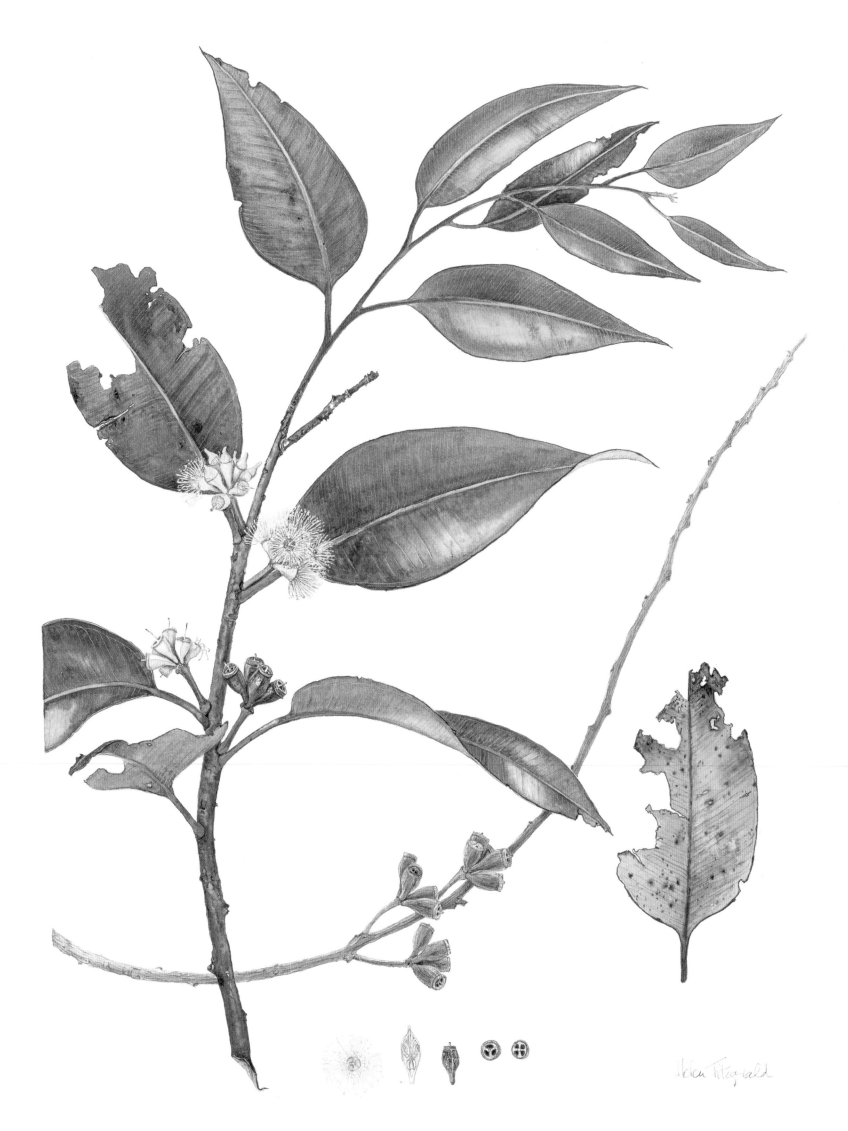

Pinus pinaster Aiton

Pinaceae

Pinus (pine); *pinaster* from *pinus* (pine).

Native to north-western Africa and southern Europe, this pine has been widely cultivated in Australia. Consequently, it has naturalised and is an extremely hardy species, escaping from gardens and establishing small populations in southern Australia.

A tall tree with dark reddish brown and deeply fissured bark, the needle-like leaves are long and grouped in pairs. The cones form in clusters at the ends of the branches, sometimes as many as 10 in a cluster.

The Maritime or Cluster Pine, *Pinus pinaster*, described by William Aiton in 1789, was an early introduction to Sydney, although it does not feature on Governor King's 1803 list of plants growing in the colony. *Pinus pinea*, Stone Pine, was the first pine introduced to New South Wales. In 1820, Fraser compiled a list of 'Plants Cultivated from Seeds Received from Europe' for JT Bigge, who was appointed Commissioner of an inquiry into the colony of New South Wales by Earl Bathurst, Secretary of State for the Colonies. Among the plants growing in the Government Garden was *Pinus pinaster*, giving the species the status of being one of the earliest exotic ornamental trees to be grown at the Royal Botanic Garden, Sydney. JH Maiden chose 15 trees from allied nations in World War I to be planted to celebrate the centenary of the Botanic Gardens in 1916, and *Pinus pinaster* was chosen to represent Portugal.

Artist Jennifer B Wilkinson

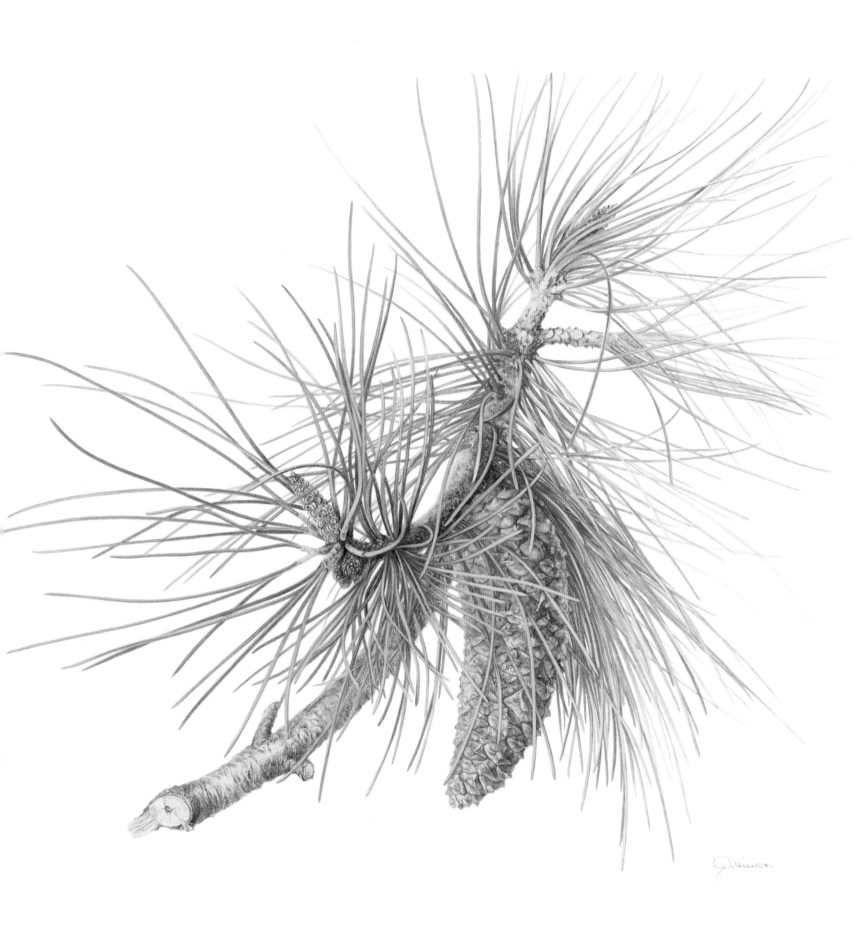

Liriodendron tulipifera L.

Magnoliaceae

Liriodendron (lily tree); *tulipifera* (like a tulip).

The Tulip Tree is so named because the flowers and large stamens resemble the shape of a tulip. It is native to eastern North America, where it can grow to more than 50 metres tall in virgin forests. The leaves are an interesting shape and when fully grown are bright green, smooth and shining above, paler green beneath, with downy veins. In autumn they turn a clear, bright yellow.

Named by Carl Linnaeus in 1753, *Liriodendron tulipifera*, the Tulip Tree, was introduced to the Sydney Botanic Garden in 1822, sent by Mons Thouin, *professeur de culture* at the *Jardin des Plantes* in Paris. André Thouin was a significant figure in the networks of plant exchange that Charles Fraser established, and by 1828 Fraser had received more plants from Thouin than from any other international correspondent. *Liriodendron tulipifera* grew in the Sydney Garden up to at least the 1960s. It is now grown in the Blue Mountains Botanic Garden, Mount Tomah.

Artist Ruth Walter

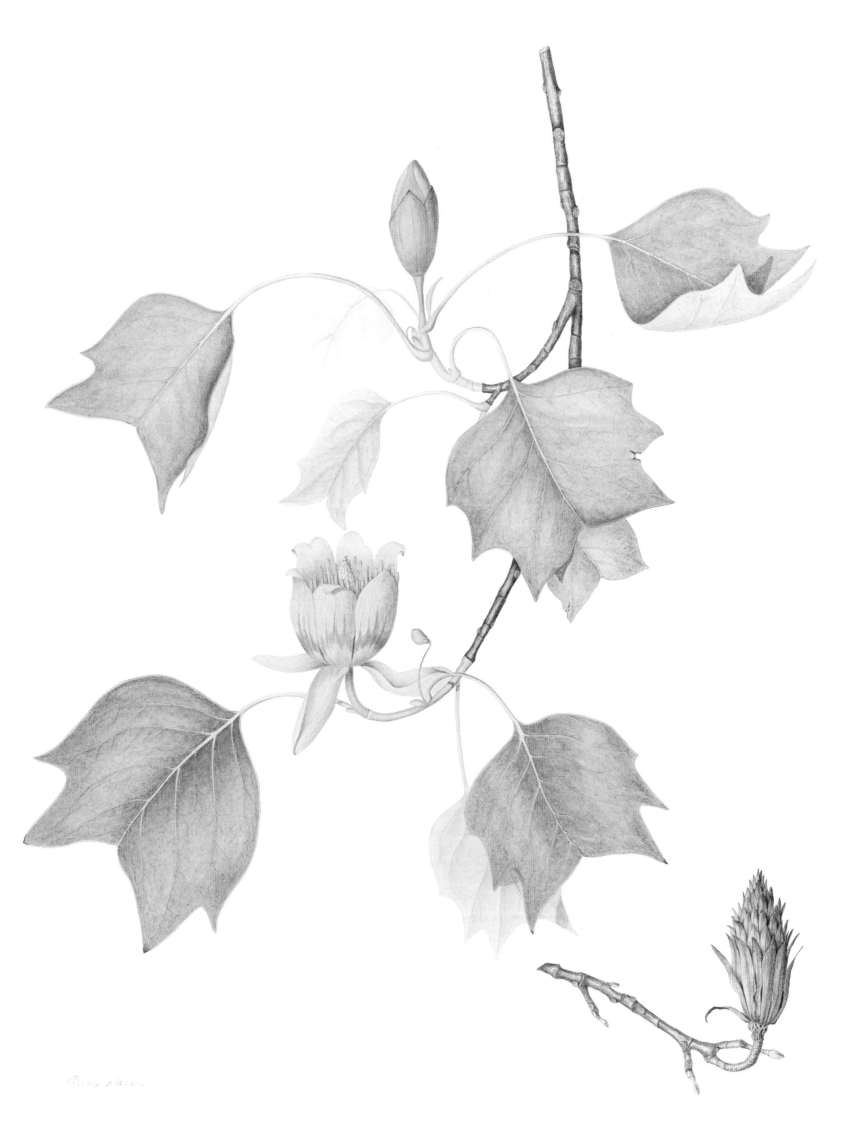

Ficus macrophylla Desf. ex Pers. f. macrophylla

Moraceae

Ficus is the Latin for fig; *macrophylla* from *macro* (large) and *phylla* (leaves).

Ficus macrophylla forma *macrophylla* naturally occurs in all rainforest types north from the Shoalhaven River in New South Wales to Bundaberg in Queensland. It is widely cultivated, and the fruit is eaten by many birds and the Grey Flying Fox (*Pteropus poliocephalus*).

This is a very large spreading tree, starting life as an epiphyte and strangling a host tree in the early stages; the trunks finally become massive and all-consuming until the host tree dies. The large oval leaves are 10–25 cm long, very dark green on the upper surface; the lower surface rust-coloured due to a covering of minute scales. Fruits are orange, or when riper, purple, and are on long pedicels, either in pairs or solitary. They ripen throughout the year.

Lord Howe Island has the other form, *Ficus macrophylla* forma *columnaris*, and it is recognisable from its many roots cascading down from the branches and forming columns.

A description of *Ficus macrophylla* appeared in Christiaan Persoon's *Synopsis Plantarum* in 1807, the material having been described by French botanist René-Louiche Desfontaines in 1804. *Ficus macrophylla*, Moreton Bay Fig, was collected and planted in the Sydney Botanic Garden by Charles Fraser in 1823.[18] Under Charles Moore, Director 1848–96, it became the favoured tree for planting in public spaces across Sydney. The luxuriant Fig Tree avenue of *Ficus macrophylla* formed one of the principal routes through the Domain to the former main entrance of the Botanic Garden and was a dominant feature until it was almost entirely removed in 1958–59 to make way for the construction of the Cahill Expressway; in 2003, the marooned survivors were finally removed. Many mature specimens of the umbrageous Moreton Bay Fig, with its wide-spreading buttressed roots, form an important part of the character and atmospheric magic of the Royal Botanic Garden, Sydney and the Domain. Aborigines used fibres from the wood to make nets.

Artist Kate Nolan

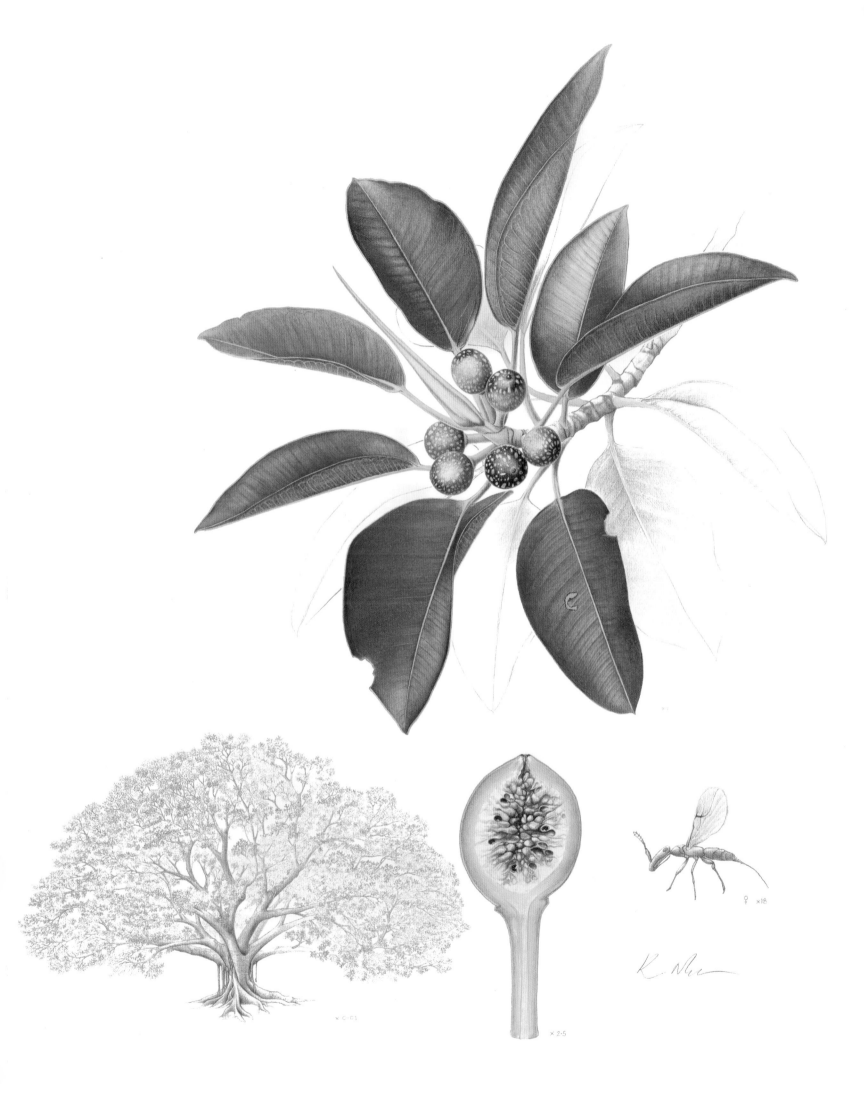

Araucaria cunninghamii Mudie

Araucariaceae

Araucaria from Arauco, a former province of south-central Chile where the related species *Araucaria araucana* was first discovered; *cunninghamii* named for Allan Cunningham.

Occurring in warm rainforest north from the Nambucca River in New South Wales along coastal areas of Queensland and into New Guinea, these trees are often seen in the landscape as large emergent trees growing to 50 metres high with trunks up to 1.5 metres in diameter. Male and female flowers of *Araucaria cunninghamii* are usually on the same tree, with male flowers forming a dense cluster of cylindrical spikes. Female cones are round and occur near the top of the tree; however, they don't form until the tree is at least 15 years old, trees normally living up to 450 years. The trunk is straight and rough with circular 'hoop' markings, which give rise to the common name, Hoop Pine.

Explorer and surveyor-general John Oxley first sighted the Hoop Pine in Moreton Bay, Queensland, in 1823, and in 1824 he returned with King's Botanist Allan Cunningham. Charles Fraser recorded that he received the *Araucaria* species from Moreton Bay from Governor Sir Thomas Brisbane in 1824.[19] Visiting French explorer Baron Hyacinthe de Bougainville mentioned the new species when he visited the Sydney Botanic Garden in 1825.[20] In 1828, Fraser and Cunningham collected plants and botanical specimens along the banks of the Brisbane River. On his return, Fraser planted his new finds, including this species, in the Experimental Garden, now the Palm Grove where the *Araucaria cunninghamii* is the tallest tree in the Garden and among its most significant. It was already 60 feet (18.29 m) tall in 1864.[21]

Named for Allan Cunningham, who was later Superintendent of the Sydney Botanic Garden in 1837–38, *Araucaria cunninghamii* was described by William Aiton from material sent by Cunningham. Robert Mudie was the first to publish a brief description of the new species in *The Picture of Australia* (1829).[22]

Artist Marta Salamon

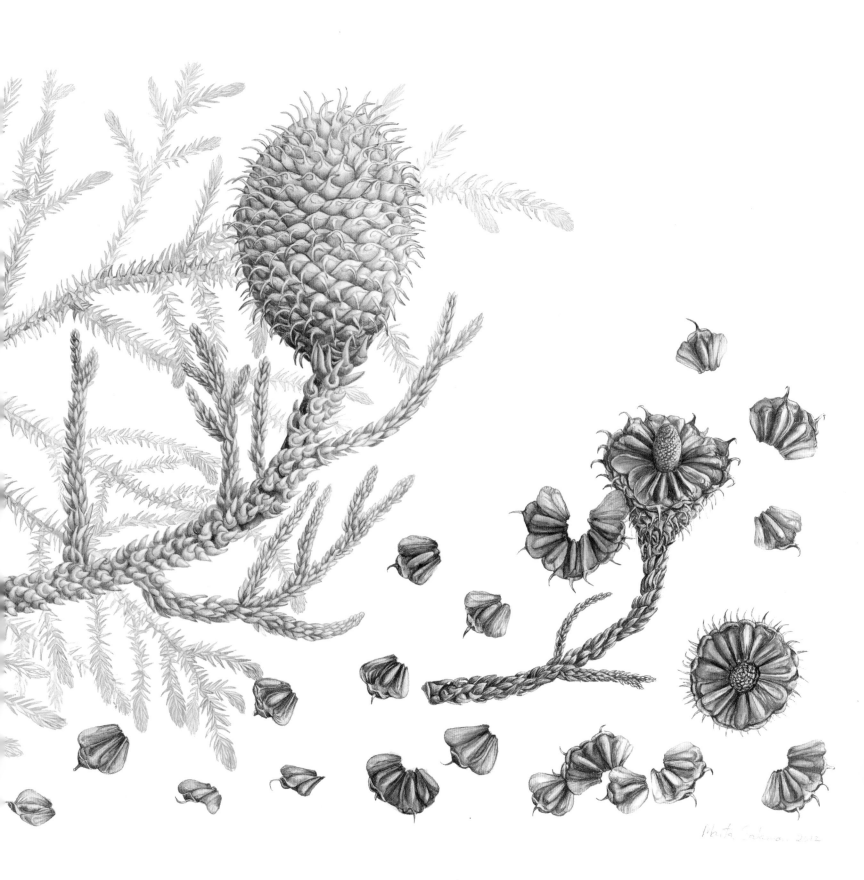

Waterhousea floribunda (F.Muell.) B.Hyland

Myrtaceae

Waterhousea named for John T Waterhouse (1924–1983), Senior Lecturer in Botany and Director of the Herbarium at the University of New South Wales, the John T Waterhouse Herbarium; *floribunda* from *floribundus* (having an abundance of flowers).

Native to the east coast and widespread in riverine rainforests from the Hunter Valley in New South Wales to just north of Cairns in Queensland, *Waterhousea floribunda* is a medium to large tree to 30 metres high. It has dark grey, flaky bark and lance-shaped to elliptical leaves that taper to a point. The white flowers appear from late spring to mid summer, with their long stamens giving the tree a fluffy appearance, and are followed by round fruits 15–20 mm in diameter, green in colour, maturing with a pink to red tinge. The research in this area of the family Myrtaceae is ongoing, hence this name is the preferred name and *Syzygium floribundum* F.Muell. is a synonym.

Waterhousea floribunda, the Weeping Lilly Pilly, was planted in the Sydney Botanic Garden in 1828 from material collected on the banks of the Brisbane River by Charles Fraser and Allan Cunningham. Ferdinand von Mueller, Director of the Melbourne Botanic Gardens, described the species as *Syzygium floribundum* in 1864[23]. During the 19th and early 20th centuries, the trees in the Sydney Botanic Garden were mistakenly labelled *Eugenia Ventenatii*, the 'Drooping Myrtle' of New South Wales. In *A Guide to the Botanic Gardens, Sydney* (1903), JH Maiden, the Director at the time, considered that the large tree in the Palm Grove was a very fine specimen. This tree is among the oldest trees in the Royal Botanic Garden, Sydney.

Artist Colleen Werner

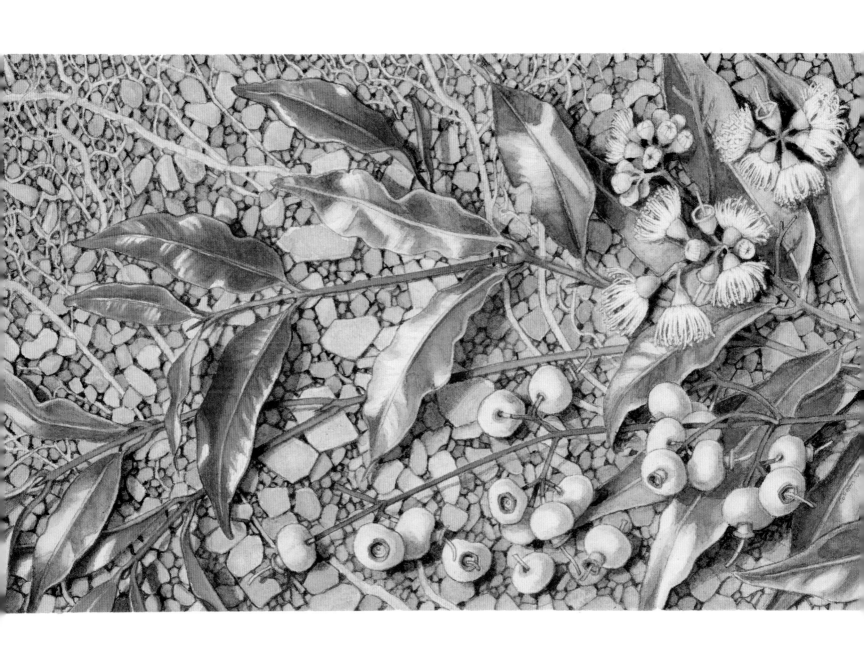

Stenocarpus sinuatus Endl.

Proteaceae

Stenocarpus from the Greek *stenos* (narrow) and *carpos* (a fruit), referring to the characteristics of the seed follicles; *sinuatus* refers to the wavy leaves.

This medium to large tree is native to warmer rainforest in coastal areas north from Nambucca Heads in New South Wales and extending to the Macpherson Range in southern Queensland. It is one of the most spectacular flowering trees; the circular arrangement of the brilliant scarlet flowers gives us the common name Firewheel Tree. This species is slow-growing and can take up to 10 years to produce flowers, which usually occurs in summer through to autumn. The leaves show considerable variation in their vein patterns and shape.

The Firewheel Tree, or 'Yiel-Yiel' to the Aborigines of the north coast of New South Wales, *Stenocarpus sinuatus* was one of the species collected by Allan Cunningham and Charles Fraser on their 1828 trip to Moreton Bay. It is thought that an old specimen in the Palm Grove dates from that period. The striking flowers were increasingly admired during the 20th century, and it was widely promoted for park and street tree planting by GF Hawkey, Botanic Gardens Curator from 1934 to 1945.

In his *Hortus Britannicus supplement* (1832), JC Loudon referred to the species as '*Agnostus sinuata* from Moreton B.' based on Cunningham's manuscript name 'Agnostus sinuatus'. Botanically related to a *Stenocarpus salignus*, collected and described by pioneer botanist and explorer Robert Brown, the species was described as *Stenocarpus cunninghamii* by William Hooker in 1846.[24] This name was used in the *Catalogue of Plants in the Government Botanic Garden, Sydney, New South Wales, 1857* compiled by Director Charles Moore. It was renamed *Stenocarpus sinuatus* by Stephan Endlicher in 1848. When English nurseryman John Gould Veitch visited Sydney in 1864, he considered a tree of this species, 33 feet (10 m) in height, to be among the most remarkable in the Sydney Garden.[25]

Artist Angela Lober

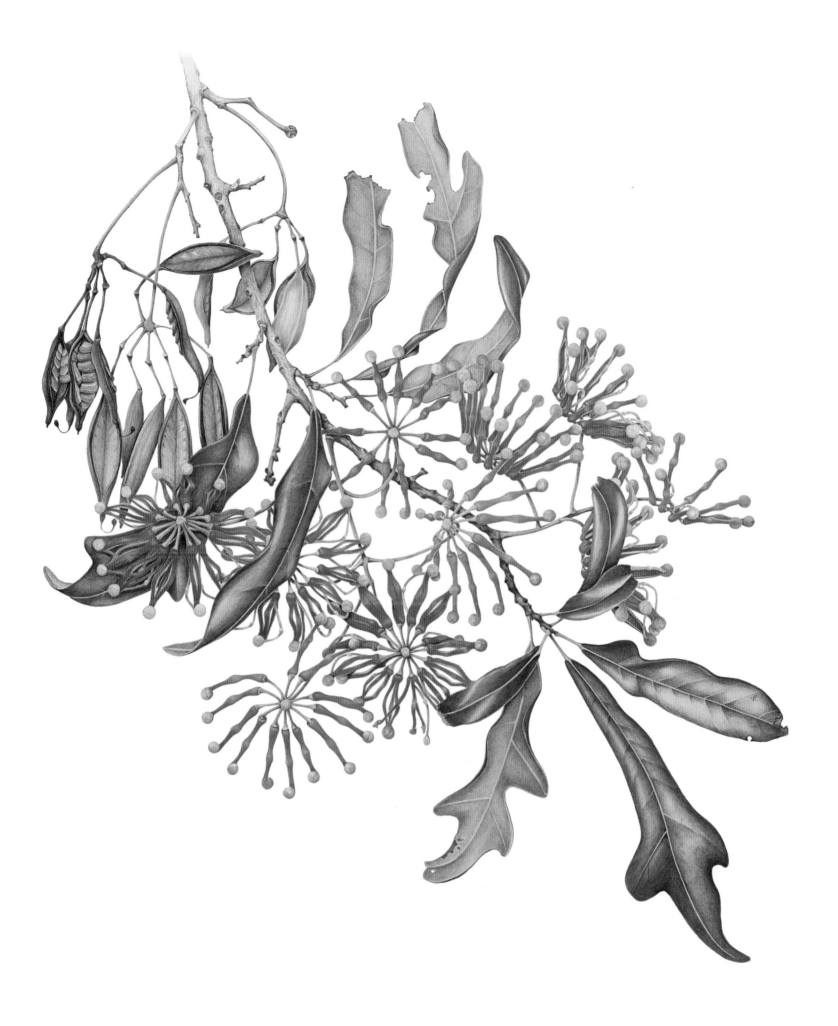

ALOBER 2008

Castanospermum australe A.Cunn. & C.Fraser ex Hook.

Fabaceae

Castanospermum from *castanea* (chestnut) and the Greek *sperma* (seed); *australe* (southern), Australia in this instance.

This species can be a large tree up to 35 metres tall with a trunk up to 1.5 metres in diameter, although it is usually smaller in its natural habitat. It is widespread and grows in warmer rainforest, north from the Orara River in New South Wales into Queensland at the Pascoe River in Iron Range National Park, Cape York Peninsula. The leaves consist of many leaflets that have a glossy upper surface. The brilliant orange-red flowers are tubular with the yellow stamens protruding; the flowers grow in groups from the old stems and the trunk. The fruits are large pods, mostly 10–20 cm long, with 1–5 large bean seeds that fall to the ground as the fruits split open, the pods often falling as well.

Castanospermum australe, the Black Bean or Moreton Bay Chestnut – 'Irtalie' and 'Bogum' according to the Aborigines of northern New South Wales – was collected by Charles Fraser and Allan Cunningham in 1828. William Hooker published Fraser's 'Journal of Two Months' Residence on the Banks of the Rivers Brisbane and Logan, on the East Coast of New South Wales', along with illustrations and a description of *Castanospermum australe* from specimens Fraser supplied in the first volume of *Botanical Miscellany* in 1830, although the credit for the first brief description of the species in 1829 goes to the journalist Robert Mudie.[26]

On his return to Sydney, Fraser planted the material he had collected in the Garden. The Black Bean was possibly among the first plantings in the Lower Garden, which commenced in 1829. Elizabeth Macarthur, mother of gentleman horticulturist William Macarthur, described the new section of the Botanic Garden as beautiful, with the new introductions from Moreton Bay giving it a tropical appearance.[27] Two 'very fine Moreton Bay Chestnuts ... among the finest specimens in the Garden' stood on the upper edge of the 'Band Lawn' of the Lower Garden in 1903.[28]

Artist Penny Price

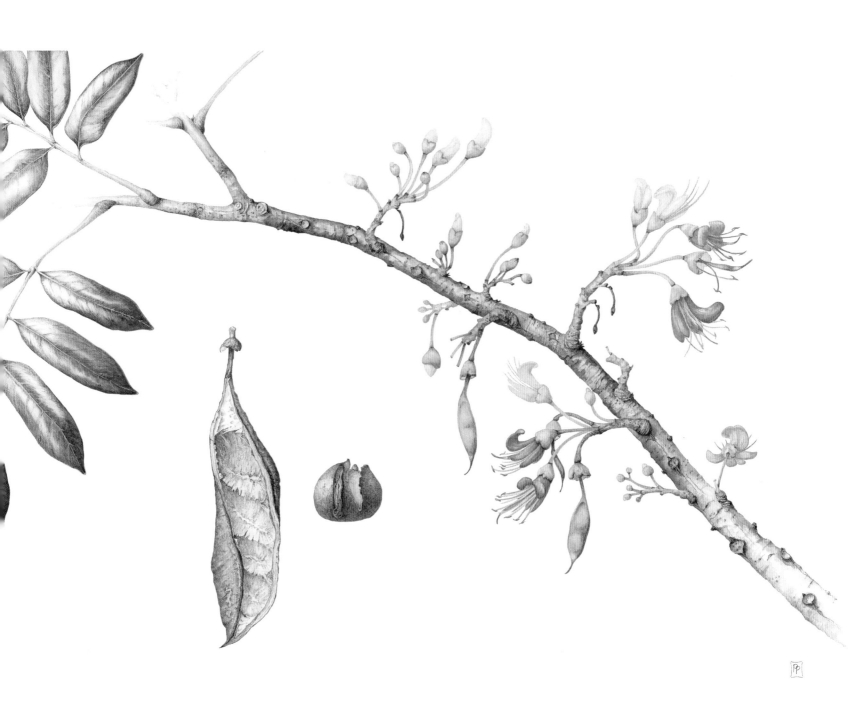

Flindersia xanthoxyla (A.Cunn. ex Hook.) Domin

Rutaceae

Flindersia for Captain Matthew Flinders by Robert Brown in recognition of his merits as a commander; *xanthoxyla* (yellow wood).

Flindersia xanthoxyla occurs naturally from the Richmond River in New South Wales to Gympie in south-east Queensland. It is a rainforest tree to 45 metres high. The leaves are bright green and consist of opposite pairs of leaflets. The flowers are yellow and are in panicles to 25 cm long that hang on the ends of the branches. The fruit that forms is a woody capsule that opens into five valves, resembling a star, and holds seeds that are winged on both sides; the seeds dehisce and fall to the ground.

Flindersia xanthoxyla, Yellow Wood, was collected by Charles Fraser and Allan Cunningham in 1828 during their trip to Moreton Bay. Cunningham and Fraser suggested the name *Oxleyana xanthoxyla* to celebrate their explorer colleague, surveyor John Oxley. In his description of the new species, William Hooker noted the similarity to the genus *Flindersia* but respected Cunningham's wish.[29] Like *Castanospermum australe*, this new species was described and illustrated in *Botanical Miscellany*, Volume 1, 1830. On his return to Sydney, Fraser planted the new 'Oxleyana' he had collected in the Experimental Garden, later called the Palm Grove. The old specimen of *Flindersia xanthoxyla* is among the most significant in the Royal Botanic Garden, Sydney. The Aborigines of the Richmond River region in northern New South Wales used the name 'Yeh' for Yellow Wood when JH Maiden prepared *The Forest Flora of New South Wales*.

At the time Fraser and Cunningham collected specimens, Yellow Wood was already being used for carpentry and boat building. During the 19th century the species was known as *Flindersia oxleyana*, as described by Ferdinand von Mueller in 1858, maintaining the two collectors' original intent. It was renamed *Flindersia xanthoxyla* in 1927 by Czech botanist Karel Domin, who had collected in Queensland between 1909 and 1910.

Artist Anne Hayes

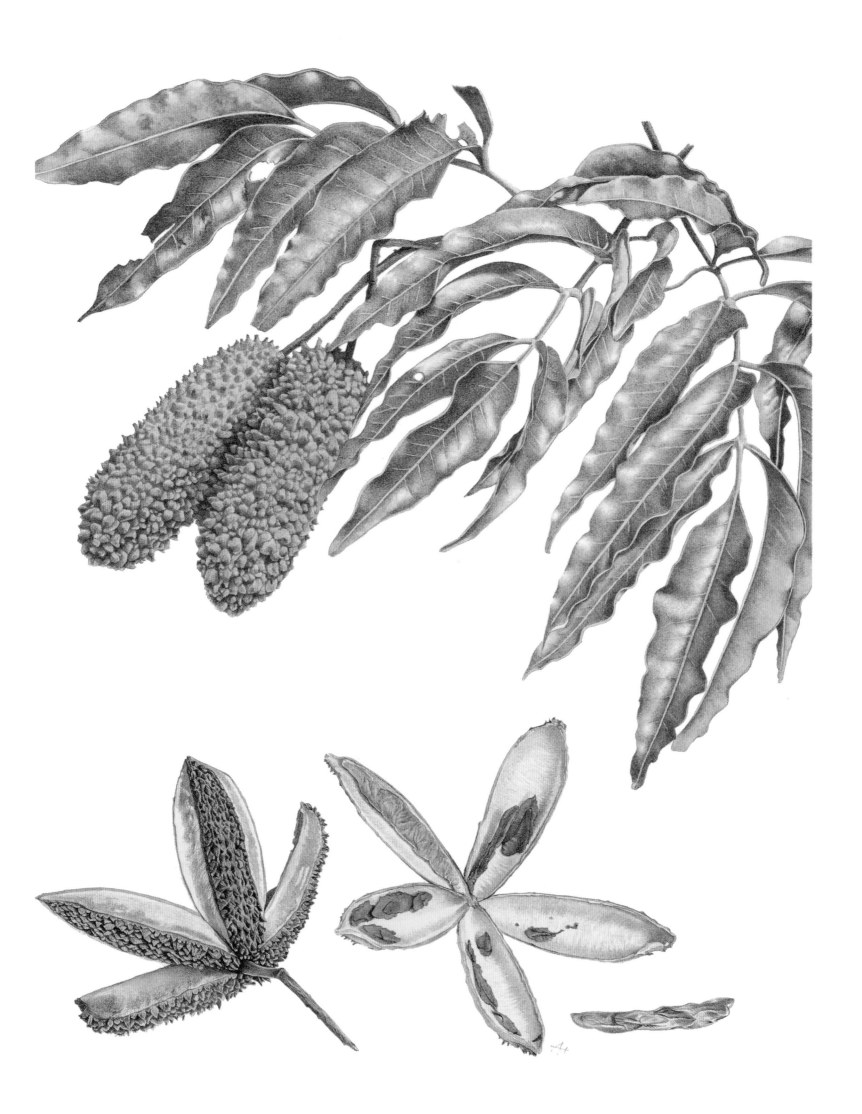

Syzygium jambos (L.) Alston

Myrtaceae

Syzygium from the Greek *syzygos* (joined), referring to the paired leaves; *jambos* from *jambu*, possibly from India (guava or rose apple), referring to the shape and consumption of the fruit.

Syzygium jambos is native to Southeast Asia but is cultivated widely on every continent except Antarctica, and it has become established and invasive in several regions. Due to the wide distribution, the species has many common names.

This attractive tree grows to about 10 metres tall. The leaves are opposite and glossy green. The inflorescence is four-angled with flowers with four petals, and stamens white to creamy-white to 4 cm long. The yellowish fruits are up to 6 cm long and have a thin layer of pale yellow flesh and a hollow central cavity containing 1–3 large brown seeds. These crisp and juicy fruits are distinctly rose scented and highly prized for use in jellies and confections, hence the English common name of Rose Apple.

In Fraser's 'Catalogue of Plants cultivated in the Botanic Gardens, Sydney, January, 1828' the Rose Apple, *Syzygium jambos*, was listed as *Eugenia jambos*, the name used by Carl Linnaeus in 1753. Eugenia or 'Pomme rose' had been among the plants loaded onto the First Fleet when it called at Rio de Janiero in 1787 en route to Botany Bay in New South Wales. Trees that produced edible fruits were a high priority for introduction to colonial Sydney, and as the fruit could be used for jam-making, the Rose Apple became more commonly grown than it is today. It was available for sale in Sydney in 1851 from TW Shepherd, Nurseryman. In the late 19th century it was part of the plant palette used in the planting of institutions that came under the purview of the role of the Botanic Garden. It was placed in the genus *Syzygium* in 1931.

Artist Catherine M Watters

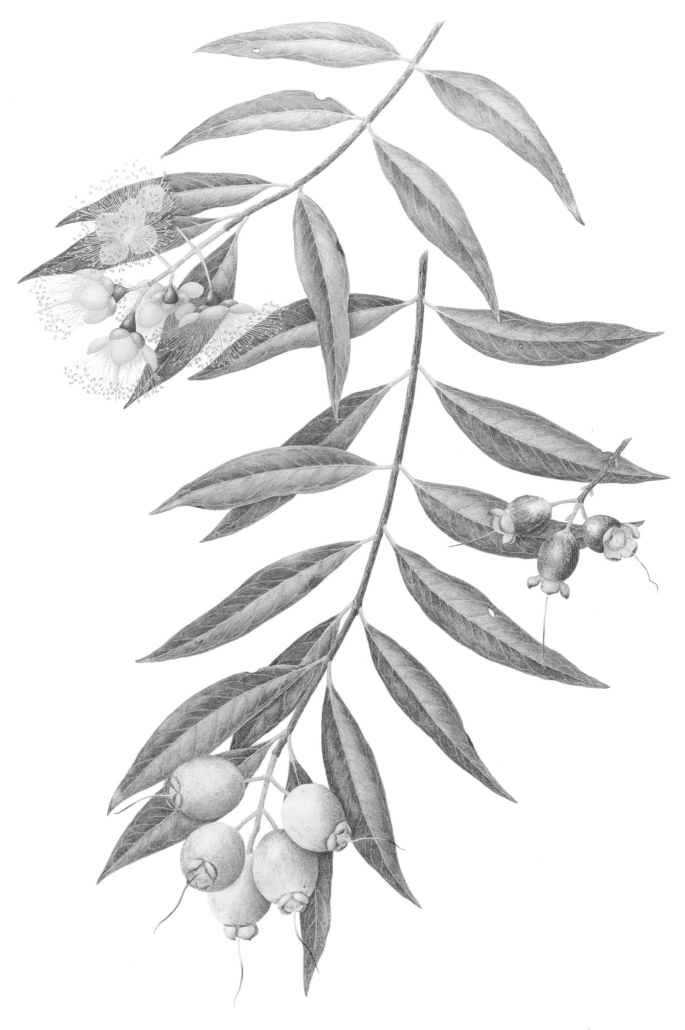

Catherine M. Watters

Banksia praemorsa Andrews

Proteaceae

Banksia named for Joseph Banks, the naturalist on board the *Endeavour*, accompanying Captain James Cook on his first Pacific voyage when *Banksia* specimens were collected at Botany Bay, between 28 April to 5 May 1770; *praemorsa* from *praemorsus* (bitten off).

Banksia praemorsa grows to about 4 metres tall and is native to the shrubland and woodland on the south coast of Western Australia. The leaves are broad, about 50 mm long by 15 mm wide, with toothed margins and with the ends truncated, giving rise to both the scientific and common names. The cylindrical flower spikes are conspicuous and up to 350 mm long by 100 mm in diameter at maturity. The flower colour is primarily wine red.

Banksia praemorsa, Cut-leaf Banksia, was described by Henry Andrews in 1802 using a plant grown at Kew from seed collected in 1791 at King George Sound, Western Australia, by Archibald Menzies.[30] Charles Fraser sent seed to Glasgow Botanic Garden, where it was raised and described as *Banksia marcescens* in *Curtis's Botanical Magazine* in 1828, the name used in 1857 when it grew in the Sydney Botanic Garden.[31] Western Australian banksias are difficult to grow in the Sydney climate and although still in the Garden in 1866, by 1895 only species from New South Wales remained in the collection. *Banksia praemorsa* is grown at the Australian Botanic Garden, Mount Annan.

Artist Margaret Pieroni

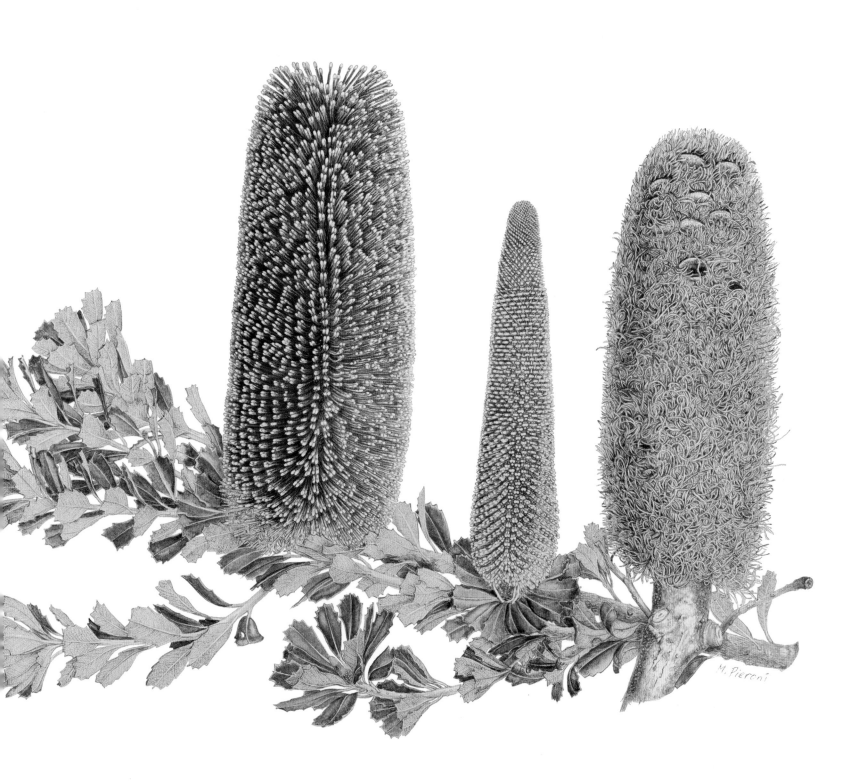

Magnolia grandiflora L.

Magnoliaceae

Magnolia for French botanist Pierre Magnol (1638–1715), Professor of Botany and Director of the Royal Botanic Garden of Montpellier; *grandiflora* refers to the very large flowers.

This magnolia is native to the south-eastern United States of America, from Virginia south to central Florida and west to eastern Texas and Oklahoma. It is found on margins of ponds and swamps in rich moist soil, in association with *Liquidambar styraciflua*, *Quercus nigra* and *Nyssa sylvatica*.

Magnolia grandiflora is a tall, evergreen tree up to 30 metres high. Leaves are alternate, simple, elliptic, 12–25 cm long, dark green above, lighter green below and often with rusty hairs on the undersides. It has perfect, creamy-white, beautifully fragrant flowers that are large, up to 30 cm diameter, solitary, usually with six tepals, each thick and concave.

Large specimens of *Magnolia grandiflora*, Bull Bay or Southern Magnolia, first described by Carl Linnaeus in 1753, are prominent throughout the Royal Botanic Garden, Sydney. The species was probably introduced to New South Wales by William Macarthur of Camden Park. The Colonial Secretary of the Colony, Alexander McLeay, acquired a plant from Macarthur for his garden at Elizabeth Bay in 1836.[32] The Colonial Botanist was directly responsible to the Colonial Secretary, and McLeay took a keen interest in the Botanic Garden, so this species was probably introduced to the Botanic Garden in the late 1830s–early 1840s. William Macarthur listed the species in his *Catalogue of plants cultivated at Camden, 1843*, and it was listed in Charles Moore's 1857 *Catalogue of Plants in the Government Botanic Garden, Sydney*.

Magnolia grandiflora, possibly chosen by James Kidd, Acting Superintendent 1844–47, formed part of the early plantings at Government House. It was one of the species Charles Moore, Director 1848–96, chose for his bolder plantings in the Lower Garden as it was extended from 1848 to 1879. A horticultural journalist visiting the Botanic Garden in 1864 wrote that soon after entering the garden he noted the *Magnolia grandiflora* 'with its noble white flowers, diffusing its powerful perfume'.[33]

Artist Jenny Phillips

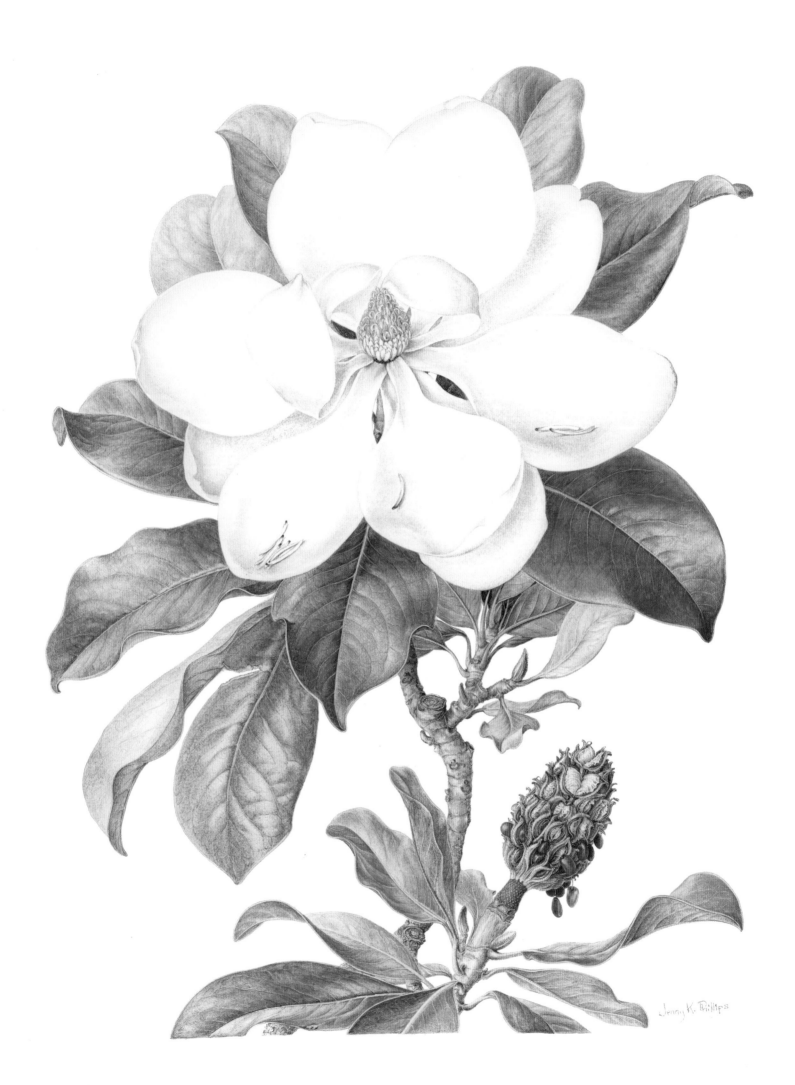

Araucaria bidwillii Hook.

Araucariaceae

Araucaria from Arauco, a former province of south-central Chile; *bidwillii* named after John Carne Bidwill.

This majestic conifer tree occurs naturally in coastal ranges in two widely separated locations near Gympie in south-east Queensland (Bunya Mountains) and near Mount Molloy north of Cairns.

Reaching sometimes to 50 metres high and 20 metres wide, with attractive shape, leaves and cones, it was, and still is, an iconic tree in the cultivated landscape. Its very large cones containing the seed, the Bunya Nut, fall at certain times, causing a loud cracking sound and when in a forest of these trees the sound is continuous. The nut is edible and was eaten by Aborigines in southern Queensland in the Bunya Mountains area.

Sacred to the local Aboriginal people of the Bunya Mountains, Queensland, the Bunya Bunya or Bunya Pine was first seen by the explorer and Foreman of Works at Moreton Bay, Andrew Petrie, in 1838–39. In 1842, botanist John Carne Bidwill collected a specimen, which he sent to William Hooker; he took a live tree to him the following year, from which Hooker named 'this noble tree' *Araucaria bidwillii* in 1843.[34] Bidwill supplied seed for propagation to William Macarthur of Camden Park, with whom he had a close association. John Carne Bidwill was the Government Botanist and first Director, rather than Superintendent, of the Botanic Gardens, his appointment lasting five months in 1847–48 until the arrival of Charles Moore, and it is possible the species was introduced to the Garden then. It was listed as growing in the Garden in 1857. The Bunya Bunya was planted in many botanic and municipal gardens, farm homesteads and large gardens in the early settlement of areas throughout the east of Australia, and its presence in the landscape often signals an important 19th century property.

Artist Dorothee Nijgh de Sampayo Garrido

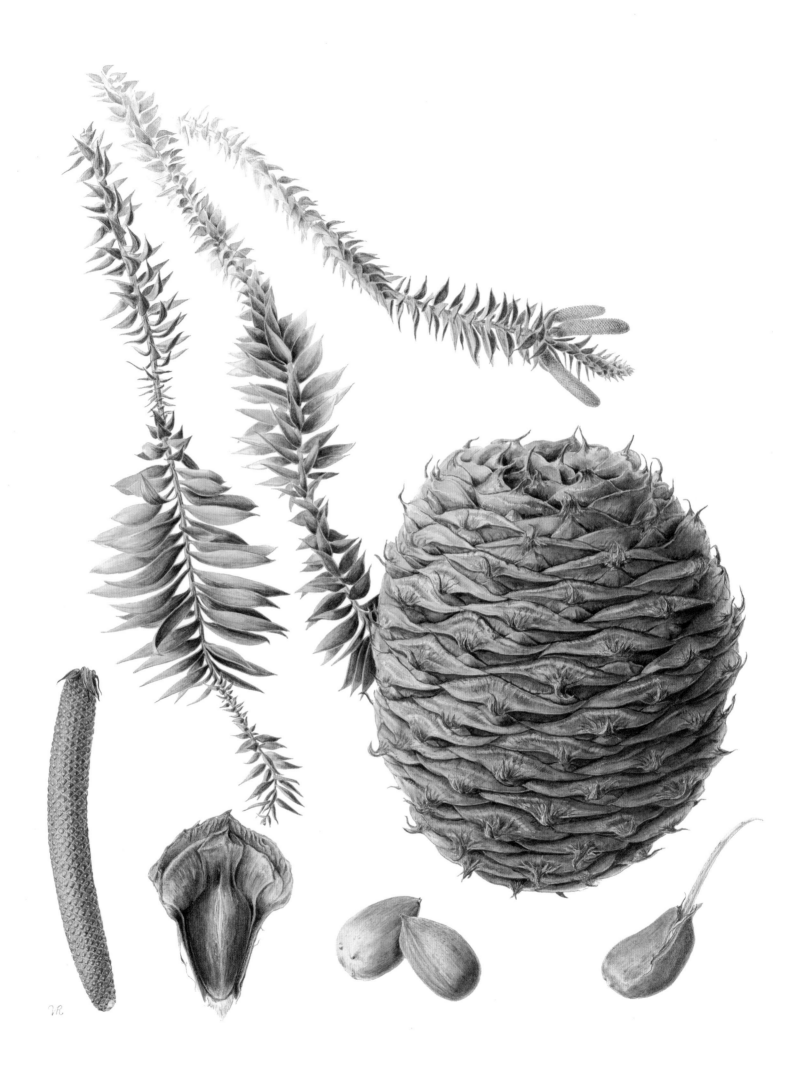

Agathis robusta (F.Muell) F.M.Bailey

Araucariaceae

Agathis from the Ancient Greek meaning 'ball of thread' in reference to the appearance of the female cone; *robusta* from the Latin *robustus* (strong or stout).

Agathis robusta grows to be a 45-metre majestic, forest emergent tree. It is endemic in Queensland and is widespread in coastal north-east Queensland. It occurs in New Guinea as a separate subspecies. It has broad, flat, thick, leathery foliage with parallel veins along the leaves. The long, straight trunk has bark that is brown to grey and smooth, except for scattered flakes. The tree has male and female cones, the female cones being the largest at 8–11 cm in diameter and with over 400 cone scales. *Agathis robusta* was highly prized as a timber and was especially heavily logged during World War II and up to the 1980s.

The oldest Queensland Kauri Pine, *Agathis robusta*, in the Royal Botanic Garden, Sydney is believed to be progeny of seed collected by JC Bidwill, first Director of the Botanic Gardens (1847–48), on 1 January 1849 in the Wide Bay area, on the site of the future Queensland town of Maryborough. Planted by Charles Moore in 1853, it is highly likely that William Macarthur raised the young tree from seed sent to him by Bidwill.[35] It is the 'type' specimen of this species, first described by Ferdinand von Mueller in 1859.[36] Following Bidwill's death in 1853, Moore went to Wide Bay to collect seeds and plants and wood samples for the Paris Exposition of 1855; among the wood samples sent to Paris was 'Dammara sp. Le 'Kaurie Tree' de Wide Bay'.[37]

Charles Moore took a great interest in this genus, often called *Dammara* in the 19th century until Frederick M Bailey, Colonial Botanist of Queensland, changed the name to *Agathis* in 1883. Moore collected new species in the Pacific region and developed a considerable group within the Sydney Garden.

Artist Dorothee Nijgh de Sampayo Garrido

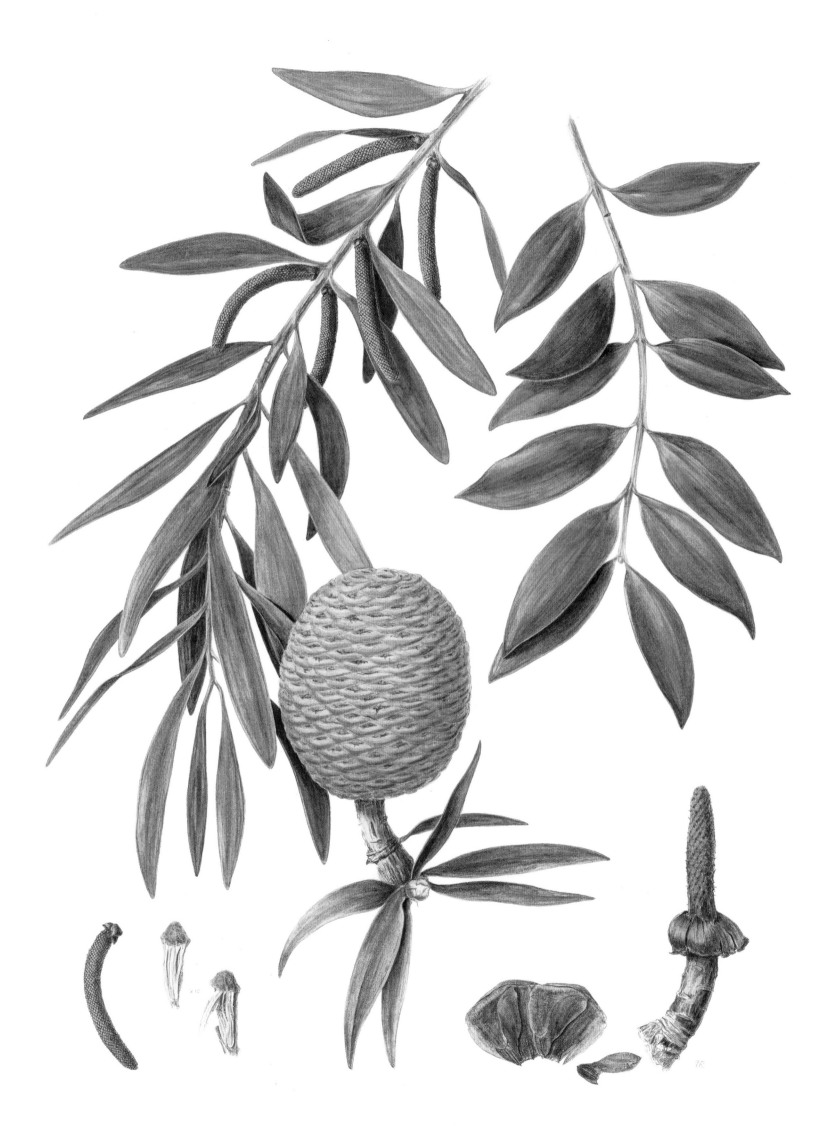

Pinus roxburghii Sarg.

Pinaceae

Pinus (pine); *roxburghii* named for William Roxburgh, 18th century Scottish botanist who specialised in the flora of India.

Recorded across the Himalayas, from Pakistan to north-east India, Nepal and Bhutan, *Pinus roxburghii* is widespread and common in the north–south oriented outer valleys of the Himalayas and their foothills and often forms pure stands, especially on dry slopes. It has a large, broad crown and grows 40 metres tall or more; older trees are known for their grey bark with red-orange fissured plates on the trunks. The leaves are grouped in threes and often fall to the ground, giving the tree a deciduous look at certain times of the year.

The Chir Pine, *Pinus roxburghii*, known as *Pinus longifolia* when it was introduced to Australia, was first described in 1796. It was later named for the botanist in charge of the East India Company's Botanic Garden in Calcutta, William Roxburgh, who wrote *Hortus Bengalensis* and *Flora Indica; or Descriptions of Indian Plants*. Charles Fraser and his successors exchanged plants with Roxburgh's former assistant, Nathaniel Wallich, Superintendent of the Botanic Garden, Calcutta. The pine was available in Sydney in the 1840s, and it is likely that it was first planted in the Garden then. It appears in the *Catalogue of Plants in the Government Botanic Garden, Sydney, New South Wales, 1857*, and old specimens grow in both the Sydney Gardens and the Domain.

Artist Elaine Musgrave

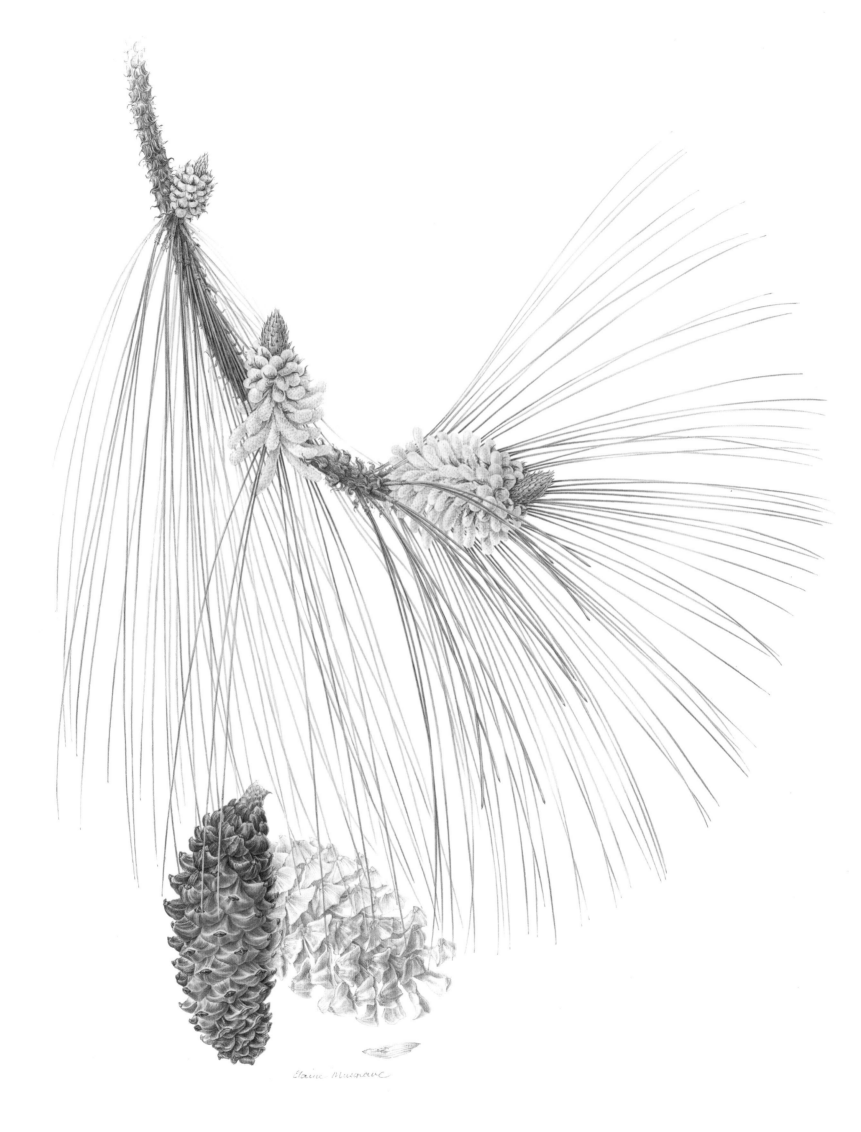

Elaine Musgrave

Calathea zebrina Lindl.

Marantaceae

Calathea from the Greek *kalathos* (a basket); *zebrina* (striped or banded), referring to the leaves.

Native to south-east Brazil where it grows in the humid forests, this perennial is well known as a popular indoor plant due to its spectacular striped lime-green and dark-green foliage. The large, oval leaves stand erect at the apex of the plant and spreading at the sides. Plants can grow to 1 metre in height. The small, pink and tubular flowers are inconspicuous among the foliage and are rarely produced in cultivation.

Calathea zebrina was one of the plants collected by Allan Cunningham and James Bowie in 1815 when they were Collectors of plants for His Majesty's Botanic Garden at Kew in Brazil. They identified it as *Maranta bicolor*.[38] It was described as *Maranta zebrina*, Striped-leaved Maranta, by John Sims in *Curtis's Botanical Magazine* in 1817. Although it had been growing in the Chelsea Physic Garden for some years, it first flowered there in 1817, providing the opportunity for the botanical artist to capture the moment. John Lindley reclassified it as *Calathea zebrina* in the *Botanical Register* in 1828–29. It was growing in the Sydney Botanic Garden by 1857, and its handsome leaves appealed to mid 19th century gardeners fascinated by plants with variegated foliage. It is still used as an understorey planting in these Gardens, enhancing their subtropical appearance.

Artist Laura Silburn

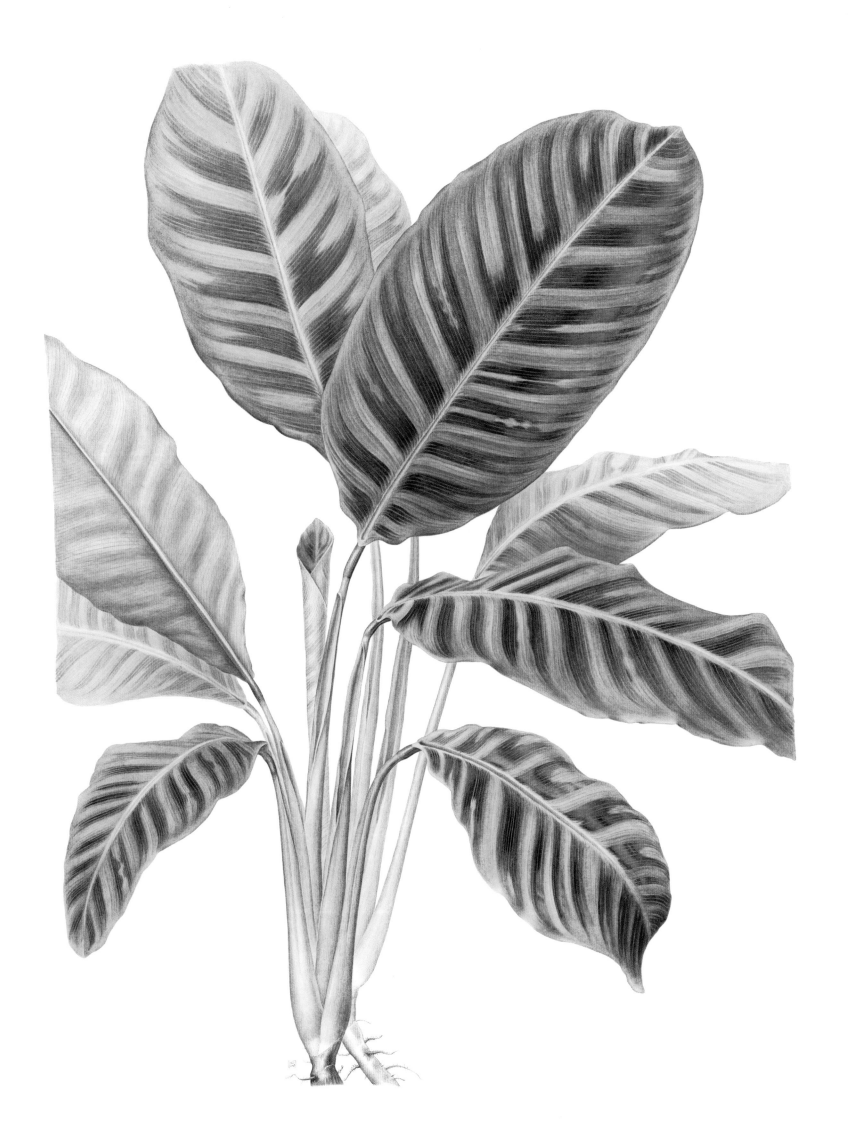

Dierama pendulum (L.f.) Baker

Iridaceae

Dierama from the Greek word for funnel, describing the flower shape; *pendulum* (hanging or suspended), also in reference to the flowers.

Dierama pendulum is native to eastern South Africa, where much of its habitat has been destroyed. It is now found sporadically over east of the Cape, but is most common in the viable and humid hot area of KwaZulu–Natal.

It has numerous common names, such as Fairybells, Wandflowers, Angel's Fishing Rod, Wedding Bells and Hairbell. Loved for its grace and bell-shaped flowers, which range from pink to mauve, this plant is cultivated widely around the world. It is easily grown from the bulb-like structure called a corm, and it produces numerous tough, linear, basal leaves up to 90 cm long. The flowers are then borne on long, arching and branched inflorescences. *Dierama pendulum* excels in humid environments and can grow to 2 metres high, with each flower twisting itself open to approximately 5 cm long.

Dierama pendulum was collected in South Africa by the Swedish naturalist Carl Peter Thunberg in 1772. Cape 'bulbs' were commonly grown in colonial New South Wales, brought by the ships that replenished supplies in Cape Town. It was known by one of its synonyms, *Ixia pendula*, when it was listed as growing in the Sydney Botanic Garden in 1857. It was described as *Dierama pendulum* in 1877.[39]

It still grew in the Royal Botanic Garden, Sydney in 2013, but since then has only been grown in the Blue Mountains Botanic Garden, Mount Tomah.

Artist The Hon. Gillian Foster

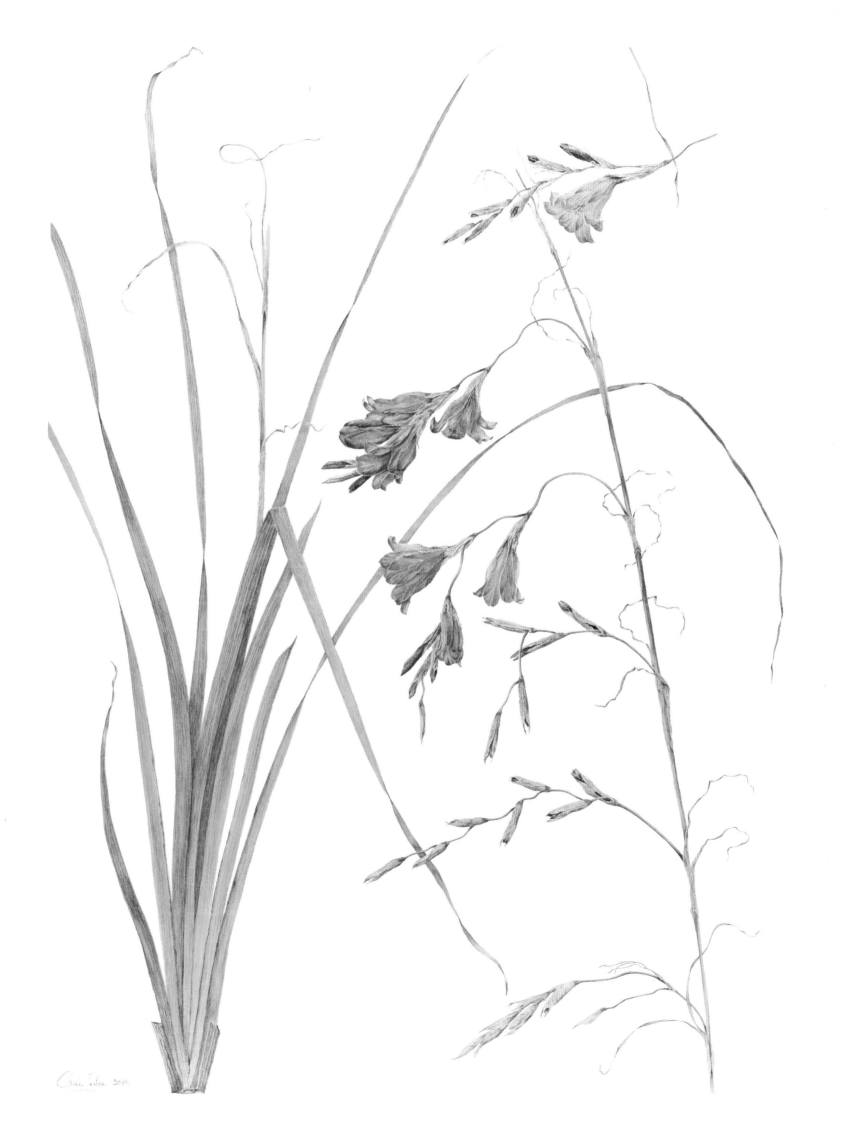

Zygopetalum maculatum (Kunth) Garay

Orchidaceae

Zygopetalum from the Greek *zygon* (yoked petal), referring to the fused flowers; *maculatum* from *macula* (spotted or blotched).

This epiphytic orchid has large fleshy roots and a large bulb. The flower spikes usually carry five or six very large and handsome flowers. Each flower is striking and presents differently with the purple and white markings of the large labellum and the green with red blotches on the upper petals.

Mr Mackay's Orchid was described by William Hooker in *Curtis's Botanical Magazine* in 1827 as *Zygopetalum mackaii*, the first species described for this genus. It was imported by a Mr Mackay of Dublin College Botanic Garden in that year, along with a few other orchid species from Brazil. It was growing in the Sydney Botanic Garden in 1857. In 1970, the name of Mr Mackay's Orchid was revised to *Zygopetalum maculatum*. Many hybrids have been developed from this species.

The artist donated a division of this plant to the Royal Botanic Garden, Sydney, part of a collection of orchids she inherited from her father.

Artist Fiona McGlynn

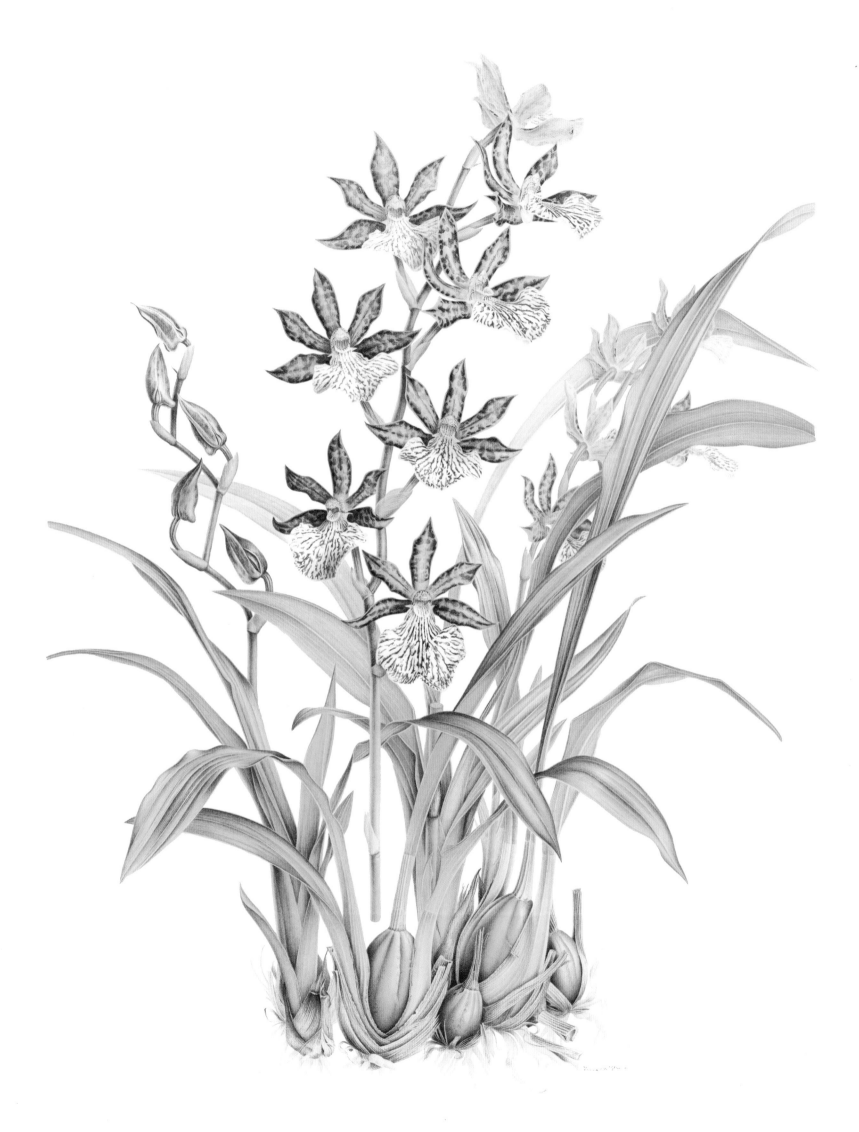

Gardenia thunbergia L.f.

Rubiaceae

Gardenia named for the Scottish physician, botanist and zoologist Alexander Garden (1730–1791); *thunbergia* for botanist Carl Peter Thunberg, who collected extensively in South Africa.

This plant has a striking appearance especially in summer with its creamy-white, fragrant flowers with eight distinct petals. The shiny, oval leaves occur in whorls of three or four towards the ends of the branches. Native to the east coast of South Africa, it occurs mainly in evergreen forests and their margins.

Described by Carl Linnaeus in 1781, *Gardenia thunbergia*, the White Gardenia or Tree Gardenia, was one of the first of the South African gardenias known to botanists; it was introduced to Kew in 1773.[40] *Gardenia thunbergia* (listed as *Thunbergiana*) was in the Camden Park Nursery catalogues from 1843 onwards; it was advertised for sale in *The Australian* newspaper by John McMahon of Camden in 1848 and was available at Shepherd's Darling Nursery, Sydney, in 1851.[41] It is likely that it was planted in the Sydney Botanic Garden at least a decade prior to 1857 when Charles Moore compiled his *Catalogue of plants in the Government Botanic Garden, Sydney*.

By 1919, the garden writer in the *Sydney Mail* noted that '*Gardenia thunbergii*' [sic.] was a shrub 'rarely seen, but should be grown more for its pure, white, star-shaped, exquisitely scented flowers and dense dark green foliage'. The writer recommended that its proper position be at the back of the shrubbery.[42]

Artist Sandra Sanger

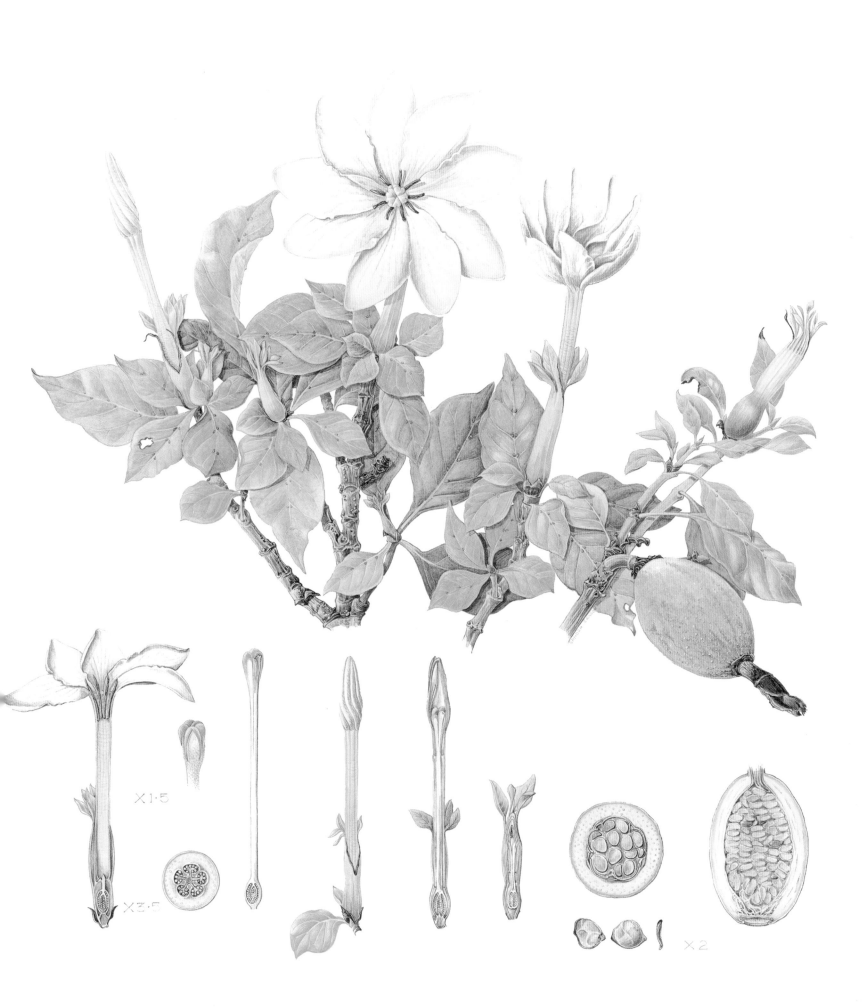

X1·5

X3·5

X2

Lapageria rosea Ruiz & Pav.

Philesiaceae

Lapageria commemorates Napoleon I's wife, Josephine Tascher de la Pagerie (1763–1814), who was brought up on a sugar plantation called *La Pagerie* in Martinique; *rosea* (rose like).

This is an evergreen, twining climber with dark-green, leathery leaves and bell-shaped, pale pink to red flowers that show in autumn to midwinter. The sweet, fleshy fruits are edible.

Lapageria rosea, the Chilean Bellflower or Copihue, was first described in 1802 and is the national flower of Chile, the native country of the artist. It was growing in the Sydney Botanic Garden in 1857 when Charles Moore compiled a catalogue of plants in the Garden, and again in 1895. In the *Hand-Book of Australian Horticulture* (1892), HA James wrote that the Lapageria, which did best in a bush house, 'rank among the most valued of all climbing plants'.[43] However, the Copihue, with its love of moist mountainous regions, did not survive long term in the Sydney Botanic Garden, and in 1914 Mr EN Ward, Acting Superintendent, reported that the Lapageria had been 'almost a complete failure'.[44]

A Royal Botanic Gardens and Domain Trust collecting expedition in 1985 travelled to Pichirropulli, in the mountainous region of central Chile, to collect the propagation material from the wild. This beautiful vine was successfully cultivated in many different parts of the Blue Mountains Botanic Garden, Mount Tomah. The Copihue there produced its first solitary flower in June 1998.

Artist Annie Hughes

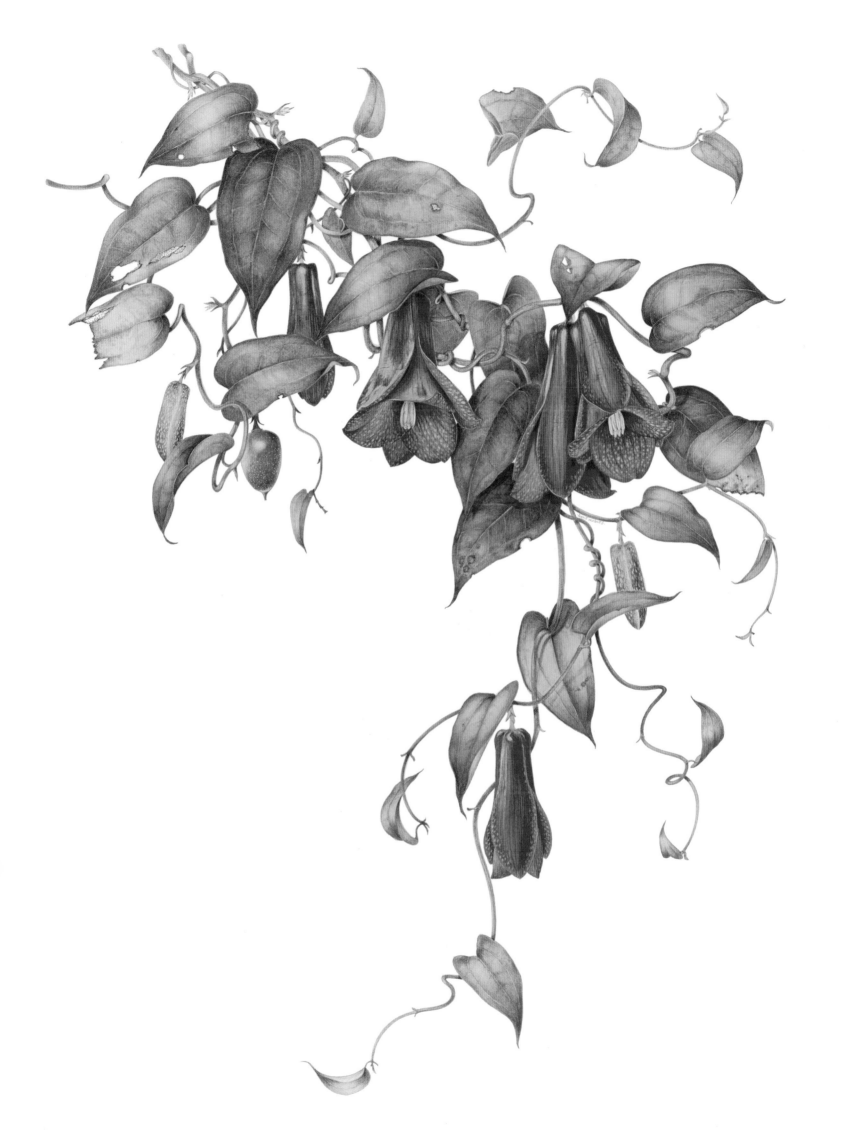

Opuntia ficus-indica (L.) Mill

Cactaceae

Opuntia possibly referring to the ancient Greek town Optus; *ficus-indica* (fig of India).

The origin of this species is somewhat obscure, due to cultivation since ancient times for its edible fruit, but it is thought to have originated in Mexico. Other than being naturalised in Australia, it is also invasive in southern Europe, Africa, southern Asia, around Los Angeles and southern USA and on some oceanic islands with warm climates. It prefers a semi-arid habitat.

Opuntia ficus-indica is a succulent shrub or tree, usually 1.5–3 metres high, although it can grow to 5 metres. It develops a sturdy trunk with age and holds the branches (called cladodes) at various angles. The cladodes are flattened and grey to grey-green in colour. As they age, they grow younger cladodes that branch upwards. The leaves shed early and are minute. The flowers are large, bright and conspicuous in bright yellow or shades of orange or red. The edible fruit are succulent berries that are reddish when ripe, with clusters of minute spines.

The Indian Fig, *Opuntia ficus-indica*, was first described by Carl Linnaeus in 1768. It was available at Shepherd's Darling Nursery in Sydney in 1851 and was listed as growing in the Sydney Botanic Garden in 1857.

Researching opuntia is one of the scientific 'stories' of the Royal Botanic Garden, Sydney. Although not a problem in the Sydney climate, as early as 1860 Director Charles Moore noted that opuntia and the Common Indian Fig were growing wild in the bush of western New South Wales to an alarming extent.[45] By the end of the century, it was referred to as a prickly pear 'invasion'. Moore's successor, Joseph Henry Maiden, undertook detailed research into opuntias to identify the problematic species. The Royal Botanic Garden's first botanical illustrator, Margaret Flockton, beautifully illustrated his extensive research, published in 1912. This species is grown in Sydney for its fruit, which is prized for its delicate flesh although the preparation for the table is a somewhat prickly operation.

Artist Elisabeth Dowle

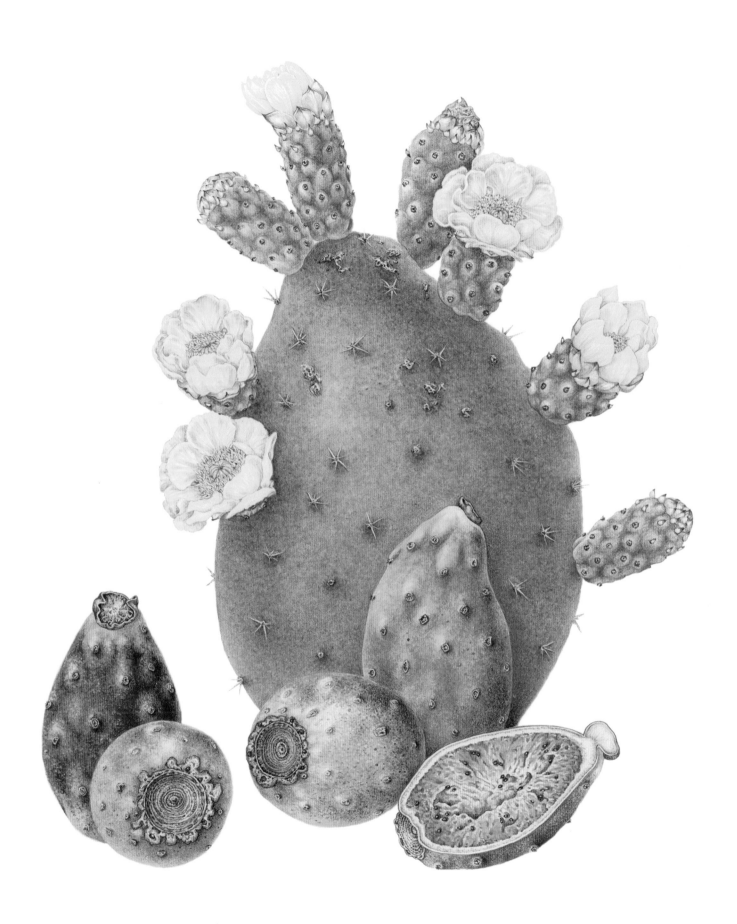

Elisabeth Dowle

Dracaena draco L.

Asparagaceae

Dracaena means a female dragon; *draco* also means dragon.

Native to the Canary Islands, Madeira and Cape Verde Islands, this tree is now endangered in its natural habitat.

Strangely in the asparagus family, after many other family placements, *Dracaena draco* is a monocot whose subfamily Nolinoideae, where it now sits, diverged 47 million years ago. It is very slow-growing and long-lived.

It has a single stem that becomes multi-stemmed and umbrella-like when the plant is 10–15 years old. The blue-grey leaves are strap-like and firm, and form bunches at the ends of the branches, giving the plant its distinctive shape. The flower spikes project out from the leaves with an inflorescence of white lily flowers that are richly perfumed, followed by red-orange fruits. After fruiting, terminal buds start to show and new stems emerge and grow very slowly until the next flowering episode. Although endangered in its native habitat, the tree is widely cultivated as a drought-resistant sculptural tree. If the bark is damaged, it exudes a reddish sap, hence the common name Dragon's Blood Tree. The resin is believed to have medicinal and magical properties.

Described by Carl Linnaeus in 1767, a number of remarkable specimens of the Dragon's Blood Tree, *Dracaena draco*, have been a feature of the Royal Botanic Garden, Sydney over many years. A good-sized specimen was noted in the Botanic Garden in 1884.[46] In 1903, JH Maiden wrote that the tree in the Palm Grove was planted 'over forty years ago and is probably the oldest plant of its kind in Australia'.[47] A number of Dragon's Blood Trees were planted in public institutions by Director Charles Moore and the Overseer for the Domain (1884–1913), James Jones. Maiden, who succeeded Moore, also had a particular interest in Canary Islands flora. One of the most striking of the Sydney Garden's *Dracaena draco* toppled over but survived in 2008. Its tilted form became a curiosity for visitors.

Artist Tanya Hoolihan

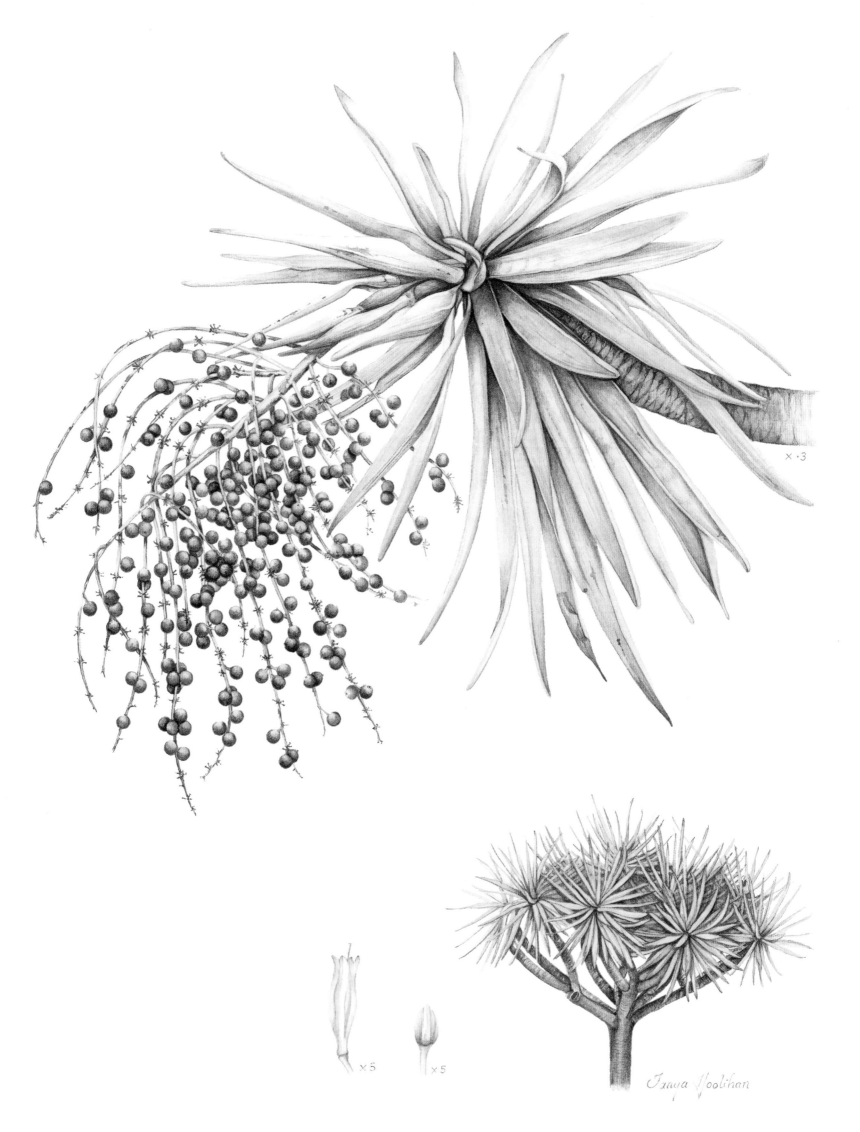

× .3

× 5 × 5

Tanya Hoolihan

Brugmansia × *candida* Pers.

Solanaceae

Brugmansia named from Sebals Justin Brugmans (1763–1819), a Dutch professor of natural history; *candida* (dazzling white), referring to the colour of the flowers.

Brugmansia × *candida* is a large shrub to small tree that is highly variable, especially in flower colour, but white in this painting. It usually has one trunk and many spreading branches. The species that this hybrid originates from are geographically segregated, and therefore the occurrence of this hybrid has been brought about by human intervention. It occurs on the eastern and western slopes of the Andes mountains in central Ecuador, and has been an entity as a hybrid for a long time. It has a wide ecological tolerance, in the tropics from sea level to over 3000 metres, and is naturalised in many warmer parts of the world.

Known and cultivated in gardens for the lovely trumpet flowers that hang in profusion, the lime-yellow buds appear, followed by the blossoming of the pure-white trumpet flower with its conspicuous long petal tips. The large mid-green leaves show the venation prominently, particularly on the underside.

Brugmansia × *candida* is a hybrid between *Brugmansia aurea* and *Brugmansia versicolor* species and their many combinations.

Brugmansia candida, a hybrid Angel's Trumpet, was first described by Christiaan Persoon, a South African botanist, in 1805. It has long been grown at the Royal Botanic Garden, Sydney and was a sought-after colonial species – it could be grown outside in the Sydney climate rather than in a glasshouse, denoting a horticultural extravagance recognised by Sydney's European counterparts. It is likely to have been listed under a number of alternative names – *Brugmansia* 'Knightii', for example, was listed as growing in the Sydney Garden in 1857 and 1866, and *Brugmansia arborea* was listed in JH Maiden's 1903 *Guide to the Botanic Gardens, Sydney*.

Dr Alistair Hay, who joined the staff of the Royal Botanic Garden, Sydney in 1987 and was Senior Research Scientist and Director Botanic Gardens and Public Programs before his retirement c. 2003, undertook definitive research into the genus and its nomenclature, culminating in the book, *Huanduj, Brugmansia*, published in 2012.

Artist Mayumi Hashi

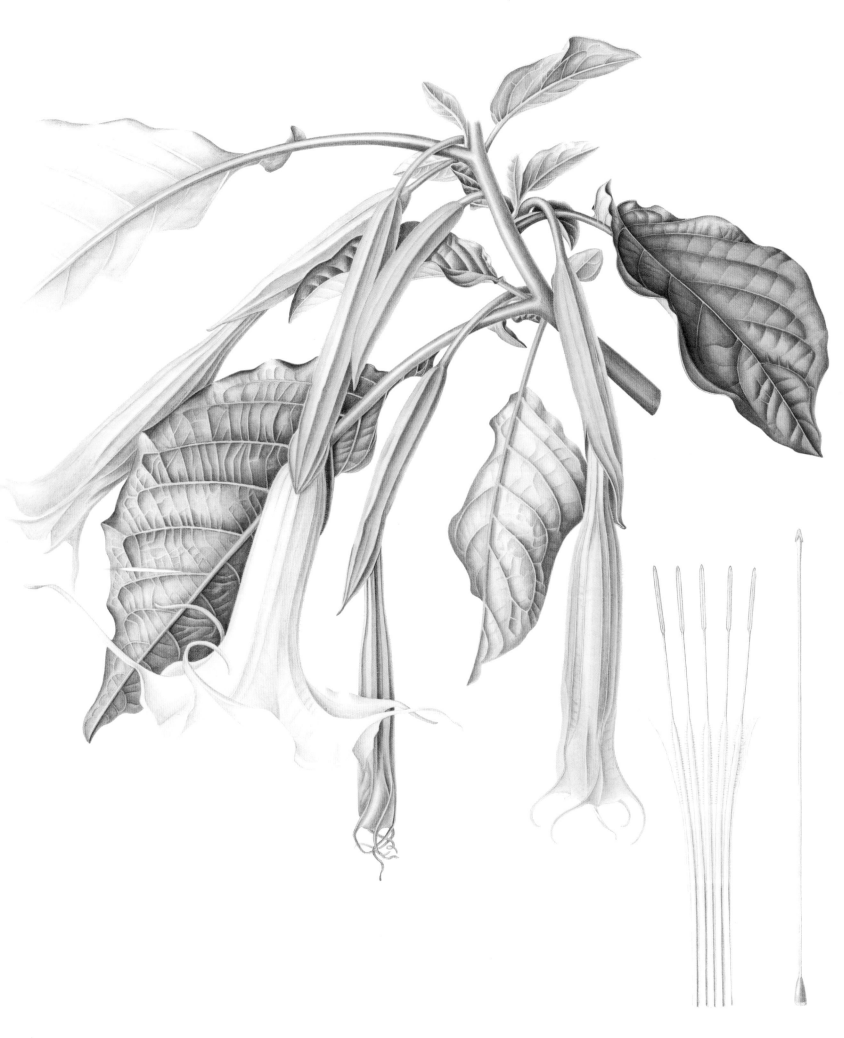

Clark 2015

Camellia japonica 'Cleopatra'
Theaceae

Camellia after Georg Kamel or *Camellus* (1661–1706), author of the first descriptions of the Philippine flora and fauna including the birds; *japonica* (from Japan).

Camellias have grown in the Royal Botanic Garden, Sydney since 1823 when three plants, including a single white camellia, were sent from Canton by John Reeves, a tea inspector and keen naturalist and artist. In the same year Lady Brisbane, the wife of Governor Sir Thomas Brisbane, gave the Botanic Garden a double red camellia. The waratah-flowered camellia 'Anemoniflora' and a double striped camellia were introduced in 1824, and in 1825 Alexander McLeay donated the double white 'Alba Plena'.

Camellia japonica 'Cleopatra' is among the old camellias in the Government House grounds at Sydney, which are early stock brought from Camden Park, the home of the Macarthur Family, to the south-west of Sydney. William Macarthur imported a shipment of camellias in 1831 and became increasingly engaged with camellia breeding. Early Macarthur varieties include this one, 'Cleopatra', which was raised by William Macarthur. He described it as 'Crimson, three rows of outer petals large and well shaped, good substance, inner smaller and more crowded. Very handsome.'[48] Camellia expert Thomas J Savige, in *The International Camellia Register*, describes it as having been mentioned in the 1849 *Annual Report of the Australasian Botanical and Horticultural Society*. It was first listed in the Camden Park Nursery catalogue in 1857. Nurseryman John Baptist also offered it for sale in 1861.

Camellia japonica 'Cleopatra' was planted in the grounds of Government House around 1860 and is now a sight to behold when in flower with its old-fashioned brilliant pink double flowers and yellow stamens.

Artist Beverly Allen

84

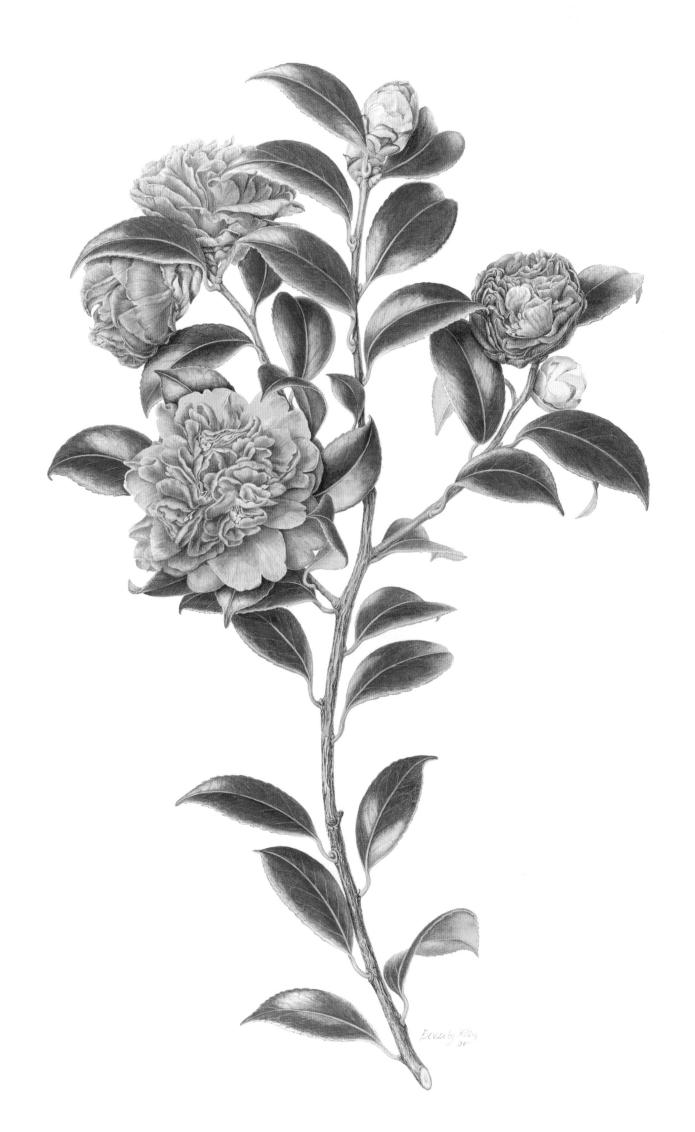

Angiopteris evecta (G.Fost.) Hoffm.

Marattiaceae

Angiopteris from the Greek *angion* (vessel) and *pteris* (a fern), in reference to the shape of the sporangia; *evecta* from *evectus* (carried, moved forward).

Angiopteris evecta is an ancient, distinctive, large, ground-dwelling fern with arching fronds to around 5 metres long. The leaves are in twos along the frond and are shiny green; the trunk is short, but broad and massive.

Its distribution in Australia is sporadic, but it is known from Carnarvon Gorge, Fraser Island and then more commonly in the wet tropics of far north Queensland, the Northern Territory (where there is only one small population in north-eastern Arnhem Land) and on the far north coast of New South Wales (where it is considered endangered). The population in Arnhem Land is known from a single perennial spring in a narrow sandstone gorge. It also grows naturally in New Guinea and Polynesia. Requiring a moist habitat, it has been planted widely throughout Asia and the tropics and has become invasive in Jamaica, Hawaii and Costa Rica.

Commonly known as Giant Fern, *Angiopteris evecta* had been introduced to the Sydney Botanic Garden by 1866, at the height of the 19th century 'mania' for ferns. One of the largest of all ferns, it was originally described as *Polypodium evectum* in *Florulae insularum Australium: prodromus* by Georg Forster in 1786; a decade later it was reclassified to its current name by Georg Hoffmann.

This fern is considered primitive, and very similar fossilised fronds have been found in rocks some 300 million years old. The genus has one variable species occurring in rainforests and secondary forests, often near streams. In his 1879 lecture 'Ferns of Australia', the Reverend William Woolls, a well-known botanist in Sydney circles, described *Angiopteris evecta* as 'amongst the most splendid of our ferns'.[49]

Artist Elizabeth Mahar

86

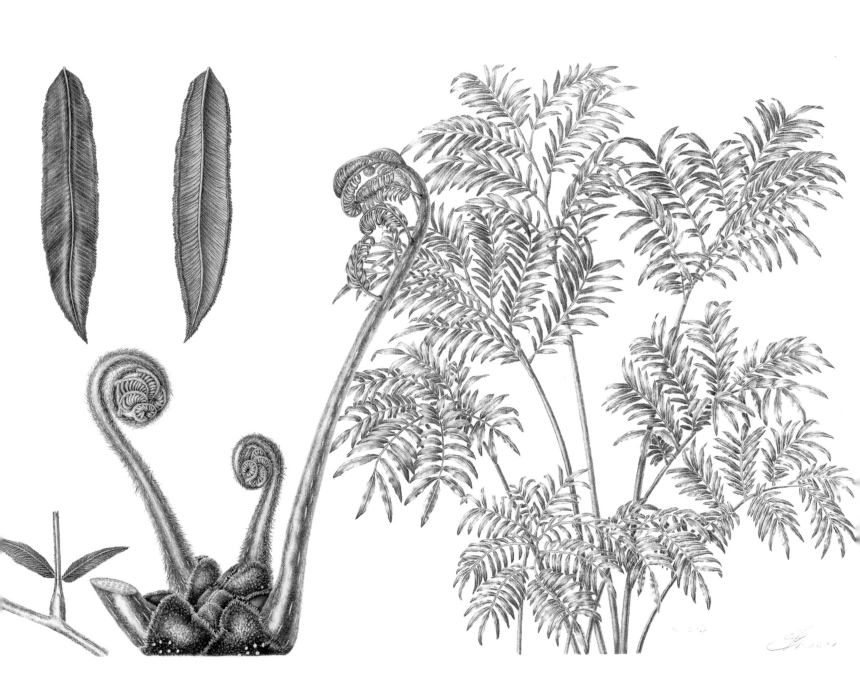

Podocarpus elatus R.Br. ex Endl.

Podocarpaceae

Podocarpus from the Greek *podos* (foot) and *karpos* (fruit); *elatus* (tall).

These trees grow in the dense subtropical, riverine and seashore rainforests on the east coast of Australia from Jervis Bay in New South Wales to McIlwraith Range in far north Queensland.

They originated in the Gondwanan forests of the Triassic period, 245 million years ago, where they grew alongside trees resembling the Wollemi Pines. This tree is of interest because the colour and shape of the fruit; unlike other conifers that have cones, there is a single seed attached by a fleshy stem to the branch. This fleshy part is edible and was a known food to the Aborigines.

Material is hard to find because there are male and female trees and because of their irregular (mast) flowering pattern. However, the artist was able to draw the male catkin from the herbarium specimens at the National Herbarium of New South Wales.

Podocarpus elatus, commonly called the Plum Pine, She Pine or Brown Pine, is a coastal tree that has its southernmost extent in the Illawarra to the south of Sydney. The Dharawal people of the Illawarra call the Plum Pine 'Dyrren Dyrren'. John McMahon, a gardener of Camden, listed 'Podocarpus (Illawarra Pine)' in pots for sale in 1848.[50] A sample of its wood was among the collection of timber woods assembled by William Macarthur, a leading gentleman-horticulturist and member of the Committee of Management of the Sydney Botanic Garden, and sent to the Paris International Exhibition of 1855.[51] It is associated with Charles Moore's collecting in the Richmond River area, and Moore would have almost certainly encountered the species when he collected timbers for the London International Exhibition of 1862 in the Northern Rivers area of New South Wales. The species was among the samples from New South Wales sent to the 1862 Exhibition. In the Botanic Garden's 1866 *Catalogue* it seems it was mistakenly listed as *Podocarpus spinulosus*, the name used when the *Podocarpus* planting throughout the Domain in the 1870s was reported.[52]

Artist Annie Hughes

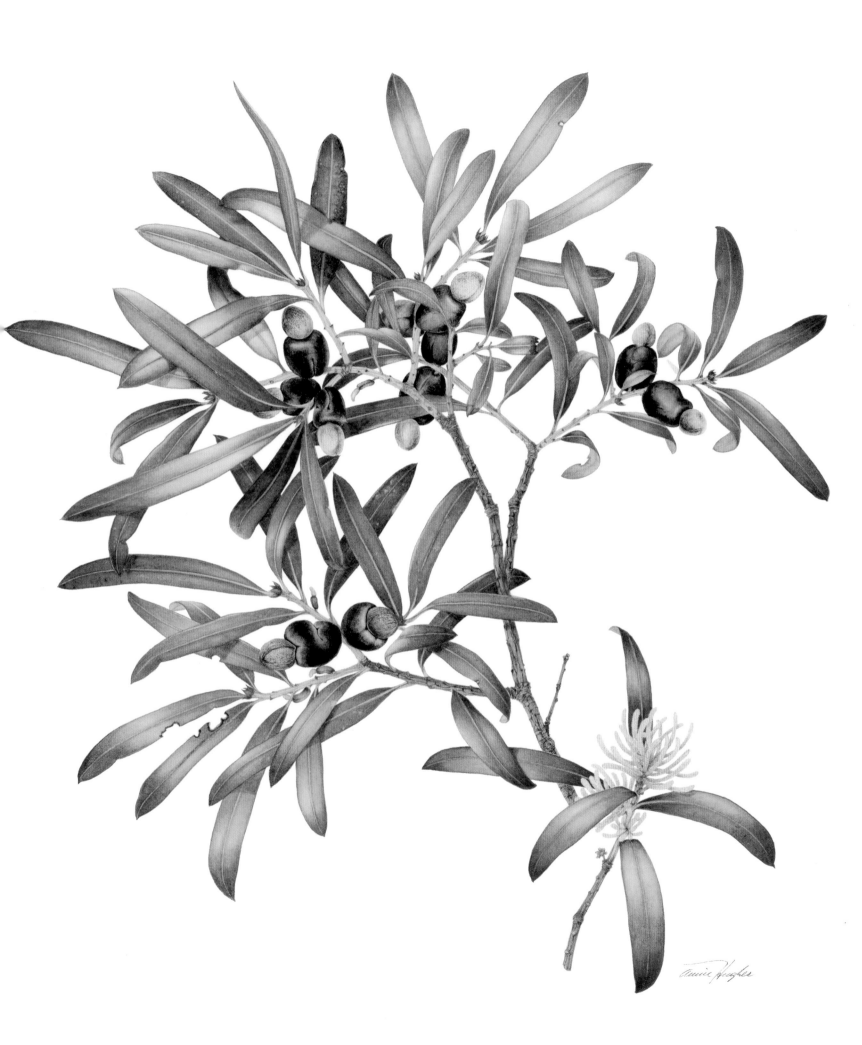

Keteleeria fortunei Carriere

Pinaceae

Keteleeria named for JB Keteleer (1813–1903), a French nurseryman; *fortunei* for Robert Fortune who, in 1844, collected seeds in China and distributed them to the west.

Keteleeria fortunei is native to China and Hong Kong. It is a protected species in China. This tree is an evergreen conifer growing up to 25 metres high. It has corky bark, which is furrowed in a vertical pattern, and the branches are distinctively horizontal and spreading. The branchlets are orange-red and hairy. Leaves are linear and stiff with shiny tips. The female cones are cylindrical, 10–18 cm long, purple or brownish in colour, holding glossy brown winged seeds.

Keteleeria fortunei was introduced to Britain from south-east China by Robert Fortune in 1844 and first described by Carriere in *Revue Horticole* in 1866. It apparently failed to survive in Britain, but trees planted in the 19th century did survive in both Sydney and Melbourne Botanic Gardens, one of these being the source of its reintroduction to Britain in the early 20th century.[53] Photographic evidence suggests that it was probably planted in the Sydney Botanic Garden in the 1860s. However, it was not correctly identified until the publication of JH Maiden's 1903 *Guide to the Botanic Gardens, Sydney*. This species thrives in Sydney's subtropical climate.

A younger and fine specimen of *Keteleeria fortunei* was incorporated into the Hong Kong Shanghai Bank sponsored Oriental Garden, designed and developed by Ian Innes, Horticultural Development Officer. The Oriental Garden was designed to display the East Asian thematic collection that Dr Alistair Hay, Horticultural Botanist, had consolidated. The garden included wild-sourced material from China and Vietnam and a wisteria collection donated by Dr Peter Valder, former senior lecturer in Botany at the University of Sydney.

Artist Linda Catchlove

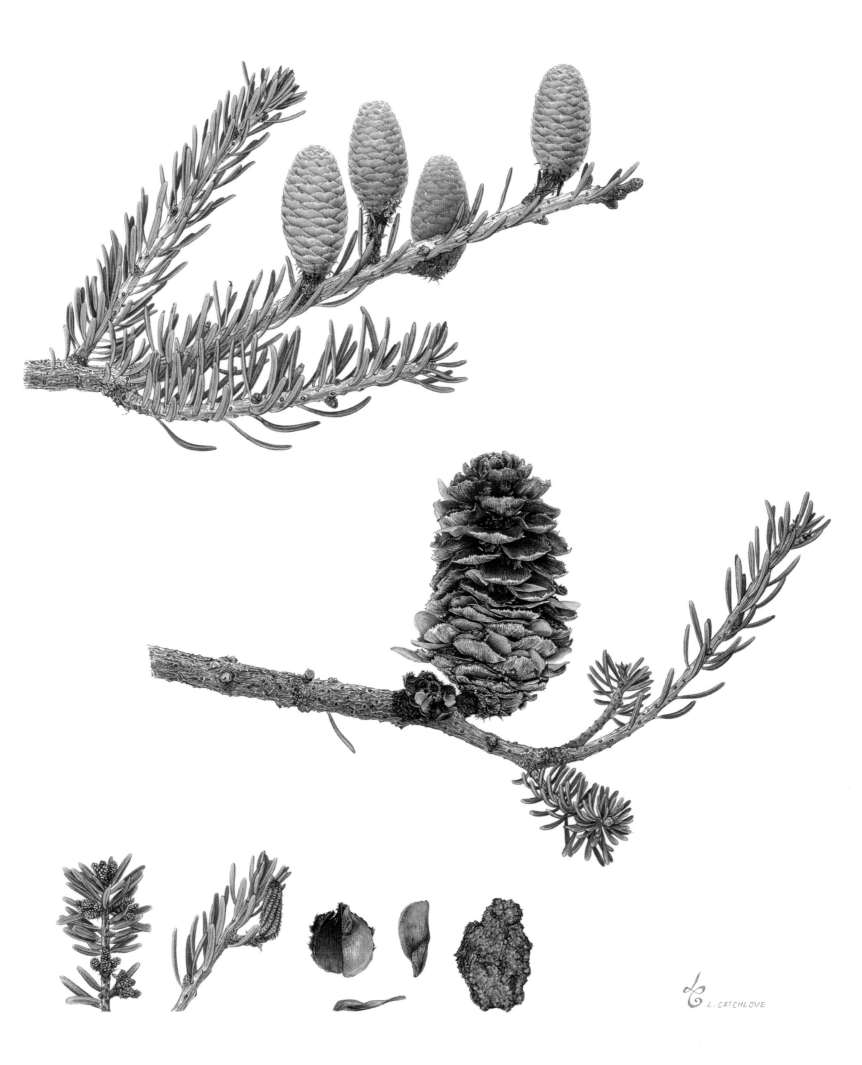

L. CATCHLOVE

Dichorisandra thyrsiflora J.C.Mikan

Commelinaceae

Dichorisandra from the Greek *di* (two), *chori* (separate) and *andro* (the male components), with reference to the arrangement of the stamen; *thyrsifolia* (flowers in a thyrse).

There are at least 35 species of *Dichorisandra*, but this is the only one frequently grown by gardeners. Native to Brazil, this species has been in cultivation for over 100 years, mostly as a glasshouse plant. In Sydney's climate it thrives in the garden, provided it has some of the comforts of its original tropical jungle environment: a warm sheltered site, with shade and a rich and fertile soil. Blue Ginger is a misleading common name for this spectacular plant, which belongs to the very different family, the spiderworts.

Dichorisandra thyrsiflora was first described in 1823 by Johann Mikan, one of the naturalists on the Austrian Expedition to Brazil. Allan Cunningham and James Bowie had collected it when they were Collectors of plants for His Majesty's Botanic Garden at Kew in Brazil from 1814 to 1816, and William Hooker credited them for its introduction to the Royal Botanic Gardens, Kew.[54] In New South Wales, it was listed in William Macarthur's *Catalogue of plants cultivated at Camden Park, New South Wales, 1857*, but was not introduced to the Sydney Botanic Garden until later. Listed as growing in the Botanic Garden in 1895, it is one of the striking subtropical plants that contribute to the Garden's character.

Artist Beverly Allen

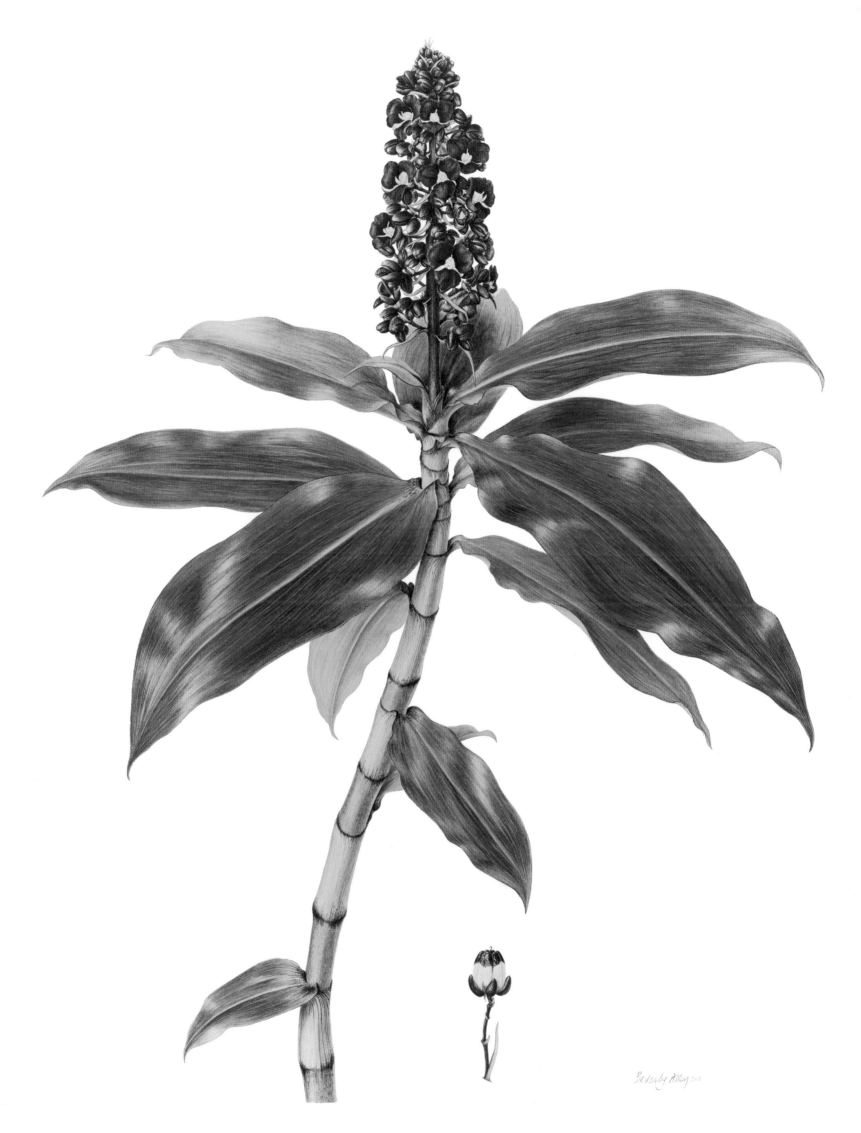

Epiphyllum crenatum (Lindl.) G.Don

Cactaceae

Epiphyllum refers to the leaf being like branches; *crenatum* (scalloped).

Epiphyllum crenatum occurs from Mexico to Honduras and is a member of the cactus family that grows on, or is supported by, other vegetation. These plants grow in moist and wet forests at high altitudes. In cultivation, they hybridise easily.

Epiphyllum crenatum, the Crenate Orchid Cactus, was first listed by one of its synonyms, *Phyllocactus crenatus*, as growing at the Sydney Botanic Garden in 1895. Given the array of unresolved names used for both *Cereus* and *Epiphyllum*, it may have been grown in the Botanic Garden much earlier. John Lindley described this cactus as *Cereus crenatus* in 1844, and in 1855 its name was revised to *Epiphyllum crenatum*.

This painting was one of eight *Epiphyllum* and related species that the artist painted for the Royal Horticultural Society, London Botanical Art Show in January 2007. She was awarded a Gold Medal for the series of eight paintings. Epiphyllum are commonly found growing outdoors in the 19th century gardens of western Sydney, and the specimen for this painting of *Epiphyllum crenatum* is from Ellensville near Camden, probably planted around 1890 and now a huge old plant. The Royal Botanic Garden in Sydney still has several plants growing.

Artist Beverly Allen
Donated by Wendy Pratten and Susan Rothwell

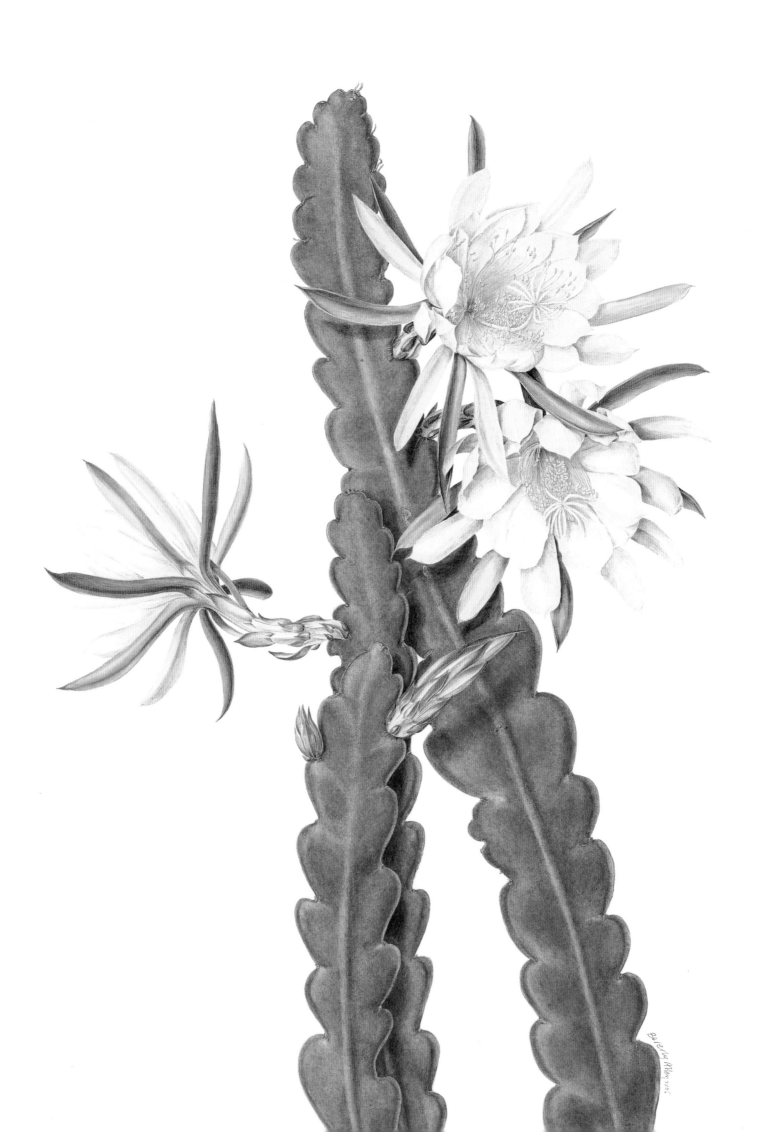

Clivia miniata (Lindl.) Bosse

Amaryllidaceae

Clivia named for the Duchess of Northumberland, nee Clive, who died in 1866; *miniata* (cinnabar red), referring to the bright flowers.

This clump-forming lily is native to the Natal Province, South Africa. In its native habitat it grows in warm, dry habitats in dappled shade. The leaves are strap-like and dark green. The flowers are on long pedicles in bunches of 12–20, and are bright orange-scarlet with a yellow throat and large yellow stamens. *Clivia miniata* flowers in spring to early summer.

John Lindley first described *Clivia miniata*, the Natal Lily, as the new plant *Vallota Miniata* in *The Gardeners' Chronicle* in 1854.[55] It was introduced to the Sydney Botanic Garden before 1895. This species was planted extensively as a border plant in the Palm Grove, where it has been a feature for decades. It is a significant element of the Palm Grove, particularly in the early spring when its orange and yellow flowers glow against its dark foliage in the dappled shade of the palms.

Artist Helen Yvonne Burrows

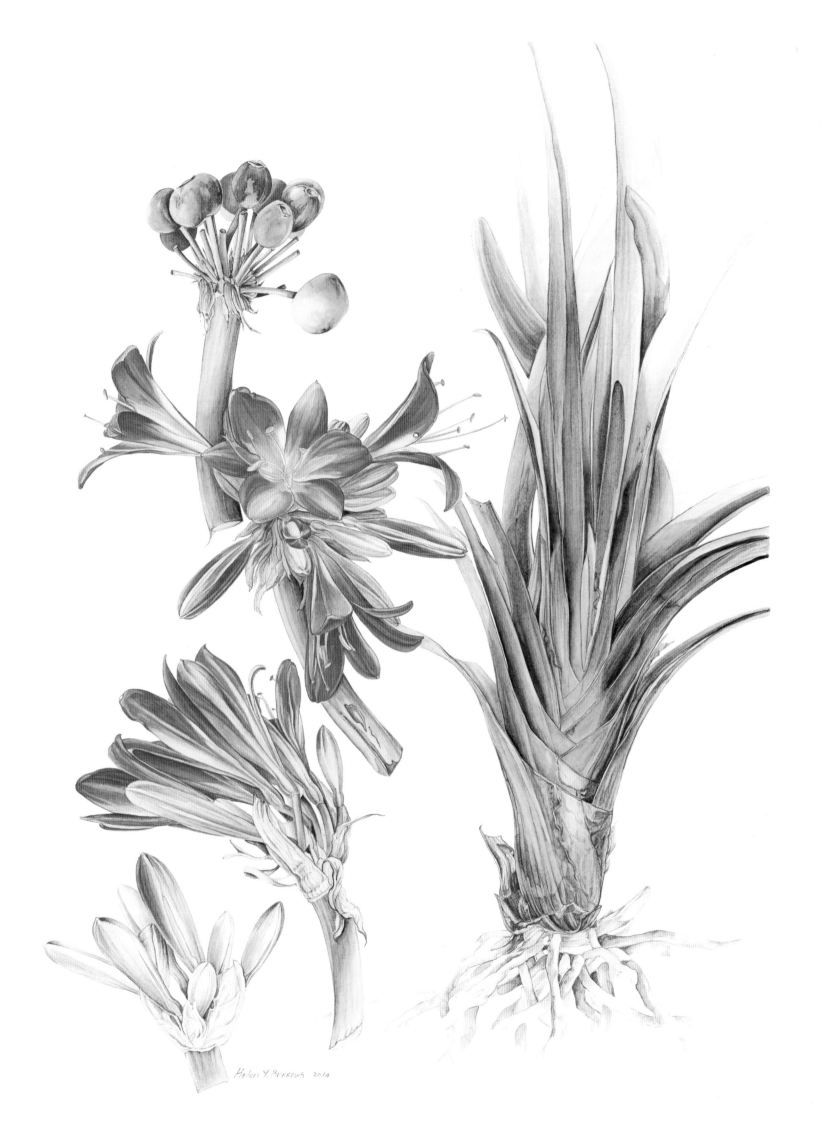

Helen Y. Burrows 2014

Lilium auratum Lindl.

Liliaceae

Lilium from the Greek *leírion* (true, white lilies); *aurantum* (golden yellow or decorated with gold).

Native to Japan, this is one of the most beautiful and largest lilies in the world. It can grow up to 2 metres high and hold as many as 20 flowers. The flower colour is typically white, with gold radial markings and orange spots, and the flowers have a strong and spicy fragrance. The life span of this lily is short, only 3–4 years. It is therefore important to have this plant conserved in botanic gardens around the world.

The Golden Ray Lily of Japan, *Lilium auratum*, was first described by John Lindley in *The Gardeners' Chronicle* in 1862 after it was seen growing wild on the hills near Yokohama after that port was opened to foreign trade. In 1864, Charles Moore announced it was among the 'many new and valuable plants lately introduced to the colony by my friend Mr John Veitch, of the Royal Exotic Nursery, Chelsea, London, now on a visit to these colonies'.[56] Unfortunately, five out of six bulbs had been stolen from the Botanic Gardens,[57] providing an explanation as to why it was not listed in the 1866 catalogue of plants growing in the Botanic Garden. Presumably, horticultural theft diminished as the lily's availability increased, and it was listed as the 'Golden Japanese Lily' in the 1895 *Catalogue of Plants in the Government Botanic Gardens, Sydney*. A further 10 bulbs arrived from Yokohama, Japan in 1902. It is now grown in the Blue Mountains Botanic Garden, Mount Tomah.

Artist Tricia Oktober

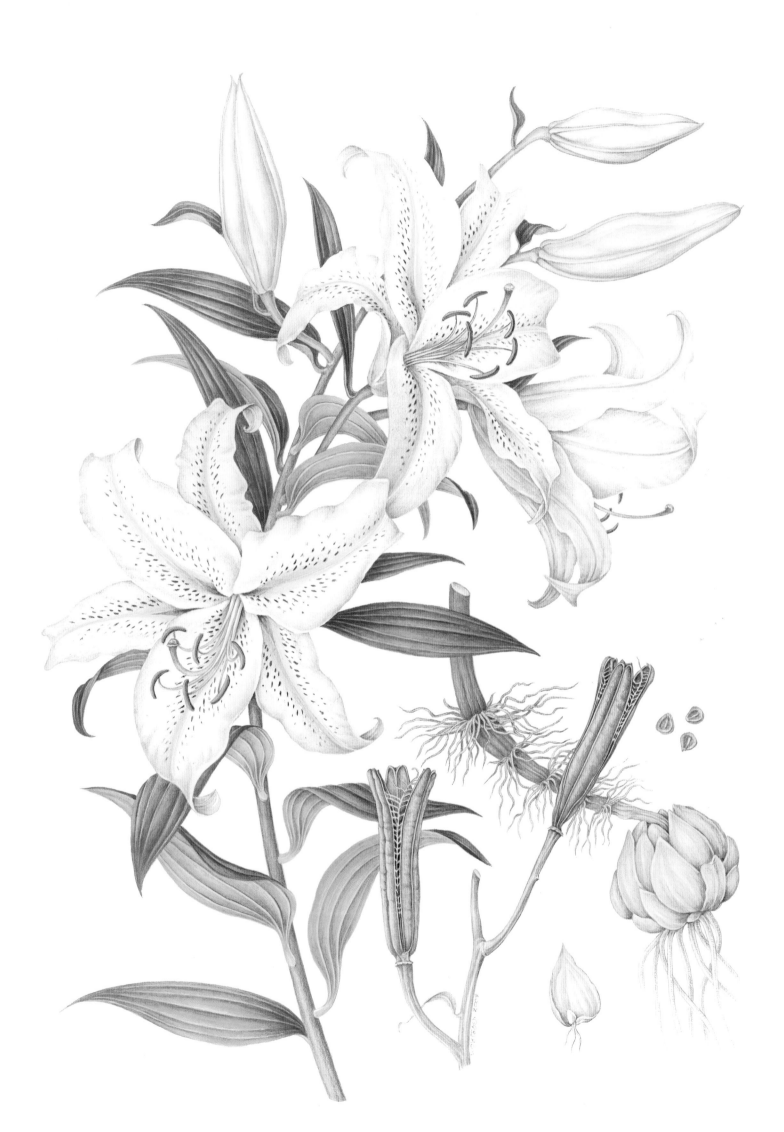

Brachychiton bidwillii Hook.

Malvaceae

Brachychiton from the Greek *brachys* (short) and *chiton* (tunic), referring to the bristles surrounding the seed in the fruit; *bidwillii* after John Carne Bidwill, Director of the Royal Botanic Garden, Sydney, 1847–48.

This species is native to Queensland in rainforests from Boonah, close to the New South Wales border, to Bowen in northern Queensland. It is a small tree, 2–5 metres tall, with bright coral red flowers and deeply lobed, dark-green, leathery leaves. As the plants grow and age, flower production increases, and after eight years or so they may produce bunches of up to 50 flowers coming directly from the trunk, as well as the usual flowers on twigs and branches. The flowers are 4–5 cm across; they appear just before new leaves, as most forms of this species drop their leaves before flowering. Both flowers and new shoots are softly hairy.

Brachychiton bidwillii, the Little Kurrajong, was described by William Hooker in *Curtis's Botanical Magazine* in 1859 from material 'sent to the Royal Gardens of Kew in 1851,' from the Wide Bay district, Queensland, by 'the late Mr Bidwill'.[58] It grew in the Sydney Botanic Garden when a *Catalogue* was prepared in 1895, but was not listed among the *Brachychiton* growing there in 1963, although it has since been replanted. Little known in cultivation, it is also grown at the Australian Botanic Garden, Mount Annan.

Artist Nalini Kumari Kappagoda

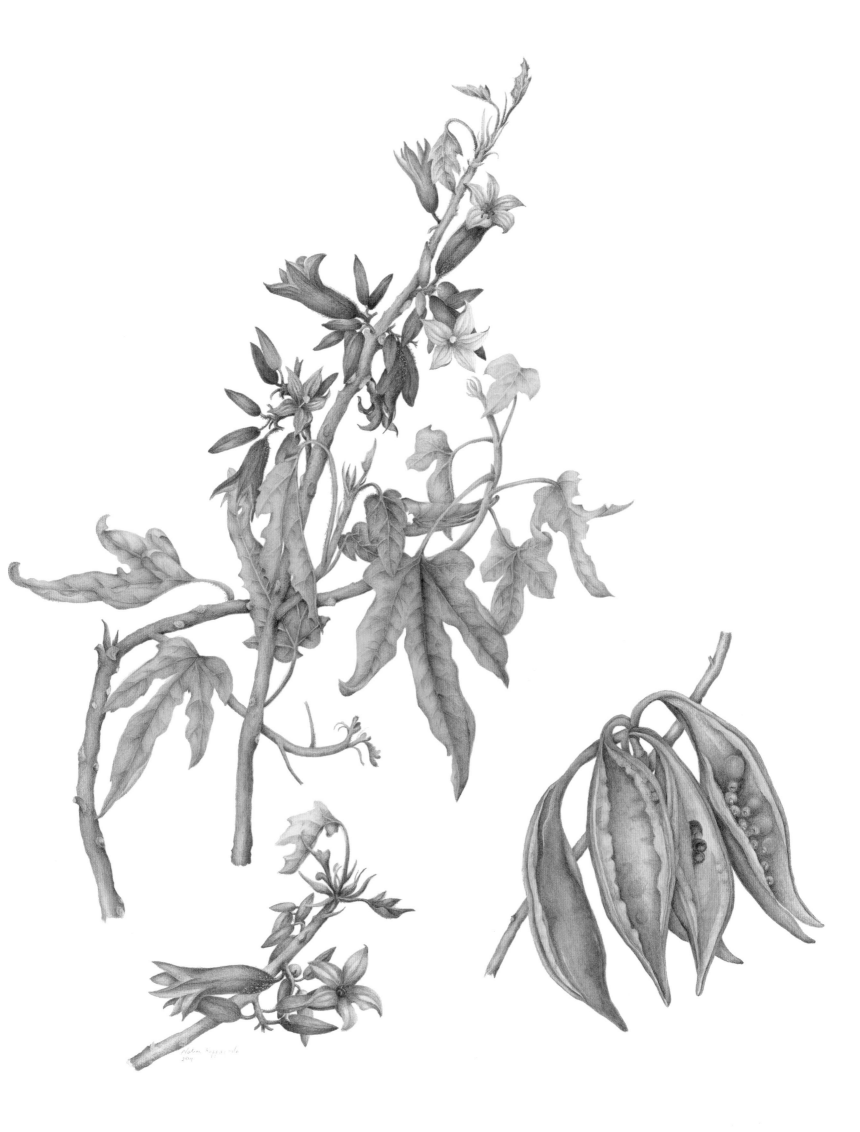

Firmiana simplex (L.) W. Wight

Sterculiaceae

Firmiana after a Lombardian (Italy) Governor, Karl Joseph von Firmian (1716–1782), a promoter of the arts and sciences; *simplex* (simple), referring to the leaves.

Firmiana simplex is native to China and Japan and widely cultivated. It is a deciduous tree to 16 metres tall with alternate palmate leaves up to 30 cm across. The leaves provide good shade but also form the shape of the tree, which is rather like a parasol. The trunk is straight with smooth, grey-green bark.

Small, fragrant, greenish and hairy flowers are in a large inflorescence 20–50 cm long, with both male and female flowers on the same tree (monoecious). The fruit forms as a follicle, which resembles a membranous wing with 2–4 seeds attached; the fruit are attractive as they droop down when still on the tree. The tree is short-lived but is prolific in reproducing itself, causing some concern in countries where it may become weedy. At different times of day, when the tree is in flower, the perfumes varies from a citronella fragrance to chocolate. The wood is used to make Chinese musical instruments.

Firmiana simplex, the Chinese Parasol Tree, Japanese Varnish Tree or Wutong, was first listed as growing in the Sydney Botanic Garden in 1895 under a synonym, *Hibiscus collinus*, the name nominated by William Roxburgh (1751–1815) in India. It was also known as *Sterculia platanifolia*, which was used when it was listed in JH Maiden's 1903 *Guide to the Botanic Gardens, Sydney*. William Macarthur of Camden Park obtained trees of *Sterculia platanifolia* from a South Australian nurseryman in 1844, which he reported grew well.[59]

American plant collector William Franklin Wight renamed the tree *Firmiana simplex* in 1909. It is a species that is widely grown as a street tree in South Korea, which is where the artist lives.

Artist Jee-Yeon Koo

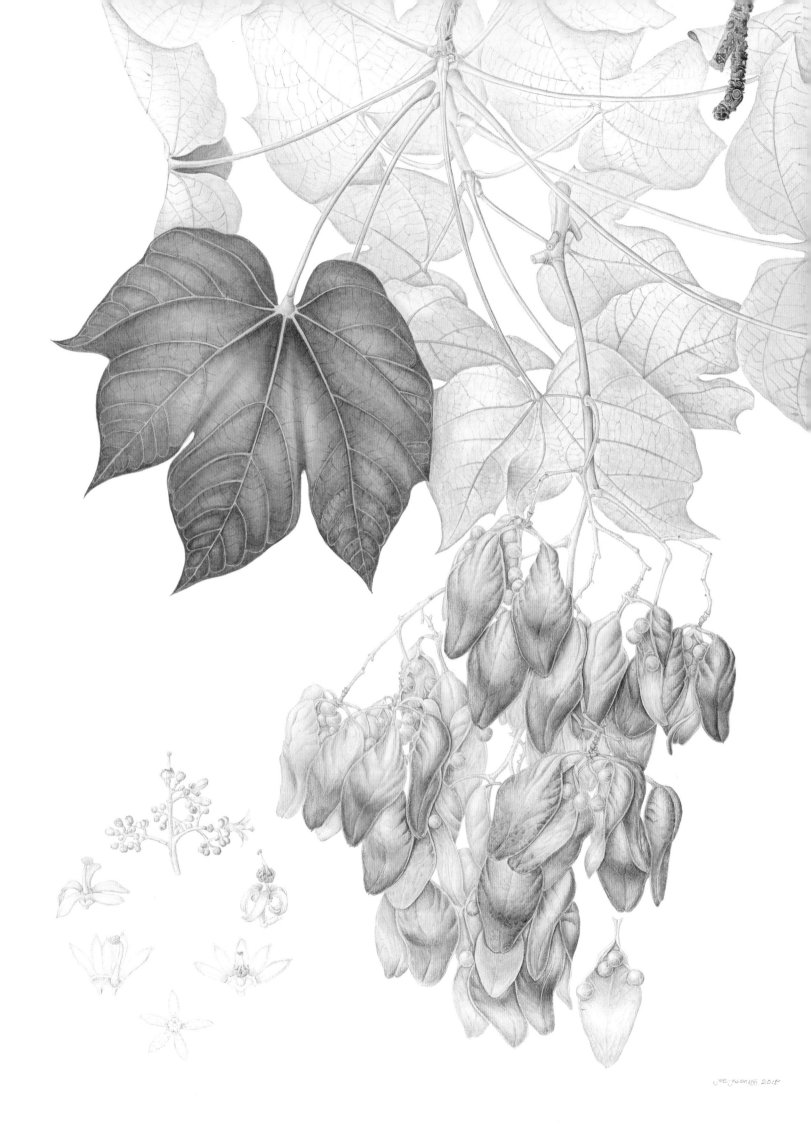

Trachycarpus fortunei (Hook.) H.Wendl.

Arecaceae

Trachycarpus from *trachy* (rough); *carpus* (fruit), referring to the rough fruit; *fortunei* after Robert Fortune (1812–1880), the Royal Horticultural Society's collector in China who returned with many new species for horticulture.

This fan palm is widely cultivated worldwide but now rare in forests. It grows between 100 and 2400 metres altitude south of Qin Ling Mountains in China as well as in Bhutan, India, Myanmar, Nepal and Vietnam. It has a solitary, slender, brownish grey trunk, often covered with old leaf bases. The leaves are often 1 metre broad, palmate and look circular in outline, dark green above and greyish on the lower surface. The flowers arise among the leaves and are yellow; the fruits are kidney-shaped and pale bluish white in colour.

Fibres are collected from the leaf bases and made into coats and other items (brooms, brushes, doormats); wax is collected from the fruits; and a haemostatic drug is extracted from the seeds.

Trachycarpus fortunei, the Chinese Windmill or Chusan Palm, was first introduced to Europe from Japan in 1830. However, its introduction to Kew by Robert Fortune some 20 years later is celebrated in its attribution. It was described by William Hooker as *Chamaerops fortunei* in 1860,[60] the name used when it was listed as growing in the Sydney Botanic Garden in 1895. In 1862, Charles Moore began planting 'hardy kinds' of palm in the area known as the 'Experimental Garden', which was used for newly collected plants. A handwritten addition to the list of palms in the Garden's 1866 *Catalogue* is undated but indicates it was planted in the period when Charles Moore was expanding the size of the Palm Grove. By 1871, Moore considered the Palm Grove 'perhaps the most attractive feature of any part of the grounds'.[61] Slow-growing and one of the most cold-tolerant palms, *Trachycarpus fortunei* was commonly used as a specimen palm in late 19th and early 20th century Australian gardens. This palm also grows in the Blue Mountains Garden, Mount Tomah, where species associated with Robert Fortune are planted. Fortune first saw cultivated specimens of this palm on Chusan Island.

Artist Shirley Slocock

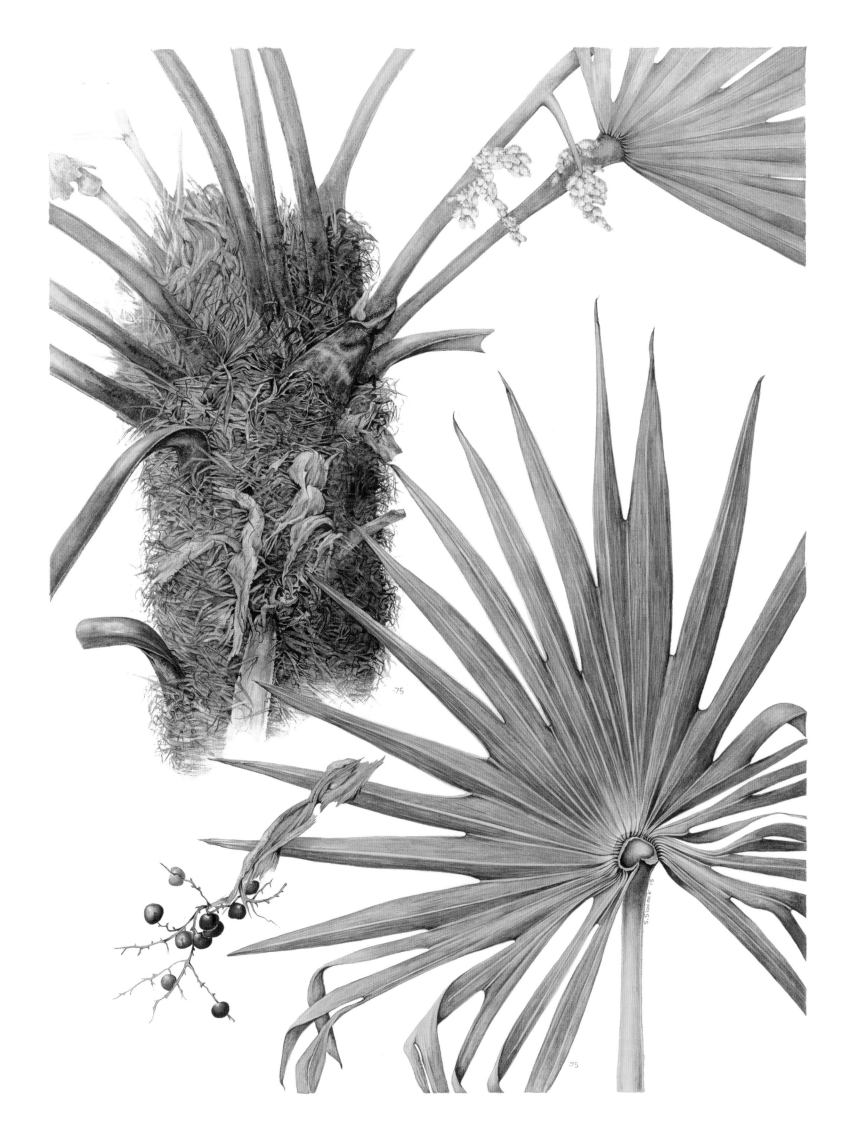

Barringtonia neocaledonica Vieill.

Lecythidaceae

Barringtonia named for Daines Barrington, 18th century English judge and naturalist; *neocaledonica* meaning from New Caledonia.

This small ornamental tree native to New Caledonia has become an attractive tree for gardens, growing well in the tropical north but adapting to the warm Sydney climate. This beautiful tree with a round crown and large green leaves, which first come out as a brilliant red, grows to a height of 10 metres. It sporadically produces fluffy white flowers from tight, pale pink buds in long racemes followed by woody fruits.

Barringtonia neocaledonica, an attractive small tree from New Caledonia, was first described by Eugene Vieillard in 1866, and it makes a handsome contribution to the subtropical theme throughout the Royal Botanic Garden, Sydney.[62] It may have been collected by Charles Moore, or could have been introduced to Sydney following John Gould Veitch's 1865 plant-collecting expedition in the Polynesian Islands. Veitch's tour prompted a number of Sydney nurserymen, including William Guilfoyle, to mount their own expeditions.[63] It was erroneously listed as *Barringtonia alba* in the Gardens' 1895 *Catalogue* and labelled as such until 1974 when botanist Tony Rodd accurately identified an old specimen growing with other species from New Caledonia as *Barringtonia neocaledonica*.[64]

An additional new tree of the species was planted in the Royal Botanic Garden, Sydney on 9 July 2006 to celebrate the 25th anniversary of the Australian Garden History Society.

Artist Beverly Allen

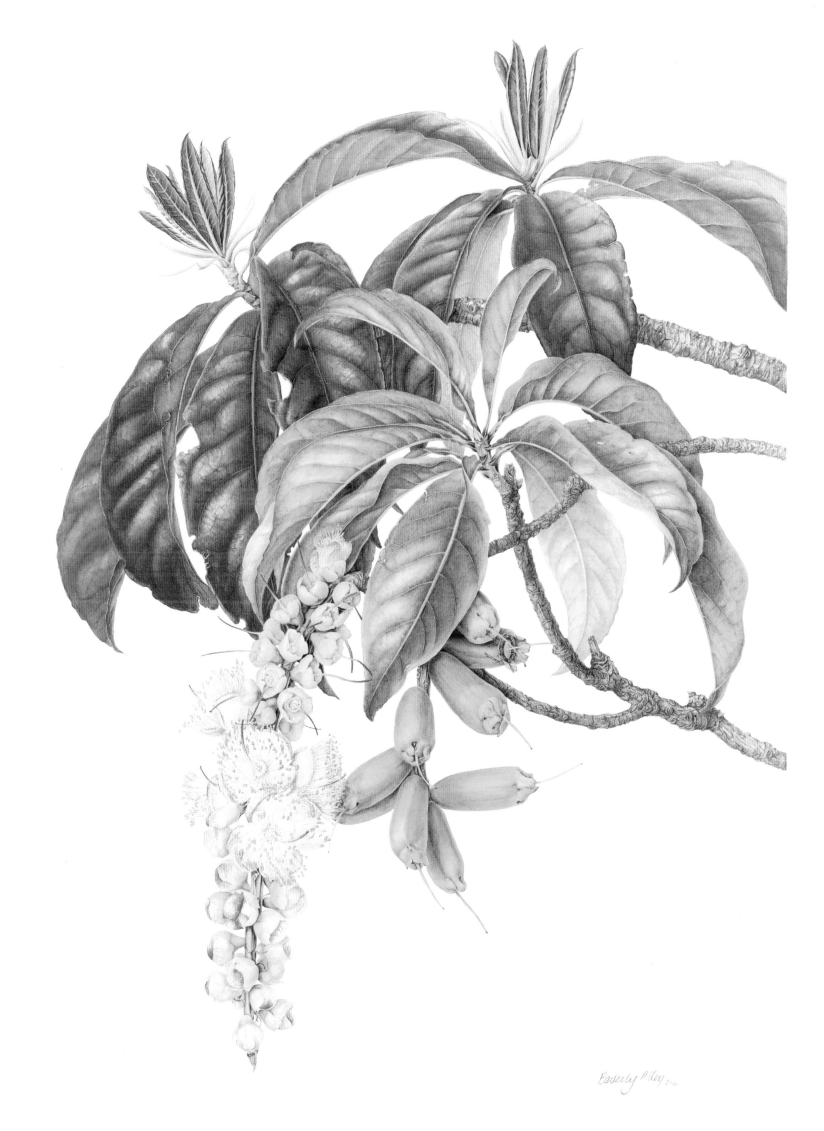

Baverley Riley 2012

Erythrina crista-galli 'Hendersonii'

Fabaceae

Erythrina from the Greek *erythro* (red); *crista-galli* refers to the similarity between the comb of a rooster and the broad crimson petals in the flower.

The species from which this cultivar is derived occurs in South America, east of the Andes mountains in eastern Brazil, Bolivia, Paraguay, Argentina and Uruguay.

Erythrina crista-galli 'Hendersonii' is a small tree with a large crown. When in flower it has a proliferation of very large spikes, 30–40 cm long, of bright scarlet or coral-red, pea-like flowers. The fruits are large green pods turning brown which contain large bean seeds. This species spreads by seeds and vegetative reproduction, and unfortunately it has become a noxious weed along streams and rivers on the north coast of New South Wales and in Queensland.

Erythrina crista-galli, the Cockspur or Cock's Comb Coral Tree from Brazil, first described by Carl Linnaeus in 1767, was introduced to the Sydney Botanic Garden prior to 1866. According to naturalist Dr George Bennett, by 1860 there were many species of *Erythrina* growing in the Sydney Garden, and they were conspicuous because their leafless branches were covered in bright scarlet flowers.[65] By the 1880s, *Erythrina crista-galli*, the most hardy of the genus in a cool climate, was referred to as a 'fine old-fashioned plant'. In the same volume of *The Gardeners' Chronicle*, it was noted that gardeners increasingly desired to give this species a more 'prominent place in their arrangements than it has hitherto held ... Few plants are more worthy of a good position in the foliage or subtropical garden'.[66]

The English garden writer William Robinson, a good friend of the Director of the Sydney Botanic Garden, Charles Moore, wrote in *The English Flower Garden* (1893) that these trees were general through the tropics. He listed '*E. crista-galli*' and '*E. Hendersoni*' separately. *Erythrina* 'Hendersoni, Hort.' was listed in the Garden's 1895 *Catalogue*.

Artist Annie Patterson

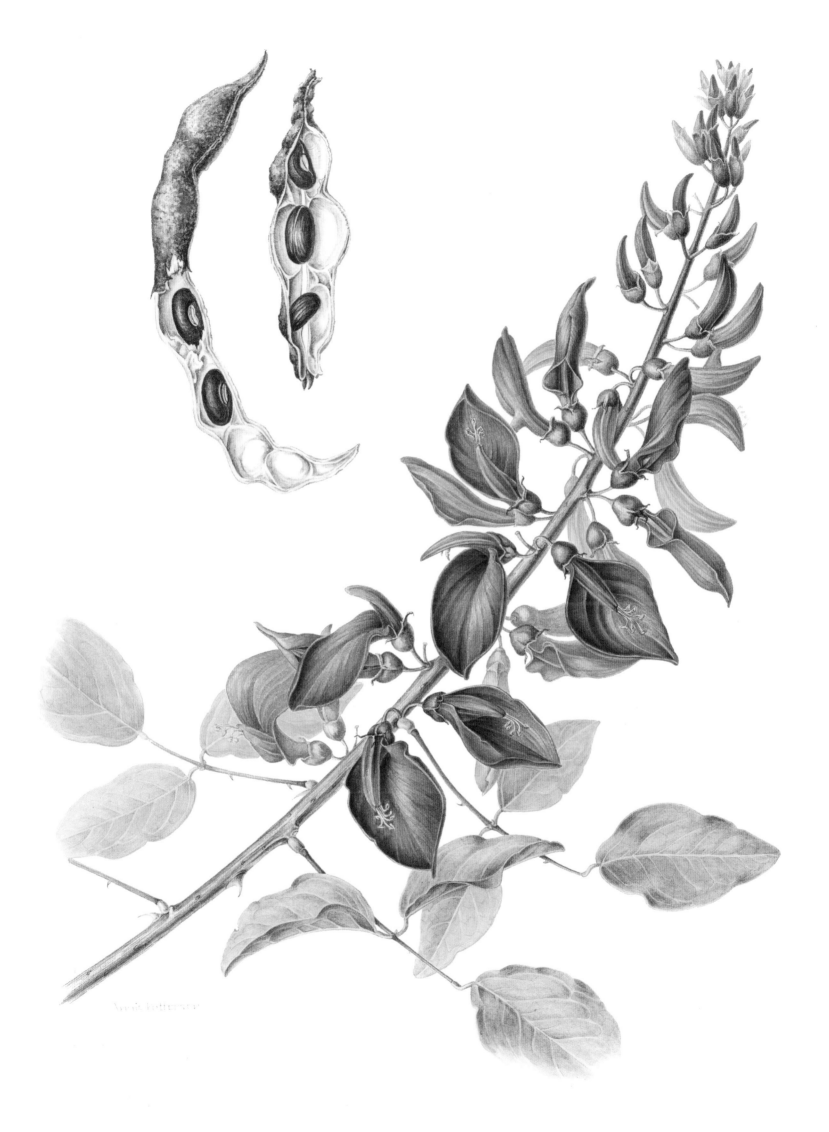

Schotia brachypetala Sond.

Fabaceae

Schotia for Richard van der Schot, one-time head gardener at Schonbrunn, Vienna (d. 1819); *brachypetala* (the flowers have short petals).

Native to South Africa, *Schotia brachypetala* grows in dry, hilly woodlands away from the coast in Swaziland, Botswana, Mozambique and Zimbabwe. It is a wide-spreading evergreen tree growing to 15 metres tall. The leaves consist of 4–8 pairs of leaflets, each having an entire, wavy margin. Flowers are numerous, deep red in colour, and produce copious quantities of nectar. Fruit is a hard, woody pod up to 15 cm long; the seeds are attached by a fleshy, yellow aril. This highly ornamental species is spectacular in flower in September and October.

Schotia brachypetala, Weeping Boer Bean or African Walnut, was described by Otto Sonder in 1850. It was listed in the Garden's 1895 *Catalogue.* In the 1965 *An A.B.C. of the Royal Botanic Gardens, Sydney*, RH Anderson, Director 1959–64, listed it as an example of one of the South African trees that are a feature of the Sydney Garden. Although there is a very old tree in the Macarthur 'Camden Park' estate, it was not commonly grown in domestic gardens, giving the Botanic Garden specimen special appeal.

Spectacular in flower, the current specimen in the Sydney Botanic Garden was planted in about 1979.[67] It attracts rainbow lorikeets, which feed on its nectar, at times becoming intoxicated on the sweet liquor; this prompted one journalist to describe their behaviour as a 'Party in the botanic gardens'.[68]

Artist Margaret Best

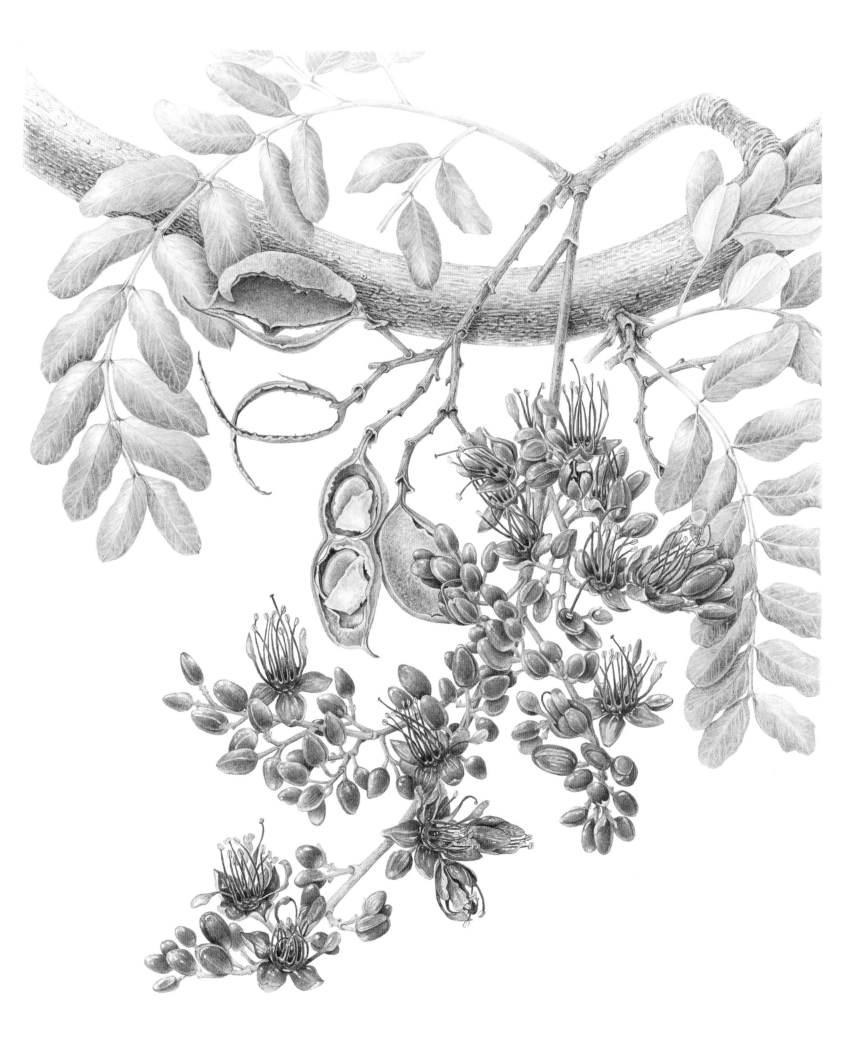

Gordonia axillaris (Roxb. ex Ker Gawl.) Endl.

Theaceae

Gordonia after British nurseryman James Gordon (d. 1781). After serving as gardener to Lord Petre of Thorndon Hall in Essex, Gordon established his own nursery at Mile End in London. During his life he also corresponded with Swedish naturalist and physician Carl Linnaeus; *axillaris* from *axilli* (borne in the leaf axils).

This is a fragrant member of the tea family which also includes the usually non-fragrant and much more diverse genus *Camellia*. *Gordonia* is a shrub or medium-sized tree native to the island of Taiwan and to Vietnam. Often seen in gardens, it is an attractive plant, especially with its beautiful white petals and the deep yellow or orange mass of central stamens. Although its native habitat is subtropical woodland, it is now widely cultivated and tolerates much cooler climates. Additional colour is produced by its leaves, some of which turn red.

Gordonia axillaris, Fried Egg Plant, was first described as *Camellia axillaris* in 1819 from material sent by William Roxburgh. It was reclassified by Stephan Endlicher in 1842. The 1895 *Catalogue* lists it as growing in the Sydney Botanic Garden under one of its synonyms, *Gordonia anomala*, but it must not have survived and was reintroduced in 1916.[69] RH Anderson, in *An A.B.C. of the Royal Botanic Gardens, Sydney*, published in 1965, wrote that *Gordonia* 'is quite attractive with its large white flowers with yellow centres'. Australian botanist and expert on Chinese flora Dr Peter Valder has praised the *Gordonia axillaris* as one of the best small trees for Australian conditions.[70] A new tree of *Gordonia axillaris* was planted in the Royal Botanic Garden, Sydney in 1971, and it is an important tree in the Blue Mountains Botanic Garden, Mount Tomah.

Artist Fiona McKinnon

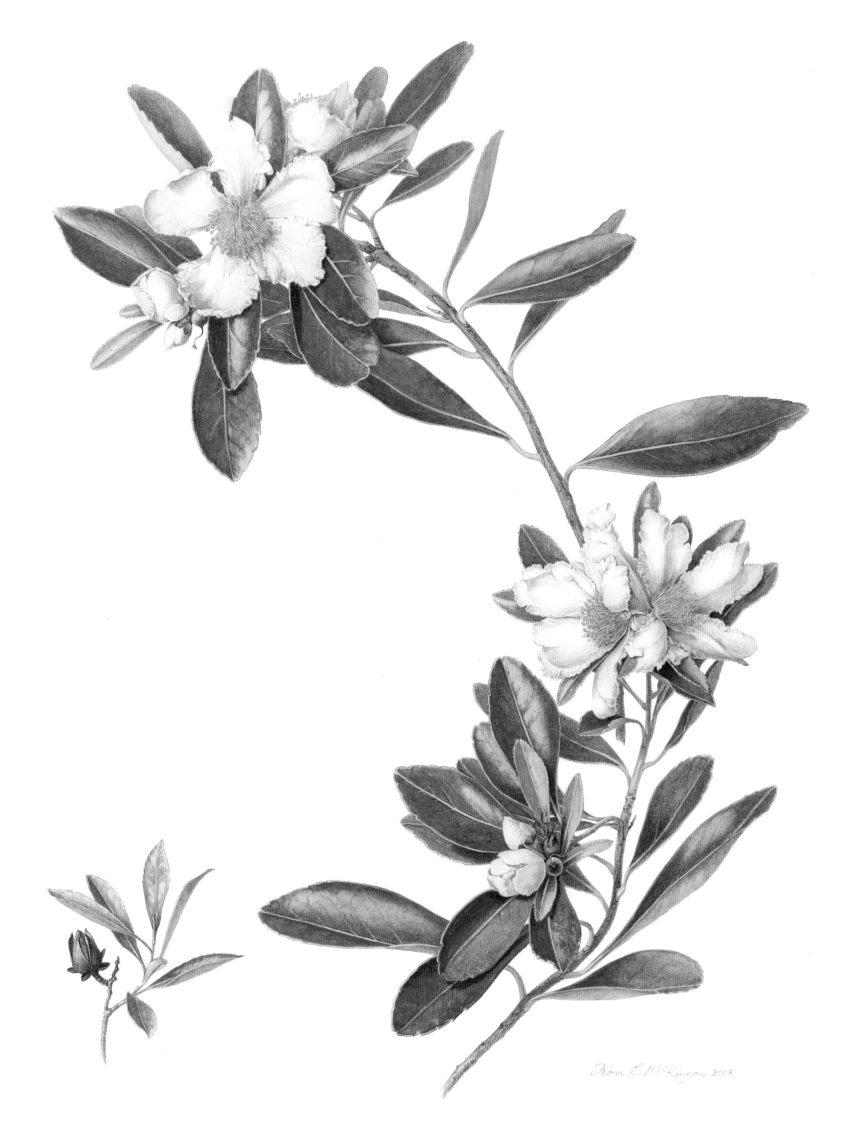

Fiona E McKinnon 2008

Crataegus persimilis 'Prunifolia'

Rosaceae

Crataegus (flowering thorn); *persimilis* (similar tree); 'Prunifolia' (small tree).

Crataegus persimilis 'Prunifolia' is a small, broad-crowned, deciduous tree with long thorns and glossy, broadly oval leaves. The flowers are white and are grouped at the ends of branches. Their long white stamens with green anthers give the flowers the appearance of being spotty. In autumn, the leaves dramatically turn to display crimson and orange leaves; they are complemented by the fruit, which are on the tree at the same time and are in bunches of deep-red berries.

The Broad-leaved Cockspur Thorn 'Prunifolia', *Crataegus persimilis* 'Prunifolia' (syn. *Crataegus prunifolia*), was once thought to be a hybrid between two species from eastern United States of America, *Crataegus crus-galli* and *C. succulenta* var. *macrantha*.[71] This hawthorn was first listed as growing in the Sydney Botanic Garden in 1895 under the misapplied synonym *Crataegus crus-galli* var. *prunifolia*. In 1965, former Director RH Anderson wrote that in spring the *Crataegus crus-galli* was 'decked out with a mass of white flowers' and 'is one of the most attractive smaller trees' in the Garden.[72]

The tree of this hybrid that now grows in the Royal Botanic Garden, Sydney was planted in 1966.

Artist Sally Strawson

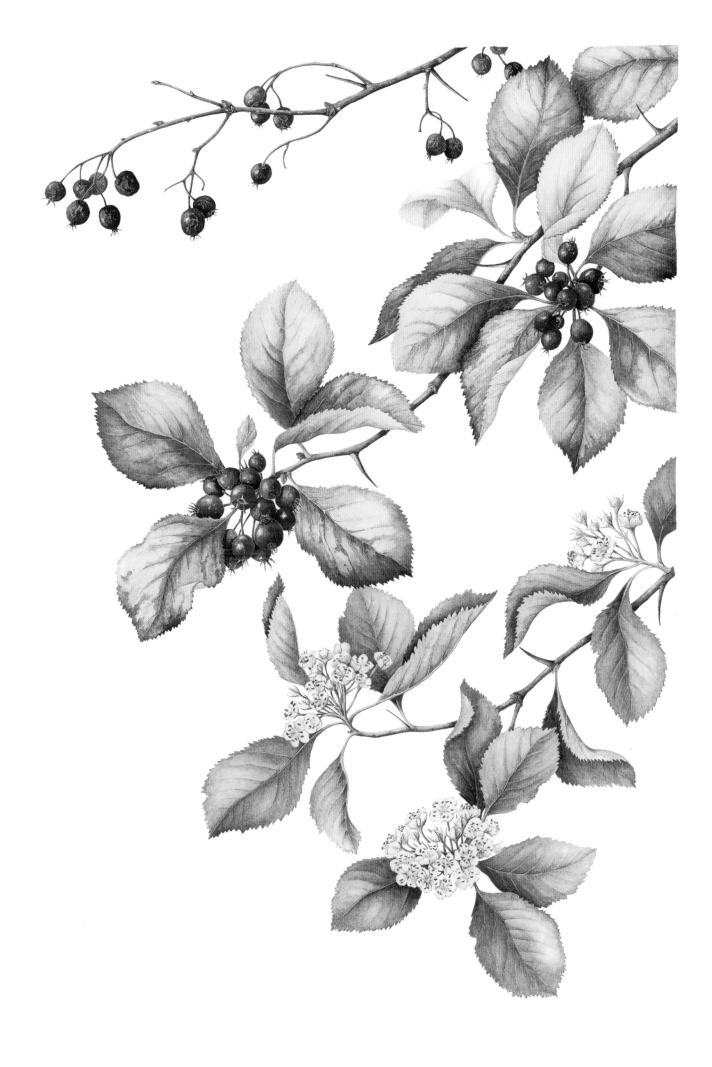

Sally Swanson

Pritchardia maideniana Beccari

Arecaceae

Pritchardia for William T Pritchard (1829–1907), an adventurous 19th century British consul in Fiji and author of *Polynesian Reminiscences* (1866)[73]; *maideniana* after JH Maiden, Director of the Royal Botanic Garden, Sydney 1896–1924.

An attractive palm native to Hawaii, growing to 5 metres tall, it has a dense crown of fan-shaped leaves erect and yellowish green in colour with short, thick leaf stalks. This palm fruits in winter.

In 1914, Mr JL Boorman, Collector for the Botanic Gardens, reported on the newly identified *Pritchardia maideniana*, Maiden's Palm, named for the Garden's Director. Boorman wrote that the palm had been growing in the Botanic Garden for many years under the name of *P. Martii*, Wendl. var., 'but being doubtful as to the correctness of the name, this, with other South Sea Islands palms, was sent to Dr Beccari, of Florence Italy, who pronounced it to be a new species'.[74] *Pritchardia martii* from the Hawaiian Islands was listed in the Garden's 1895 *Catalogue*, indicating that the palm grew in the Sydney Botanic Garden prior to Maiden's directorship.

For decades it was thought that two trees of this rare species in the Sydney Garden were the only mature specimens in existence, and seed from the trees was distributed internationally. However, in 2009 botanist Don Hodel from California found that they were identical to the populations of *Pritchardia affinis* in Kona, Kau and Puna, although *Pritchardia maideniana* is the older name and holds precedence.[75] Until this discovery, it was thought that the plant only survived because of the propagation by the Royal Botanic Gardens and Domain Trust staff.

Artist Julie Nettleton

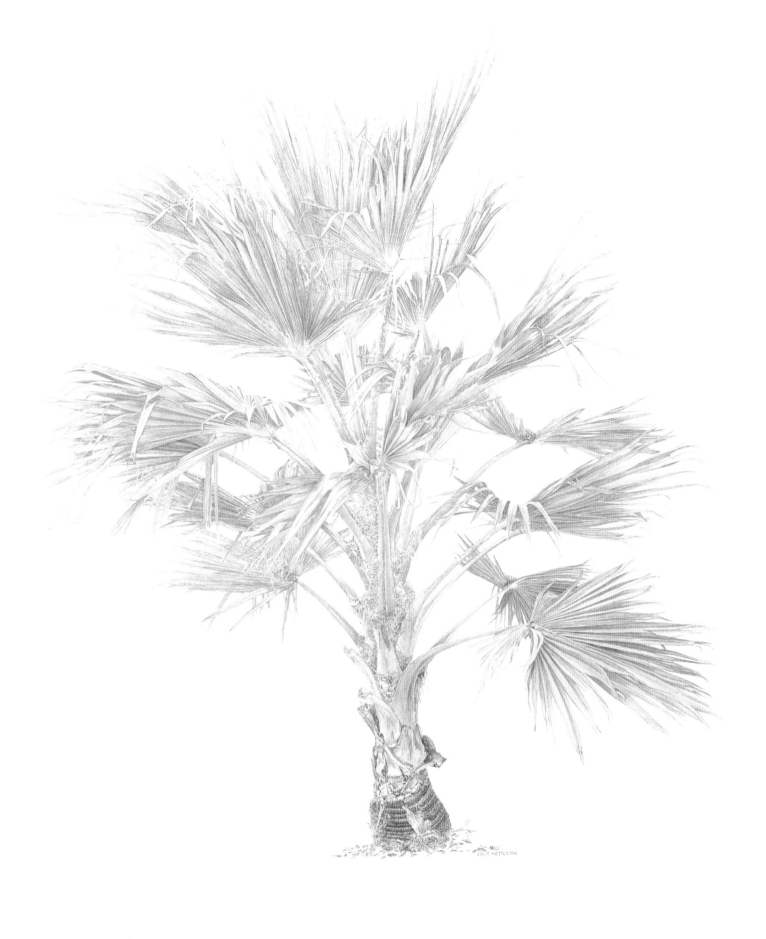
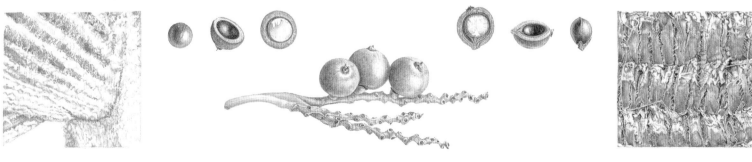

Millettia grandis (E. Mey.) Skeels

Fabaceae

Millettia can commemorate one or more people, the most often quoted being JA Millet, a French botanist living in the 18th century. However, a British resident in China, Charles Millett, is also suggested. He was probably a physician, and is said to have introduced several Chinese plants to the United Kingdom through Glasgow University's Botanical Garden; *grandis* is Latin for big and showy.

Native to south-eastern South Africa, and common in the warm coastal forests from Natal to Transkei, this tree is striking when in flower. *Millettia grandis* is a semi-deciduous tree that reaches 10–25 metres tall. The leaves have 3–7 pairs of leaflets with one leaflet terminal; the entire leaf is 25 cm long, glossy dark green or blue-green on the upper surface and yellow-green on the underside. New leaf growth is a reddish brown and velvety. The flowers are pea-like and are mauve to purple. The fruits are woody pods covered with a layer of reddish to golden hairs; when they spilt open they make a popping noise and the oblong seeds drop to the ground.

In 1896–97, two plants of *Millettia caffra*, a synonym for *Millettia grandis*, were sent from the State Forest Nursery, Gosford, NSW, to the Sydney Botanic Garden.[76] In 1908, George Harwood, the Superintendent under Director JH Maiden, reported that it was one of the 'noteworthy plants' that had done well during the past year.[77] *Millettia grandis* – Tree Wisteria, Ironwood or Umzimbeet – was officially described in 1912.

A 1954 census of plants growing in the Botanic Garden by botanist George Chippendale indicates that the specimen near the Henry Lawson Gate on Mrs Macquarie's Road was already there. When it is in flower, visitors are treated to a magnificent sight. The seedpods have a habit of exploding when ripe, a characteristic that has had dramatic effects in some artists' studios.

The hard strong wood is used in the manufacture of furniture, domestic implements and even walking sticks. The seeds are poisonous when eaten in large quantities, but when they are ground up and soaked in milk they provide a remedy for roundworm. The ground roots can also be used to induce sleep and as a tranquilliser.

Artist Beth McAnoy

118

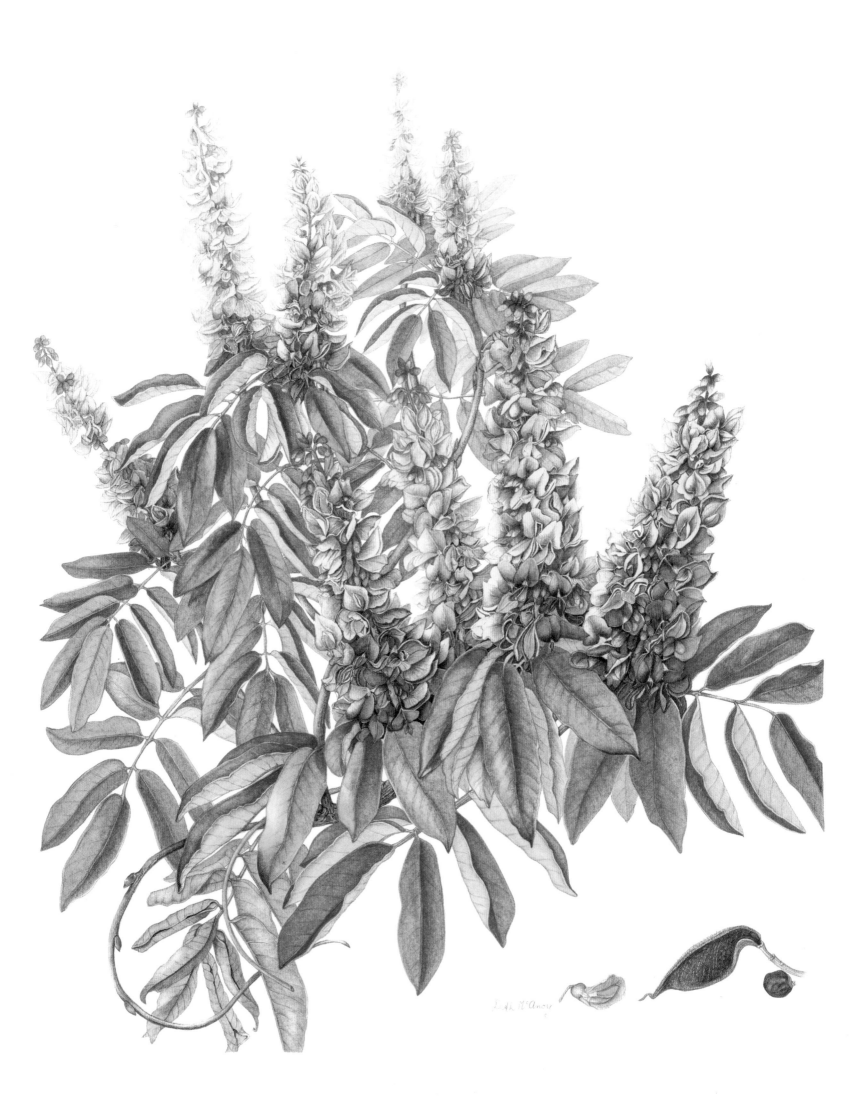

Diploglottis campbellii Cheel

Sapindaceae

Diploglottis from the Greek *diplo* (in pairs) and *glottis* (tongue); *campbellii* named for its collector, Mr RA Campbell of the Tweed River District.

This is a rare species native to a riverine rainforest area in northern New South Wales, from the Richmond River to the Tweed River, known as the Big Scrub, and extending into southern Queensland in the Bunya Mountains. It is easily spotted when in fruit because the seeds are a brilliant red and sit in threes within a brown hairy capsule; the inside of the capsule is also red. The mid-green leaves are very glossy. This endangered species grows into a medium-sized tree and is sometimes planted in parks and also as a street tree. It produces acidic fruits, which have been used for preparing drinks and for making jam.

Diploglottis campbellii, the Small-leaved Tamarind, was well known to 19th century settlers, but for many years it escaped the notice of botanical collectors. *Diploglottis campbellii* was botanically described by Edwin Cheel, Principal Botanical Assistant at the National Herbarium, Sydney, in 1923. Cheel became Botanist and Curator from 1933 to 1936. He recounted that 'it was originally collected by M[r]. Bauerlen in February 1892 at Tintenbar, when it was determined as *Amoora nitida*'.[78] At the time, William Bauerlen was a botanical collector for Joseph Henry Maiden at the Technological Museum in Sydney. In 1904 and in 1918, Mr RA Campbell sent samples from the Tweed River to the Sydney Botanic Garden, and it was from the latter sample of ripe fruits and leaves that the species was correctly identified.

The artist is particularly interested in rainforest species that she has propagated and has growing on her property near the Werrikimbe wilderness in New South Wales. Her Small-leaved Tamarind was grown from seed collected from a tree in the Royal Botanic Garden, Sydney.

Artist Colleen Werner

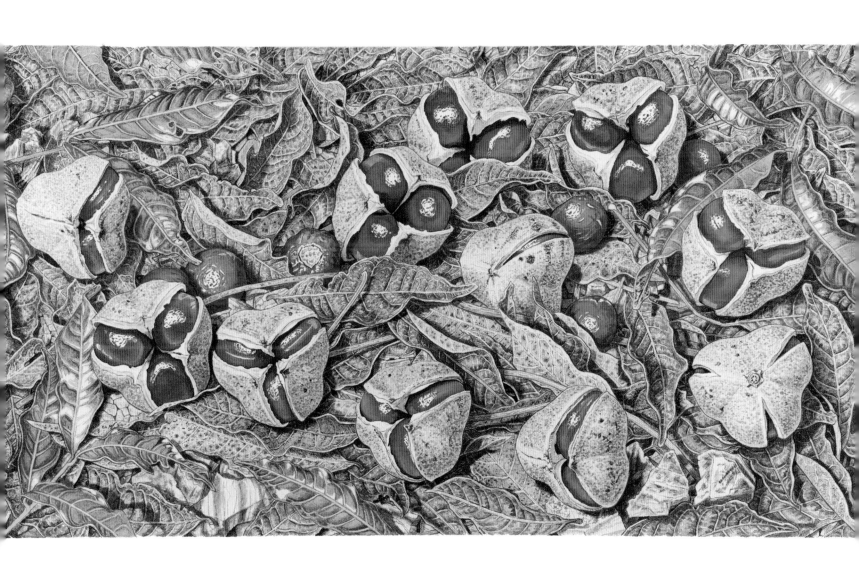

Citrus × virgata 'Sydney Hybrid' Mabb.

Rutaceae

Citrus (*Citrus* species), referring to the fruit; *virgata* (wand), referring to the plant's very numerous slender, straight, whip-like twigs.

This twig-like plant has very long branches, sometimes up to 2 metres long, with spines, and small, opposite, mid-green leaves. The flowers are white and perfumed, with 4–5 petals, resembling other *Citrus*. The fruits are elliptic to egg-shaped limes, 35–50 cm long, with the narrower end attached to the pedicel and branch. They have bumpy lime-green skin, and when cut open the lime juice exudes from small vesicles.

One of the parents of this hybrid, *Citrus australis*, the Australian lime or dooja, was very likely introduced to the Sydney Botanic Garden soon after it was collected in Moreton Bay; it was named *Limonia australis* by Allan Cunningham in 1829. Charles Fraser wrote of finding an unpublished species of *Limonia* in Moreton Bay.[79] *Limonia australis* was listed in the Garden's 1857 *Catalogue*, and in 1864 an article in the Horticultural Society of Sydney's journal, *Horticultural Magazine and Gardeners' and Amateurs' Calendar* noted it growing in the Botanic Garden and commented it was 'worthy of cultivation on account of the distinctness of its foliage'.[80] The other parent, *Citrus australasica*, the Australian Finger Lime, was listed as growing in the Garden in 1895.

Citrus virgata 'Sydney Hybrid' was raised from seed sent to the U.S. Department of Agriculture's Agricultural Research Service by JH Maiden, Director of the Sydney Botanic Gardens (1896–1924). It is unclear whether Maiden had made the cross prior to sending the seeds or whether WT Swingle made the cross in the United States.[81] A tree of the 'Sydney Hybrid' in the Royal Botanic Garden, Sydney may date from JH Maiden's time, but its origin is unknown.

This hybrid is also associated with Professor David Mabberley, who researched the Australian Citreae and was Executive Director of the Royal Botanic Gardens, Sydney from 2011 to 2013.

Artist Elisabeth Dowle

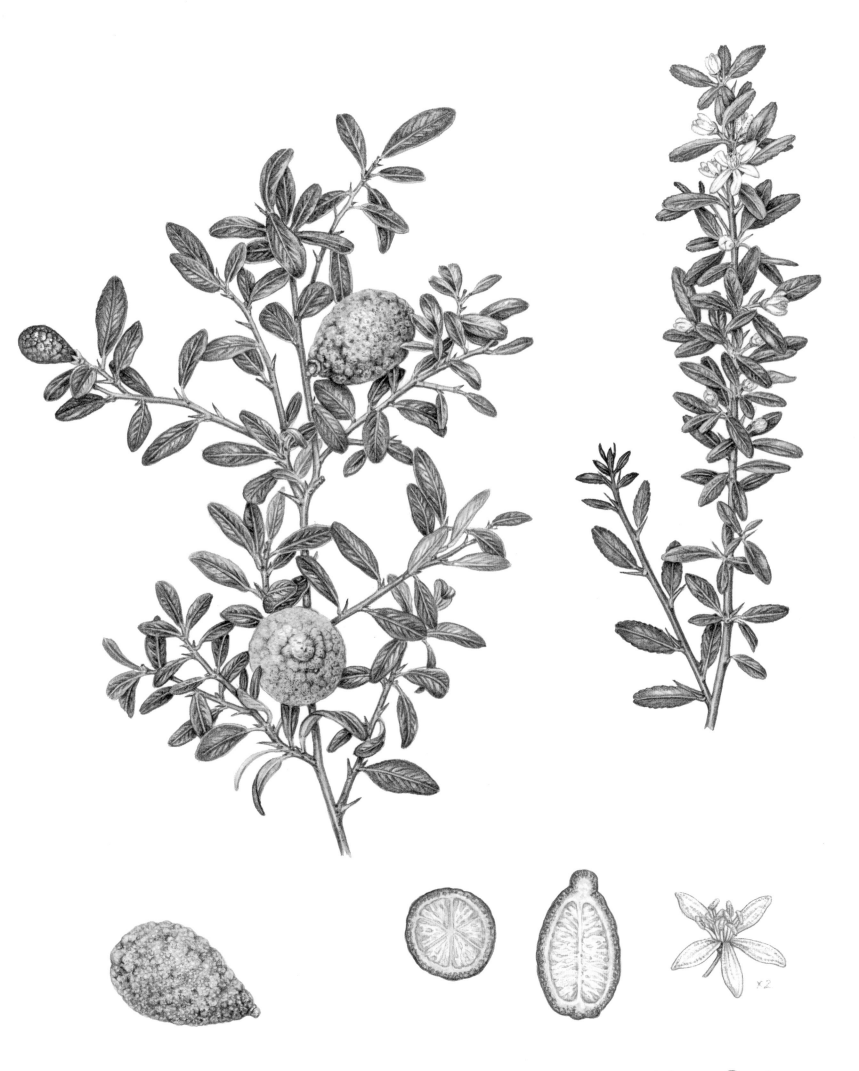

Elizabeth Dowle

Alloxylon flammeum P.H. Weston & Crisp.

Proteaceae

Alloxylon from the Greek *allos* (another or foreign) and *xylon* (wood or tree); *flammeum* from *flammeus* (flame-coloured or fiery red).

The native habitat of this species is tropical rainforest near Atherton in north-east Queensland, which has been almost completely cleared for agriculture. It survives in a few remnant patches of rainforest, including some small national parks, and grows on basalt-derived soils at an altitude of 700–820 metres above sea level. It is much sought after as a horticultural subject, and cultivated plants probably outnumber those remaining in the wild.

Related to the waratah, this species is a small to medium tree with a dense, bushy canopy. The leaves are dark green and leathery, younger leaves bright green and lobed, and the large bright orange-red flowers are spectacular when seen in late spring to early summer. The fruits are large, brown, canoe-shaped pods containing 8–10 seeds each with a large membranous wing.

Mistakenly known as *Oreocallis wickhamii* for many years, the Tree Waratah or Red Silky Oak, Waratah Oak or Dorrigo Oak, *Alloxylon flammeum*, was recognised as a separate species by Peter Weston and Mike Crisp of the Royal Botanic Garden, Sydney in the 1980s and it was allocated to a new genus in 1991.[82]

A specimen of *Alloxylon flammeum* was planted in the Sydney Botanic Garden in 1950 from Dr George Hewitt's Arboretum in Bellingen, NSW. Dr Hewitt, a keen amateur botanist who corresponded with staff at the National Herbarium of New South Wales, established an arboretum attached to the Bellingen District Hospital, where he grew a broad range of unusual tropical and subtropical plants. In his 1965 *An A.B.C. of the Royal Botanic Gardens, Sydney*, RH Anderson drew attention to this 'little known tree, the Pink Silky Oak', which flowers in late spring and early summer.

In 1997, *Alloxylon flammeum* was listed as a vulnerable species on the IUCN (International Union for the Conservation of Nature) Red List of Threatened Species.

Artist Sue Wickison

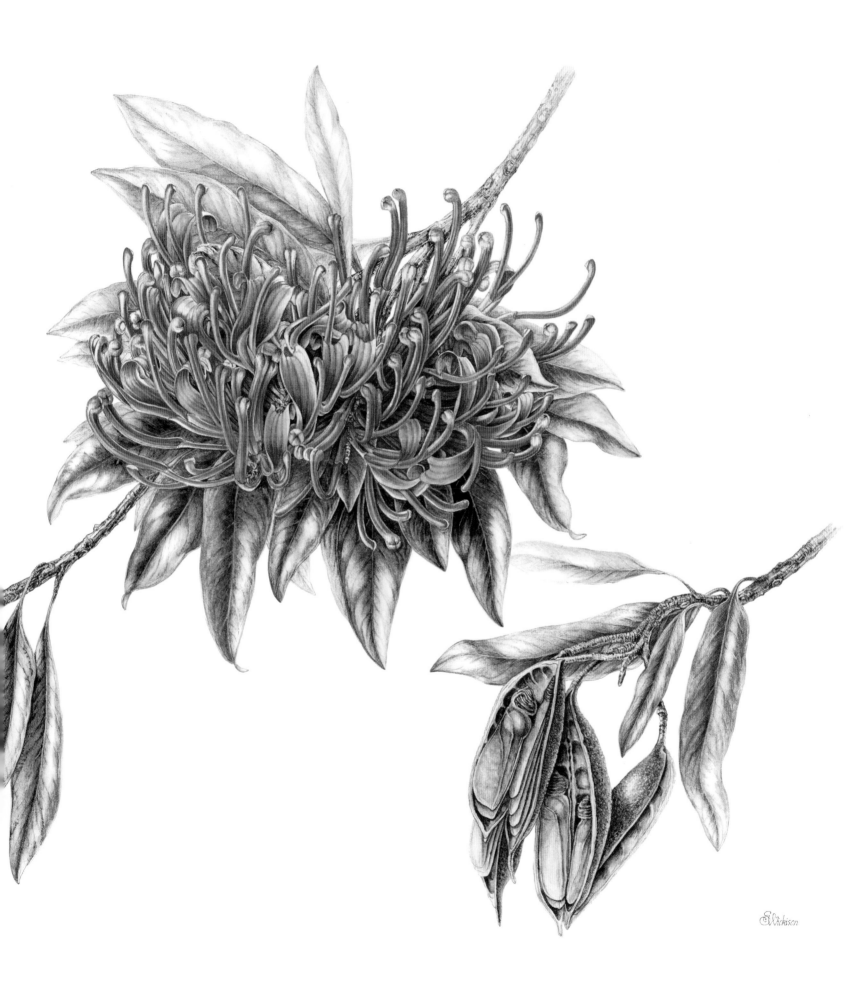

Tibouchina mutabilis (Vell.) Cogn.

Melastomataceae

Tibouchina from *tibouch*, the native name in Guiana; *mutabilis* (varying), referring to the change of flower colour.

Tibouchina mutabilis is a native shrub in southern Brazil, mostly in Sao Paulo state where it grows as a small tree to 5 metres high. It is extensively grown as a garden plant in southern Brazil, but is not common in other parts of the world. It is well known when in bloom as a very striking small tree with five-petalled flowers in a riot of colours in bright pinks and purples.

Tibouchina mutabilis was described by Célestin Cogniaux in 1885 in *Flora Brasiliensis*. It is believed that this species was introduced to the Royal Botanic Garden, Sydney from Dr George Hewitt, a medical doctor in Bellingen on the north coast of New South Wales. Dr Hewitt, who arrived in Bellingen in 1927 and lived there for 60 years, was a keen amateur botanist of subtropical trees and shrubs, propagating and exchanging species throughout Australia and internationally.

For many years, a very large shrub or small tree of *Tibouchina mutabilis* near the St Mary's Gate entry into the Domain was a breathtaking sight when in flower, but it senesced in 2014. Attempts to propagate from the tree were unsuccessful.

Artist Gabrielle Pragasam

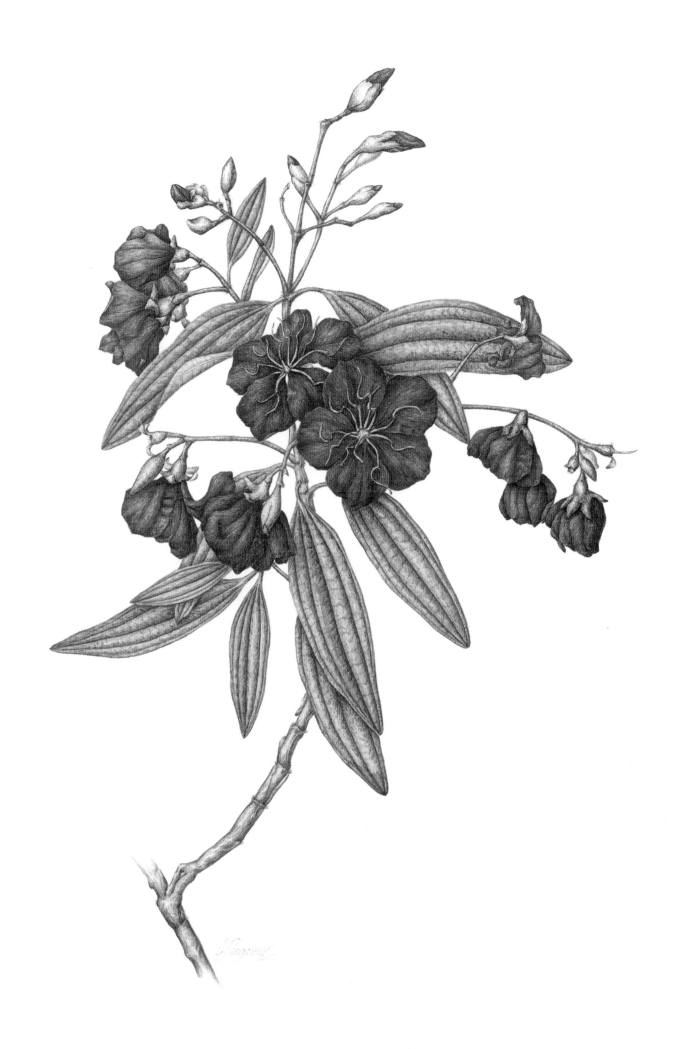

Spathodea campanulata P. Beauv.

Bignoniaceae

Spathodea from the Greek *spathes*, referring to the calyx shape; *campanulata* (bell-shaped), referring to the flower shape.

The African Tulip Tree is native to tropical Africa. It is a large tree with big compound leaves with the leaflets arranged in pairs along the branches. Its large and very showy orange-red, tulip-shaped flowers are 10–12 cm long, and are borne in clusters at the tips of the branches. The fruits are long pod-like capsules which split open to reveal a long papery membrane with the seeds imbedded within. Due to its spectacular flowers, it has become popular as an ornamental garden tree or street tree in tropical and subtropical parts of Queensland. It is now a serious weed in Queensland and the Northern Territory.

Spathodea campanulata was first described in 1805 by French naturalist Ambroise Palisot de Beauvois. The date of its introduction to the Sydney Botanic Garden is unclear. It was well known in Brisbane by the 1930s and was used in gardens in frost-free areas around Sydney when Walter Hazlewood published his *Handbook on Trees, Shrubs, and Roses* in 1960. There is a large African Tulip Tree in the Palm Grove in the Sydney Botanic Garden. Another mature specimen, in the grounds of Government House, Sydney, fell down in a storm in 1999.

Artist Gillian Condy

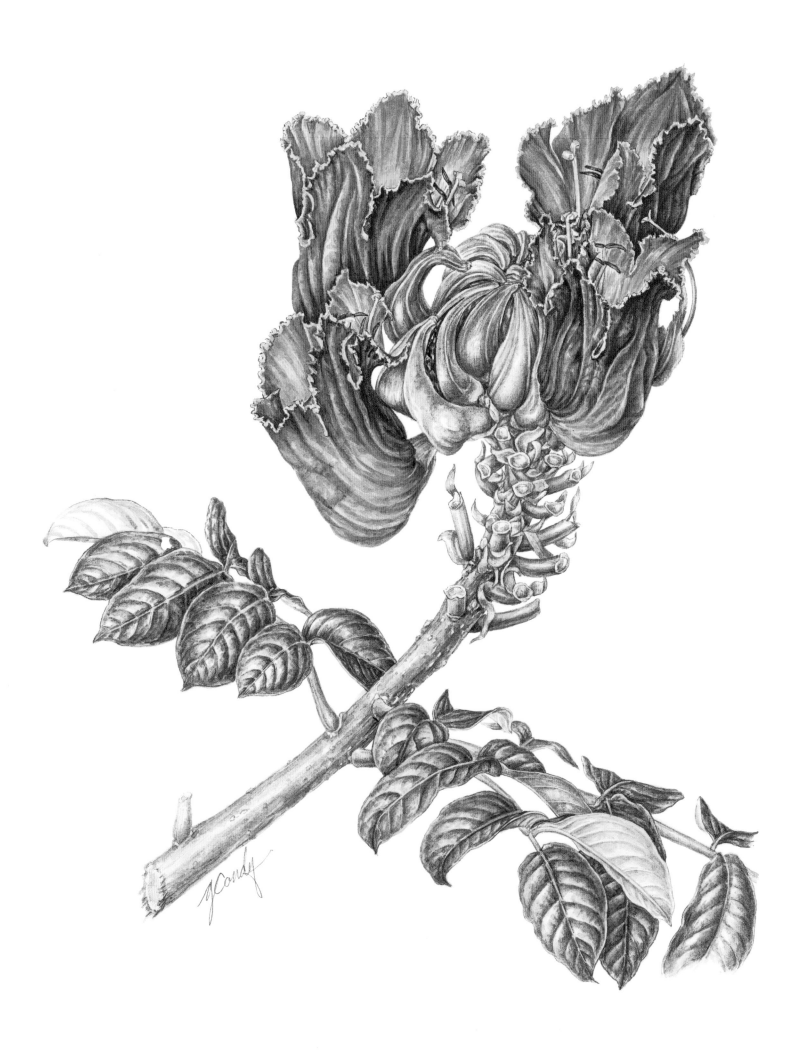

Hibiscus insularis Endl.

Malvaceae

Hibiscus from the Latin *hibiscum* and from the ancient Greek *biskos* (marsh-mallow); *insularis* from the Latin for *insula* (on an island).

This critically endangered plant is endemic to Phillip Island, which lies 6 kilometres to the south of Norfolk Island in the South Pacific Ocean. Early settlers introduced pigs, goats and rabbits to Phillip Island, which destroyed large areas of the native vegetation. This attractive shrub or tree is one of the plant treasures to survive on the island, but only as a few trees. *Hibiscus insularis* is now cultivated in various parks and botanic gardens of the world, however being only known from small populations in the wild, there is little genetic diversity.

Hibiscus insularis, the Phillip Island Hibiscus, was collected and sketched by artist Ferdinand Bauer at 'Pig-Island' (Phillip Island) in 1804. Botanist Robert Brown and Ferdinand Bauer were partly based in Sydney in 1803–05. While in Sydney, Bauer, one of the finest botanical artists of all time, lived in a house on a leased property in Farm Cove, the site of the Royal Botanic Garden, Sydney.[83] *Hibiscus insularis* was described by Stephan Endlicher in *Prodromus Florae Norfolkiacae* in 1833.

Former Horticultural Botanist of the Royal Botanic Garden, Tony Rodd, recalls that two old gnarled specimens of the hibiscus grew in the Garden in the mid-1960s, implying a much earlier planting date.[84] One, near the Macquarie Wall, was photographed in 1982–83 for the Royal Botanic Gardens *Annual Report*. Phillip Island Hibiscus also grows in the Australian Botanic Garden, Mount Annan.

Artist Halina Steele

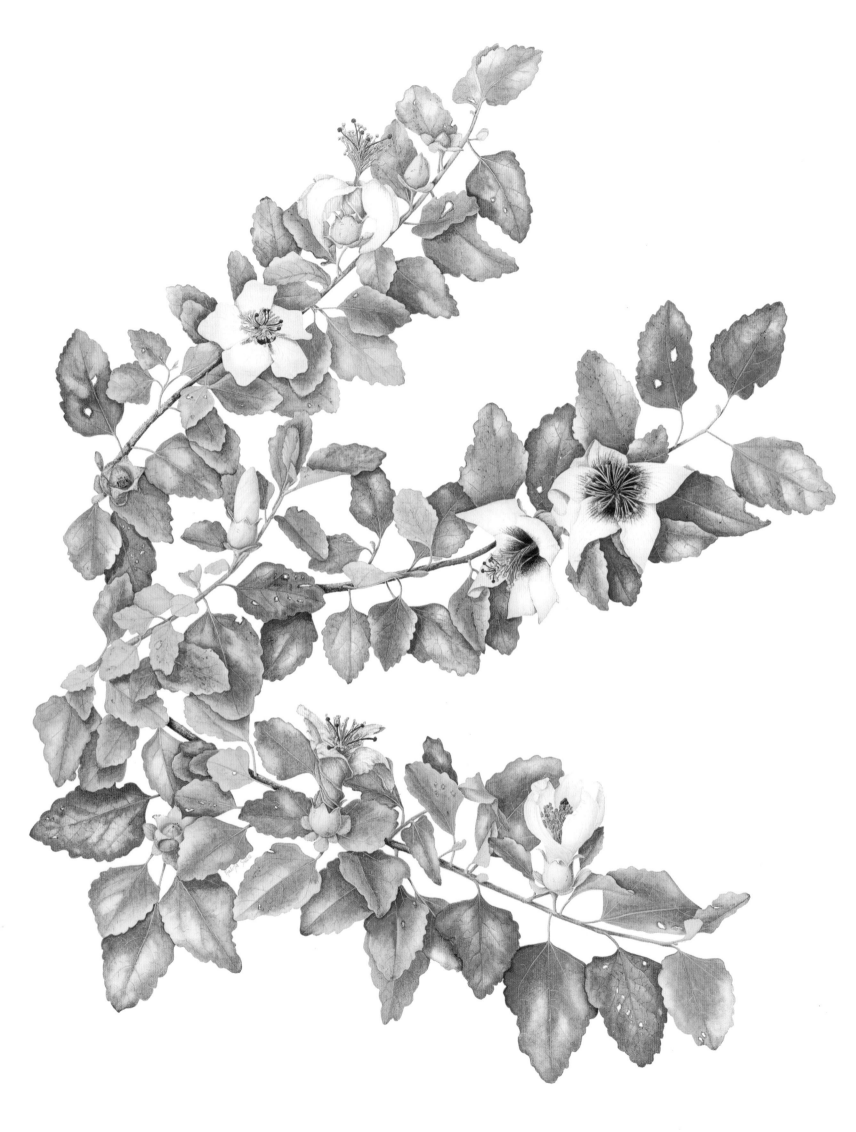

Narcissus 'King Alfred'

Amaryllidaceae

Narcissus from the Greek *narkissos* and Greek mythology; the young man who died as a result of abandoning all else to gaze at his own reflection. Or from *narkao*, Greek for 'I numb myself' in reference to the narcotic properties of the bulb and leaves.

Probably one of the most outstanding daffodils for its size, its large, golden-yellow flowers are 10 cm or more in diameter. The long, flaring trumpet, also called a corona or cup, is in a slightly deeper shade of yellow and protrudes from the gently twisted, golden-yellow tepals. Leaves are strap-like and dark green to grey-green.

The 'King Alfred' Daffodil, named for the 9th century King of Wessex, Alfred the Great, was the result of work by English plant breeder John Kendall, prior to his death in 1890. It was registered by the Royal Horticultural Society in 1899 and had instant appeal.[85]

'King Alfred' or Golden Trumpet Daffodil and similar cultivars imported from Holland grew at the cut-flower nursery that Alfred and Effie Brunet operated at Mount Tomah from the 1930s to the 1960s. Robert Anderson, Director 1959–64, and his successor Knowles Mair, Director 1964–70, were strongly supportive of the Brunets' proposal to donate their nursery site to the Royal Botanic Garden, Sydney. Mair foresaw the opportunity to establish a cool-climate satellite garden, and after Alfred Brunet's death in 1968 commenced the complex task of acquisition, which was completed in 1972.

The daffodils grow in naturalistic drifts in the area known as the 'Brunet Meadow' and in the garden around the Brunet's former residence at the Blue Mountains Botanic Garden. New 'King Alfred' Daffodils have been sourced from Victorian growers.

Artist Anita Walsmit Sachs

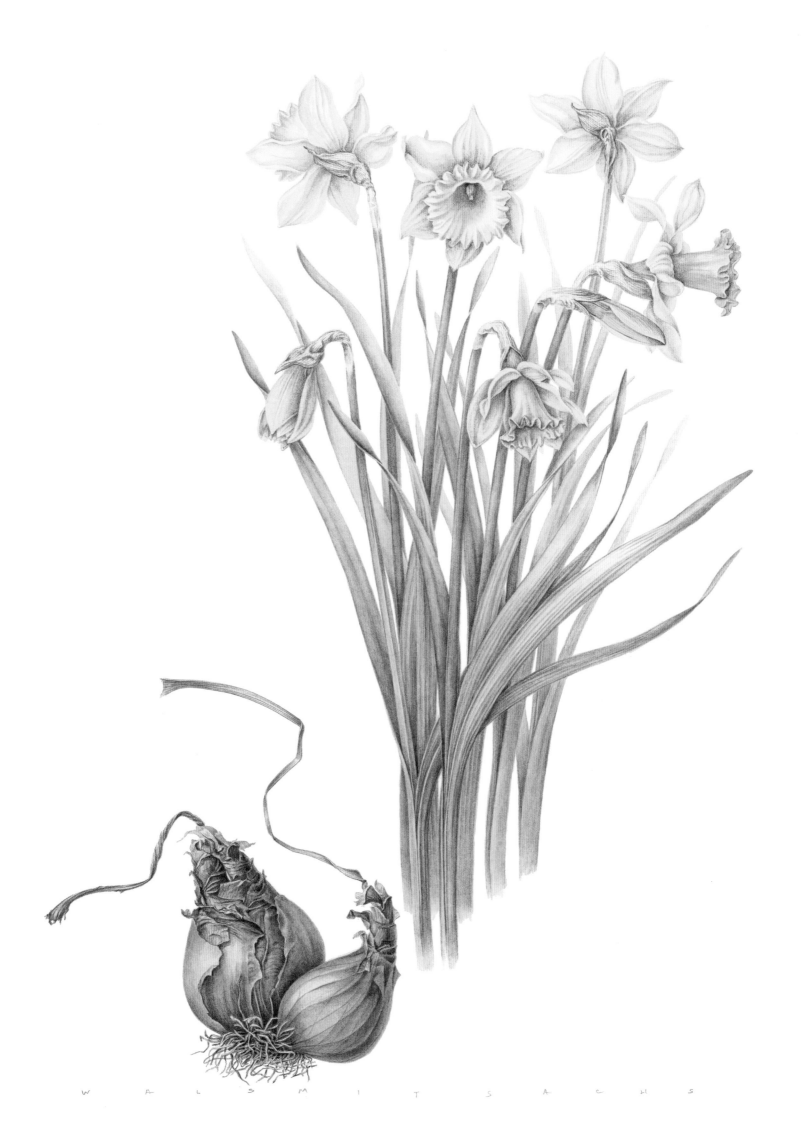

Begonia venosa Skan ex Hook.f

Begoniaceae

Begonia named after Michel Bégon (1638–1710), a French official and passionate plant collector; *venosa* (with veins).

Begonia venosa is a statuesque plant of intriguing contrasts: large leathery leaves covered in fine soft hairs, slender bright pink stems topped by small, white, delicate flowers with a golden-yellow calyx and the finest wing-like bracts along the main stem. It is such a hardy plant that it has been named the 'Great Survivor'.

Begonia venosa was described by Sidney Alfred Skan, and the name was published by Joseph Dalton Hooker in *Curtis's Botanical Magazine* in 1899. A species from the desert that likes full sun and dry conditions, *Begonia venosa* was initially obtained from the University of Turku Botanical Garden, Finland, for the Sydney living collection in 1972. It was planted in the Tropical Centre in 1990. In the same year, additional plants were sourced from the wild in Brazil. The Royal Botanic Garden, Sydney has one of the largest outdoor begonia collections in the world. Since the early 1990s, the Begonia Society of New South Wales has been involved in the care of the collection. *Begonia venosa* was planted as part of the outdoor collection.

Artist Julie Nettleton

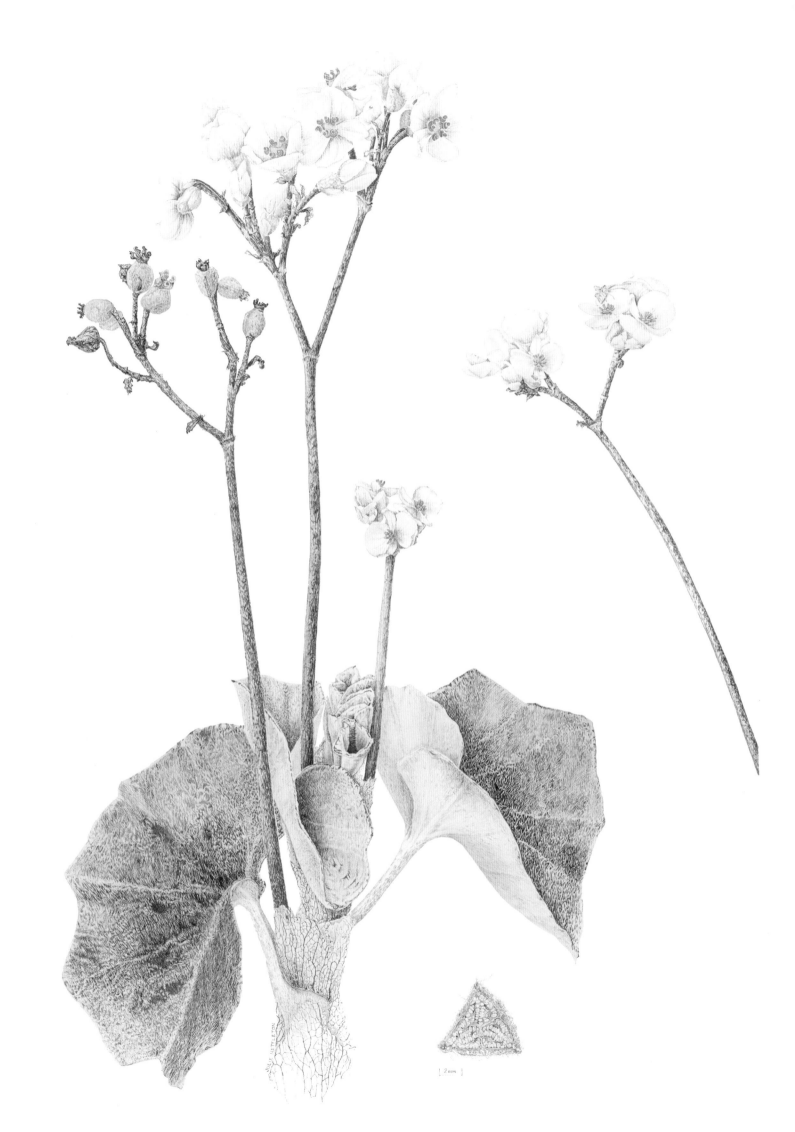

JULIE NETTLETON

[2mm]

Idiospermum australiense (Diels) S.T.Blake

Calycanthaceae

Idiospermum from the Greek *idio* (distinct or peculiar) and *sperma* (seed); *australiense* from Australia.

Idiospermum australiense, the Idiot Fruit or Ribbonwood, is a threatened Australian tropical rainforest species of ancient origins and may have originated in the Late Cretaceous, also known as the Age of Angiosperms. The plants were first found in 1902 by German botanist Ludwig Diels, who matched it with a fossil held in the Dresden Herbarium and placed it in the genus *Calycanthus*. It was thought to be extinct a short time later in the early 1900s, due to clear felling of the forests for production of sugar cane.

Idiospermum was rediscovered in 1971 by a Daintree farmer, when its toxic fruit turned up in the stomachs of dead cattle. In 1972, botanist ST Blake placed it in its own genus, *Idiospermum*, because of the high number of cotyledon leaves.

Idiospermum australiense was planted in the Royal Botanic Garden, Sydney in 1980. This rare species, considered to be one of the most primitive flowering plants in existence, has high conservation significance among the plants of Australia's Wet Tropics World Heritage Area.

Artist Angela Lober

136

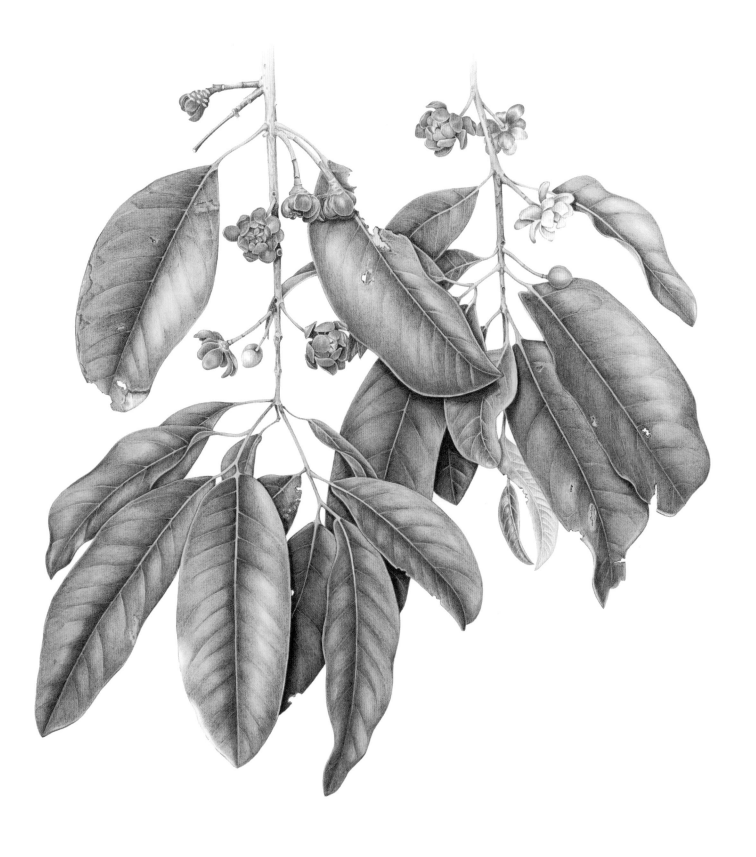

Prunus persica 'Versicolor'

Rosaceae

Prunus is Latin for plum tree; *persica* refers to its widespread cultivation in Persia before being translocated to Europe; 'Versicolor' refers to the variety of pinks in the flowers.

The peach species *Prunus persica* is a deciduous tree native to north-west China.

This cultivar is a vase-shaped small tree, upright to spreading with toothed, light-green lanceolate leaves to 14 cm long. This unusual flowering peach has double flowers up to 5 cm in diameter and has a range of colours of pale pink, deep pink and almost white flowers with deeper pink stripes, flowering together. It is a spectacular flowering tree.

Prunus persica and its varieties have been grown in the Royal Botanic Garden, Sydney since the 19th century. *Prunus persica* 'Versicolor' is part of the Spring Walk display in the Garden. Charles Moore first established the tradition of a 'Spring Walk' to the south of the old stone Macquarie Wall in 1855–56. It was replanted, reinforcing Moore's earlier theme under Curator Edward Naughton Ward in 1927. This element that 'had long been a feature of the Sydney Gardens' was redesigned and improved in 1950–51, expanded in 1984 and, due to the presence of *Armillaria* or Honey Fungus, entirely dug up in 2001 and replanted in 2002–04.

Trees of *Prunus persica* 'Versicolor' were first planted in the Royal Botanic Garden in 1981; they were replenished in 2002 and additional plantings were made in 2007. The trees will be replaced as they decline in vigour to ensure the fine display visitors enjoy each spring.[86]

Artist Rosemary Joy Donnelly

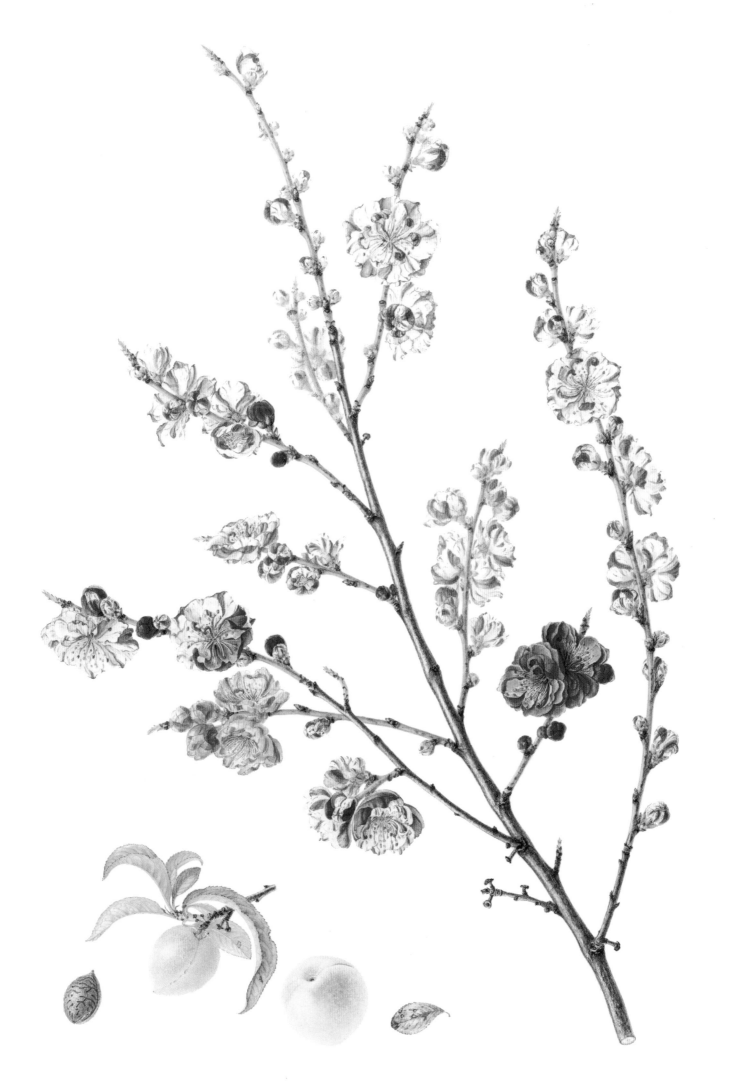

R Donnelly

Scaevola albida (Sm.) Druce

Goodeniaceae

Scaevola from the Latin *scaevus* (left-handed); *albida* (whitish).

This prostrate to ascending herb to 0.5 metre high is often woody at its base. Flowering throughout the year with blue or white fan-shaped flowers, it grows in sclerophyll forest and low-growing coastal communities, chiefly on the coast and ranges, inland to the upper Hunter Valley and Mount Kaputar National Park in New South Wales, to Gympie in Queensland and across Victoria, mainly near the coast, and into South Australia.

Scaevola albida was first described by James Edward Smith as *Goodenia albida* in 1794 and officially reclassified by George Druce in 1917 into the genus *Scaevola*. *Scaevola albida*, Pale Fan-flower, is native to the Australian Botanic Garden, Mount Annan and is part of the Cumberland Plain Woodland vegetation, an endangered ecological community of western Sydney.

In 1984, influenced by both the remnants of this vegetation community and the opportunity afforded by cleared land Dr Barbara Briggs, then Acting Director, Don Blaxell, Assistant Director, and Doug Benson, ecologist, decided on Mount Annan as the location for a new botanic garden for Australian native species.

Artist Sue Bartrop

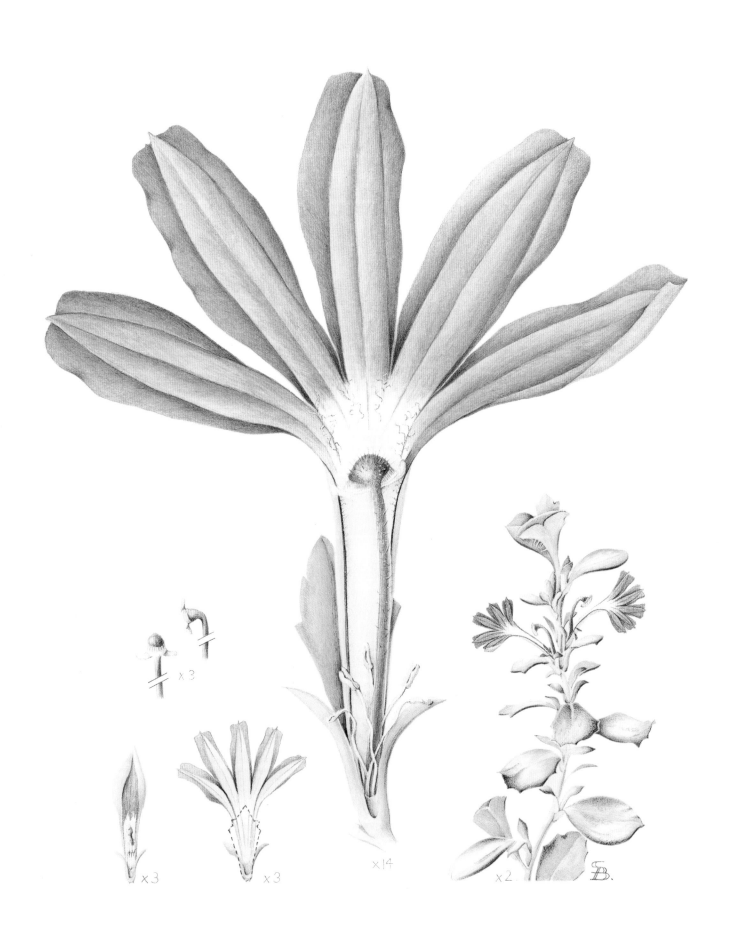

x3

x3

x3

x14

x2

B.

Acacia implexa Benth.

Fabaceae – Mimosoideae

Acacia from the Greek *akis* (a sharp point), in reference to the African and Asian *Acacia* species which have thorns; *implexa* from *implexus* (entangled or entwined), referring to the pods which are folded and twisted, often forming a tangled mass.

This species is widespread in Queensland, south from Cairns, coastal and inland to Deniliquin in New South Wales and Victoria; from coastal areas inland. It is an erect or spreading tree 5–12 metres high with very pale yellow flowers and strongly curved leaves. The small black seeds sit within the pods, which become more and more twisted as they dry.

Acacia implexa, Hickory Wattle, was collected by Allan Cunningham in the ravines of the Shoalhaven River, on the south coast of New South Wales, and named by George Bentham in the *London Journal of Botany* in 1842. Bentham named 228 Australian acacias in this volume.[87]

Widespread in eastern Australia, it is one of the species of the Cumberland Plain Woodland and is native to the Australian Botanic Garden, Mount Annan. William Macarthur of nearby Camden Park recorded that the local Aboriginal name was 'Wee-tjellan' and 'Millewah' was an Aboriginal name formerly in use.[88]

Artist Maggie Munn

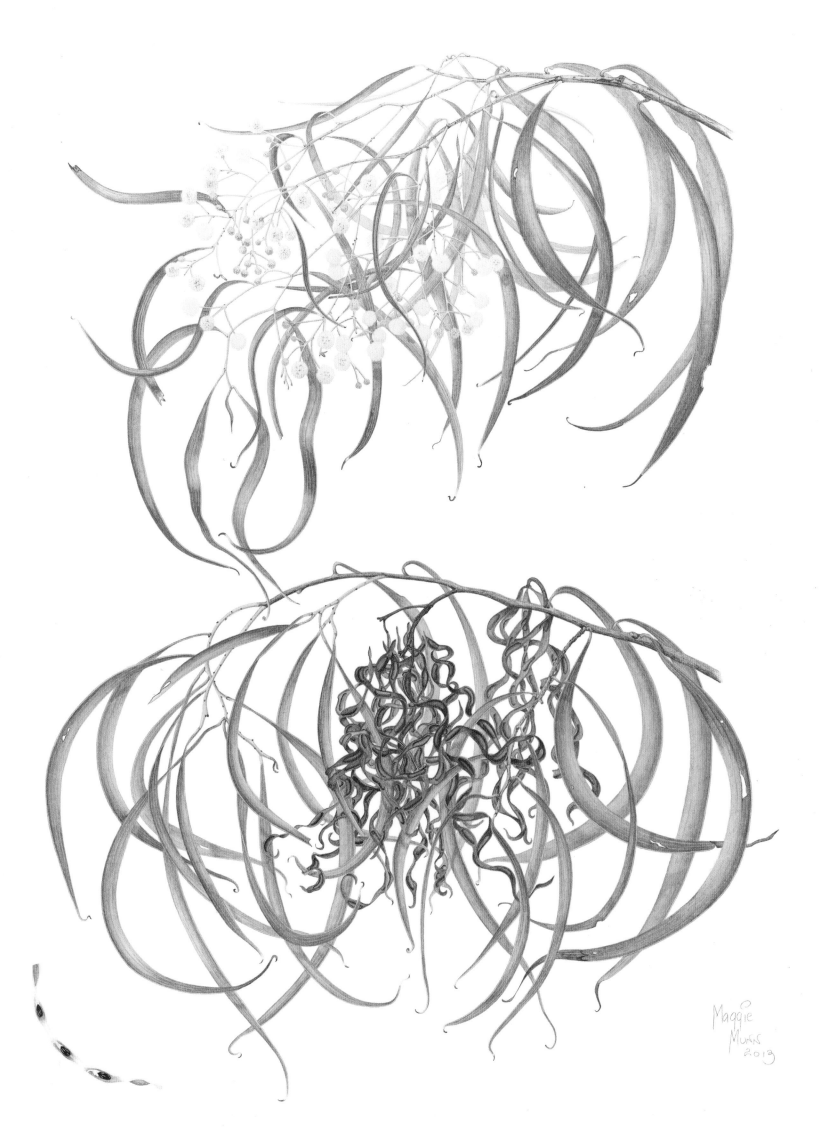

Maggie
Muir
2013

Rosa chinensis f. mutabilis (Correvon) Rehder

Rosaceae

Rosa (rose); *chinensis* (from China); *mutabilis* (varying), referring to the change of flower colour.

The dark plum-coloured shoots, thorns and young leaves give this rose a special quality, but the flowers are even more striking; the slender purple buds open to display the petals, their colour best described as chamois yellow changing within a day to a soft coppery pink and then on the third day deepening to a coppery crimson before they fall with all the colours on the tree at the same time.

The Butterfly Rose, often simply referred to as 'Mutabilis', made its horticultural debut in *Revue Horticole*, Paris, in 1934, introduced by the Swiss botanist Louis Henri Correvon. It is unknown whether the plant originated in China or was a created hybrid. Professor Carrick Chambers, Director 1986–96, had a great interest in establishing new rose plantings. Mutabilis was first planted in the Royal Botanic Garden, Sydney in 1987 and was obtained from Kew-trained Australian nurseryman Roy Rumsey and his wife Heather of Rumsey's Nursery, a Sydney nursery specialising in old garden roses.

Artist Narelle Thomas

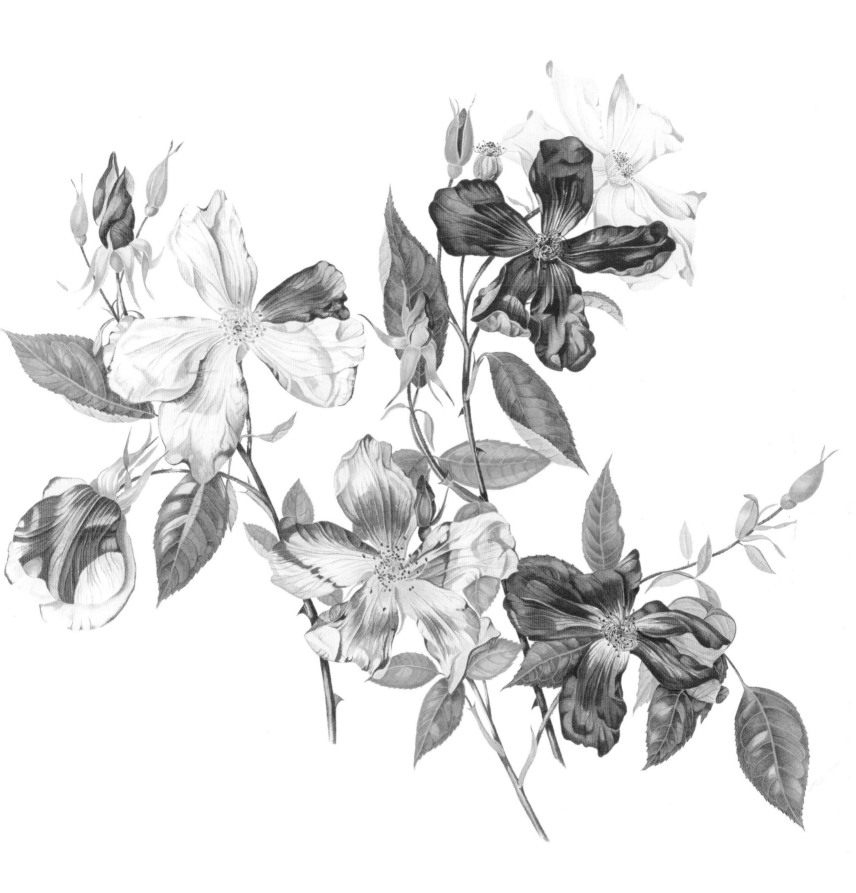

Narelle Thomas 2008

Atkinsonia ligustrina (Cunn. ex Lindl.) F.Muell.

Loranthaceae

Atkinsonia named after Louisa Atkinson (1884–1872), a great naturalist and botanical artist; *ligustrina* (looking like privet).

Confined to a small area in the Blue Mountains west of Sydney, NSW, this small woody shrub is the only species of *Atkinsonia* known. This may be the first colour illustration made of the species. *Atkinsonia* belongs to the Loranthaceae family, a large family of over 900 species in at least 65 genera, and almost all known for their parasitic habit. This species is the living ancestor to all mistletoes in the world. It is reported that a single specimen of this species can parasitise the roots of a wide range of different species of nearby plants, so do not be tempted to cultivate it in your garden! The fragrance of the flowers is exceptional.

Atkinsonia ligustrina, Louisa's Mistletoe, was first collected by Allan Cunningham in 1817 and described as *Nuytsia ligustrina* by John Lindley in 1839.[89] It was renamed by Ferdinand von Mueller, Director of Melbourne Botanic Gardens, in 1865. At the suggestion of botanist the Reverend Dr William Woolls, it was named for naturalist and botanical artist (Caroline) Louisa Atkinson, one of von Mueller's collectors, who lived at Kurrajong Heights for many years and knew Mount Tomah.

Louisa's Mistletoe is native to Mount Tomah. It grows on Mount Tomah Spur, land owned by the Blue Mountains Botanic Garden, but it has been reluctant to grow within the Garden itself.

Artist Delysia Jean Dunckley

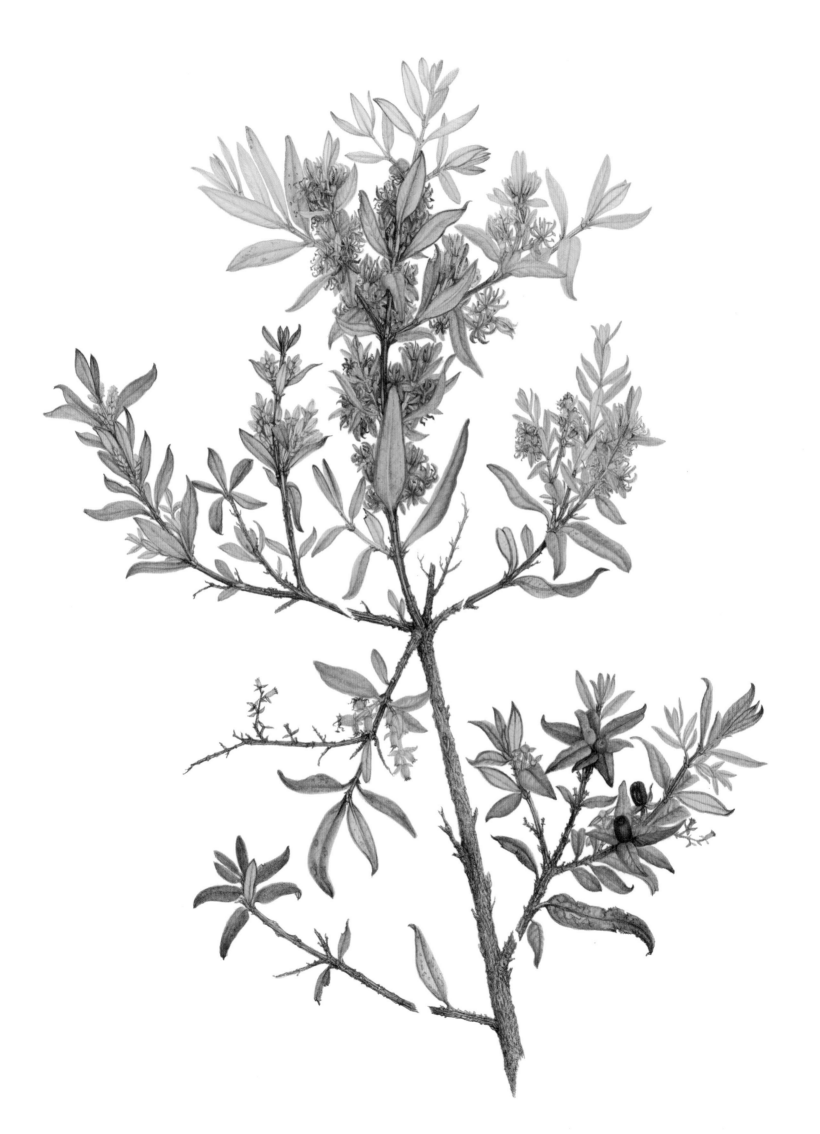

Nothofagus obliqua (Mirb.) Oerst.

Fagaceae

Nothofagus (false beech); *obliqua* (oblique), probably referring to the leaf base where the two sides of the leaf blade are unequal and do not meet the petiole at the same place.

Central Chile near Santiago to south of Valdivia and a small area of adjacent Argentina is the natural distribution of *Nothofagus obliqua*, the most widespread of the nine South American *Nothofagus* species. It is valued for its timber.

Nothofagus obliqua (syn: *Lophozonia heterocarpa* Turz.) is a deciduous tree that grows to 30 metres in height with silver-grey, flaky bark. The leaves are toothed, alternate, and form a herringbone pattern with the stem, starting deep green in spring and turning gold, orange and red in autumn. The small inconspicuous flowers are wind pollinated and are either male or female, with both sexes on the plant.

Nothofagus obliqua, Roblé, was first described as *Fagus obliqua* by Charles de Mirbel in 1827; its name was revised by Anders Oersted in 1871. During the development of the Blue Mountains Botanic Garden, Mount Tomah, which was opened in 1987, the thematic botanical focus was on the families and genera of Southern Hemisphere plants that typified ancient Gondwanan flora. The Southern beeches, *Nothofagus*, was part of this focus and collecting trips to Tasmania, New Zealand and Chile commenced in 1984–85, resulting in the propagation of 14 of the 35 species in this genus.[90] The seed of *Nothofagus obliqua* collected in the wild arrived from Chile in September 1986. From 1988 to 1990, seedlings of the Roblé were planted in the Chilean section of the Gondwana Walk and as an avenue with *Nothofagus moorei* on the front entrance driveway.[91]

Artist Susan Ogilvy

148

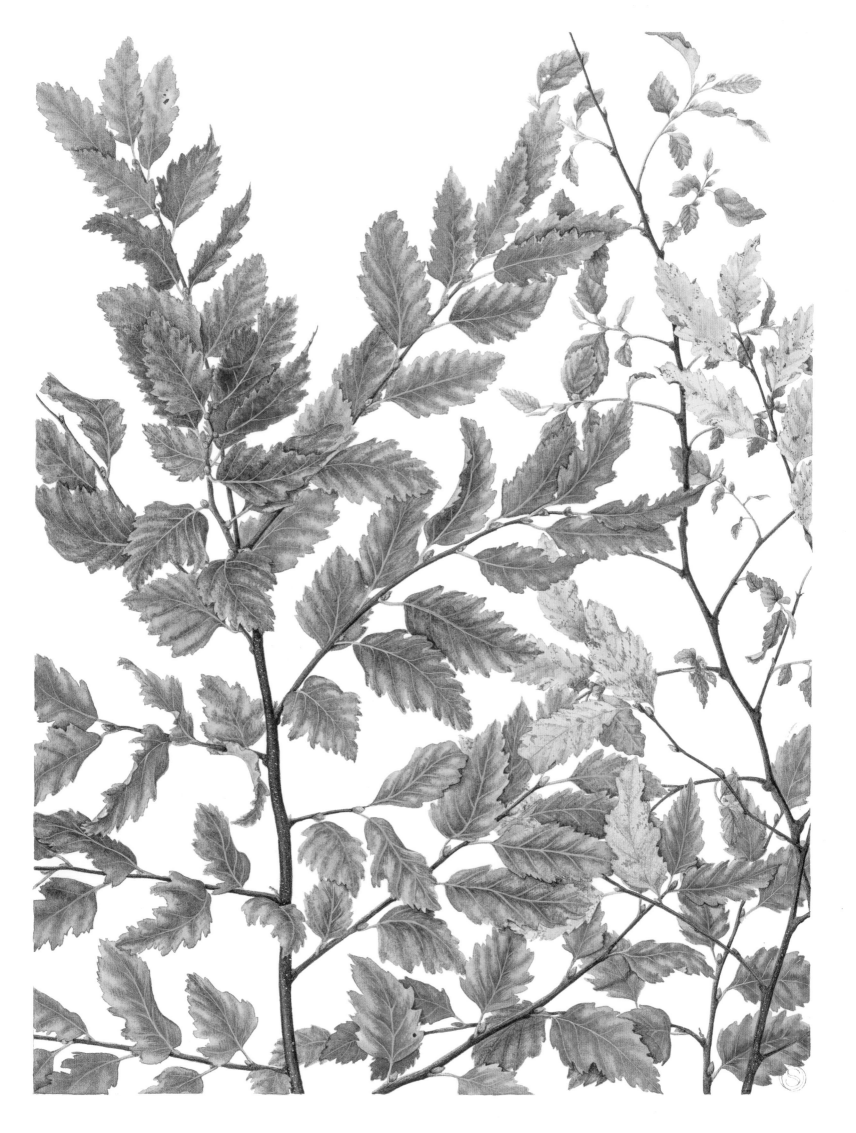

Kalopanax septemlobus (Thunb.) Koidz.

Araliaceae

Kalopanax from the Greek *kalos* (beautiful) and *Panax* (the Ginseng genus); *septemlobos* (seven-lobed), referring to the lobed leaves.

This tree is native to and a dominant species in China, Japan, Korea and far east Russia.

Kalopanax septemlobus is the sole species in the genus. It is a deciduous tree growing to 12–18 metres tall, in cultivation, taller in its native habitat. The glossy dark-green leaves are toothed and usually seven-lobed, with very obvious venation. The trunk, branches and particularly the younger stems are armed with spines that disappear as the tree matures. Tiny white flowers appear profusely in large, terminal, umbel-like panicles in late summer followed by tiny black fruits.

Kalopanax septemlobus, Tree Aralia, Haragiri or Sen-no-ki, was described by Japanese botanist Gen-ichi Koidzumi in 1925. Botanist Carl Peter Thunberg had first described the tree as *Acer septemlobum* in 1784.[92] This tree appealed to the 19th century European taste for 'tropical' foliage plants and became popular because it could be grown in a cool climate.

A tree of *Kalopanax septemlobus* cultivated from seed from Hangzhou Botanic Garden, China, that arrived at the Blue Mountains Botanic Garden in 1978, was planted in March 1988 and was a well-developed tree when photographed in 1999.[93] Fittingly, a Japanese artist painted this species.

Artist Noriko Watanabe

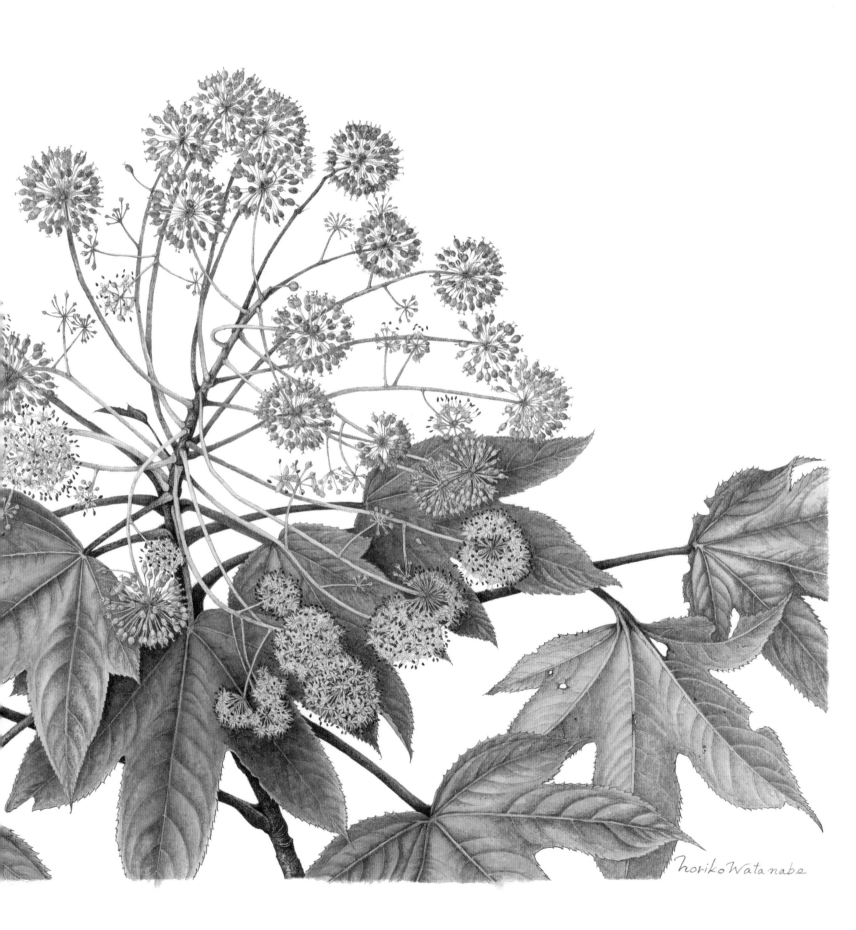

noriko Watanabe

Erica verticillata P.J. Bergius

Ericaceae

Erica from the Greek *ereike* (heath or heather); *verticillata* referring to a whorl around an axis, describing the position of the flowers and leaves whorled around the branches.

Erica verticillata was thought to be extinct, but one plant was rediscovered cultivated in a park in Pretoria, South Africa, in 1984 and thought to have been cultivated there since the 1940s. It has been brought back into cultivation at Kirstenbosch Botanical Garden. This heath plant grew in Cape Town, South Africa, in vegetation known as the Cape Flats Sands, which is now threatened by agriculture, urban sprawl and fragmentation. Sunbirds were the chief pollinator of this plant in South Africa, and at the Blue Mountains Botanic Gardens the Eastern Spinebill finds the flowers irresistible. The clusters of pink, bell-shaped flowers are much larger than the leaves, and put on a great show. There are many cultivars of this species around the world.

Erica verticillata was described by Swedish doctor and botanist Peter Jonas Bergius in 1767. Bergius, a disciple of Carl Linnaeus, was the founder of Bergius Botanic Garden, Stockholm University. The species is now classified as extinct in the wild.

During the 1980s, the erica horticulturist at Kirstenbosch National Botanical Garden, Cape Town, Dan Kotze, began searching for the species, using herbarium sheets as a reference. David von Well, Kirstenbosch scholar in 1984 recognised that a plant growing in Protea Park, Pretoria was the same as the one on the sheets. Another plant was recognised at Kew and material from both was cultivated at Kirstenbosch.[94]

Erica verticillata was introduced to the Blue Mountains Botanic Garden in 1988 when it was cultivated from plant material sent from the Royal Botanic Gardens, Kew.[95] Although the species is rare, the artist painted this piece from a plant growing in her South African garden.

Artist Vicki Thomas

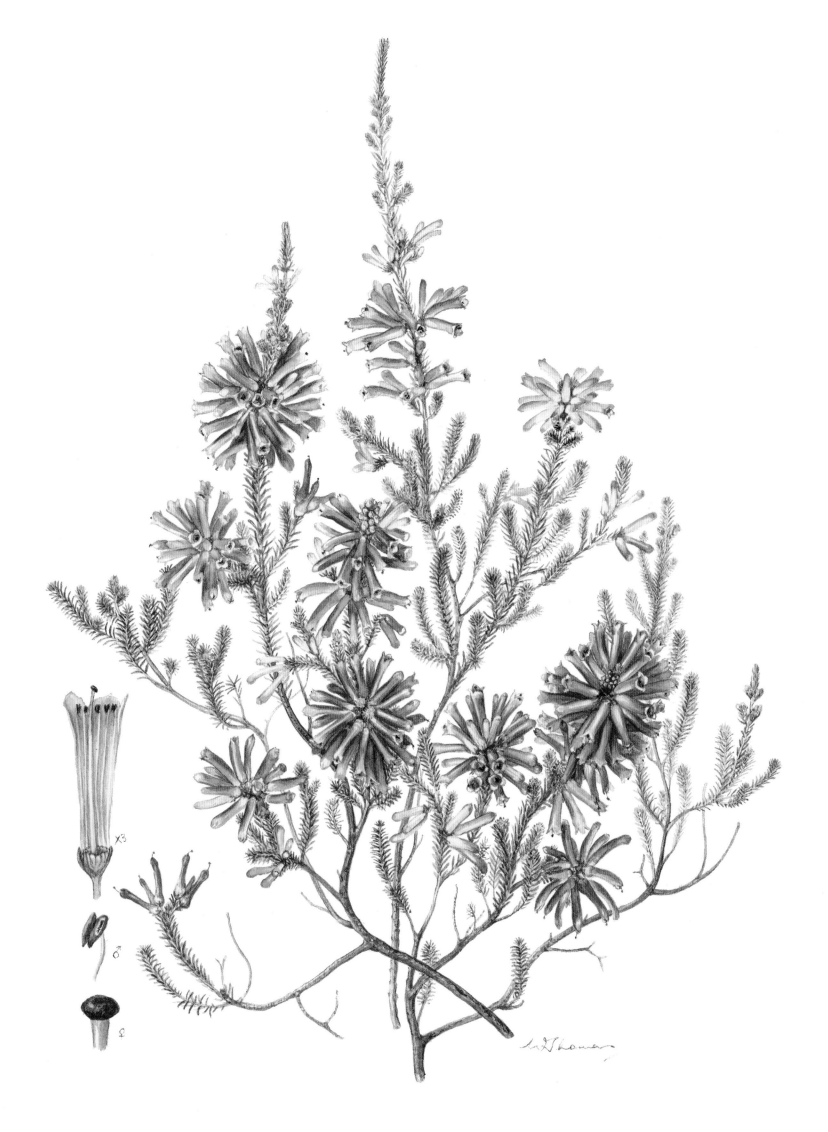

Protea cynaroides (L.) L.

Proteaceae

Protea after *Proteus*, a mythical sea god who assumed many forms, referring to the diversity of this genus; *cynaroides* after the genus *Cynara* (flower heads looking like an artichoke).

Protea cynaroides has one of the widest distribution ranges of all the Proteaceae in South Africa and occurs from the Cedarberg mountains in the north-west to Grahamstown in the east. It occurs on all mountain ranges in this area, except for the dry interior ranges, and at all elevations, from sea level to 1500 metres above sea level. As it occurs at such different altitudes, there is great variety in the size and colour of the flower. It is widely cultivated throughout the world and used in the cut-flower trade; it is renowned for its exceptional, large, cup-shaped flower with pink bracts and bright-green oval leaves.

Protea cynaroides, the King Protea or Grootsuikerkan, was originally described as *Leucadendron cynaroides* by Carl Linnaeus in 1753. Linnaeus gave the species its current name in 1771. It is the national flower of South Africa.

The earliest thematic planting at the Blue Mountains Botanic Garden, Mount Tomah was the families and genera of Southern Hemisphere plants that typified ancient Gondwanan flora. The concept was to interpret the evolutionary links between the countries that once made up the supercontinent, Gondwana. Species of the Proteaceae, as an important Southern Hemisphere group, were collected or purchased prior to the Botanic Garden opening in 1987. Plants of *Protea cynaroides* were planted in 1988. It is also grown in the Royal Botanic Garden, Sydney.

Artist Narelle Thomas

154

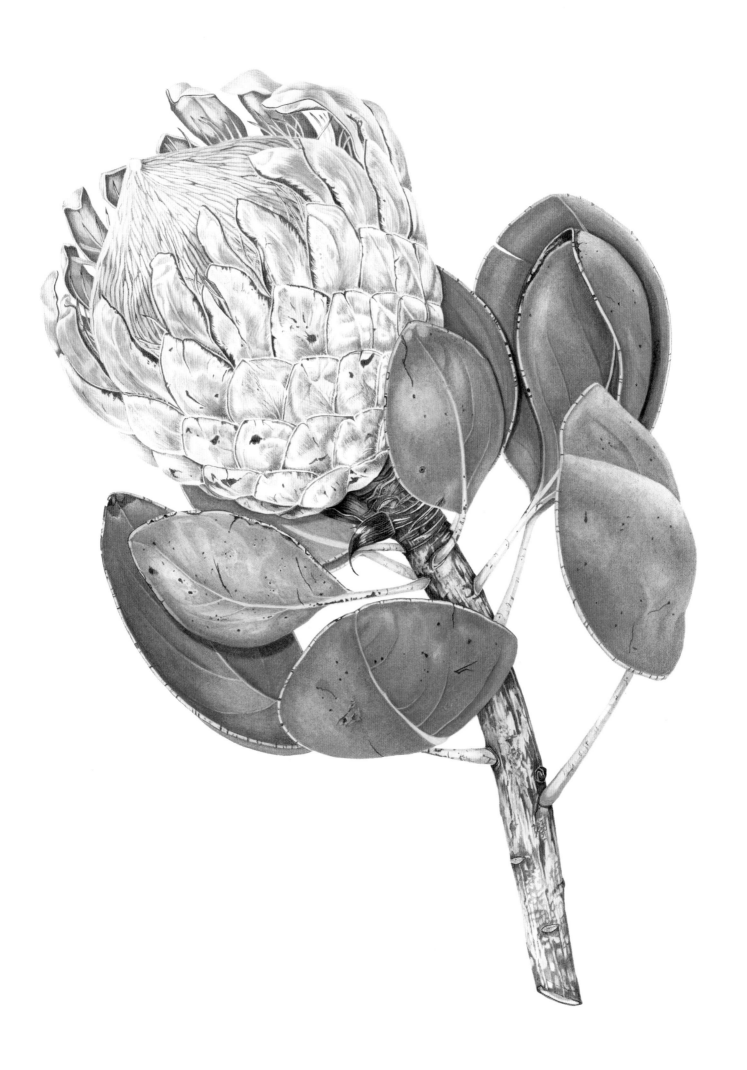

Bleasdalea bleasdalei (F.Muell.) A.C.Sm. & J.E.Haas

Proteaceae

The genus and species names celebrate British-born Reverend John Ignatius Bleasdale who arrived in Victoria in 1851. Bleasdale was a member of both the Linnean and Geographical societies and a founding member of the Melbourne Microscopical Society.[96]

The Blush Silky Oak is a beautiful small tree of rainforest margins, where it stands out brightly because of its red and yellow to bronze young leaves. It is found in the mid-montane to montane rainforest between Cairns and Mackay, Queensland. From November to March, the mature blue fruit drop to the ground from where many are picked up and eaten by cassowaries. It makes a very attractive garden plant, the colours in the young leaves being enhanced by yellow to orange flowers and autumn colours in the older leaves.

Bleasdalea bleasdalei, Blush Silky Oak, was first described in 1865 as *Grevillea bleasdalei* by Ferdinand von Mueller. The specimen von Mueller used was collected by John Dallachy, a former curator of the Melbourne Botanic Gardens, who collected in North Queensland for the Melbourne Herbarium. In 1908, JH Maiden wrote that Dallachy was perhaps the best Australian botanical collector 'to whom justice has not been done'.[97] The species went through numerous name changes before being named *Bleasdalea bleasdalei* in 1975 by American botanist Albert Smith and Judith Haas from the Royal Botanic Gardens, Kew.

This species has been planted a few times both in the Royal Botanic Garden, Sydney and the Blue Mountains Botanic Garden, Mount Tomah, where the Proteaceae are a particular focus as Gondwanan flora. Although long-lived in the wild, the species has proved to be difficult to keep alive in cultivation.

Artist David Mackay
Donated by Prof. Caroline Gross

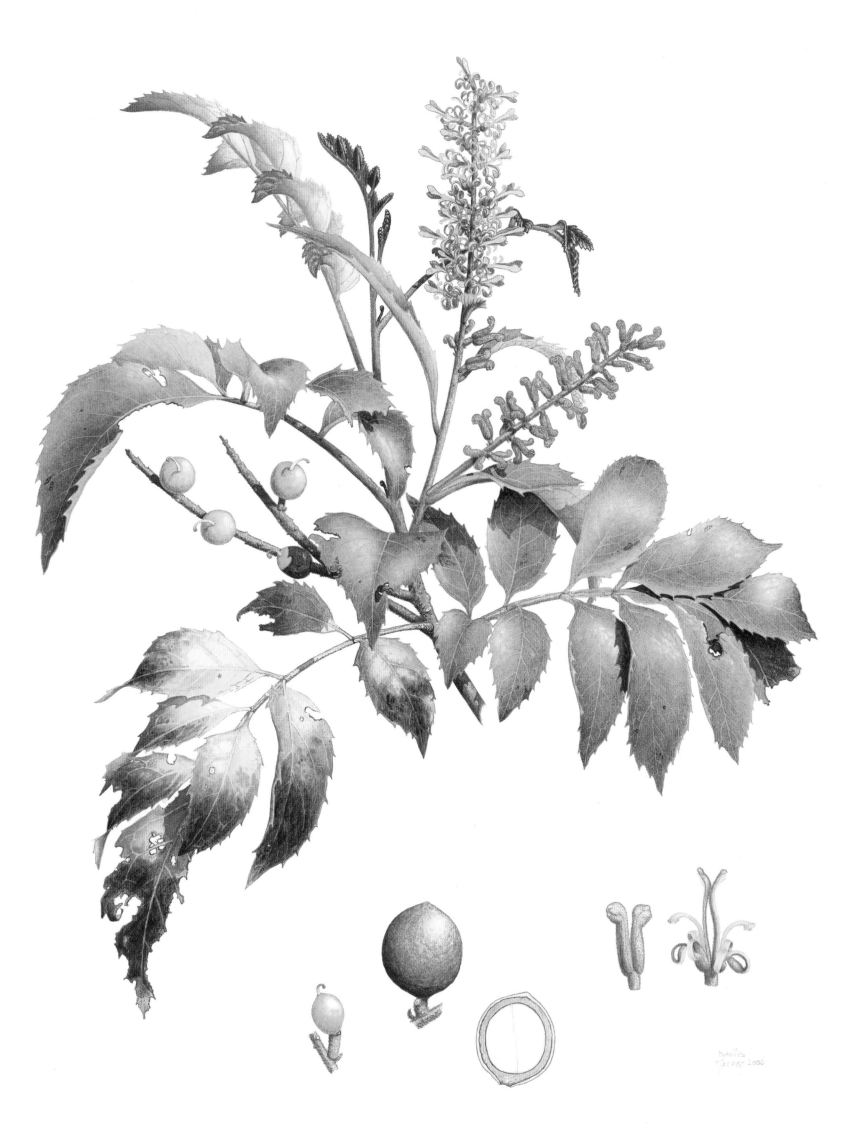

Eucalyptus sideroxylon 'Fawcett's Pink' Woolls

Myrtaceae

Eucalyptus from the Greek *eu-*, *eu-* + Greek *kaluptos* (covered), referring to the cap covering of the buds; *sideroxylon* from the Greek *sideros* (iron) and *xylon* (wood), referring to the very hard wood of this species. 'Fawcetts Pink' named for Stella Grace Maisie Carr nee Fawcett (1912–1988), who undertook comprehensive morphological and taxonomic research into the genus *Eucalyptus* and was a senior lecturer in botany at Melbourne University.

This is a pink-flowering form of a species that is very common on the east coast of Australia in from Carnarvon in Queensland, through inland New South Wales to north-eastern Victoria, in open forest and usually on poor soils.

This natural hybrid is popular in cultivation, although it is a large tree. Known for the red bark on young trees ageing to a red-black bark on older trees, it contrasts well with the blue-grey foliage.

Eucalyptus sideroxylon, Mugga or Red Ironbark, was collected by Allan Cunningham and described by William Woolls in 1886. 'Mugga' is an Aboriginal name for the species, and its timber is red when cut. *Sideroxylon* refers to the species as having woodlike iron and in the past it has been used to make railway sleepers. *Eucalyptus sideroxylon* 'Fawcett's Pink' is a signature planting at the old front entrance of the Australian Botanic Garden, Mount Annan, opened in 1988 to celebrate the bicentenary of European settlement in Australia.

Artist Helen Lesley Fitzgerald

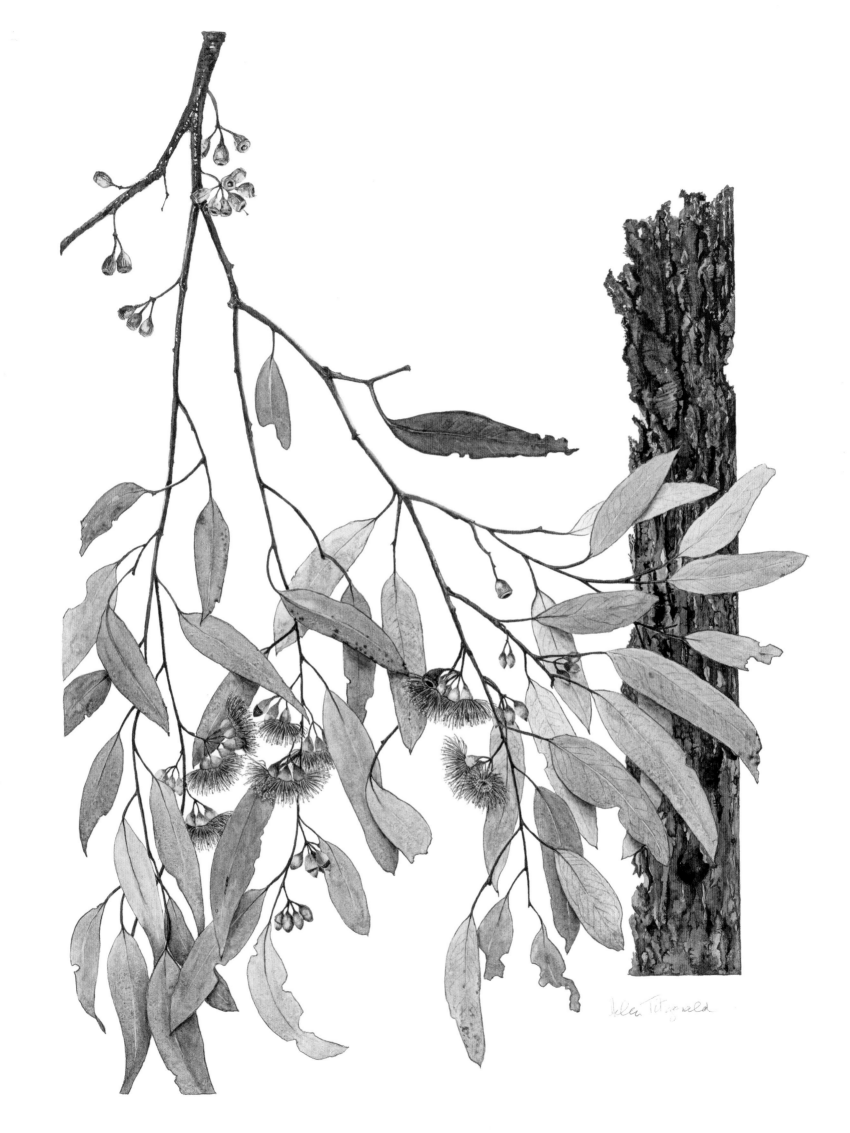

Banksia blechnifolia F.Muell.

Proteaceae

Banksia named for Joseph Banks, the naturalist on board the *Endeavour*, accompanying Captain James Cook on his first Pacific voyage when specimens were collected at Botany Bay, between 28 April to 5 May 1770; *blechnifolia* from the Latin *blechnum* (a fern) and *folium* (a leaf), referring to the fern-like leaves.

This species of *Banksia* occurs naturally at Jerramungup and Gibson in southern Western Australia where it is found in sandy soils in sand plain country, in heath, and sometimes associated with mallee. It is vulnerable in its native habitat.

Banksia blechnifolia is a prostrate plant with branchlets lying on the ground. The extraordinary leaves are bright pink or orange and hairy when they first emerge; they then grow into large green, leathery, deeply lobed leaves that are 25–45 cm in length and 4–10 cm wide, coming off the branches and standing up erect. The inflorescence is at ground level and also large and erect, displaying a stunning rusty orange flower cone. Flowering is generally in spring but may occur in late winter. The cone becomes woody in fruit and the seeds are enclosed in large follicles and are generally retained within the cone until burnt.

Banksia blechnifolia, Southern Blechnum Banksia or Groundcover Banksia, was collected near the south coast of Western Australia in 1861 and described by Ferdinand von Mueller in 1864. The species name refers to the similarity of the foliage to *Blechnum*, a fern genus.

Banksia blechnifolia is one of the hardier Western Australian banksias for eastern coast conditions, although not often seen. It grows at the Australian Botanic Garden, Mount Annan and in the Royal Botanic Garden, Sydney.

Artist Robyn Seale

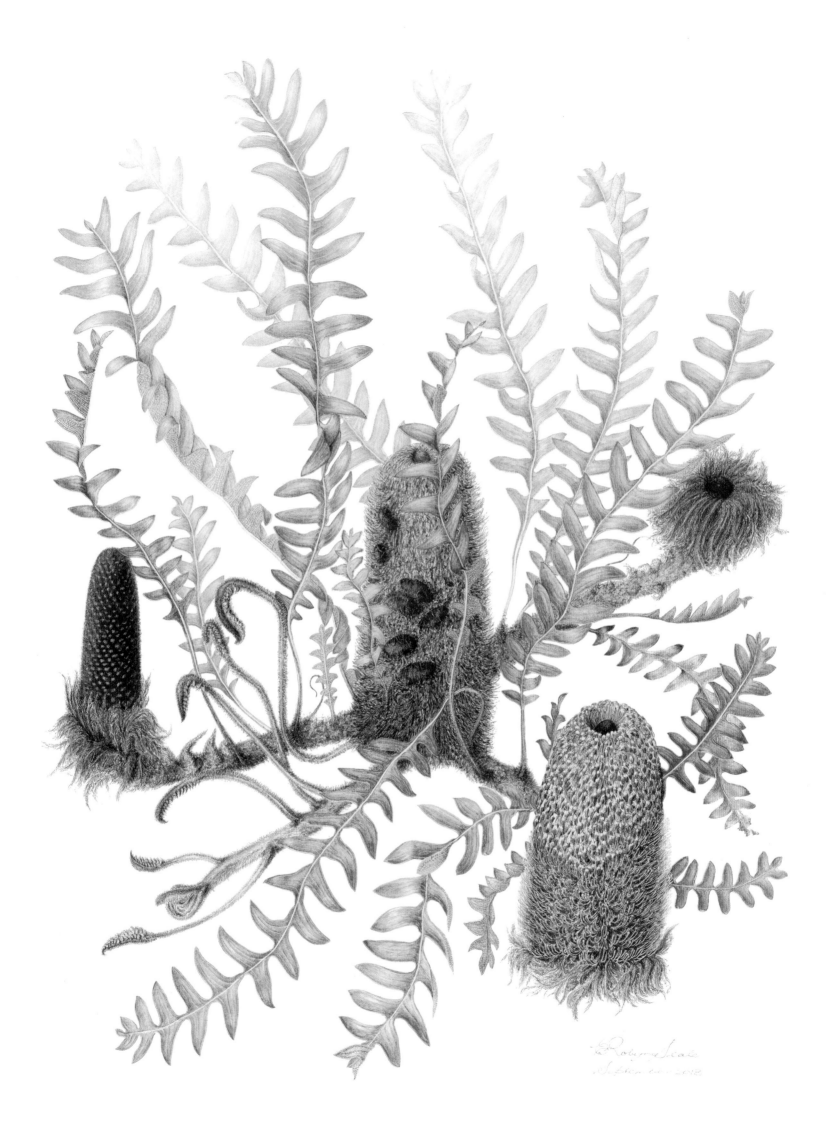

Begonia leathermaniae O'Reilly and Kareg.

Begoniaceae

Begonia named after Michel Bégon (1638–1710), a French official and passionate plant collector; *leathermaniae* for Sylvia Leatherman, a Begonia breeder who also collected plants in the wild in Brazil.

This begonia is native to South America, in Bolivia and Santa Cruz at altitudes of 1000–2500 metres above sea level. *Begonia leathermaniae* has divided leaves that are almost palm-like in appearance with very long petioles. The pink flowers are grouped together in a cyme.

Described in 1983, *Begonia leathermaniae* replaced the synonym *Begonia platanifolia* var. *acuminatissima* originally collected by German botanist Carl Kuntze in Bolivia in 1892.

Begonia leathermaniae was introduced to the Royal Botanic Garden, Sydney in 1989 and was first planted in the Arc Tropical Centre in 1995. Although *Begonia* had long grown in the Garden, from 1990 Peter and Shirley Sharp, members of the Begonia Society of New South Wales and volunteers, began work to establish an outdoor begonia garden. The first plantings were in 1994, and by 2007 they had developed the world's largest outdoor begonia collection.[98]

Artist John Pastoriza-Piñol

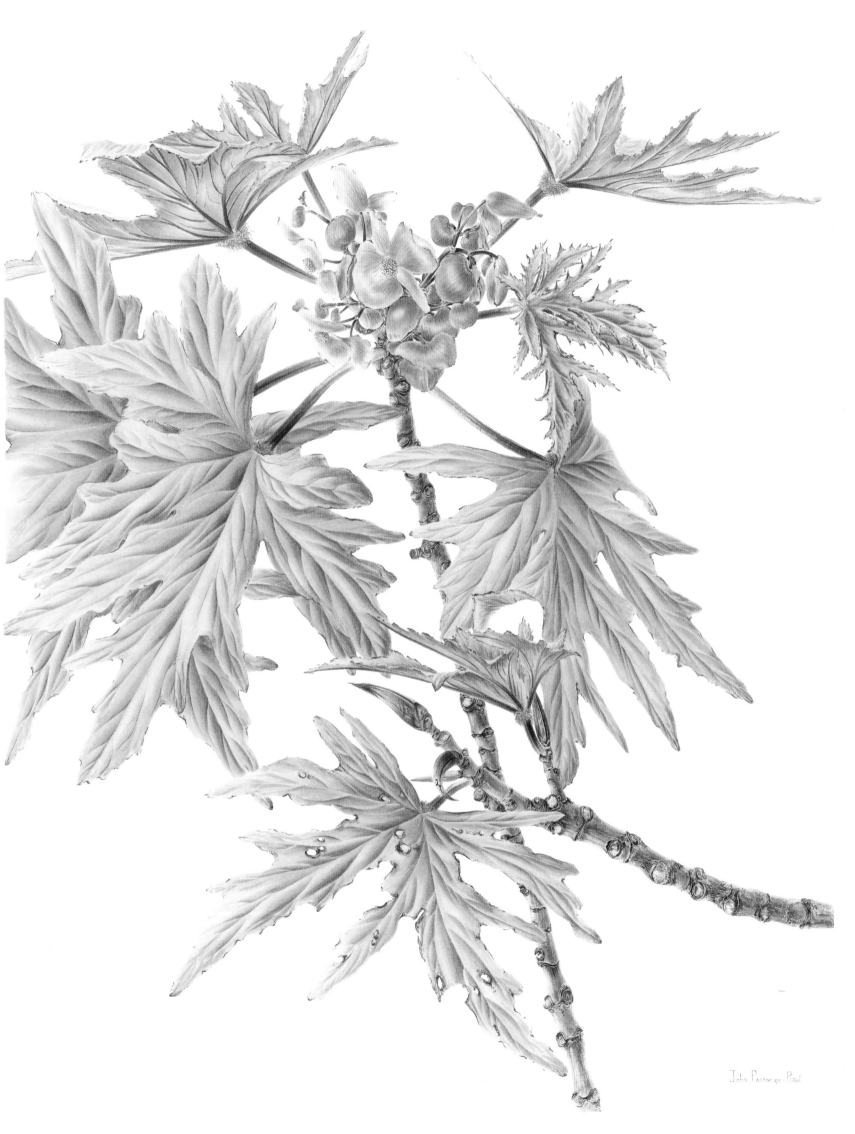

John Pastoriza-Piñol

Tillandsia streptophylla Scheidw. ex E.Morren

Bromeliaceae

Tillandsia for Swedish botanist Elias Tillands; *streptophylla* (twisted leaf).

Native to Central America and often found in cultivation, *Tillandsia streptophylla* is an air plant that does not need soil to survive. It is also called the 'Shirley Temple' plant because as the leaves dehydrate, they curl up into tighter and tighter ringlets.

Tillandsia streptophylla was described in 1836 by Michael Joseph François Scheidweiler in *L'Horticulteur Belge, Journal des Jardiniers et Amateurs*. Scheidweiler was a German-born professor of botany and taxonomist who settled in Belgium and described 14 species of Bromeliaceae.[99] A plant of *Tillandsia streptophylla* that came from R. Phillips in Coffs Harbour, NSW, in 1990 seems to be the first to be successfully grown in the Royal Botanic Garden. It was planted in the Arc Tropical Centre in August 1990.

Artist Mariko Aikawa

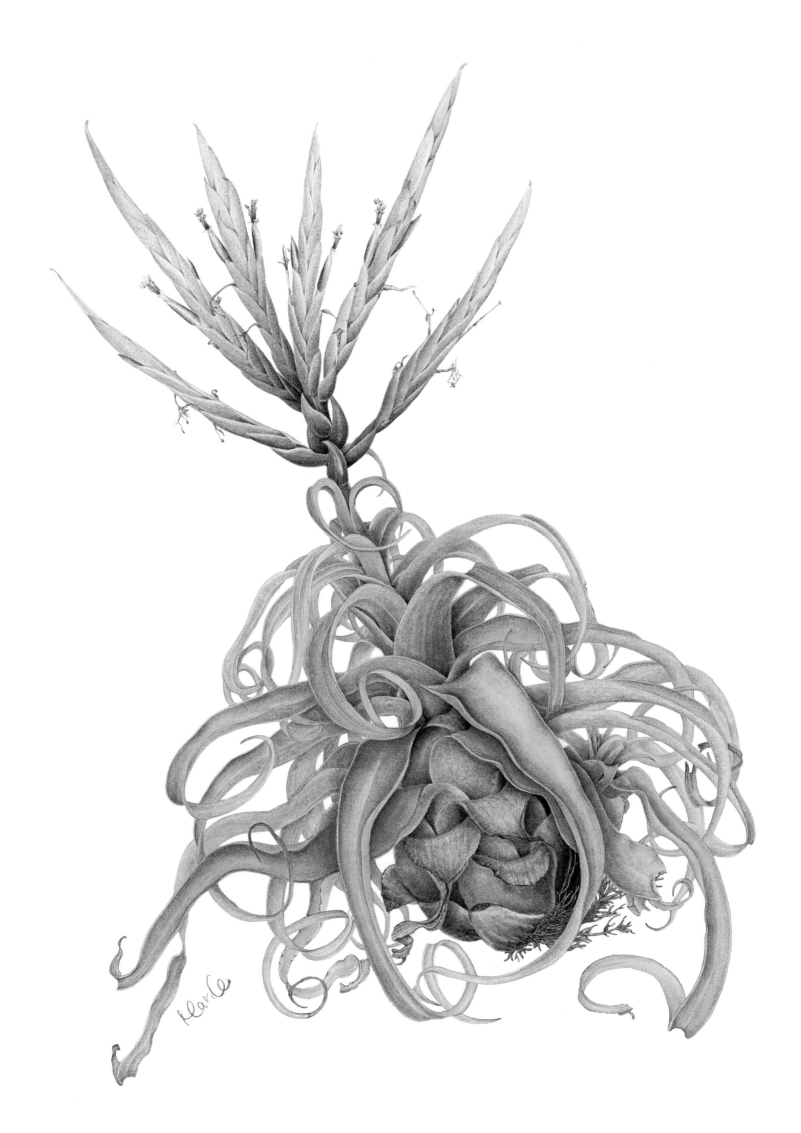

Strongylodon macrobotrys A.Gray

Fabaceae

Strongylodon from the Greek *strongylos* (round) and *odontos* (tooth), referring to the rounded teeth of the calyx; *macrobotrys* from *macro* (large) and *botrys* (a cluster), referring to the very large cluster or inflorescence of flowers and then fruits.

Native to the tropical forests of the Philippines on Luzon, Mindoro and Catanduanes Islands, this massive vine cannot be missed when in flower from late spring to early summer with the extraordinary flowers hanging down on pendent trusses. The flower colour is luminous and varies from a pale mint-green to a sea-green turquoise. The fruits are fleshy pods up to 15 cm long, holding 12 seeds, and are not typical of a legume fruit. As the vine is pollinated by bats in its wild habitat, it can be difficult to propagate in cultivation.

Strongylodon macrobotrys, Jade Vine or Emerald Vine, was one of the botanical discoveries of the United States Exploring Expedition of 1838–42 to the countries in and around the Pacific, including Australia, under Charles Wilkes. Asa Gray, Professor of Botany at Harvard University, described the species in 1854.

The first living accession of *Strongylodon macrobotrys* to the Royal Botanic Garden, Sydney came from the Department of Forests, Lae, Papua New Guinea, in 1987. It was planted in June 1990 in the Arc Tropical Centre.

Artist Dianne Sutherland

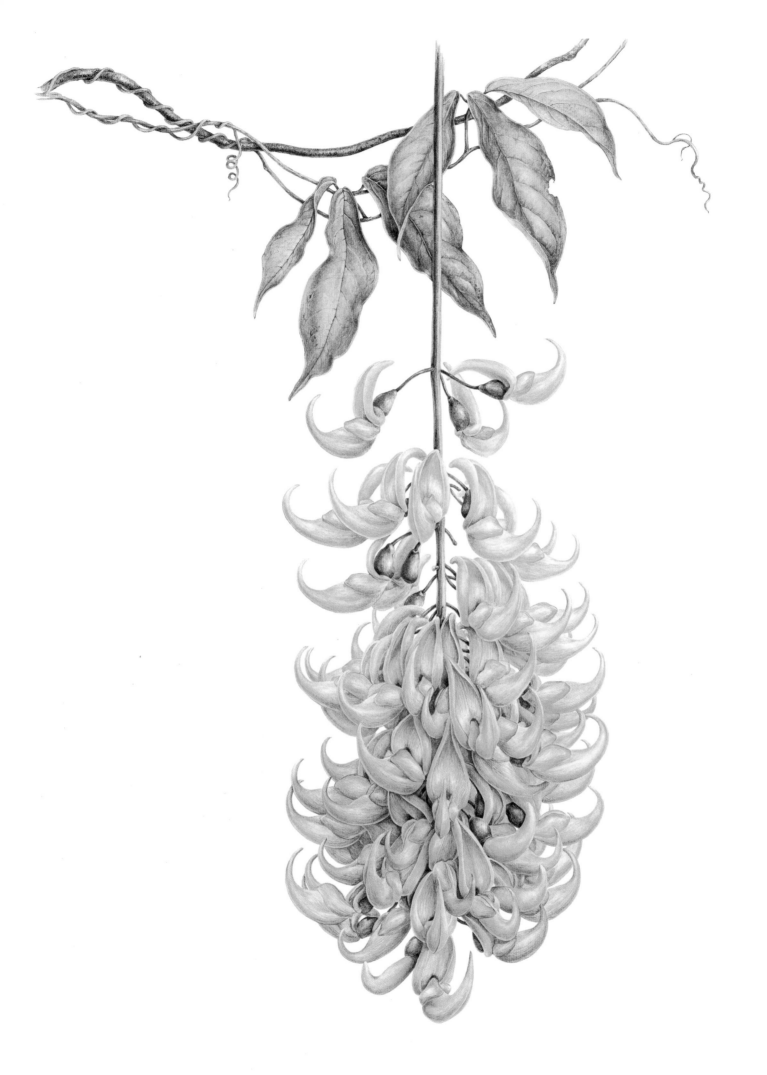

Dianne Sutherland

Rhododendron oldhamii Maxim.

Ericaceae

Rhododendron meaning rose tree, referring to the flower colours of many species; *oldhamii* for Richard Oldham.

Rhododendron oldhamii occurs naturally in mountain thickets in Taiwan at about 2800 metres above sea level. It is an evergreen shrub to 3 metres high and known for the large, bright brick-red inflorescences of 2–4 flowers that are produced in summer.

Rhododendron oldhamii was first collected in 1864 by Richard Oldham when he visited Taiwan as a collector for the Royal Botanic Gardens, Kew.[100] Carl Johann Maximowicz, a Russian botanist who spent most of his life studying the flora of the far east, described the species in 1871.

Eminent Australian botanist and educator Dr Peter Valder donated *Rhododendron oldhamii* to the Royal Botanic Garden, Sydney and the Blue Mountains Botanic Garden, Mount Tomah. Valder's plants came from a collection made by J Patrick in Taiwan in 1971.[101] It was planted in the Blue Mountains Botanic Garden prior to 1991 and in the Spring Walk in the Royal Botanic Garden when it was replanted in 2002–04.

Artist Leigh Ann Gale

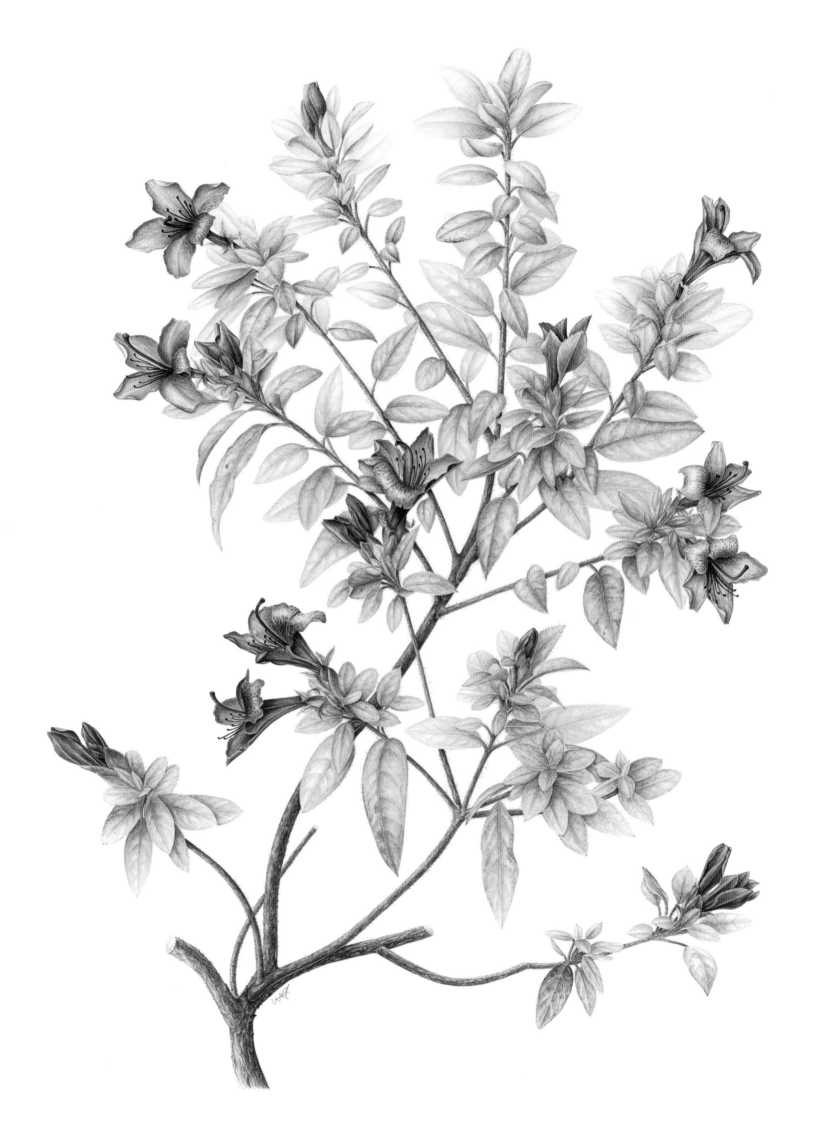

Sarracenia leucophylla Raf.
Sarracenia alata (Alph. Wood) Alph. Wood
Sarracenia unidentified species

Sarraceniaceae

Sarracenia commemorates a French naturalist and physician, Michel Sarrazin (1659–1734), who from the age of 25 lived in New France, Canada; *leucophylla* (white leaves); *alata* derived from *ala* (winged).

All the *Sarracenia* are native to the New World and inhabit moist and low-nutrient Long-Leaf Pine, *Pinus palustris*, savannas along the United States Gulf Coast, generally west of the Apalachicola River on the Florida Panhandle. All species are under threat of their habitat becoming endangered due to the loss of unique wetland to development along the Gulf Coast, as well as forest succession that was historically kept in check by fire.

Sarracenias have become vulnerable to poachers and are threatened by increasing interest from the cut-flower trade; the cut autumn pitchers are popular for use in arrangements. *Sarracenia leucophylla* produces crimson flowers in the spring before its characteristically small spring pitchers appear. Flat, non-carnivorous leaves known as phyllodia generally follow in mid summer. The most robust and handsome pitchers are then produced in the early autumn. This is one of the largest and showiest *Sarracenia* species, with its autumn pitchers sometimes reaching almost 1 metre in height.

Dr Michel Sarrazin worked in Québec, Canada, and was a keen botanist, amassing a large herbarium.[102] *Sarracenia leucophylla*, White Pitcher Plant, was described in 1817 by the eccentric polymath Constantine Rafinesque, who, born near Constantinople, settled in Ohio, USA, in 1815. *Sarracenia alata*, West Coast Pitcher Plant or Pale Pitcher Plant, was described by American botanist Alphonso Wood, initially in 1861 and again in 1863.

Sarracenia was initially introduced to the Bog Garden at the Blue Mountains Botanic Garden, Mount Tomah in 1991, with additional planting in 1997. Commencing in 2007, carnivorous plants have been promoted in yearly 'Plants with Bite' displays and fairs.

Artist Marion Westmacott

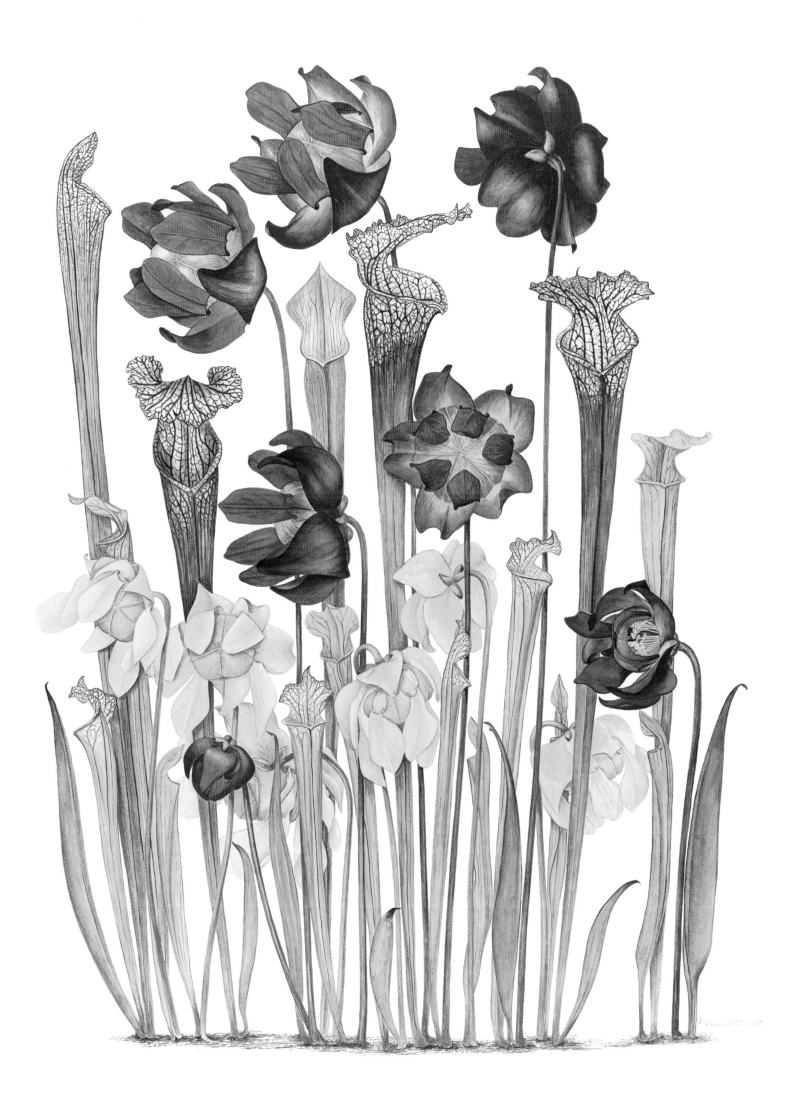

Acer griseum (Franch.) Pax

Aceraceae

Acer (sharp); *griseum* (grey), referring to the silver-grey hairs on the undersides of the leaves.

This slow-growing maple is endangered in its native central China habitat, surviving between 1500 and 2000 metres. It is widely cultivated in temperate climates around the world and renowned as a very attractive ornamental tree with its copper-brown bark peeling and flaky, which when leafless in winter is spectacular. In summer the leaves are bright green turning to deep red in autumn.

Acer griseum, Paperbark Maple, was originally described as *Acer nikoense* var. *griseum* in 1894 by French botanist Adrien Franchet, who is noted for his work describing the flora of China and Japan. Ernest Henry Wilson collected the maple on his first expedition for Veitch's Nurseries in 1899–1902, on the same trip that he collected *Davidia involucrata*; the Paperbark Maple was introduced in 1901.[103] The maple was renamed *Acer griseum* by German botanist Ferdinand Albin Pax in 1902. It was given the Royal Horticultural Society's Award of Merit in 1922 and an Award of Garden Merit in 1984.

EH 'Chinese' Wilson and plants collected by him are featured in the Blue Mountains Botanic Garden. *Acer griseum* was first planted there in 1992.

Artist Anita Walsmit Sachs

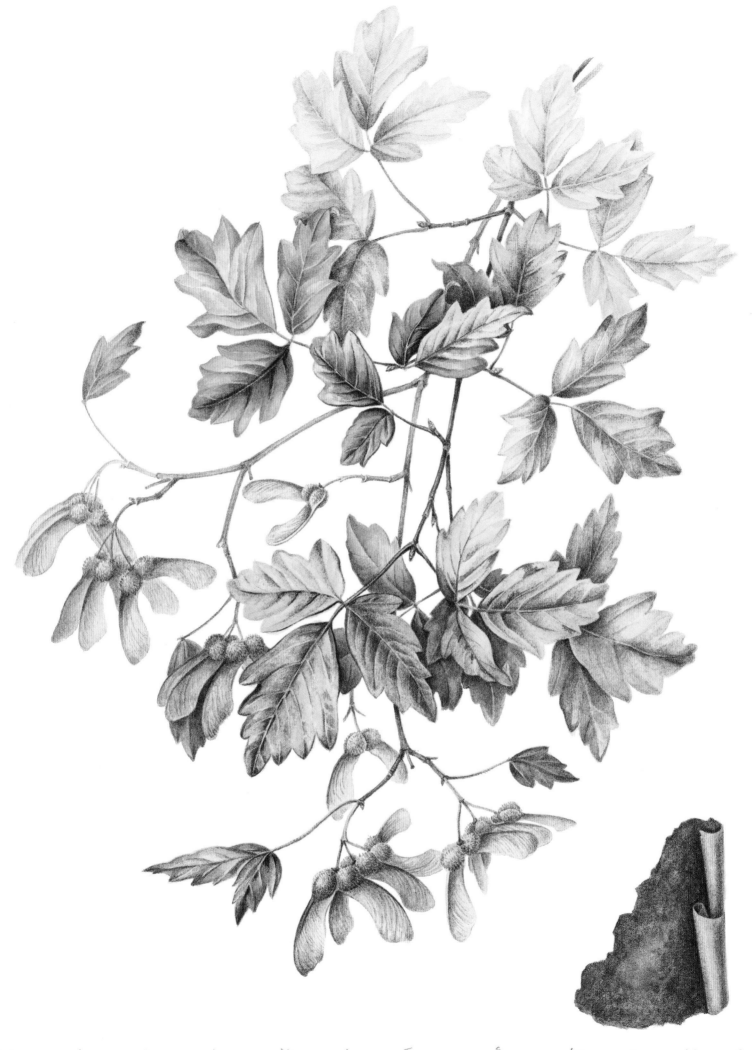

Hydrangea sargentiana Rehder

Hydrangeaceae

Hydrangea from the Greek *hydro* (water) and *aggos* (jar), referring to the cup-shaped fruit; *sargentiana* named for Charles Sprague Sargent, an early 19th century botanist and Director of the Arnold Arboretum of Harvard University.

A small to large shrub, this hydrangea has very large dull-green leaves. The upper leaf surface has bristly hairs and the under leaf surface has grey soft hairs. The large inflorescences, which spectacularly cover the shrub, are made up of the small and blue to deep purple fertile inner flowers, surrounded by white flowers that are more typical of a hydrangea flower.

Hydrangea sargentiana was among the plants Ernest Wilson collected in western China for the Arnold Arboretum of Harvard University. Wilson collected for the Arboretum between 1907 and 1909 and commenced another trip in 1910, returning to Boston in 1911 after an accident. Taxonomist Alfred Rehder, who worked at the Arnold Arboretum, named the *Hydrangea* for Charles Sprague Sargent, the renowned Director when Wilson's introductions were published in 1911. In 1919, Ernest Wilson became Associate Director of the Arnold Arboretum and succeeded Sargent as Keeper of the Arboretum.[104] Rehder, in Wilson's obituary, wrote that Wilson had introduced 'more than a thousand species previously unknown to cultivations'.[105]

EH 'Chinese' Wilson and plants collected by him are featured as part of the Plant Explorers Walk, opened in 1997 on the tenth anniversary of the Blue Mountains Botanic Garden, Mount Tomah. *Hydrangea sargentiana* was sourced from a specialist Australian nursery in 1992 and planted in 1994 and 1996.

Artist The Hon. Gillian Foster

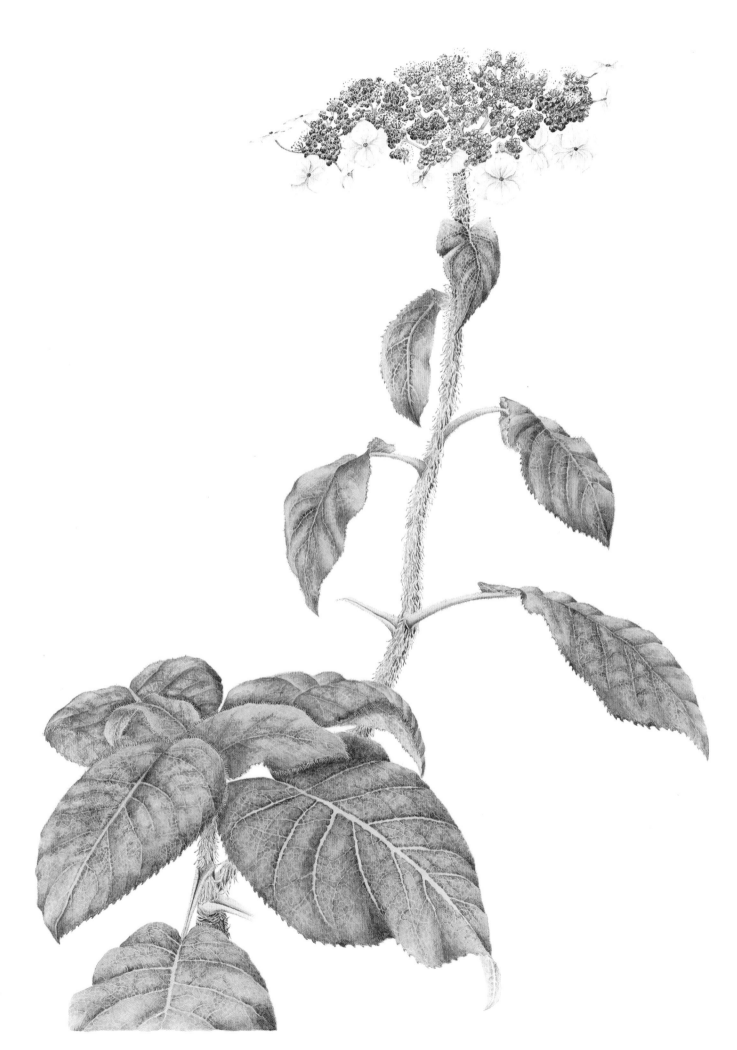

Iris delavayi Micheli

Iridaceae

Iris (rainbow); *delavayi* named for Père Jean Marie Delavay (1834–1895), a plant collector who sent over 200,000 herbarium plant specimens from western China to France.

Iris delavayi is native to western China in the provinces of Guizhou, Sichuan, Xizang and Yunnan, and occurring in its native habitat of forest margins, meadows and damp places along ditches between 2400 and 4500 metres above sea level. It is a vigorous, clump-forming, rhizomatous perennial to 1.5 metres high, with narrow leaves and branched stems bearing large, very attractive, dark-violet flowers with the centre a dark violet and white mottled pattern.

Iris delavayi, Chinese Stream Iris, was first described by Marc Micheli in *Revue Horticole* in 1895. It is named for its collector, Père Jean Marie Delavay, a French missionary and keen botanist. Delavay found this iris in the marshes of Yunnan province on his second trip to China from 1882 to 1891. Delavay sent seeds of the iris to the *Jardin des Plantes* in Paris in 1889, and the plants were raised by Micheli.[106] Delavay, who died in Yunnan in 1895, is said to have 'probably discovered more plants suitable for gardens than any other botanist'.[107]

The development of a Plant Explorers Walk at the Blue Mountains Botanic Garden, Mount Tomah commenced in 1990. It commemorated the work of 14 explorers in Asia, especially Himalayas and western China, Delavay among them. It had strong support from the Director, Professor Carrick Chambers, who had a great interest in the flora from this region. *Iris delavayi* was planted along the Plant Explorers Walk in December 1995 and February 1996 from seed accessioned in 1995 wild collected in Cang, Shan, Dali, China. It also grows in the Royal Botanic Garden, Sydney.

Artist Gillian Barlow

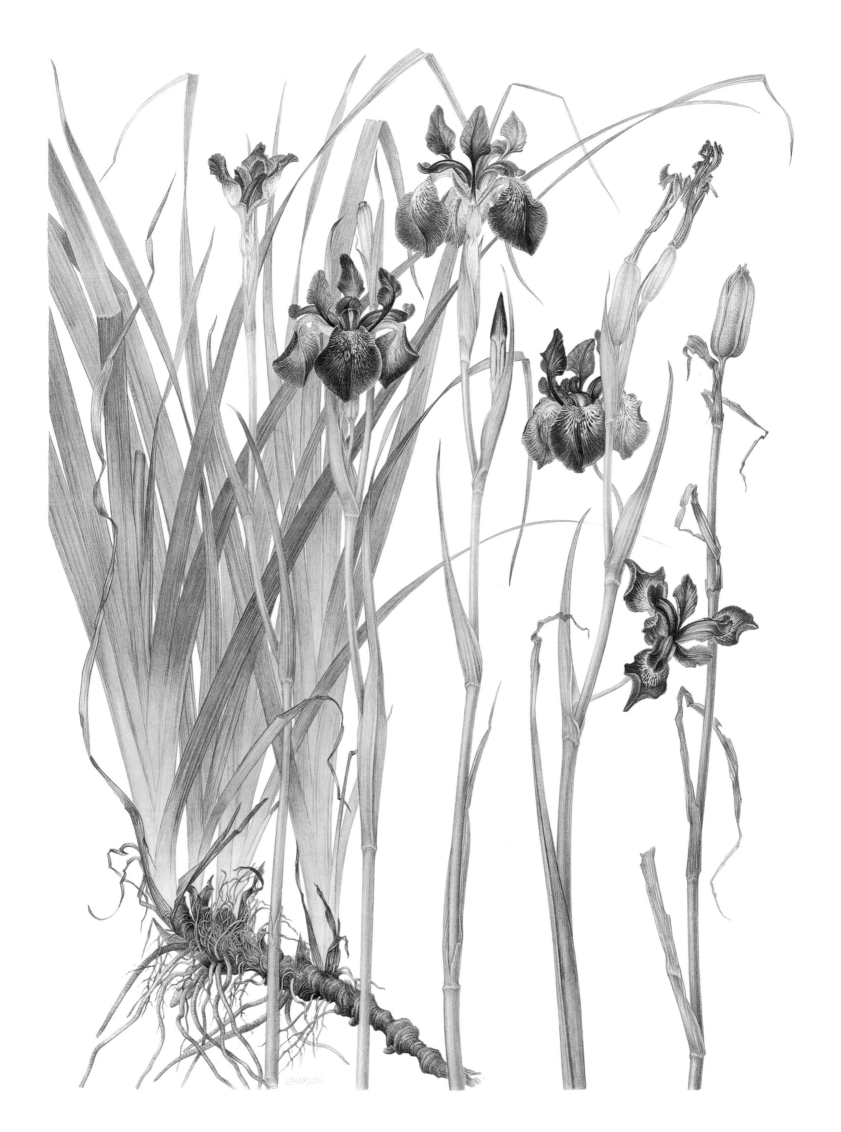

Magnolia sieboldii K.Koch

Magnoliaceae

Magnolia commemorates the French physician and botanist Pierre Magnol (1638–1715), who was Professor of Medicine at Montpellier; *sieboldii* named after the German collector Phillipp Franz von Siebold (1796–1866), an eye surgeon whose medical expertise opened up to him otherwise forbidden parts of Japan in the 19th century.

This magnolia is the emblem of Korea, and it is native there as well as in China and Japan. It is a large shrub or small tree, 5–10 metres high. The flowers are white with bright crimson stamens and a mild fruity perfume. They are cup-shaped and pendulous along the branches. This plant is well documented in cultivation and rare in the high mountain regions of its natural habitat.

Magnolia sieboldii, Siebold's Magnolia or Oyama Magnolia, was described by Karl Koch in 1853, replacing *Magnolia parviflora*, the earlier name assigned to it by Siebold and German botanist Joseph Gerhard Zuccarini. Siebold is among those celebrated on the Plant Explorers Walk at the Blue Mountains Botanic Garden, Mount Tomah, which was opened in 1997. *Magnolia sieboldii* was planted in the Garden in 1998.

Artist Elaine Musgrave

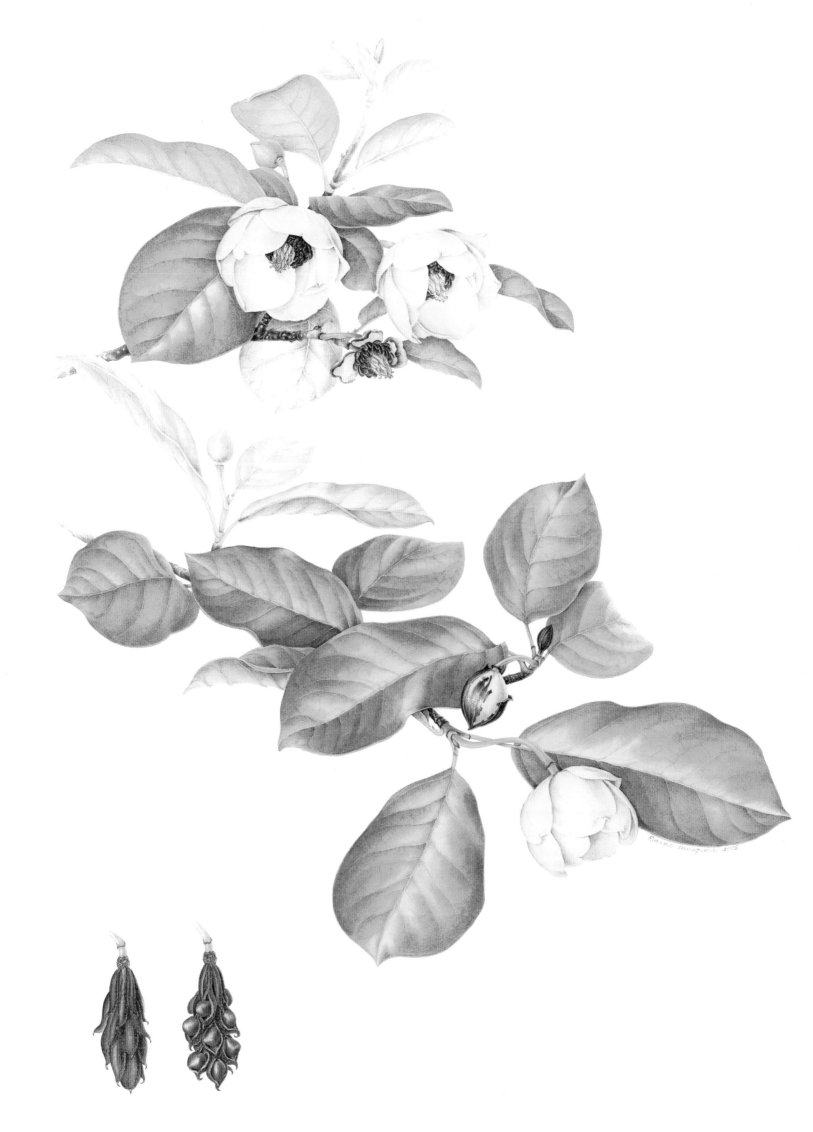

Wollemia nobilis W.G.Jones, K.D.Hill and J.M.Allen

Araucariaceae

Wollemia from an Aboriginal word meaning 'look around you, keep your eyes open and watch out'; *nobilis* named for David Noble, the first person to collect a sample of the tree.

This majestic tree occurs in a valley in the World Heritage site of Wollemi National Park north-west of Sydney. It grows to a height of up to 40 metres, with the trunk up to 1 metre in diameter. The bark is particularly unusual, looking very much like 'chocolate crackles'. The Wollemi has two types or phases of leaves. Its broad-based juvenile leaves are bright lime-green and grow in low light under the rainforest canopy. The adult leaves, which grow in much harsher conditions above the canopy, are tougher and a deeper bluish green. There are also two types of branches, one growing erect and the other sideways at 90 degrees. The Wollemi Pine, like its closest living relatives, has both male and female cones on the same tree. The round female cones produce the seeds, and the long male cones produce the pollen. They appear on separate branches, at the very tips. One of the world's rarest trees, and listed as critically endangered, there are fewer than 100 adult trees known; only discovered in 1994 despite occurring within 150 kilometres of the Sydney metropolitan area.

In 1994 David Noble, an officer with the National Parks and Wildlife Service of NSW, discovered *Wollemia nobilis*, the Wollemi Pine, and began the most remarkable and significant botanical adventure the staff of the Royal Botanic Gardens had encountered. This botanical 'dinosaur' was described in 1995 by naturalist Wyn Jones, Jan Allen of Mount Tomah Botanic Garden and Ken Hill, Senior Research Scientist of the Royal Botanic Gardens, Sydney.

The first propagated tree ever planted was by the Hon. Pam Allan MP, NSW Minister for the Environment, on 9 February 1998, in the Royal Botanic Garden, Sydney. The spot chosen was the site of the first 'Wishing Tree', an *Araucaria heterophylla* planted 180 years previously.

The international wonder at this 'living fossil' triggered concerted efforts to protect the small colony in the wild and research its successful propagation. Staff at all three botanic gardens were involved, and the process of bringing the Wollemi Pine to the world took a decade, spanning three directorships – Professor Carrick Chambers, Frank Howarth and Dr Tim Entwisle – before the auction of the first trees in 2005. In early 2006, trees were released for sale to the general public, thus ensuring the continuity of the genus. *Wollemia nobilis* was planted in all three gardens of the Royal Botanic Gardens, Sydney.

Artist Beverly Allen

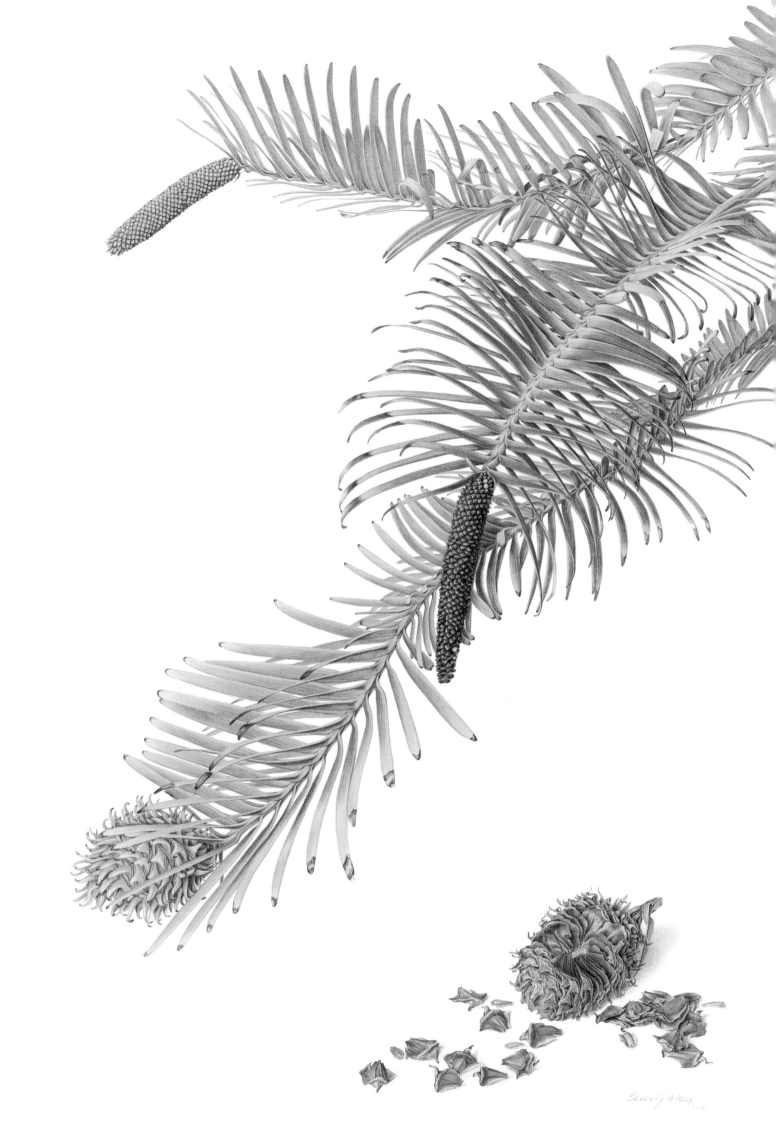

Worsleya procera (Duchartre) Traub

Amaryllidaceae

Worsleya after Arthington Worsley (1861–1943), a British botanist and civil engineer; *procera* refers to the unusually large neck of the bulb.

Worsleya procera is one of the rarest and largest bulbs in the world and is notorious for its intermittent and unreliable flowering. The natural habitat of *Worsleya procera* is a 2-kilometre wide area near the town of Petropolis in the Organ Mountains north of Rio de Janeiro, Brazil. It grows about 1.5 metres high in narrow basalt-rich crevices 750 metres above sea level. These plants are slow-growing but long-lived; they are cultivated by plant enthusiasts and are represented in botanic gardens around the world.

Worsleya procera, the Blue Amaryllis or Empress of Brazil, was first described as *Amaryllis procera* by French botanist Pierre Duchartre in 1863. Joseph Dalton Hooker described it as *Amaryllis rayneri* in 1871. William Watson, Curator at Kew Gardens, proposed a revised name, *Worsleya procera*, in 1912, a name officially published by Hamilton Traub in 1944.[108] *Worsleya* commemorates British botanist and explorer Arthington Worsley, an expert on the species who collected 27 bulbs of it in Brazil.[109]

Leo Schofield, journalist, impresario and avid gardener, grew the precious *Worsleya* when he lived at Bronte House, and drew attention to its spectacular blooms in his column in *The Sydney Morning Herald* in 1999. This large and rare bulb was donated to the Royal Botanic Garden, Sydney by Anne Needham in the same year. Its beauty has been brought to a wider audience through paintings displayed at the Friends of the Gardens *Botanica* exhibitions.

Artist Elaine Musgrave

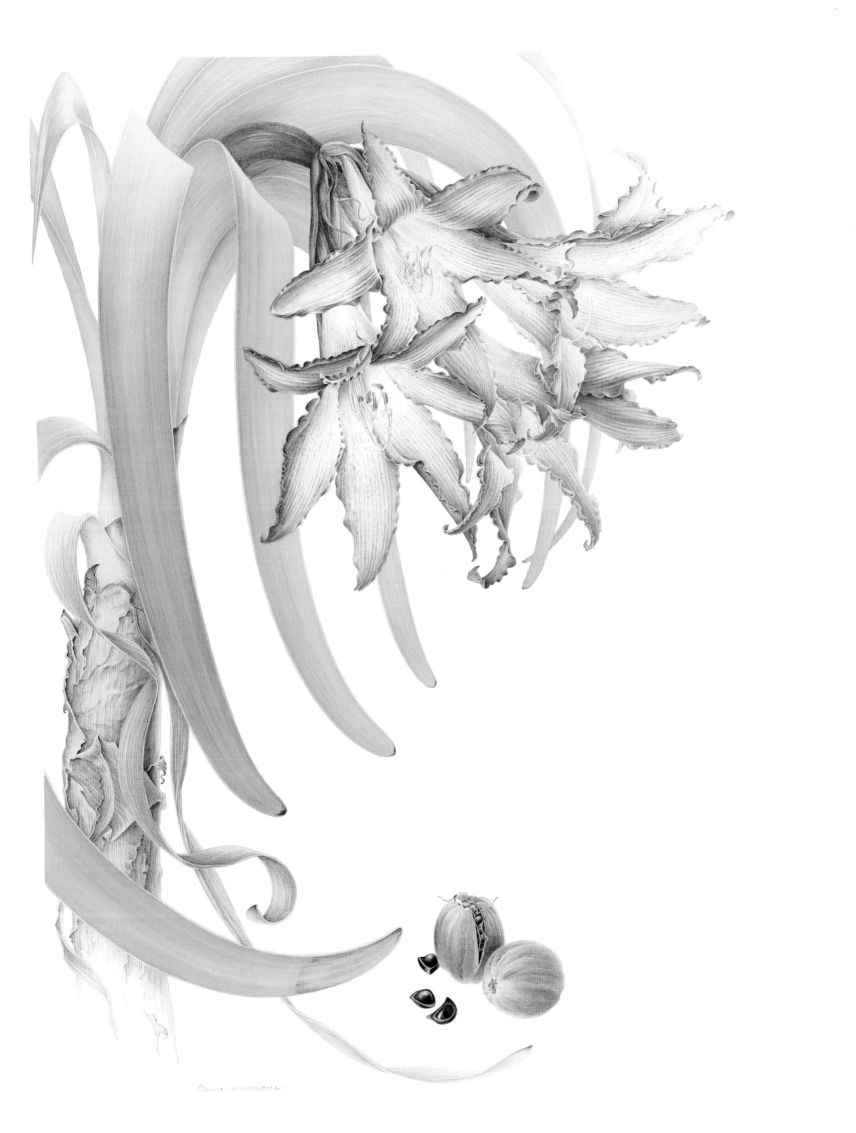

Crocus tommasinianus Herb.

Iridaceae

Crocus from the Greek *krokos* (saffron); also from the Greek word *kroke* (a thread); *tommasinianus* after botanist Muzio G Spirito de Tommasini.

This crocus is native to the woods and shady hillsides of Eastern Europe where it grows at about 1000 metres altitude, often on limestone. This stunning purple crocus is beautiful as a single flower and spectacular when grown in large clumps or drifts. *Crocus tommasinianus* is easy to grow, as it simply requires slight moisture during the resting stage to prevent the bulbs drying out.

Crocus tommasinianus, Tommasini's Crocus, Tommies or Snow Crocus, a woodland 'bulb', or more correctly, corm, was described by William Herbert in *The Journal of the Horticultural Society of London* in 1847. Herbert named the crocus after Muzio G Spirito de Tommasini, botanist and Mayor of the city of Trieste.

Crocus tommasinianus was introduced to the Blue Mountains Botanic Garden from a cultivated source in South Hobart, Tasmania, in 2001. It was planted under two large oaks in a display of woodland bulbs. The sight of a mass of Tommies in flower soon became a favourite with visitors. It received a Royal Horticultural Society Award of Garden Merit in 2003. *Crocus tommasinianus* is one of the easiest crocuses to grow in the Australian climate, and it will seed freely in optimum conditions.

Artist Hazel West-Sherring

Rhododendron dalhousiae Hook.f.

Ericaceae

Rhododendron (rose tree), refering to the flower colour of many species; *dalhousiae* named for Lady Susan Georgiana Ramsay (Hay) Dalhousie, first Marchioness of Dalhousie Castle.

This species of *Rhododendron* grows in the forests on the lower slopes of the Himalayas near the border of Tibet, Bhutan and north-east India. It typically grows in large trees, but is also found on cliffs, boulders and occasionally on steep slopes.

Rhododendron dalhousiae is renowned for the large clusters of long, pale creamy-yellow, trumpet-shaped flowers flushed with rose and with a slight fragrance. The plant can be quite straggly and open in its growth habit, ranging from upright and shrub-like to procumbent and sprawling. The leaves are narrow elliptic and on the upper surface are dark green with deeply impressed veins; the lower surface has dark brown to reddish scales.

Rhododendron dalhousiae, collected in 1848, was one of Joseph Dalton Hooker's most spectacular finds on his expedition to Sikkim and surrounding areas. He described it in *The Rhododendrons of Sikkim-Himalaya* in 1849. Walter Fitch prepared a lithograph based on Hooker's sketch of *R. dalhousiae* for the publication.[110] Hooker considered it to be 'the noblest species of the whole race'.[111]

Botanist Dr Peter Valder, of the celebrated garden 'Nooroo' at Mount Wilson, donated cuttings from his 'Nooroo' plant of *Rhododendron dalhousiae* in 1992. Valder's *Rhododendron* had been 'sent to Australia by Tse Tse, Gangtok, Sikkim', collected in the wild in 1971.[112] The propagated *Rhododendron dalhousiae* was planted in the Blue Mountains Botanic Garden in 2003.

Artist Christine Battle

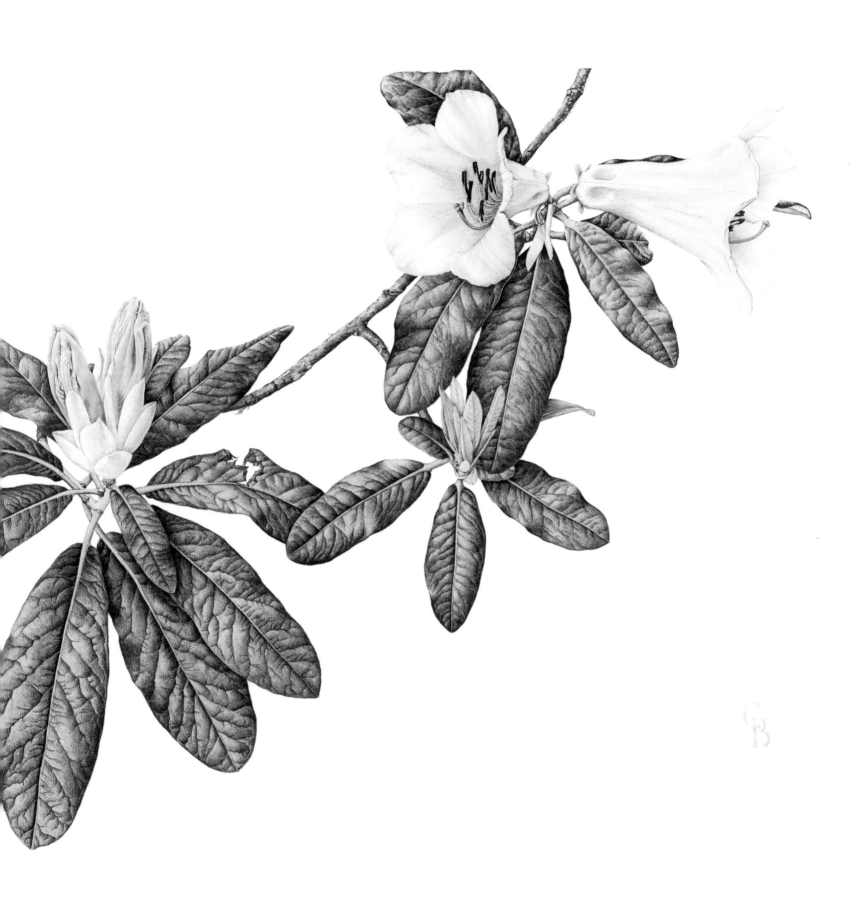

Eucalyptus copulans L.A.S.Johnson & K.D.Hill

Myrtaceae

Eucalyptus from the Greek *eu-*, *eu-* + Greek *kaluptos* (covered), referring to the cap covering of the buds; *copulans* (joining), referring to the characteristics of the two eucalypts, *Eucalyptus moorei* and *E. stellulata* because *E. copulans* is intermediate between these species, sharing many of their characteristics but becoming a distinct species in a separate population.

Eucalyptus copulans was presumed to be extinct. However, following recent collections from two plants it is now known to be occurring in open woodland on swampy sandy soil near Wentworth Falls in the Blue Mountains west of Sydney, NSW. Collection of seed has been carried out by botanists at the Royal Botanic Garden, Sydney and propagation of this species is underway at the Australian Botanic Garden, Mount Annan.

This small mallee eucalypt grows 6–10 metres tall and has a very open canopy that is sparsely vegetated with glossy green leaves with the veins running parallel to the length of the leaf.

A specimen of *Eucalyptus copulans* was first collected by Julius Camfield, Overseer at the Sydney Botanic Garden in 1899. Camfield assisted JH Maiden in the establishment of the National Herbarium of New South Wales and the expansion of its library. In 1991, former Director Lawrie Johnson and botanist Ken Hill described *Eucalyptus copulans* from a specimen Johnson had collected with Ernie Constable in 1957.[113] This critically endangered species was known from a single population near Wentworth Falls, and there are currently only two known trees in the wild.

It was planted in the 'Rare and Threatened' garden bed in the Royal Botanic Garden, Sydney by Professor Peter Crane, Director of the Royal Botanic Gardens, Kew on 10 November 2003, at the launch of SeedQuest NSW, an international partnership between the NSW Seedbank at the Australian Botanic Garden, Mount Annan and the UK Millenium Seed Bank Project.

Artist Lesley Elkan

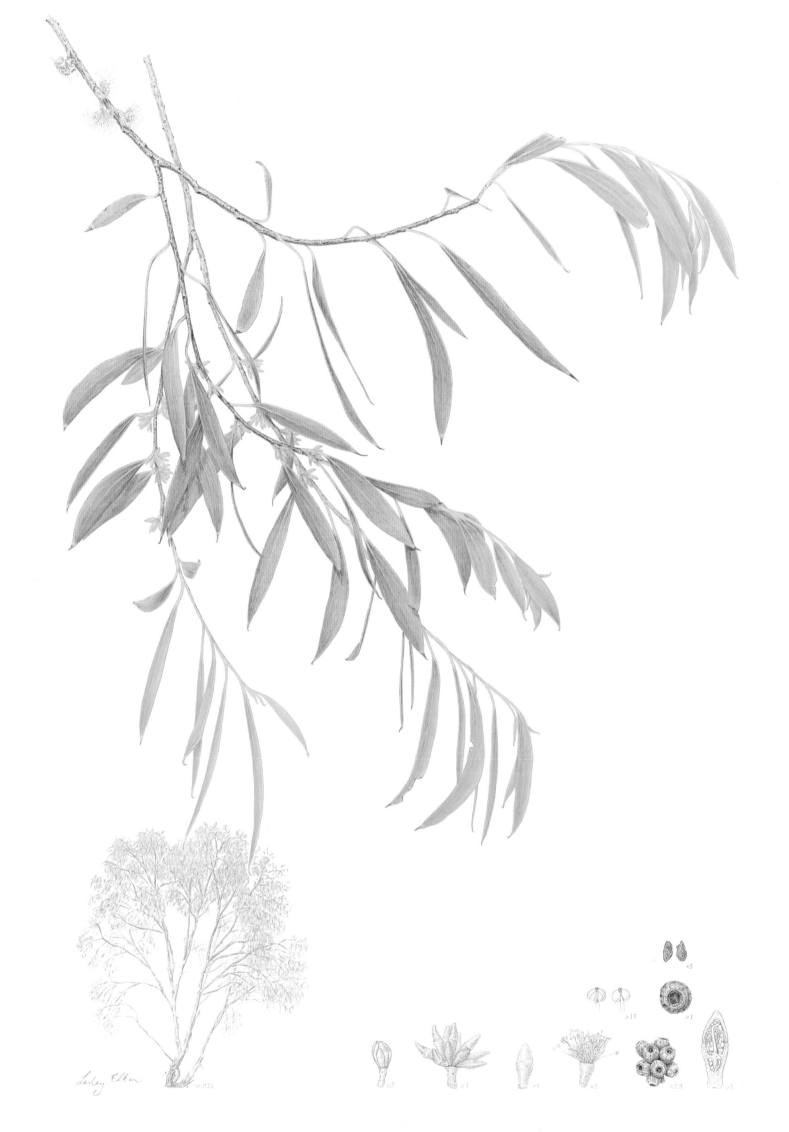

Lesley Elkan

Allocasuarina portuensis L.A.S.Johnson

Casuarinaceae

Allocasuarina from the Greek *allos* (other); *casuarina* from *casuarius* meaning cassowary because the branchlets of the trees resemble that bird's feathers; *portuensis* (inhabiting a port).

A member of the she-oak family, *Allocasuarina portuensis* is a slender shrub, 3–5 metres high, with branchlets that are in fact modified dark-green leaves. The branchlets often look wiry and have a tendency to droop. The species has separate male and female plants, with the female plants bearing the characteristic fruit-bearing cones. This species is endangered.

Allocasuarina portuensis was first collected and recorded in 1986 by botanist Karen Wilson and Lawrie Johnson, Director of the Royal Botanic Garden, Sydney from 1972 to 1985; its name was published in 1989 in *Flora of Australia*, Volume 3. It was found at Nielsen Park, part of Sydney Harbour National Park, near Vaucluse. The species name refers to its location beside Port Jackson.

By 1994, the natural population had been reduced to two female plants.[114] Staff from the Royal Botanic Garden, Sydney worked with the NSW National Parks and Wildlife Service to devise and implement a recovery plan for the species.[115] Plants were propagated at the Australian Botanic Garden, Mount Annan from seed taken from the original 10 trees found. These were used for study and display, ensuring the continuation of the species. The trees were successfully propagated at the Australian Botanic Garden in 2006.

Artist Deirdre Bean

Camellia azalea C.F.Wei

Theaceae

Camellia after Georg Kamel or *Camellus* (1661–1706), author of the first descriptions of the Philippine flora and fauna including the birds; *azalea* in this instance meaning beautiful and showy flowers.

Camellia azalea (syn: *Camellia changii* C.X.Ye) is native to the Guangdong province in south-west China where it grows in evergreen forest. It is rare and categorised as Critically Endangered on the IUCN (International Union for the Conservation of Nature) Red List of Threatened Species.

This beautiful red camellia has flowers 10–12 cm in diameter, which is notably large for the genus. They are borne at the tips of the stems, where there can be as many as seven buds. This species grows 1–2.5 metres high and has long, glossy dark-green leaves. This superb camellia blooms frequently, notably during summer months. Unfortunately, the fruits are not as prolific as the flowers, causing the species reproduction rate to be very low.

This rare camellia was only discovered in 1984, and *Camellia azalea* C.F. Wei was published as a newly discovered species in 1986. Although collected as a herbarium specimen in the past, it had been recognised under the name *Camellia azalea*. In 1987, for reasons unknown, this species was published for the second time and named *C. changii* C.X. Ye. In accordance with the rules of the International Code of Nomenclature, the name *C. azalea* C.F. Wei takes precedence over that of *C. changii* C.X. Ye.[116] Bob Cherry, Australian plant hunter and breeder of camellia, and Dr George Orel were the first non-Chinese to visit the site of *Camellia azalea*, and introduced the plant to Australia from China as part of an ongoing Camellia Research project at the Royal Botanic Garden, Sydney. Plants of *Camellia azalea* syn. *Camellia changii* were planted in a new camellia garden at the Royal Botanic Garden in 2006. Cuttings and seed collection has taken place, but the exact location of the plant has been kept secret because only just over one thousand plants remain in the wild.

Artist Annie Hughes

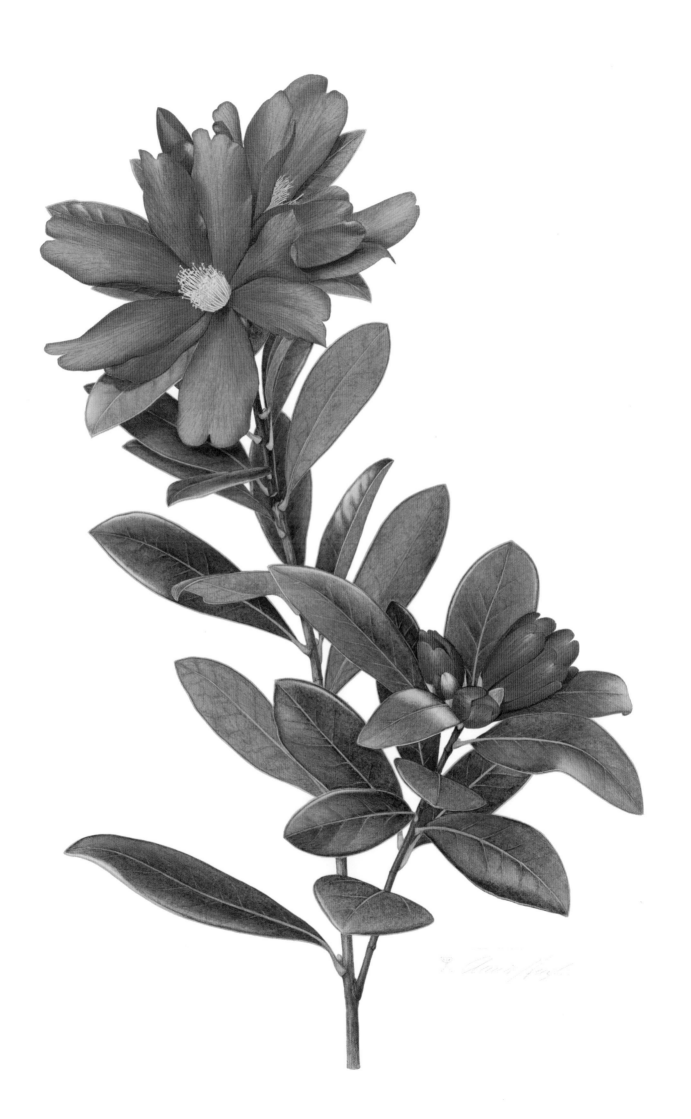

Dendrobium engae × Dendrobium shiraishii

Orchidaceae

Dendrobium from the Greek *dendron* (tree) and the Greek *bios* (life); *engae* named for the Enga Province in Papua New Guinea, where this orchid is native; *shiraishii* named after Shigeru Shiraishii, a Japanese orchid enthusiast and author of Japanese orchid books.

Dendrobium engae × *Dendrobium shiraishii* is one of the earlier flowering seedlings from a project to breed 'show-bench quality orchids' that would grow cold; that is, not needing to be housed in a glasshouse for Sydney and other cities of similar latitudes.

Dendrobium shiraishii grows down to sea level in nature, and *Dendrobium engae* comes from 3000 metres altitude; both species come from New Guinea. Its cold tolerance has been inherited by the hybrid seedlings, which have grown in winter temperatures from 0–4 degrees Celsius. This hybrid displays the typical erect leaves and pseudobulbs of *Dendrobium* species, and has sprays of green-yellow flowers with purple spotting or mottling towards the centre.

A hybrid of two New Guinea Latouria type dendrobiums, this orchid was bred by Phil Spence (assisted by Ed Wilson), both associated with the Royal Botanic Garden, Sydney, with the help of a grant from The Hermon Slade Foundation in 2003–06. This hybrid *Dendrobium* was painted in 2008 from the first plant – the first bulb is shown in this painting. Honorary research associate Phil Spence, a world-renowned orchid specialist, assisted the Royal Botanic Garden, Sydney in bringing more than 20 new hybrid orchids into cultivation.[117]

Artist Beverly Allen

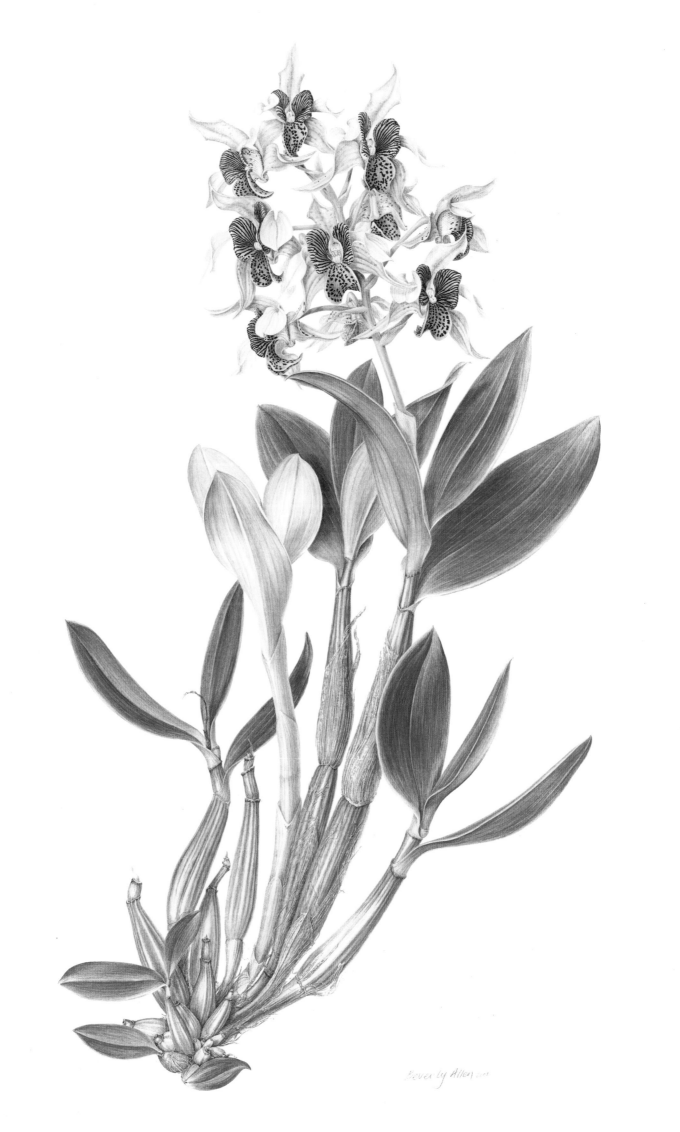

Beverly Allen

Endnotes

Historic overview

1 James Edward Smith, *A specimen of the botany of New Holland*, Vol 1, 1793–1795, pp. 9–10.

2 *Baron Charles von Hügel, New Holland Journal*, translated and edited by Dymphna Clark, Melbourne University Press at the Miegunyah Press in association with the State Library of NSW, 1994, p. 191.

3 Richard Clough, 'Opening the Wardian Case, experiments in plant transportation,' *Australian Garden History*, Australian Garden History Society, Vol 19, No 1, July/August 2007, pp. 4–6.

4 'Death of Mr Charles Moore', *The Sydney Morning Herald*, 2 May 1905, p. 7.

5 *The Gardeners' Chronicle*, 13 January 1866, p. 31.

6 JH Maiden, *A Guide to the Botanic Gardens, Sydney*, William Applegate Gullick, Government Printer, 1903, p. 9.

7 RH Anderson, *An A.B.C. of the Royal Botanic Gardens, Sydney*, 1965, p. 9.

8 Knowles Mair (Director 1964–70) organised for the seed to be sent to Sydney. Three propagated trees were planted in various locations by Mair and Allan Correy. Correy, who began as an apprentice gardener and worked in the Landscape Design Service established by RH Anderson, went on to study overseas and become a prominent landscape architect and lecturer before returning to the Royal Botanic Garden, Sydney as a volunteer guide after his retirement. Personal communication, Allan Correy to the author.

9 Edward Hyams and William MacQuitty, *Great Botanical Gardens of the World*, Thomas Nelson and Sons, London, 1969, p. 251.

10 Royal Botanic Gardens and Domain Trust, *Annual Report 1984–1985*, p. 27.

11 Royal Botanic Gardens and Domain Trust, *Annual Report 2013–2014*, p. 7.

Historic text

1 Helen Hewson, *Australia: 300 Years of Botanical Illustration*, CSIRO Publishing, Melbourne, 1999, pp. 34–37.

2 JH Maiden, *Critical Revision of the Genus Eucalyptus*, Part 31, CLVIII, *E. tereticornis*, Smith.

3 ibid.

4 JH Maiden, *The Forest Flora of New South Wales*, Vol. 1, Part 1, No. 2, 1902; http://dharug.dalang.com.au/plugin_wiki/index.html

5 George Bennett, *Gatherings of a Naturalist in Australasia*, John Van Hoorst, Paternoster Row, London, 1860, p. 2.

6 Sophie Ducker, 'Early Austrian influence on Australian Botany' in PS Short (ed), *History of systematic botany in Australasia*, Australian Systematic Botany Society Inc, Melbourne, 1990, pp. 298–99.

7 Miss AF Walker, '*Flowers of New South Wales*, painted and published by Miss A. F. Walker of Rhodes, Ryde, Parramatta River, NSW', Sydney Turner and Henderson, 1887.

8 JH Maiden, *The Forest Flora of New South Wales*, op. cit., Vol. 1, Part VIII, No. 27, 1904, p. 171.

9 JH Maiden, Royal Botanic Gardens, Sydney, *Annual Report*, 1914.

10 Colleen Morris, *Lost Gardens of Sydney*, Historic Houses Trust of New South Wales, 2008, p. 27.

11 John Calaby (ed) *The Hunter Sketchbook: Birds & Flowers of New South Wales drawn on the Spot in 1788, 89 & 90 By Captain John Hunter RN of the First Fleet*, National Library of Australia, Canberra, 1989, p. 160.

12 ibid.

13 Alan Fairley, 'Doryanthes excelsa', *Doryanthes*, A Southern Sydney Journal of History, Heritage and the Arts, Vol. 6, No. 1, February 2013, p. 6.

14 Daphne Nash, *Aboriginal Plant Use in South-eastern Australia*, Australian National Botanic Gardens, February 2004, p. 9.

15 Richard Neville, *Mr JW Lewin, Painter & Naturalist*, State Library of NSW and NewSouth Publishing, Sydney, 2012, p. 67.

16 JH Maiden, *The Forest Flora of New South Wales*, op. cit., Vol. 7, Part LXVIII, No. 265, 1921, p. 363.

17 National Herbarium of New South Wales, Daniel Solander Library, Royal Botanic Gardens and Domain Trust Rare Book and Manuscript Collection.

18 Charles Fraser, 'Catalogue of Plants cultivated in the Botanic Garden, Sydney, NSW, January 1828', Royal Botanic Gardens and Domain Trust Rare Book and Manuscript Collection. Fraser refers to it as 'Ficus sp. Moreton Bay Fig'.

19 Fraser, op. cit.; Sir Thomas Brisbane inspected Moreton Bay in December 1824.

20 Marc Serge Riviere (ed), *The Governor's Noble Guest, Hyacinthe de Bougainville's account of Port Jackson, 1825*, Miegunyah Press, Melbourne, 1999, p. 44.

21 *The Gardeners' Chronicle*, 13 January 1866, p. 31.

22 For comment on Mudie see David Mabberley, 'Robert Mudie (1777–1842) and Australian Botany, or the Saga of the Black Bean', *Australian Systematic Botany Society Journal*, Vol. 70, 1992, pp. 13–15.

23 Mueller, FJH von, *Fragmenta Phytographiae Australiae*, Vol. 4, No. 26, p. 58.

24 AE Orchard, AS George and RK Brummitt, 'Publication and lectotypification of the name *Stenocarpus sinuatus*, (Proteaceae)', *Australian Plant Census Precursor Papers 1, J. Adelaide Botanic Garden 21* (2007), pp. 85–87.

25 *The Gardeners' Chronicle*, 13 January 1866, p. 31.

26 Mabberley, op. cit.

27 Elizabeth Macarthur to her son Edward, 26 May 1832, quoted in Lionel Gilbert, *The Royal Botanic Gardens, Sydney: A History 1816–1985*, Oxford University Press, Melbourne, 1986, pp. 47–48.

28 JH Maiden, *A Guide to the Botanic Gardens, Sydney*, William Applegate Gullick, Government Printer, Sydney, 1903, p. 78.

29 William Jackson Hooker, *Botanical Miscellany*, Vol. I, John Murray, London, 1830, pp. 246–247.

30 Kevin Collins, Kathy Collins and Alex George, *Banksias*, Blooming Books, Melbourne, 2008, p. 301.

31 William Jackson Hooker, *Curtis's Botanical Magazine*, Vol. LV, plate 2803.

32 Alexander McLeay (Macleay) Notebooks, 1826–1853, State Library of New South Wales, ML MSS 2009/1–2.

33 'Botanic Gardens, Sydney', *Horticultural Magazine and Gardeners' and Amateurs' Calendar*, The Horticultural Society of Sydney, 1864, p. 41.

34 See two articles in *Queensland Review*, Vol. 9, No. 2, 2002, Anne Haebich (ed): John Huth, 'Introducing the Bunya Pine – A noble denizen of the scrub', p. 15; Thom Blake, '"This Noble Tree"': J.C. Bidwill and the naming of the bunya pine', pp. 39–42.

35 David J Mabberley, 'The Agathis brownii case (Araucariaceae)', *Telopea*, Vol. 9, No. 4, 2002, p. 744.

36 'Dammara robusta' F.Muell., *Quarterly Journal and Transactions of the Pharmaceutical Society of Victoria*, Vol. 2, 1860, https://biodiversity.org.au/boa/reference/apni/29418; Sydney Botanic Gardens Report, 1871.

37 Mabberley, 'The Agathis brownii case (Araucariaceae)', op. cit., p. 745.

38 AE and TA Orchard, *King's Collectors for Kew: James Bowies and Allan Cunningham, Brazil 1814–1816*, Australia, 2015, p. 68.

39 Published on the Internet http://www.ipni.org: Baker, John Gilbert, J.Linn.Bot.16:99.1877.

40 John Sims (ed), *Curtis's Botanical Magazine*, Vols. 25–26, 1807, p. 1004.

41 Advertisement, *The Australian*, Sydney, Thursday 24 August 1848, p. 2.

42 'Garden Notes, Hints for the Amateur', *Sydney Mail*, Wednesday 12 February 1919, p. 33.

43 HA James, *Hand-Book of Australian Horticulture*, Turner and Henderson, Sydney, 1892, p. 21.

44 JH Maiden, *Botanic Gardens and Domains (Report for the Year 1914,)*, Legislative Assembly, NSW, 1915, p. 7.

45 'Lectures on Botany', *The Sydney Morning Herald*, Friday December 1860, p. 6.

46 'A Half-Hour in the Sydney Botanic Garden' By A Rambler, *The Australasian*, Melbourne, Saturday 23 August 1884, p. 12.

47 Maiden, *A Guide to the Botanic Gardens, Sydney*, op. cit., p. 45.

48 ML A2948-6 transcribed by Colin Mills http://hortuscamden.com/plants/view/camellia-japonica-l.-var.-cleopatra accessed 10 August 2015.

49 William Woolls, *Lectures on the Vegetable Kingdom with special reference to the Flora of Australia*, C.E. Fuller, Sydney and Parramatta, 1879, p. 193.

50 'Advertisement, *The Australian*, op. cit..

51 'Australian Economic Plants' *The Sydney Mail and New South Wales Advertiser*, Saturday 25 July 1891, p. 174.

52 ibid.; 'Horticultural', *The Sydney Morning Herald*, Friday 12 January 1877, p. 8.

53 AN Rodd notes, www.flickr.com/photos/tony_rodd/5135452436/

54 Sir William Jackson Hooker, 'Late Allan Cunningham Esq', *The Journal of Botany*, Vol. 4, 1842, p. 237.

55 www.cliviasociety.org/clivia-genus/clivia-miniata/

56 'Acclimatisation Society of New South Wales', *The Sydney Morning Herald*, Tuesday 6 December, 1864, p. 5.

57 ibid.

58 Published on the Internet http://www.ipni.org accessed 4 November 2015.

59 http://hortuscamden.com/plants/view/firmiana-simplex-w.f.wight

60 *Curtis's Botanical Magazine*, 86:t.5221. 1860.

61 Royal Botanic Gardens, *Annual Report*, 1871, pp. 1–2.

62 www.ipni.org *Barringtonia neocaledonica* Vieill.

63 See for example, William Guilfoyle, 'A Botanical Tour Among the South Sea Islans', *The Sydney Morning Herald*, Friday 18 December 1868, p. 5; John Baptist also sent collectors.

64 *Barringtonia neocaledonica*, National Herbarium, Sydney, Collection record.

65 Bennett, op. cit., p. 335.

66 *The Gardeners' Chronicle*, July–December 1882, London, p. 405.

67 Richard Macey, 'Party in the botanic gardens', *The Sydney Morning Herald*, 29 October 2004.

68 ibid.

69 JH Maiden, *Report of the Botanic Gardens, Government Domains and Centennial Park, for the Year 1916*, Legislative Assembly, NSW, 1917–18, p. 6.

70 Jan Allen, Garden Information Officer, Plant of the Month, 'Gordonia from Yunnan, 1 Jun 2012', Blue Mountains Botanic Garden, Mount Tomah.

71 https://www.rhs.org.uk/plants/details?plantid=574

72 RH Anderson, *An A.B.C. of the Royal Botanic Gardens, Sydney*, 1965, p. 12.

73 http://nativeplants.hawaii.edu/plant/view/Pritchardia_maideniana accessed 9 August 2015.

74 JH Maiden, *Botanic Gardens and Domains (Report for the Year 1913,)*, Legislative Assembly, NSW, 1914, p. 6.

75 www.abc.net.au/local/stories/2009/05/05/2561588.htm

76 JH Maiden, *Botanic Gardens and Domains &c.(Report for the Year 1897)*, Legislative Assembly, NSW, 1898, p. 8.

77 JH Maiden, *Botanic Gardens and Domains (Report for the Year 1907)*, Legislative Assembly, NSW 1908, p. 4.

78 E Cheel, 'New or Noteworthy Plants from the National Herbarium', *Proceedings of the Linnean Society of NSW*, Vol. 48, 1923, p. 686.

79 WJ Hooker, *Botanical Miscellany*, Vol. I, 1830, p. 246.

80 'Botanic Gardens, Sydney', *Horticultural Magazine and Gardeners' and Amateurs' Calendar*, The Horticultural Society of Sydney, 1864, p. 42.

81 DJ Mabberley, 'Australian Citreaea with notes on the other Aurantioideaea (Rutaceae)', *Telopea*, Vol. 7, No. 4, 1998, pp. 333–344.

82 https://en.wikipedia.org/wiki/Alloxylon_flammeum accessed 8 August 2015.

83 Peter Watts, Jo Anne Pomfrett, David Mabberley, *An Exquisite Eye: The Australian Flora and Fauna Drawings 1801–1820 of Ferdinand Bauer*, Historic Houses Trust of New South Wales, 1997, p. 21.

84 https://www.flickr.com/photos/tony_rodd/2892167874/ accessed 9 August 2015.

85 Jan Allen, Blue Mountains Botanic Garden Plant of the Month, Narcissus 'King Alfred', 1 August 2012, Blue Mountains Botanic Garden.

86 Communication from Paul Nicholson, Senior Horticulturist, The Royal Botanic Garden, Sydney.

87 Sophie Ducker, 'Botanical history of the floral emblems of Australia', University of Melbourne Library *Journal*, Vol. 5, No. 2, 1999, p. 25.

88 JH Maiden, The Forest Flora of New South Wales, op. cit. 1913, Vol. 5, Part XLI, No. 149, 1910, p. 9.

89 Published on the Internet http://www.ipni.org, International Plant Name Index, Nuytsia ligustrina Lindl., accessed *10 August 2015*.

90 Royal Botanic Gardens and Domain Trust, Annual Report *1984–1985, pp. 27–28*.

91 Jan Allen, Garden Information Officer, Blue Mountains Botanic Garden, Nothofagus obliqua (Mirb) O*erst. 4 May 2012*.

92 Carl Peter Thunberg, Flora Japonica sistens plantas insularum japonicarum, Aug. 1784, the *name was validated in A. Murray Syst. Veg. (ed.14)*.

93 Jan Allen, Plant of the Month, 15 February 1999; communication with Jan Allen, 11 August 2015.

94 Anthony Hitchcock, http://www.plantzafrica.com/plantefg/ericaverticil.htm

95 Jan Allen, 'South African Rarity', Mount Tomah Botanic Garden Summer Plant of the Month, archived source.

96 http://sgaptownsville.org.au/Bleasdalea-bleasdalei.html accessed 10 August 2015.

97 Alan Gross, 'Dallachy, John (1808–1871)', Australian Dictionary of Biography, National Centre of Biography, Australian National University, http://adb.anu.edu.au/biography/dallachy-john-3355/text5055, published first in hardcopy 1972, accessed 10 August 2015.

98 Stevie King, 'World's largest outdoor Begonia Garden', 26 June 2007, Royal Botanic Gardens and Domain Trust, Media Release.

99 Published on the Internet http://www.ipni.org, List of Plants described by Scheidweiler, accessed 11 August 2015.

100 http://www.rhododendron.org/v5on1p23.htm accessed 11 August 2015.

101 Information supplied by Jan Allen, Blue Mountains Botanic Garden.

102 http://www.bluemountainsbotanicgarden.com.au/the-garden/plant-of-the-month/pitcher-plants/ Jan Allen, 29 November 2014; accessed 10 August 2015.

103 CJ and DM van Gelderen, Maples for Gardens: A Color Encyclopedia, *Florilegium, Australia, 1999, p. 67*.

104 Published on the Internet http://www.ipni.org, *Hydrangea sargentiana*; http://www.arboretum.harvard.edu/library/image-collection/botanical-and-cultural-images-of-eastern-asia/ernest-henry-wilson/ accessed 10 August 2015.

105 Alfred Rehder, 'Ernest Henry Wilson', reprinted from the Journal of the Ar*nold Arboretum, Vol. XI, 1930*, http://www.kewguild.org.uk/media/pdfs/v5s38p1-67.pdf accessed 10 August 2015.

106 https://en.wikipedia.org/wiki/Iris_delavayi accessed 10 August 2015.

107 Penny Farrant, 'Plant Hunters Asian Explorers Walk at Mount Tomah', Australian Garden History, Vol. 9, No. 4, Janu*ary/February 1998, p. 11*.

108 Published on the Internet http://www.ipni.org, Worselya procera; The Gardeners' Chronicle, ser.3, lii.73 (1912), *in obs., nomen provis.*

109 Arlington Worsley, 'Hippeastrum Procerum (Worsleya Procera)', The Gardeners' *Chronicle, 25 May 1929*.

110 Ray Desmond, Sir Joseph Dalton Hooker, Antique Collector's Club with Royal Botanic Gard*ens, Kew, 1999, p. 118*.

111 http://rhodygarden.org/cms/species-profile-r-dalhousiae/ accessed 11 August 2015.

112 Information from Jan Allen, Blue Mountains Botanic Garden, 11 August 2015.

113 *Telopea*, Vol. 4, No. 2, 1991.

114 Australian Seedbank Partnership, http://www.seedpartnership.org.au/partners/nsw/allocasuarina accessed 29 July 2011.

115 National Parks and Wildlife Service of NSW (2000), *Allocasuarina portuensis* Recovery Plan, NSW NPWS, Hurstville, NSW.

116 G Orel and AS Curry, *In Pursuit of Hidden Camellias; or 32 New Camellia Species from Vietnam and China*, Theaceae Exploration Associates, Sydney, Australia, 2015.

117 Nicky Phillips, 'Orchid species named after Botanic Gardens benefactor', *The Sydney Morning Herald*, 10 December 2010. This article referred to *Dendrobium* 'Nancy Fairfax', *Dendrobium engage Dendrobium johnsoniae*.

References

FOR SPECIES INFORMATION

Most of the species information was extracted from the databases (NSW collections and living collections database) and are authored by staff of the Royal Botanic Gardens and Domain Trust over the period of time 2000 to 2015. This includes PlantNET – Flora on Line. http://plantnet.rbgsyd.nsw.gov.au/floraonline.htm

For botanical meanings

http://www.backyardgardener.com/gardendictionary/alata.html

http://www.plantlives.com/plant_botanical_def.php

Baines, A, *Australian Plant Genera,* Surrey Beatty and Sons P/L, 1981

Gledhill, D, *The Names of Plants,* Cambridge University Press, UK, 1989

Hyman, R & Pankhurst, R, *Plants and Their Names: A Concise Dictionary,* Oxford University Press, UK, 1995

Sharr, FA, *Western Australian Plant Names and Their Meanings: A Glossary,* University of Western Australia Press, Perth, 1978

Stearn, WT, *Botanical Latin,* Timber Press Inc., Portland, OR, 2004

Other references

Blombery, A & Rodd, T, *Palms: An informative, practical guide to the palms of the world; their cultivation, care and landscape use.* Angus & Roberson, Australia, 1982, p. 150

Hall, N, Johnson, RD & Chippendale, GM, *Forest Trees of Australia,* Department of Agriculture Forestry and Timber Bureau, Canberra, 1970, pp. 62 & 92

Harris, JG & Harris, MW, *Plant Identification Terminology: An Illustrated Glossary,* Spring Lake Publishing, Utah, 2007

Hay, H, Gottschalk, M & Holguín, A, *Huanduj Brugmansia,* Florilegium, Glebe, Australia, 2012, pp 154–56

Mabberley, David J, 'A classification for edible Citrus (Rutaceae)', *Telopea,* Vol. 7, No. 2, 1997, pp. 167–72

Mabberley, DJ, *Mabberley's Plant Book: A Portable Dictionary of Plants and Their Classification,* Cambridge University Press, UK, 2008

Orel, G & Curry, AS, *In Pursuit of Hidden Camellias; or 32 new Camellia species from Vietnam and China,* Theaceae Exploration Associates, Sydney, Australia, 2015

Weston, PH & Crisp, MD, '*Alloxylon* (Proteaceae), a new genus from New Guinea and eastern Australia', *Telopea,* Vol. 4, 1991, pp. 497–507

Flora of China

Acer griseum
 http://www.efloras.org/florataxon.aspx?flora_id=2&taxon_id=200012991

Iris delavayi
 http://www.efloras.org/florataxon.aspx?flora_id=2&taxon_id=200028164

Kalopanax septemlobus
 http://www.efloras.org/florataxon.aspx?flora_id=2&taxon_id=200015231

Keteleeria fortunei
 http://www.efloras.org/florataxon.aspx?flora_id=2&taxon_id=200005276

Magnolia grandiflora
 http://www.efloras.org/florataxon.aspx?flora_id=2&taxon_id=200008470

Trachycarpus fortunei
 http://www.efloras.org/florataxon.aspx?flora_id=2&taxon_id=200027121

Australian Tropical Rainforest Plants

http://www.anbg.gov.au/cpbr/cd-keys/rfk/index.html

Araucaria bidwillii
 http://keys.trin.org.au:8080/key-server/data/oeofo504-0103-430d-8004-060do7080do4/media/Html/taxon/Araucaria_bidwillii.htm

Araucaria cunninghamii
 http://keys.trin.org.au:8080/key-server/data/oeofo504-0103-430d-8004-060do7080do4/media/Html/taxon/Araucaria_cunninghamii.htm

Agathis robusta
 http://keys.trin.org.au:8080/key-server/data/oeofo504-0103-430d-8004-060do7080do4/media/Html/taxon/Agathis_robusta.htm

Ficus rubiginosa
 http://keys.trin.org.au:8080/key-server/data/oeofo504-0103-430d-8004-060do7080do4/media/Html/taxon/Ficus_rubiginosa_f._rubiginosa.htm

Strongylodon macrobotrys
 http://www.kew.org/science-conservation/plants-fungi/strongylodon-macrobotrys-jade-vine

The IUCN Red list of Threatened species
 http://www.iucnredlist.org/

LIST OF ABBREVIATIONS FOR AUTHOR BIOGRAPHIES

ASBA American Society of Botanical Artists

BASA Botanical Art Society of Australia

Botanica The Royal Botanic Garden, Sydney's annual exhibition

HSNY Horticultural Society of New York

Hunt Institute Hunt Institute for Botanical Documentation

Margaret Flockton Award Margaret Flockton Award for Excellence in Scientific Botanical Illustration

RHS Royal Horticultural Society

SBA Society of Botanical Artists

The Highgrove Florilegium *The Highgrove Florilegium* for The Prince of Wales's Charitable Foundation

Transylvania Florilegium Transylvania Florilegium for the Prince of Wales's Foundation Romania

For abbreviations see previous page

Mariko Aikawa

Born in Hyogo, Japan, in 1953, Mariko Aikawa worked as a translator and interpreter for the Embassy of the Republic of Kenya in Tokyo from 1980 to 1996 and has been painting botanical art since 2004. She has exhibited regularly in Japan with the Masako Sasaki Botanical Art Group and the Japanese Association of Botanical Illustrators. She has also shown in Spain and at the Society of Botanical Artists (SBA) Annual Exhibition in London, where she won Highly Commended for the Joyce Cuming Presentation Award in 2010. She also won the SBA Margaret Granger Memorial Silver Bowl in 2011. In the past two years, Mariko has also contributed to the annual *Botanica* exhibition at the Royal Botanic Garden, Sydney.

Beverly Allen

Born in Sydney in 1945, Beverly Allen previously worked as a freelance graphic designer and illustrator. She has a BA (Fine Arts) from Sydney University. Beverly has exhibited annually at the Royal Botanic Garden, Sydney's *Botanica* exhibition since 1999 and internationally including in New York, Amsterdam, Tokyo, Pisa and London.

Her paintings are held in the Royal Botanic Garden, Sydney, the Shirley Sherwood Collection, *The Highgrove Florilegium*, the Transylvania Florilegium, the RHS Lindley Library, the collection of the Royal Botanic Gardens, Kew, the Hunt Institute for Botanical Documentation and the Alisa and Isaac M Sutton Collection.

Beverly was awarded a Gold Medal at the 2007 RHS London Botanical Art Show, the Gold Medal for Botanical Art from the New York Botanical Garden in 2011 and their Silver Medal in 2014. She has taught masterclasses at the Royal Botanic Garden, Sydney since 2004 where she co-founded and is president of the Florilegium Society.

Gillian Barlow

Gillian Barlow was born in Khartoum, Sudan, in 1944. She was a student of the Slade School of Fine Art in London and has an MA in History of Art from Sussex University. Gillian began her focus on botanical painting in 1985 while living in New York. She has had solo exhibitions in India and the USA, and at Spinks, London, in 1995 as well as exhibiting in Japan. Among her many awards are two RHS Gold Medals and the RHS Veitch Memorial Medal, which was awarded in 2015.

Her work is in collections worldwide including the Hunt Institute for Botanical Documentation, the Shirley Sherwood Collection, the Transylvania Florilegium, the Chelsea Physic Garden Florilegium as well as the RHS Orchid Archive 1995–2005, the RHS Lindley Library and the Royal Botanic Gardens, Kew, where she has contributed to *Curtis's Botanical Magazine* since 1998.

Gillian is a Herald painter for the College of Arms, London, a member of the Picture Committee for the RHS and is a founding member of the Chelsea Physic Garden Florilegium Society.

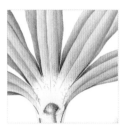

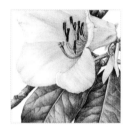

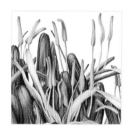

Sue Bartrop

Born in Basel, Switzerland, in 1942, Sue Bartrop trained as a registered nurse at Great Ormond Street Hospital in London before moving to Australia in 1974. She has a BA in French and Linguistics from Macquarie University and holds a Diploma in Counselling. She began botanical painting in 1999 and has exhibited in the Royal Botanic Garden, Sydney's *Botanica* exhibition since 2001, and in the Botanical Art Society of Australia (BASA) annual exhibitions from 1999 to 2010 where she won several BASA awards, including First Prize in 2007 in the Native Flora category. Sue's work was included in the *Wildflowers of Australia* exhibition held at NSW Parliament House in 2006.

Her work is found in private collections in Australia, USA, France and Switzerland.

Christine Battle

Christine Battle was born in 1956 in Montreal, Canada, and currently resides in the UK. She had a career in public relations and journalism until 1999, but gave it all up to plant and then care for a 65-acre arboretum in South Gloucestershire until 2014, when she moved to her current home in Wiltshire.

She gained a Diploma of Botanical Illustration from the English Gardening School at the Chelsea Physic Garden in 2007 and has since worked as a freelance botanical illustrator. She is represented in the Hunt Institute for Botanical Documentation and the Chelsea Physic Garden Florilegium, and has also been selected for inclusion in the Transylvania Florilegium. She has contributed plates to *Curtis's Botanical Magazine*. Christine held a solo exhibition in Tetbury, Gloucestershire, in 2011 and has exhibited widely. She was awarded an RHS Gold Medal in 2010 and an Honourable Mention at the ASBA/HSNY Annual International exhibition in 2011.

Deirdre Bean

Deirdre Bean was born in 1960 in Newcastle, NSW. She has a BA (Fine Art and Visual Culture) and recently a PhD (Natural History Illustration) from the University of Newcastle for her research into Australia's mangrove species. She has exhibited in *Botanica* since 2000 and has an extensive career in botanic art in Australia and internationally. Her work is represented in permanent collections at the Royal Botanic Gardens, Kew, the Hunt Institute for Botanical Documentation and the Royal Botanic Garden, Sydney. In 2006, she was awarded a Gold Medal at the RHS London Botanical Art Show and Silver-gilt in 2012 and 2015. She exhibited in the Waterhouse Natural Science Art Prize at the South Australian Museum in 2011 and 2012, and in 2013 was commissioned by Australia Post to paint four stamps depicting flowering shrubs of Christmas Island.

In 2013 and 2014, Deirdre travelled to Gallipoli to contribute to a touring exhibition commemorating the Anzac Day centenary. Her painting was selected as the first Executive Director's Choice (acquisitive) at *Botanica* in 2015.

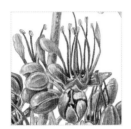

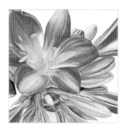

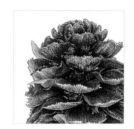

Margaret Best

Born in 1951 in Bloemfontein, South Africa, Margaret Best graduated from the University of Cape Town as a teacher of art and mathematics. She taught there and in Tehran, Iran, before immigrating to Canada. She has exhibited in England, Canada, in numerous ASBA international juried exhibitions in the USA and the 12th International Exhibition at the Hunt Institute for Botanical Documentation. In 2012, the Bermuda Society of Artists hosted a successful solo exhibition of her paintings, *Bermuda Botanica*.

Margaret writes and illustrates regularly for *Canadian Wildlife* magazine and has been commissioned to design numerous coins for the Royal Canadian Mint. Her work is in the Hunt Institute for Botanical Documentation, Royal Botanic Gardens, Kew Library and numerous private and corporate collections. She was awarded an RHS Silver Medal, in Birmingham in 2009. Since 2005, she has maintained an active teaching schedule in Canada, USA, England, Bermuda, Italy and Morocco.

Helen Yvonne Burrows

Born in 1946 in Melbourne, Victoria, Helen Burrows graduated from RMIT University with a Diploma of Art (Art and Graphic Design). She has worked as a graphic designer and in the secondary and tertiary education sectors, teaching art and lecturing in design and graphic communication. She currently teaches botanical art at the Royal Botanic Gardens, Melbourne.

Helen's work is represented in the State Botanical Collection at the National Herbarium of Victoria, *The Government House Florilegium Victoria*, the National Library of Australia, the Huntington Library, California, the Hunt Institute for Botanical Documentation, the RHS Lindley Library, the Botanical Garden and Botanical Museum of Berlin-Dahlem, the Missouri Botanical Garden Library and the Royal Botanic Gardens, Kew Library. Her work is held in private collections internationally and she has completed three volumes of camellias in limited edition.

Linda Catchlove

Born in 1969, Linda Catchlove is an Australian-born artist who began her career in graphic design. She worked in the animation industry for Walt Disney Studios in Sydney for 10 years before turning to studies of horticulture and botanical art. She now works from her studio in Adelaide, South Australia, where she produces both botanical paintings and botanically themed works with a whimsical twist. Her focus is on Australian native flora and fauna.

Linda has contributed to various exhibitions in Australia, including *Botanica*, the South Australian Museum's Waterhouse Natural Science Art Prize where she was also guest artist-in-residence in 2008, and at the Carrick Hill, Adelaide, *Spectacular Tree Stories* exhibition in 2011. Her first solo exhibition, *Botanical Whimsy*, was held in 2014 at the Hahndorf Academy, South Australia, and her first illustrated children's book, *Lilli-Pilli's Sister*, was published by Walker Books in the same year.

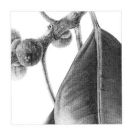 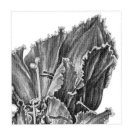 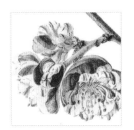

Deb Chirnside

Born in Ararat, Victoria, in 1959, Deb Chirnside started her career as a secondary art and graphic communication teacher after graduating with a Bachelor of Education from Melbourne University. She now resides in Geelong, Victoria, and has been painting botanical art since 2004. Her work has been exhibited at the Hunt Institute for Botanical Documentation's 13th International Exhibition, as well as at the 2013 ASBA/HSNY Annual International exhibition. She was represented in the *Capturing Flora: 300 years of Australian botanical art* exhibition at the Art Gallery of Ballarat in 2012 and has contributed to numerous regional exhibitions.

Deb's work is in the State Botanical Collection at the National Herbarium of Victoria and received an Honorary Mention in the 2010 Celia Rosser Awards at the Royal Botanic Gardens, Melbourne *Art of Botanical Illustration* exhibition.

Gillian Condy

Born in Kenya in 1952, Gillian trained as a scientific illustrator at Middlesex Polytechnic, then gained a Masters from the Royal College of Art. Since 1983, she has been resident artist at the South African National Biodiversity Institute. She has illustrated *Geophytic Pelargoniums* (2001) and *Grass Aloes in the South African Veld* (2005) and contributed to *Peeling Back the Petals: South African Botanical Art*. She is a founding member of the Botanical Artists Association of Southern Africa.

Gillian has participated in over 90 exhibitions worldwide, including those of the RHS (seven Gold and four Silver-gilt Medals) and the Hunt Institute for Botanical Documentation. She has won a Gold Medal at the Kirstenbosch Biennale and The Jill Smythies Award from the Linnean Society of London in 1990. Her work is represented in the Shirley Sherwood Collection, in *The Highgrove Florilegium* for The Prince of Wales's Charitable Foundation and at the Royal Botanic Gardens, Kew.

In August 1996, Gillian presented then President Nelson Mandela with a painting of *Strelitzia reginae* 'Mandela's Gold', named for him.

Rosemary Joy Donnelly

Rosemary Donnelly was born in Geelong, Victoria, in 1956. She trained as a primary school teacher before studying horticulture in 2000 and taking up botanical art in 2004. She has exhibited in the ASBA/HSNY Annual International Juried Art Exhibition in New York, and her work is held in the permanent collection at the Hunt Institute for Botanical Documentation, Pittsburgh. Her work was included in the 2013 exhibition *Capturing Flora: 300 years of Australian botanical art* at the Ballarat Art Gallery, and she has had two solo exhibitions in Queenscliff, Victoria.

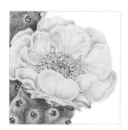

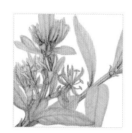

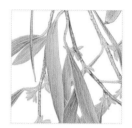

Elisabeth Dowle

Elisabeth Dowle was born in London in 1951. She is self-taught and specialises in painting food plants, particularly fruit. She has work in collections worldwide, including the RHS Lindley Library, the Hunt Institute for Botanical Documentation, the Shirley Sherwood Collection, the Wellcome Institute for the History of Medicine and *The Highgrove Florilegium* for The Prince of Wales's Charitable Foundation. She holds seven RHS Gold Medals and was winner of the SBA St. Cuthbert's Mill Award in 2004. She has had solo exhibitions at Hortus Gallery, London, in 2001 and 2003.

Elisabeth's illustrations are found in many botanical publications including *The New RHS Dictionary of Gardening* (1992), *The New Oxford Book of Food Plants* (2009) and various specialised books on violas, fuchsias, herbs, auriculas, bulbs and fruit. She has just completed *The Book of Pears*, which depicts pears from the National Collection, as a companion volume to *The Book of Apples* by Dr Joan Morgan and Alison Richards.

Delysia Jean Dunckley

Delysia Dunckley was born in Napier, New Zealand, and has lived in Australia and overseas for many years. She has extensive experience as an artist, with a focus on Australian wildflowers. She has held a number of solo exhibitions, and in 1988 she was commissioned to record wildflowers of the Australian Capital Territory region for the Australian bicentenary. Six of her paintings were also placed in the Commonwealth Park Time Capsule. Several publications, including UNESCO curriculum development books for the University of the South Pacific in Fiji, feature her work.

Her original copy of *Australian Wildflowers* was recently presented to HRH Princess Mary of Denmark, as a gift for her children. A collection of her work has been selected for an exhibition at the Canberra Museum and Gallery *Bush Capital: The Natural History of the ACT* in 2016.

Lesley Elkan

Lesley Elkan was born in Sydney in 1972 and has a BSc in Environmental Biology from the University of Technology Sydney and a Postgraduate Diploma in Art (Plant and Wildlife Illustration) from the University of Newcastle.

Lesley became a botanical illustrator for the Royal Botanic Garden, Sydney in 1995. She produces scientific illustrations of new species that are published in *Telopea, Flora of NSW, Flora of Australia* and taxonomic journals worldwide. Since 2000, she has taught and lectured in scientific and botanical illustration.

She also paints detailed watercolour botanical studies for exhibition. Her work is held in the Royal Botanic Garden, Sydney Illustration Archive, the Royal Botanic Gardens, Kew Library and international private collections. Lesley has won several awards for scientific illustration including The Jill Smythies Award from the Linnean Society of London in 2005, and First and Second Prize in The Margaret Flockton Award in 2008 and 2004, respectively. She now co-curates this award and is a founding committee member of the Florilegium Society.

Helen Lesley Fitzgerald

Helen Fitzgerald was born in Sydney, Australia, in 1945. She holds degrees in Art Education and Applied Science from the University of Canberra and has since had a career spanning 50 years teaching applied art at community and university level while pursuing her passion for painting and illustrating professionally. Her works have featured in numerous publications, including five volumes of *Flora and Fauna of the ACT*, and she was awarded an RHS Gold Medal in 2002.

Helen has exhibited extensively in and around Canberra, Sydney and Melbourne including annually at the Royal Botanic Garden, Sydney's *Botanica* exhibition. She remains actively involved in botanic art and now lives in Googong, NSW, where she continues to paint, teach and pursue her interest in flora and fauna conservation.

The Hon. Gillian Foster

The Hon. Gillian Foster was born in Dumfries, Scotland, in 1949. Gillian studied art and design at the University of Applied Arts in Vienna and has a Diploma of Botanical Illustration from the English Gardening School. She has exhibited internationally, and her work is included in international collections as well as in *The Highgrove Florilegium* and the Transylvania Florilegium.

Gillian is a member of the American Society of Botanical Artists and the Botanical Artists Association of Southern Africa. She holds an RHS Silver-gilt Grenfell Medal (1998) and a Bronze Medal from the Kirstenbosch Biennale 2006. She now lives in Northamptonshire, England.

Leigh Ann Gale

Born in 1967 in Hampshire, England, Leigh Ann Gale is a professional botanical illustrator. She holds a BA (Hons) in Graphic Design from Ravensbourne College, London, and a Diploma in Botanical Illustration from the English Gardening School, Chelsea Physic Garden. She has been teaching botanical illustration for a number of years and runs courses and workshops in the public and private sectors.

Leigh Ann's exhibition experience includes the RHS London Botanical Art Show 2015, where she was awarded a Silver Medal, and Kirstenbosch Biennale, Cape Town, where she won a Bronze Medal in 2013.

Her work is in the collections of the Hunt Institute for Botanical Documentation and the Royal Archives, Hampton Court Palace Florilegium.

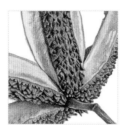

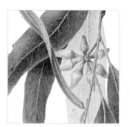

Mayumi Hashi

Mayumi Hashi was born in Nara, Japan, in 1954. She now lives in London where she tutors in botanic art and Japanese language and is a linguistics examiner. Her work features in many collections including the Hunt Institute for Botanical Documentation, Pittsburgh, *The Highgrove Florilegium*, Royal College of Physicians and the RHS Lindley Library. She has been awarded two Gold Medals, two Silver-gilt Medals and a Silver Medal at the RHS and in 2006, became the first recipient of the Royal Horticultural Society Dawn Jolliffe Botanical Art Bursary and went to Peru to photograph, draw and paint orchids.

Mayumi was Artist in Residence at the Royal College of Physicians in 2010–11 and her work has recently been selected for inclusion in the Transylvania Florilegium.

Anne Hayes

Anne Hayes was born in 1965 in Sydney. In 1992 she completed a Diploma in Commercial Art, majoring in Illustration, and furthered her skills with an Advanced Diploma in Visual Communication in 2007. She works as a freelance illustrator and graphic designer and has been exhibiting botanical art since 2011.

Her work was shown in the 2012 *Focus on Nature XII* exhibition at the New York State Museum, Albany, and in The Margaret Flockton Award, and she was a finalist in the Waterhouse Natural Science Art Prize 2013 at the Adelaide Museum. She exhibits in the Royal Botanic Garden, Sydney *Botanica* exhibition. Anne is represented in the New York State Museum collection and is published in several *Australian Geographic* magazines and, in 2013, in *The Art of Australian Geographic Illustration*.

Cheryl Hodges

Cheryl Hodges was born in 1970 and raised on a property on the outskirts of Canberra. She developed a love of nature and art at an early age. In 2000, she discovered her passion for botanical watercolour painting with a focus on native Australian species.

She has exhibited annually in *Botanica* at the Royal Botanic Garden, Sydney since 2005 and the *Canberra Botanical* exhibitions since 2003. She contributed to *The Art of Botanical Illustration* exhibition at the Royal Botanic Gardens, Melbourne in 2014. Her work is in private collections internationally. Cheryl has won several awards, including the Wildlife and Botanical Artists Inc. Dr Helen Hewson Traditional Botanical Art Award in 2007 and 2012, and Best in Show at the Botanical Art Society of Australia (BASA) *Flora: The Art and Science of the Plant* exhibition in 2015. She currently lives in Jerrabomberra in New South Wales.

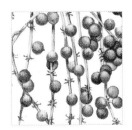

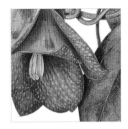

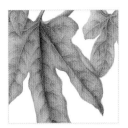

Tanya Hoolihan

Tanya Hoolihan was born in 1965 in western NSW and is now living in Jilliby on the NSW Central Coast. She completed a degree in Natural History Illustration at Newcastle University with Honours, and is currently undertaking a Research Higher Degree and lecturing at the same university in Botanical Illustration.

She has exhibited at the Royal Botanic Garden, Sydney's *Botanica* exhibition since 2010 and the Botanical Art Society of Australia annual exhibition since 2007. She has participated in several regional exhibitions in the Hunter area and has been a sentimental favourite at the BASA exhibitions, winning the People's Choice Award in 2008, 2009 and 2014.

Her work is found in several private collections as well as in the Deputy Vice-Chancellor's Collection, Newcastle University.

Annie Hughes

Annie Hughes was born in 1948 in Santiago, Chile. She qualified with a Bachelor of Design (First Class Honours) at University of Technology Sydney in 1990, after gaining a Diploma in Art and Design in the UK and moving to Australia permanently. She worked as a textile designer for 15 years before turning to botanic art.

Her accomplishments in botanic art include Gold Medals at the RHS London Botanical Art Shows in 2011, 2012 and 2013, and she was also awarded Best Painting in Show in 2012. She won a Gold Medal at the *Botanical Images* exhibition in Scotia, Edinburgh, in 2014. Her work is found in the Hunt Institute for Botanical Documentation as well as the Shirley Sherwood Collection and the RHS Lindley Library. She regularly contributes to the *Botanica* exhibition at the Royal Botanic Garden, Sydney.

Nalini Kumari Kappagoda

Nalini Kappagoda was born in 1936 in Kandy, Sri Lanka, and qualified with an MBBS as a medical practitioner. She moved to the UK to further her studies in 1963, gaining her PhD from the University of London, and arrived in Australia in 1970. She was appointed a staff specialist at the Royal Prince Alfred Hospital, Sydney, in 1971 where she worked as a specialist microbiologist until retiring in 1997.

Shortly after retiring, she started watercolour painting. Influenced by her mother's profession as a botany teacher, she focused her interest on botanical subjects and enrolled in a course in botanical drawing and illustration at the Royal Botanic Garden, Sydney. She also attended masterclasses with Susannah Blaxill. She is a regular exhibitor at the Royal Botanic Garden, Sydney's *Botanica* exhibition and at BASA exhibitions. She also exhibited in Canberra in 2014.

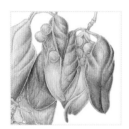

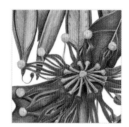

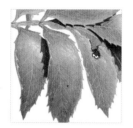

Jee-Yeon Koo

Jee-Yeon Koo was born in Seoul, South Korea, in 1952. She holds a BA from Dongduk Women's University and an MA from Chung-Ang University. While living in the USA from 1994 to 2001, she specialised in botanic art, training at the New York Botanical Garden. She now works as an ambassador for botanical art in Korea, painting, teaching and co-ordinating exhibitions, and is president of the Korean Society of Botanical Illustrators and principal art director for the Korea National Arboretum's project of illustrating rare and endangered Korean plants.

Jee-Yeon has exhibited extensively with the ASBA and since 2000 at the *Focus on Nature International Biennale* at the New York State Museum. Among her awards are Best in Show, 1999 *'Art in Science' International Exhibition* at the World Congress of Botany, an RHS Silver Medal in 2000, Silver-gilt Medals in 2002, 2004, 2013 and Jury Award of *Focus on Nature XIII* in 2014 from NYSM. Her work is held in many museum collections in Seoul, Korea, and in the Hunt Institute Collection.

Angela Lober

Born in Sydney in 1966, Angela Lober started her career as a landscape architect after graduating from University of NSW in 1990. Her interest in fine art and botany led her to complete a Postgraduate Diploma in Visual Art (Plant and Wildlife Illustration) at Newcastle University in 1995. Angela has been painting and exhibiting since 2002, and her work is found in international collections including the Alisa and Isaac M Sutton Collection in New York and the Shirley Sherwood Collection, as well as in the State Botanical Collection at the National Herbarium of Victoria. Her work has also been selected for the Hunt Institute's 15th International Exhibition for 2016.

In 2012 she was awarded a Silver-gilt Medal at the RHS London Botanical Art Show, and in 2014 she won the Celia Rosser Medal for Excellence in Botanic Art in Melbourne. She now paints full time and teaches at the Royal Botanic Garden, Sydney as well as serving on the committee of the Florilegium Society.

David Mackay

David Mackay was born in 1958 in Hornsby, NSW, and began his career at the age of 15 when he illustrated *Orchids of Papua New Guinea* by Andrée Millar. He worked as a scientific illustrator at the National Botanic Gardens of Papua New Guinea between 1974 and 1976, at the Royal Botanic Garden, Sydney from 1979 to 1995 and as a visiting artist at the University of California, Kew Gardens and the Linnean Society Herbarium in London. He holds a BSc (Hons) Botany from the University of Sydney.

David has illustrated over 200 books and scientific papers, and more than 5000 of his works have been published. His paintings have been exhibited internationally and are represented in public collections in Australia, England, USA and Papua New Guinea and in private collections internationally. He paints and teaches in Armidale, NSW, and at the time of publication David was also Macleay Fellow at the Linnean Society of NSW and conducting research in environmental science towards a PhD at the University of New England.

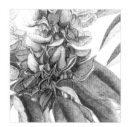

Elizabeth Mahar

Elizabeth Mahar was born in 1950 in Mount Gambier, South Australia. She qualified as a nurse and worked as a nursing sister before completing a Diploma of Visual Art in Geelong, Victoria. She began exhibiting in 2005 and has since contributed annually to *The Art of Botanical Illustration* at the Royal Botanic Gardens, Melbourne. In 2013, she showed at the Royal Botanic Garden, Sydney's *Botanica* exhibition.

In 2010 and 2014, Elizabeth was awarded an Honourable Mention for the Celia Rosser Medal for Botanical Art at *The Art of Botanical Illustration* biennial exhibition at the Royal Botanic Gardens, Melbourne. She now resides in Geelong, Victoria.

Beth McAnoy

Beth McAnoy was born in Melbourne, Victoria, in 1941. She began her career in interior design and decoration. In 1983, Beth started a school for florists and went on to become one of Melbourne's leading wedding and function co-ordinators, managing florist shops in the eastern suburbs. Beth became a student of Jenny Phillips at the Botanical Art School of Melbourne and started painting. She exhibits at the Botanical Art School of Melbourne exhibitions at the Villa Mulberry, and has also exhibited in *Botanica: The Masters & Moore* at the Royal Botanic Garden, Sydney in 2013.

Her work is represented in editions of the National Trust Diary and in The Government House Florilegium Victoria. The paintings for this florilegium are held in the State Library of Victoria.

Fiona McGlynn

Fiona McGlynn was born in Sydney, the daughter of a keen orchid collector, and this has shaped her personal subject focus in botanical art. She graduated from the University of Technology Sydney in 1987 with a Bachelor of Engineering (Civil) Hons 1 and the University Medal and then worked as a consultant structural and civil engineer for several years.

In 2000, she began studies in botanical art and first exhibited at the Royal Botanic Garden, Sydney's *Botanica* in 2003, and then showing annually. She has exhibited and been awarded a Gold Medal at *Botalia: Painted Flora 2010* in Lucca, Italy, as well as exhibiting in New York and Pittsburgh. Her work is held in the collection of the Hunt Institute for Botanical Documentation and the Alisa and Isaac M Sutton Collection as well as numerous private collections.

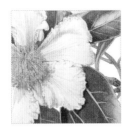 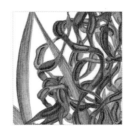 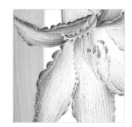

Fiona McKinnon

Fiona McKinnon was born in Sydney in 1947 and now lives in Box Hill, Victoria. She qualified with a Secondary Teachers' Certificate (Art & Craft) and began her career as a secondary school teacher. She commenced freelance illustration work in 1988 and has been teaching botanical painting at the Botanical Art School of Melbourne since 1996. She has exhibited widely including *Botanica* at the Royal Botanic Garden, Sydney, *The Art of Botanical Illustration* at the Royal Botanic Gardens, Melbourne (where she won the Celia Rosser Medal in 2014 and was given an Honourable Mention in 2004) as well as at the Hunt Institute for Botanical Documentation.

Her paintings are in *The Highgrove Florilegium*, *The Government House Florilegium Victoria* and the State Botanical Collection at the National Herbarium of Victoria. Fiona's work has been acknowledged with a solo retrospective at Artspace, City of Whitehorse, Victoria in 2015.

Maggie Munn

Maggie Munn was born in 1950 in Winchester, England, and now lives in Mt Eliza in Victoria. She trained in botanic art at the Botanic Art School of Melbourne under the tutelage of Jenny Phillips and Fiona McKinnon.

She exhibits regularly at the Royal Botanic Gardens, Melbourne and at *Botanica* at the Royal Botanic Garden, Sydney as well as in many regional galleries in Victoria. She showed at the RHS London Botanical Art Show in 2009 and was awarded a Silver-gilt Medal. Her work is held in the collection of the Royal Botanical Gardens, Kew, the State Botanical Collection at the National Herbarium of Victoria and in private collections in Australia, the USA and England.

Elaine Musgrave

Elaine Musgrave was born in Sydney in 1945. She began her career as a commercial artist in Sydney and London and started painting botanical art in 1995. She was owner and curator of Fernbrook Garden and Art Gallery from 1995 to 2009 before moving to Wildes Meadow in the NSW Southern Highlands.

Elaine has exhibited annually in *Botanica* at the Royal Botanic Garden, Sydney since 1999. She was awarded a Gold Medal at the RHS London Botanical Art Show in 2003. Her work is in the Hunt Institute for Botanical Documentation, the Alisa and Isaac M Sutton and Hawkesbury Regional Gallery Collections. Elaine is a founding committee member of the Florilegium Society.

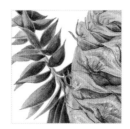

Julie Nettleton

Born in Sydney in 1954, Julie began her career as an interior designer before taking up botanical art in 2002. She has exhibited in The Margaret Flockton Award in 2009 and in the Royal Botanic Garden, Sydney *Botanica* exhibition since 2006. She was also represented in *The Eternal Order in Nature: The Science of Botanical Illustration* exhibition at the Royal Botanic Gardens, Melbourne in 2011.

Her work is found in the State Botanical Collection at the National Herbarium of Victoria, the Shirley Sherwood Collection and the Hunt Institute for Botanical Documentation. Her painting was selected for the prestigious catalogue cover of the Hunt Institute's 14th International Exhibition of Botanical Art and Illustration in September 2013. Julie now specialises in painting the native plants of North Head Sanctuary, Manly. She is secretary of the Florilegium Society's committee.

Dorothee Nijgh de Sampayo Garrido

Dorothee Nijgh de Sampayo Garrido was born in The Hague, The Netherlands, and now lives in Kenmore, Queensland. She holds a Master of Laws, University of Leiden, and has had a career in the Dutch Foreign Service, as a judge in The Netherlands and Curacao and has been a senior staff member at the United Nations.

Dorothee received tuition in botanic art by Christabel King at Kew Gardens, and has a Distance Learning Course Diploma (with Distinction) from the SBA. She moved to Australia in 2005, where she began exhibiting at the Botanical Artists' Society of Queensland's annual shows and in the Royal Botanic Gardens in Sydney and Melbourne. She has held solo exhibitions in The Hague and Curacao and has also participated in exhibitions in the Hunt Institute and the New York State Museum, where her work is held in their permanent collections. She also has work in the State Botanical Collection at the National Herbarium of Victoria.

Kate Nolan

Kate Nolan was born in 1969 and grew up in Gippsland. She moved to Melbourne to study and graduated from the University of Melbourne with a Bachelor of Science (Botany) in 1992. She went on to complete a Diploma in Visual Art (Plant and Wildlife Illustration) at the University of Newcastle in 1994 before moving back to Melbourne where she then completed a Diploma in Education (Science).

From 1996 to 1999 she was employed as scientific illustrator at the Museum of Victoria, and has since been engaged by various government and private agencies and the University of Melbourne to produce scientific illustrations for publication. She exhibits regularly at the Sydney and Melbourne Royal Botanic Garden shows; in Melbourne she received an Honourable Mention for the Celia Rosser Medal in 2010. She showed at *Focus on Nature International Biennale* at the New York State Museum in 2010. Kate now lives in Macedon, works as a freelance natural history artist and teaches specialised aspects of botanical illustration at the Royal Botanic Gardens in Sydney, Melbourne and Adelaide, as well as to private groups.

Anne O'Connor

Born in Sydney in 1939 and now residing in Mornington, Victoria, Anne O'Connor began her career as a primary school teacher. She completed a Diploma in Commercial Art and began painting landscapes in oils before focusing on botanical art. She specialises in painting species of the *Rhododendron* subgenus *Vireya*, the South-East Asian or 'tropical' rhododendrons.

Anne had a solo show at the Mornington Peninsula Gallery in 2008 and has featured in many group exhibitions including the RHS London Botanical Art Show in 2000, where she was awarded a Gold Medal. She has been a long-standing exhibitor at the Royal Botanic Gardens in Melbourne and Sydney.

Her work is in numerous Australian and international collections, including the Shirley Sherwood Collection, the RHS Lindley Library, *The Highgrove Florilegium* and *The Government House Florilegium Victoria*.

Susan Ogilvy

Susan Ogilvy was born in Kent, England, in 1948. Since 1994 Susan has had six solo exhibitions and participated in several joint exhibitions at Jonathan Cooper's Park Walk Gallery in London. Susan has contributed to both *Botanical Artists of the World* exhibitions at the Tryon & Swann Gallery. Shirley Sherwood's world-renowned collection includes eight of Susan's paintings. Her work has been shown in the Ashmolean Museum, the Smithsonian Institution, the Hunt Institute for Botanical Documentation and the Royal Horticultural Society. Susan holds an RHS Gold Medal 1997 and a Silver-gilt Medal 1995.

She is represented in several international collections including the Transylvania Florilegium, *The Highgrove Florilegium*, the Hunt Institute as well as the Alisa and Isaac M Sutton and Shirley Sherwood Collections. *Overleaf*, illustrated by Susan, was released by Kew Publishing in 2013.

Tricia Oktober

Tricia Oktober was born in Bellingen, NSW, in 1940 and now lives and gardens in Katoomba. She has exhibited around the world: in Paris in 1974, Quebec City Summer Festival 1975–79 all the way through to Leura 1993–2004 and *Botanica* at the Royal Botanic Garden, Sydney since 2000. She has worked as an author and illustrator on 25 books for children, mostly on Australian flora, fauna and the environment. She has had solo exhibitions in Europe, America and Australia and her work is in private collections in these continents.

Tricia has won the Royal Zoological Society of NSW Whitley Award for outstanding publications on Australasian fauna six times, the Environmental Award yearly 1998 to 2001, the UNESCO Award for Best Illustrator – Children's Books 1992 and a Lifetime Achievement Award from the Wilderness Society in 2004.

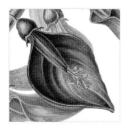 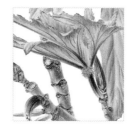 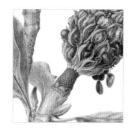

Annie Patterson

Annie Patterson was born in Buckinghamshire, UK, in 1951 and now lives in Champigny sur Veude, France. She qualified with a BA (Hons) Design, and began her professional career as a graphic designer. She has been painting since 2002 and has exhibited extensively including the Forum Botanische Kunst, Germany; Château de Villandry, France; the American Society of Botanical Artists, New York; the Shirley Sherwood Gallery at Kew; and at Hampton Court Palace.

She was awarded Best Painting in the ASBA/HSNY's 10th Annual International exhibition in New York and Best in Show in 2014. Annie was awarded a Silver-gilt and Silver Medal at the RHS London Botanical Shows in 2002 and 2006 respectively, Highly Commended in 2007 for the SBA's Joyce Cuming Presentation Award. Her work is in the collection of the Royal Botanic Gardens, Kew, *The Highgrove Florilegium*, the Hunt Institute for Botanical Documentation and the Hampton Court Palace Florilegium.

John Pastoriza-Piñol

John Pastoriza-Piñol was born in Melbourne, Australia in 1975. John is a contemporary botanical artist based in Melbourne. He studied a *doctorante* course in Botany at University of Vigo, Spain. His numerous awards include an RHS Gold Medal in 2005, a Silver-gilt in 2007 as well as the ASBA Diane Bouchier Award for Excellence.

John has held four solo exhibitions in Victoria and London and has shown extensively internationally. His work is held in many collections including Royal Botanic Gardens, Kew, *The Highgrove Florilegium*, the Hunt Institute for Botanical Documentation, Geelong Botanic Gardens in Victoria, the Art Gallery of Ballarat, RMIT University Melbourne and the Alisa and Isaac M Sutton Collection in New York. He also teaches in Australia and internationally.

Jenny Phillips

Jenny Phillips was born in Victoria in 1949 and has worked as a botanical artist since 1971. She has lectured and taught internationally on the subject for over 15 years and is Director of the Botanical Art School of Melbourne. Jenny has exhibited extensively and was honoured with a retrospective exhibition at the Mornington Peninsula Regional Gallery. She is an honorary director of the American Society of Botanical Artists, the Brooklyn Florilegium Society and the Chelsea Physic Garden Florilegium Society, the Florilegium Society at the Royal Botanic Gardens Sydney and an elected member of the Linnean Society of London.

Jenny won the Celia Rosser Medal in 2008 and an RHS Gold Medal in 1993. Her work is represented in the Shirley Sherwood Collection, the Hunt Institute for Botanical Documentation, the State Botanical Collection at the National Herbarium of Victoria as well as *The Government House Florilegium Victoria*, Filoli Gardens Florilegium in San Francisco, *The Highgrove Florilegium* and the Transylvania Florilegium.

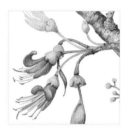

Margaret Pieroni (Hellmers)

Margaret Pieroni was born in Sydney in 1936. She attended East Sydney Technical College (now the National Art School) and worked as a commercial artist for 20 years in Sydney and London. She moved to Denmark in Western Australia in 1974 and began focusing on botanical illustration.

Margaret has illustrated numerous publications for botanists and has exhibited extensively in Western Australia. Her works are found in collections including the Royal Botanic Gardens, Kew, City of Melville, Perth, City of Victoria Park, Perth, the Perth Mint and in private collections in Australia and overseas.

Gabrielle Pragasam

Gabrielle was born in Wagga Wagga, NSW, in 1988 and currently lives in Toowoomba, Queensland. She trained in botanic art with Margaret Saul at the School of Botanic Art, Mt Coot-tha, Queensland. She began exhibiting her work as a student in 2001, and has since had extensive experience exhibiting in Queensland, including at the Queensland Herbarium at Mt Coot-tha. She has also showed in the Royal Botanic Garden, Sydney's *Botanica* exhibition and in 2010 at the Society of Botanical Artists' *Silver Jubilee Exhibition* in Westminster Central Hall in London.

Gabrielle's work is in the collection at the CSIRO in Canberra, as well as in private collections throughout Australia and overseas.

Penny Price

Penny Price was born in the UK in 1947. She initially qualified as a teacher and had a career as a professional scribe and illuminator. She is a Fellow of the Society of Scribes and Illuminators in the UK. In 2010, she studied at the English Gardening School in Chelsea, graduating with a Diploma in Botanical Illustration (Distinction), and is now teaching there as well as continuing to paint. She is a member of both the Chelsea Physic Garden Florilegium and the Hampton Court Palace Florilegium Societies in the UK.

Penny's exhibit at the Royal Horticultural Society in London in 2014 was awarded a Silver-gilt Medal. Her work is found in the Fitzwilliam Museum, Cambridge, and in private collections in the UK, Germany, USA and Australia.

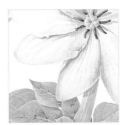

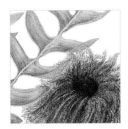

Marta Salamon

Marta Salamon was born in Augsburg, Germany, and currently lives in Mt Dandenong, Victoria. She qualified at the University of Melbourne with a BA and a Bachelor of Education (Fine Arts) before taking up botanic art in 1996. She trained with Jenny Phillips and now specialises in painting the flora of Western Australia.

She has exhibited extensively in Victoria and Western Australia, including in the Melbourne Royal Botanic Gardens exhibitions since 1996. She has also exhibited in *Botanica* at the Royal Botanic Garden, Sydney. Marta's work has been selected for the Waterhouse Natural Science Art Prize on three occasions and is found in the collections of the National Herbarium of Victoria and the Alisa and Isaac M Sutton Collection in New York.

Sandra Sanger

Born in Melbourne, Australia, in 1942, Sandra Sanger graduated with an Associate Diploma (Advertising Art) in 1961. She had a career as a graphic artist and lecturer in fashion, art and design at RMIT University from 1964 to 1999. After retiring, she joined botanical illustration classes at the Royal Botanic Gardens, Melbourne and the Botanical Art School of Melbourne.

Sandra is a regular exhibitor in The Margaret Flockton Award, and in *Botanica* exhibitions at the Royal Botanic Garden, Sydney. She also exhibits at the Royal Botanic Gardens, Melbourne and received an Honourable Mention and the Celia Rosser Award in 2006 and 2008 respectively. She has won a Gold Medal and Best in Show at the RHS Garden Show, Birmingham, in 2008 and 2010 and a Gold Medal at the RHS Orchid Show, London, in 2013. Her work is represented in the State Botanical Collection at the National Herbarium of Victoria, the Royal Botanic Gardens, Melbourne Collection and the RHS Lindley Library in London.

Robyn Seale

Born in Sydney in 1943, Robyn Seale studied pharmacy at Sydney University and worked at major city hospitals in Sydney, Melbourne and Hong Kong for over 30 years before discovering botanic art. She studied at the Botanical Art School of Melbourne with Jenny Phillips and attended masterclasses with Anne-Marie Evans at the Chelsea Physic Garden in London and with Susannah Blaxill in Melbourne.

Robyn has been a regular exhibitor at the Royal Botanic Gardens, Melbourne exhibitions since 1998 and has exhibited in galleries in South Yarra and Geelong as well as in Istanbul in 2012. Her work is in *The Government House Florilegium Victoria*, and is in private collections in Australia and overseas.

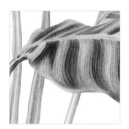

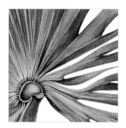

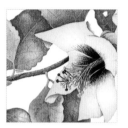

Laura Silburn

Laura Silburn was born in King's Lynn, UK, in 1973. She studied art, fashion and textiles at college and then worked in information management. In 2008, she returned to painting and studied botanical art at Mally Francis' studio at Heligan Gardens in Cornwall. She is a member of the Eden Project Florilegium Society where she teaches botanical art.

Laura exhibited at the Royal Horticultural Society in 2013 and 2014; she won two Gold Medals and Best in Show for 2014. Her work is in the collections of the RHS Lindley Library, the Eden Project Florilegium and the Shirley Sherwood Collection. She has recently had three paintings selected for inclusion in the Transylvania Florilegium.

Shirley Slocock

Born in Kent, England, in 1943, Shirley Slocock has a background in horticulture. She is a director of Knap Hill Nursery Ltd, a family business since 1795 with a worldwide reputation for the production of prize-winning rhododendrons and azaleas. She has reviewed botanical painting books for the RHS, and has exhibited extensively in the UK in London and Hampton Court Palace as well as in the USA.

Her work is held in the collections of the Hunt Institute for Botanical Documentation, Hampton Court Palace Archive and in private collections worldwide. Among other awards, she won an RHS Silver-gilt Medal in 2012 and was awarded Highly Commended in the Waterhouse Natural Science Art Prize, Adelaide, in the same year.

Halina Steele

Born in 1954 in Queanbeyan, NSW, Halina Steele has been exhibiting her botanical paintings since 2003. Her work is found in the collections at the RHS Lindley Library in London and in the Hunt Institute for Botanical Documentation. She has won a Gold Medal at the RHS Malvern Spring Show in 2015 as well as the Best Botanical Art Exhibit. She also holds an RHS London Botanical Art Show 2004 Silver Grenfell Medal.

She is a regular exhibitor at the *Canberra Botanical*, as well as with the Wildlife and Botanical Artists (ACT), and at *Botanica* at the Royal Botanic Garden, Sydney. Her work was also hung at the 10th Annual Botanical Art Exhibition, Filoli Centre, California, USA, in 2008.

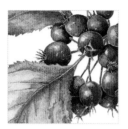

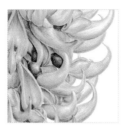

Sally Strawson

Sally Strawson was born in Yorkshire, England, in 1964. She attended an Art Foundation course at Doncaster School of Art followed by a degree course in Three-Dimensional Design. Taking up a career as an interior designer, she worked in London and then Yorkshire. She is a member of the Florilegium Society at Sheffield Botanical Gardens and has exhibited at Lincoln Cathedral and in 2014 at the RHS London Shades of Autumn Show.

Her work is in *The Highgrove Florilegium* as well as the Hunt Institute for Botanical Documentation in the USA and the Florilegium Society Archive, Sheffield Botanical Gardens. Her work has recently been accepted for inclusion in the Transylvania Florilegium. She was awarded an RHS Silver-gilt Medal in 2014.

Dianne Sutherland

Dianne Sutherland was born in Staffordshire, UK, in 1964 and holds a BSc Hons in Biology and a Dip Bot Art. She trained as part of the Royal Albert design team, painting intricate floral patterns onto china. After relocating to north-east Scotland in the 1990s, Dianne became a freelance artist and illustrator, producing work for books and educational material, then spent a short period of time working in education. She began to specialise in botanical subjects as a full-time artist around 2000.

Dianne exhibits regularly with the RHS and the Society of Botanical Artists, of which she is an elected member. She has been awarded Silver Medals in 2006, 2008, 2010 and 2014. Her work is held in the Hunt Institute for Botanical Documentation and numerous private collections. She now combines her science and art background to teach and write a regular blog on botanical art.

Narelle Thomas

Born in Young in south-western NSW in 1963, Narelle Thomas trained in fine art at East Sydney Technical College in 1981. She began her career as a photographic and watercolour artist before specialising in botanic art and taking classes with Jenny Phillips and Susannah Blaxill. She has had several solo and joint exhibitions in NSW and Victorian regional galleries and has been exhibiting at the Royal Botanic Garden, Sydney's *Botanica* exhibition since 2000. Narelle also exhibits in the *Canberra Botanical* and BASA exhibitions, and in 2002 won First Prize for Drawing at the BASA 3rd Annual Exhibition. She now lives in Wagga Wagga, NSW, where she works from her studio as a botanical artist and teaches.

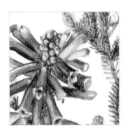

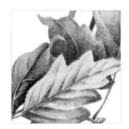

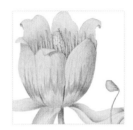

Vicki Thomas

Born in South Africa in 1951, Vicki Thomas began scientific botanical illustration in 1980 and currently teaches the Scientific Illustration module to Honours students at Stellenbosch University in South Africa. She has taught courses at the University of Cape Town's Summer School, and has lectured and taught privately around South Africa and in the UK. She is published in scientific journals and in two books dedicated to botanical illustration. She has Gold and Silver Medals from the Kirstenbosch Biennale.

Vicki's paintings are found in collections around the world, including several in the Shirley Sherwood Collection, *The Highgrove Florilegium* and the Transylvania Florilegium. She has also exhibited in the UK, USA, Japan and South Africa. Vicki is a founding member of the Botanical Artists Association of Southern Africa and a past chairperson.

Anita Walsmit Sachs

Anita Walsmit Sachs was born in The Hague, The Netherlands, in 1948 where she studied at the Royal Academy of Fine Art. Anita was head of the Art Department and scientific illustrator at the National Herbarium Nederland, University of Leiden, where she illustrated for many scientific publications. Her botanical paintings are held in the Hunt Institute for Botanical Documentation, *The Highgrove Florilegium*, the Transylvania Florilegium, the New York State Museum and the Teylers Museum in Haarlem.

Anita was awarded RHS Gold Medals in 2004 and 2005, then also Best Botanical Art in Show. She holds several SBA Botanical Merits and the Margaret Granger Memorial Silver Bowl Award, and from the ASBA, the Award for Excellence in Scientific Botanical Art. She won Second Prize in the 2012 The Margaret Flockton Award. In 2006, Anita founded and is president of the Dutch Society of Botanical Artists.

Ruth Walter

Ruth Walter was born in Warrnambool, Victoria, in 1941. She holds a B Mus, Dip Ed from the University of Melbourne and taught music until 1986. She also taught quilting before taking up botanic art. She trained at the Botanic Art School of Melbourne and began exhibiting in 2000.

Ruth has since shown extensively in Victoria and New South Wales and has had three solo exhibitions. In 2003 she received a Gold Medal at the RHS London Botanical Art Show for her eight *Dryandra* species paintings. Her work is included in the collection of the Hamilton Regional Gallery, *The Government House Florilegium Victoria* and in private collections in Australia and overseas.

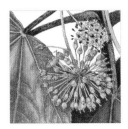

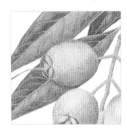

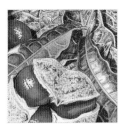

Noriko Watanabe

Noriko Watanabe was born in Hiroshima, Japan, in 1954. She completed a Bachelor of Arts at the Osaka University of Arts in 1977 and trained at California College of Arts & Crafts before taking up tuition in botanic art in 2001. She worked as a Kimono pattern designer in Kyoto and moved into botanic art in 2004.

She has exhibited in London, the USA and Canada as well as in Japan. Her work is found in the collections of the RHS Lindley Library, the Hunt Institute for Botanical Documentation, Pittsburgh, and the Shirley Sherwood Collection in Kew. Her work was featured on the cover of the Hunt Institute catalogue in 2007, and she was awarded a Gold and a Silver-gilt Medal at the RHS London Orchid & Botanical Art Show in 2006 and 2013, respectively.

Catherine M Watters

Catherine Watters was born in Paris, France, in 1952 and is now a resident in California. She has exhibited extensively since 1997, including at the Shirley Sherwood Gallery at Kew, the New York Botanical Garden, Filoli Gardens Florilegium in San Francisco, the UC Berkeley Botanical Garden, the Brooklyn Botanic Garden and at the Horticultural Society of New York. Her paintings are included in the Alisa and Isaac M Sutton Collection and the Hunt Institute, the Filoli Florilegium, the Brooklyn Botanic Garden Florilegium, the collection of the Royal Botanic Gardens, Kew and the Museum of Natural History in Paris as well as the florilegia mentioned below.

Catherine has developed curricula and taught in France and the US since 1999 and has curated exhibitions. She is the founder of two florilegia in the San Francisco area, at Quarryhill Botanical Garden and at The Gardens at Heather Farms. She is the co-founder of the Alcatraz Florilegium and the *Florilège de Brécy* in Normandy, France.

She has served on the board of directors of the American Society of Botanical Artists for many years and is a member of the Société Française d'Illustration Botanique.

Colleen Werner

Colleen Werner was born in Sydney in 1956 and currently lives in Birdwood in regional NSW. She qualified with a Bachelor of Art in Visual Arts at the City Art Institute before taking up botanic art. She has exhibited since 2003 in the *Botanica* exhibition at the Royal Botanic Garden, Sydney, and has exhibited extensively in South Korea and China as well as in Australia. She was a finalist in the Museum of South Australia's Waterhouse Natural Science Art Prize in 2010, and in 2011 when she was awarded a Highly Commended. Her work is found in the Bundanon Trust Foundation Collection, the Port Macquarie Hastings Council collection, and in the NSW Arts Council collection.

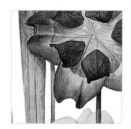

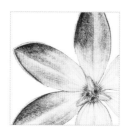

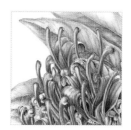

Marion Westmacott

Marion Westmacott was born in Sydney in 1940 and began her employment as an architectural draftsperson. Her botanical career began illustrating grasses 35 years ago in the outback of the Northern Territory, and she has since had an extensive career as a botanical artist, teacher and natural history illustrator. While working at the Royal Botanic Garden, Sydney, she produced illustrations for their many scientific journals including *Flora of Australia*, later illustrating numerous books including the eight Key Guides to Australian flora, fauna and exploration as well as The Australian Animal Atlas.

Marion has received several awards, including a Wilderness Society Award for Children's Literature in 1996. She has exhibited extensively since 1981 in Australia and overseas, including in Denmark, the UK and Japan. Her work is found in the Shirley Sherwood Collection and numerous private collections worldwide.

Hazel West-Sherring

Hazel West-Sherring was born in Kingston upon Hull, England, in 1957. She holds a BA (Hons) in Graphic Design and Art History from Canterbury College of Art and worked as a graphic designer for 15 years in London followed by 10 years of teaching art and craft.

Hazel has exhibited with the SBA in London, at the RHS where she was awarded a Gold Medal in 2005 and Silver-gilt in 2010, at the Shirley Sherwood Gallery in Kew as well as at the ASBA/HSNY in New York and the Hunt Institute for Botanical Documentation. She held a solo exhibition of her prints at the Garden Museum in London. Her work is in the collections of the Hunt Institute, *The Highgrove Florilegium*, RHS Lindley Library and at the Royal Botanic Gardens, Kew. Hazel is a Fellow of the Linnean Society of London.

Sue Wickison

Sue Wickison was born in 1958 and raised in Sierra Leone, West Africa. She has an Honours degree in Scientific Illustration from Middlesex University and worked at the Royal Botanic Gardens, Kew for nine years as an illustrator. She was awarded a Winston Churchill Fellowship to travel to the Solomon Islands to collect orchids for Kew, resulting in publications and an orchid, *Coelogyne susanae*, named after her. Sue has travelled extensively, illustrating agricultural and forestry publications in the Solomon Islands, Nepal and Vanuatu.

Sue has held solo exhibitions in London and New Zealand and is represented in the Shirley Sherwood Collection, the Alisa and Isaac M Sutton Collection, in the Hunt Institute and in the Royal Botanic Gardens, Kew collections. She was awarded a London RHS Silver Medal in 2006 and a Gold in 2008. She has been twice awarded the Joyce Cuming Presentation Award by the SBA and twice a Certificate of Botanical Merit. She has produced over 50 natural history stamp designs for several countries including New Zealand, where she now lives.

Author biographies

Jennifer B Wilkinson

Jennifer Wilkinson was born in Launceston, Tasmania, in 1947. After retiring from her career as a registered nurse, and many years of artistic exploration in watercolour and other media, she took up botanic art in 1996. She has taught vocational botanic art classes for 10 years and teaches painting.

Jennifer has exhibited in the Royal Botanic Gardens, Melbourne *Art of Botanical Illustration* biennial exhibition since 1996 and held many solo exhibitions in Launceston, Hobart and Scottsdale in Tasmania. She was awarded the Celia Rosser Medal for Botanical Art at the Royal Botanic Gardens, Melbourne in 2008, and is represented in *The Highgrove Florilegium* and the State Botanical Collection at the National Herbarium of Victoria.

Colleen Morris

Colleen Morris initially worked as a pharmacist before turning to garden history. She undertook a Master of Heritage Conservation at the University of Sydney and in 1992 began a long association with the Daniel Solander Library at the National Herbarium, Royal Botanic Garden Sydney.

Since 1994 Colleen has worked as a landscape heritage consultant. She devised the Colonial Plants database for the Historic Houses Trust of NSW and has prepared conservation plans for some of Australia's most significant historic gardens, including the botanic gardens of Adelaide and Sydney and Sydney's Government House and Domain. Colleen was the National Chair of the Australian Garden History Society 2003–2009. Her publications include *Terrace Houses in Australia* (1999), major entries for *The Oxford Companion to Australian Gardens* (2002), and *Lost Gardens of Sydney* (2008).

Louisa Murray

After completing a Bachelor of Science in 1979, Louisa Murray worked with the Australian Heritage Commission in Canberra and the National Parks of New South Wales in Sydney before embarking on her career at the National Herbarium of New South Wales, Royal Botanic Gardens, Sydney. She started work in the herbarium in 1981 when it was still housed in its historic building. She has worked in seven different positions, mostly working with the herbarium collection, identifying plants for the general public, and working on the 11-year project of producing the *Flora of New South Wales* books with Gwen Harden. She is currently the Flora Botanist and spends her time working at the back end of PlantNET, the database of the Plant Information Systems in the herbarium, updating all botanical information and distribution data for the *Flora of New South Wales*, NSWFloraOnline.

Louisa has a wide knowledge of plants and has travelled extensively in New South Wales and also in parts of other Australian states, collecting specimens for the herbarium. She is particularly interested in daisies and violets.

Select bibliography

Anderson, RH, *An A.B.C. of the Royal Botanic Gardens, Sydney*, 1965

Arnold, Marion I & Rourke, John P, *South African Botanical Art: Peeling Back the Petals*, Fernwood Press in association with Artlink, South Africa, 2001

Bennett, George, *Gatherings of a Naturalist in Australasia*, John Van Hoorst, Paternoster Row, London, UK, 1860

Blunt, Wilfrid & Stearn, William T, *The Art of Botanical Illustration*, Antique Collectors' Club in association with Royal Botanic Gardens, Kew, Woodbridge, UK, 1994

Botanical Art School of Melbourne, *The Government House Florilegium Victoria*, Lothian Custom Publishing, Melbourne, 2010

Brown, Andrew P, *Flower Paintings from the Apothecaries' Garden*, Antique Collectors' Club, Woodbridge, 2005

Brown, Andrew, *Botanical Illustration from Chelsea Physic Garden*, Antique Collectors' Club, Woodbridge, 2015

Calaby, John (ed), *The Hunter Sketchbook: Birds & Flowers of New South Wales drawn on the Spot in 1788, 89 & 90 By Captain John Hunter RN of the First Fleet*, National Library of Australia, Canberra, 1989

Charles, Prince of Wales, *The Highgrove Florilegium: Watercolours depicting Plants grown in the Garden at Highgrove*, Addison Publications for The Prince's Charities Foundation, London, UK, 2008

Churchill, Jennie (ed), *The Royal Botanic Garden, Sydney: The First 200 Years*, Halstead, Sydney, 2015

Clark, Dymphna (ed), *Baron Charles von Hügel, New Holland Journal*, Melbourne University Press at the Miegunyah Press in association with the State Library of NSW, Melbourne, 1994

Collins, Kevin, Collins, Kathy & George, Alex, *Banksias*, Blooming Books, Melbourne, 2008

Desmond, Ray, *Sir Joseph Dalton Hooker*, Antique Collectors' Club with Royal Botanic Gardens, Kew, 1999

Fox, James et al., *Rory McEwen: The Colours of Reality*, Royal Botanic Gardens, Kew, Richmond, UK, 2013

Gilbert, Lionel, *The Royal Botanic Gardens, Sydney, A History 1816–1985*, Oxford University Press, Melbourne, 1986

Hay, Alistair, Gottschalk, Monika & Holgun, Adolfo, *Huanduj: Brugmansia*, Florilegium, Glebe, NSW, 2012

Hewson, Helen, *Australia: 300 Years of Botanical Illustration*, CSIRO Publishing, Melbourne, 1999

Hooker, William Jackson, *Botanical Miscellany*, Vol. 1, John Murray, London, UK, 1830

Hyams, Edward & MacQuitty, William, *Great Botanical Gardens of the World*, Thomas Nelson and Sons, London, UK, 1969

International Exhibitions of Botanical Art & Illustration of the Hunt Institute for Botanical Documentation, *Catalogues* (1964–2013, 1st to 14th)

Kress, John W & Sherwood, Shirley, *The Art of Plant Evolution*, Royal Botanic Gardens, Kew, Richmond, UK, 2009

Maiden JH, *A critical revision of the genus Eucalyptus*, Government Printer, Sydney, 1903–1933

Maiden JH, *The Forest Flora of New South Wales*, William Applegate Gullick, Government Printer, [for] the Forest Department of New South Wales, Sydney, 1903–1924

Maiden, JH, *A Guide to the Botanic Gardens, Sydney*, William Applegate Gullick, Government Printer, 1903

Maiden JH, assisted by WS Campbell, *The Flowering Plants and Ferns of New South Wales*, Department of Mines and Agriculture (Forest Branch), New South Wales, Charles Potter, Government Printer, Sydney, 1895–1898

Morris, Colleen, *Lost Gardens of Sydney*, Historic Houses Trust of New South Wales, 2008

Morrison, Gordon, et al., *Capturing Flora: 300 Years of Australian Botanical Art*, Art Gallery of Ballarat, Australia, 2012

Orchard, AE & TA, *King's Collectors for Kew: James Bowies and Allan Cunningham, Brazil 1814–1816*, Australia, 2015

Pinault, Madeleine, *The Painter as Naturalist: From Dürer to Redouté*, Flammarion, Paris 1991

Riviere, Marc Serge (ed), *The Governor's Noble Guest, Hyacinthe de Bougainville's account of Port Jackson, 1825*, Miegunyah Press, Melbourne, 1999

Rix, Martin, *The Art of the Botanist*, Lutterworth Press, Guildford & London, UK, 1981

Rosser, Celia, *The Banksias: Watercolours by Celia Rosser*, Handbook to Vols. I and II, Handbook to Vol. III, Monash University in association with Nokomis Publications, Melbourne, 1993, 2001

Rosser, Celia E & George, Alexander S, *The Banksias*, 3 Vols, Academic Press, London, 1981–2000

Sherwood, Shirley, *A New Flowering: A Thousand Years of Botanical Art*, Ashmolean Museum, Oxford, UK, 2005

Sherwood, Shirley, *A Passion for Plants*, Cassell & Co, London, UK, 2000

Sherwood, Shirley, *Contemporary Botanical Artists: The Shirley Sherwood Collection*, Weidenfeld & Nicholson, London, UK, 1996

Sherwood, Shirley & Rix, Martyn, *Treasures of Botanical Art: Icons from the Shirley Sherwood and Kew Collections*, Royal Botanic Gardens, Kew, Richmond, UK, 2008

Short, PS (ed), *History of systematic botany in Australasia*, Australian Systematic Botany Society Inc, Melbourne, 1990

Smith, James Edward, *A specimen of the botany of New Holland*, Vol 1, Printed by J. Davis: Published by J. Sowerby, London, UK, 1793

Tomasi, Lucia Tongiorgi, *An Oak Spring Flora: Flower Illustration from the Fifteenth Century to the Present Time*, Oak Spring Garden Library, Upperville, VA, 1997

van Druten, Terry (ed), *Pierre-Joseph Redouté: Botanical Artist to the Court of France*, Haarlem Teylers Museum, Rotterdam, 2013

van Gelderen, CJ & DM, *Maples for Gardens: A Color Encyclopedia*, Florilegium, Australia, 1999

Walker, Miss AF, '*Flowers of New South Wales*, painted and published by Miss A. F. Walker of Rhodes, Ryde, Parramatta River, NSW', Turner & Henderson, Sydney, 1887

Watts, Peter, Pomfrett, Jo Anne & Mabberley, David, *An Exquisite Eye: The Australian Flora and Fauna Drawings 1801–1820 of Ferdinand Bauer*, Historic Houses Trust of New South Wales, 1997

Zdanowicz, Irena, *Beauty in Truth: The Botanical Art of Margaret Stones*, National Gallery of Victoria, Melbourne, 1996

Index

*Numbers in italics
refer to an illustration*

Acacia implexa 142, *143*
Acer griseum 172, *173*
Aikawa, Mariko 164, *165*, 200
Allen, Beverly 9, 84, 85, 92, 93, 94, 95, 106, 107, 180, 181, 194, 195, 200
Allocasuarina portuensis 190, *191*
Alloxylon flammeum 124, *125*
Anderson, James 16
Anderson, Robert Henry 18, 110, 112, 114, 124, 132
Angiopteris evecta 86, 87
Araucaria bidwillii 62, 63
Araucaria cunninghamii 46, *46–47*
Araucaria heterophylla 14, 18, 32, 33
Atkinsonia ligustrina 146, *147*

Banks, Sir Joseph 11, 14, 15, 22, 30, 58, 160
Banksia blechnifolia 160, *161*
Banksia integrifolia 30, 31
Banksia praemorsa 58, *58–59*
Barlow, Gillian 176, *177*, 200
Barringtonia neocaledonica 106, *107*
Bartrop, Sue 140, *141*, 201
Bathurst, Earl 14, 40
Battle, Christine 186, *186–87*, 201
Bauer, Ferdinand 9, 11, 14, 130
Bean, Deirdre 36, 37, 190, *191*, 201
Beard, Dr John 18
Begonia leathermaniae 162, *163*
Begonia venosa 134, *135*
Best, Margaret 110, *111*, 202
Bidwill, John Carne 16, 62, 64, 100
Bleasdalea bleasdalei 156, *157*
Bligh, William 14
Brachychiton bidwillii 100, *101*
Briggs, Dr Barbara 18, 140
Brown, Robert 14, 32, 50, 130
Brugmansia × candida 82, *83*
Brunet, Alfred and Effie 18, 132
Burrows, Helen Yvonne 96, 97, 202
Burton, David 14

Calathea zebrina 68, 69
Caley, George 14, 22
Camellia changii 192, *193*
Camellia azalea 192, *193*
Camellia japonica 'Cleopatra' 84, 85
Castanospermum australe 52, 53
Casuarina glauca 26, 27
Catchlove, Linda 90, *91*, 202
Chambers, Professor Carrick 12, 18, 19, 144, 176, 180
Child, Margot 9, 12, 13
Chippendale, George 18, 118
Chirnside, Deb 24, 25, 203
Citrus × virgata 'Sydney Hybrid' 122, *123*
Clivia miniata 96, 97
Condy, Gillian 128, *129*, 203

Crataegus persimilis 'Prunifolia' 114, *115*
Crocus tommasinianus 184, *185*
Cunningham, Allan 14–17, 46, 48, 50, 52, 54, 68, 92, 122, 142, 146, 158
Cunningham, Richard 15–16

Darnell-Smith, Dr George 17
Dendrobium engae × Dendrobium shiraishii 194, *195*
Dendrobium speciosum 34, 35
Dichorisandra thyrsiflora 92, 93
Dierama pendulum 70, 71
Diploglottis campbellii 120, *121*
Donnelly, Rosemary Joy 138, *139*, 203
Doryanthes excelsa 36, 37
Dowle, Elisabeth 78, 79, 122, *123*, 204
Dracaena draco 80, 81
Dunckley, Delysia Jean 146, *147*, 204

Elkan, Lesley 188, *189*, 204
Ellis, Kim 19
Entwisle, Dr Tim 12, 19, 180
Epiphyllum crenatum 94, 95
Erica verticillata 152, *153*
Erythrina crista-galli 'Hendersonii' 108, *109*
Eucalyptus copulans 188, *189*
Eucalyptus robusta 38, 39
Eucalyptus sideroxylon 'Fawcett's Pink' 158, *159*
Eucalyptus tereticornis 22, 23
Evans, Anne-Marie 9, 13, 215

Ficus macrophylla f. macrophylla 44, 45
Ficus rubiginosa 24, 25
Firmiana simplex 102, *103*
Fitzgerald, Helen Lesley 38, 39, 158, *159*, 205
Flindersia xanthoxyla 54, 55
Flockton, Margaret 17, 18, 78
Foster, The Hon. Gillian 70, 71, 174, *175*, 205
Fraser, Charles 14–15, 16–17, 19, 24, 28, 34, 36, 38, 40, 42, 44, 46, 48, 50, 52, 54, 56, 58, 66, 122

Gale, Leigh Ann 168, *169*, 205
Gardenia thunbergia 74, 75
Gordonia axillaris 112, *113*

Hardenbergia violacea 28, 29
Hashi, Mayumi 82, 83, 206
Hawkey, GF 17, 50
Hayes, Anne 54, 55, 206
Hibiscus insularis 130, *131*
Hodges, Cheryl 22, 23, 206
Hooker, Joseph Dalton 134, 182, 186
Hooker, William 15, 50, 52, 54, 62, 72, 92, 100, 104
Hoolihan, Tanya 80, 81, 207
Howarth, Frank 19, 180
Hughes, Annie 30, 31, 76, 77, 88, 89, 192, *193*, 207
Hydrangea sargentiana 174, *175*
Idiospermum australiense 136, *137*
Iris delavayi 176, *177*

Johnson, Lawrie 18–19, 188, 190

Kalopanax septemlobus 150, *150–51*
Kappagoda, Nalini Kumari 100, *101*, 207
Keteleeria fortunei 90, 91
Kidd, James 16, 60
Knowles Mair, Herbert 18, 132
Koo, Jee-Yeon 102, *103*, 208

Lapageria rosea 76, 77
Lilium auratum 98, 99
Liriodendron tulipifera 42, 43
Lober, Angela 13, 32, 33, 50, 51, 136, *137*, 208
Lophozonia heterocarpa 148, *149*

Mabberley, Professor David 19, 122
Macarthur, William 16, 26, 30, 52, 60, 62, 64, 84, 88, 92, 102, 142
Mackay, David 156, *157*, 208
Macleay (McLeay), Alexander 16
Macquarie, Elizabeth 14
Macquarie, Lachlan 14, 26, 32
Maiden, Joseph Henry (JH) 17, 22, 24, 38, 40, 48, 54, 78, 80, 82, 90, 102, 116, 118, 120, 122, 156, 188
Magnolia grandiflora 18, 60, 61
Magnolia sieboldii 178, *179*
Mahar, Elizabeth 86, 87, 209
Maple-Brown, Sue 13
McAnoy, Beth 118, *119*, 209
McGlynn, Fiona 72, 73, 209
McKinnon, Fiona 112, *113*, 210
McLean, John 15
McNab, William 15
Millettia grandis 118, *119*
Moore, Charles 16–17, 44, 50, 60, 64, 74, 76, 78, 80, 88, 98, 104, 106, 108, 138
Morris, Colleen 12, 13, 221
Munn, Maggie 142, *143*, 210
Murray, Louisa 13, 221
Murray, Stewart 15
Musgrave, Elaine 34, 35, 66, 67, 178, *179*, 182, *183*, 210

Narcissus 'King Alfred' 132, *133*
Nettleton, Julie 116, *117*, 134, *135*, 211
Nijgh de Sampayo Garrido, Dorothee 62, *63*, 64, *65*, 211
Nolan, Kate 44, 45, 211
Nothofagus obliqua 148, *149*

O'Connor, Anne 28, 29, 212
Ogilvy, Susan 148, *149*, 212
Oktober, Tricia 98, 99, 212
Opuntia ficus-indica 78, 79
Oxley, John 14, 46, 54

Pastoriza-Piñol, John 162, *163*, 213
Patterson, Annie 108, *109*, 213
Phillip, Captain Arthur 14, 32
Phillips, Jenny 9, 13, 60, 61, 209, 210, 213, 215, 217
Pieroni, Margaret 58, *58–59*, 214
Pinus pinaster 40, 40, *41*
Pinus roxburghii 66, 67
Podocarpus elatus 88, 89
Pomfrett, Jo Anne 11

Pragasam, Gabrielle 126, *127*, 214
Price, Penny 52, 53, 214
Pritchardia maideniana 116, *117*
Protea cynaroides 154, *155*
Prunus persica 'Versicolor' 138, *139*

Reeves, John 15, 84
Rhododendron dalhousiae 186, *187*
Rhododendron oldhamii 168, *169*
Robertson, Naismith 16
Rodd, Tony 18, 106, 130
Rosa chinensis f. *mutabilis* 144, *145*
Rosser, Celia 13
Rupp, the Reverend 18

Salamon, Marta 46, 47, 215
Sanger, Sandra 74, 75, 215
Sarracenia alata 170, *171*
Sarracenia leucophylla 170, *171*
Sarracenia unidentified species 170, *171*
Scaevola albida 140, *141*
Schotia brachypetala 110, *111*
Seale, Robyn 160, *161*, 215
Sherwood, Dr Shirley 9, 12, 13
Silburn, Laura 68, 69, 216
Slocock, Shirley 104, 105, 216
Spathodea campanulata 128, *129*
Steele, Halina 130, *131*, 216
Stenocarpus sinuatus 50, 51
Stones, Margaret 13
Strawson, Sally 114, *115*, 217
Strongylodon macrobotrys 166, *167*
Summerell, Dr Brett 7, 13, 19
Sutherland, Dianne 166, *167*, 217
Suttor, George 14
Syzygium jambos 56, 57

Telfair, Charles 15
Thomas, Narelle 144, *145*, 154, *155*, 217
Thomas, Vicki 152, *153*, 218
Thouin, André 15, 42
Tibouchina mutabilis 126, *127*
Tillandsia streptophylla 164, *165*
Trachycarpus fortunei 104, *105*

Veitch, John Gould 16, 50, 106

Wallace, Dr Ben 18
Wallich, Nathaniel 15, 66
Walsmit Sachs, Anita 132, *133*, 172, *173*, 218
Walter, Ruth 26, 27, 42, 43, 218
Ward, Edward 17
Watanabe, Noriko 150, *150–51*, 219
Waterhousea floribunda 48, 49
Watters, Catherine M 56, 57, 219
Watts, Peter 11
Werner, Colleen 48, 49, 120, *121*, 219
West-Sherring, Hazel 184, *185*, 220
Westmacott, Marion 170, *171*, 220
Wickison, Sue 124, *125*, 220
Wilkinson, Jennifer B 40, *40–41*, 221
Wollemia nobilis 19, 180, *181*
Worsleya procera 182, *183*
Wran, Neville 18

Zygopetalum maculatum 72, 73

Acknowledgement of subscribers

The Society gratefully acknowledges the generosity of our subscribers who supported the publication of this Florilegium.

Australian Garden History Society, Southern Highlands Branch
Australian Garden History Society, Sydney and Northern New South Wales Branch
Tony and Tor Bannon
Dr Pamela Bell OAM
Michael and Margaret Best
Bluepoint Consulting Pty Ltd
Botanical Art Society of Australia Inc – From the Madeleine Taylor Bequest
Botanical Artists' Society of Queensland Inc
Prof. Carrick Chambers and Mrs Margaret Chambers
Margot Child
Dr WB and Cecelia Clarke
Peter and Penny Curry
Elizabeth Davis OAM
Pam Duncan
Eden Gardens
Jane Garling
Raoul de Ferranti
Alexander and The Hon. Gillian Foster
Foundation & Friends of the Botanic Gardens
Deirdre and Peter Graham
Ruth and Jim Hallmark
Frances and Andrew Happ
In memory of Charles William Hermann Hinze
Dale Howe
Prof. Bob Kearney AM & Mrs Hope Kearney
Prof. Lynne Madden and Prof. Peter Sainsbury in memory of Mr Noel and Mrs Kathleen Madden
Susan Maple-Brown
Mrs BM Matthews (Barbara)
Mary-Rose McDonald
Beverly Allen in memory of Ethel Mitchell
Dr Richard Morris and Colleen Morris
Peggy M Muntz
Prue Socha
Howard Tanner AM and Mary Tanner
Brenda and Phil Venton
Malcolm Wilson
Catherine M Watters
Dr Tony White AM and Mrs Doffy White
William Fletcher Foundation
Karen and Alastair Wilson
Josette Wunder
Anonymous (two)